THE RONALD S. LAUDER COLLECTION

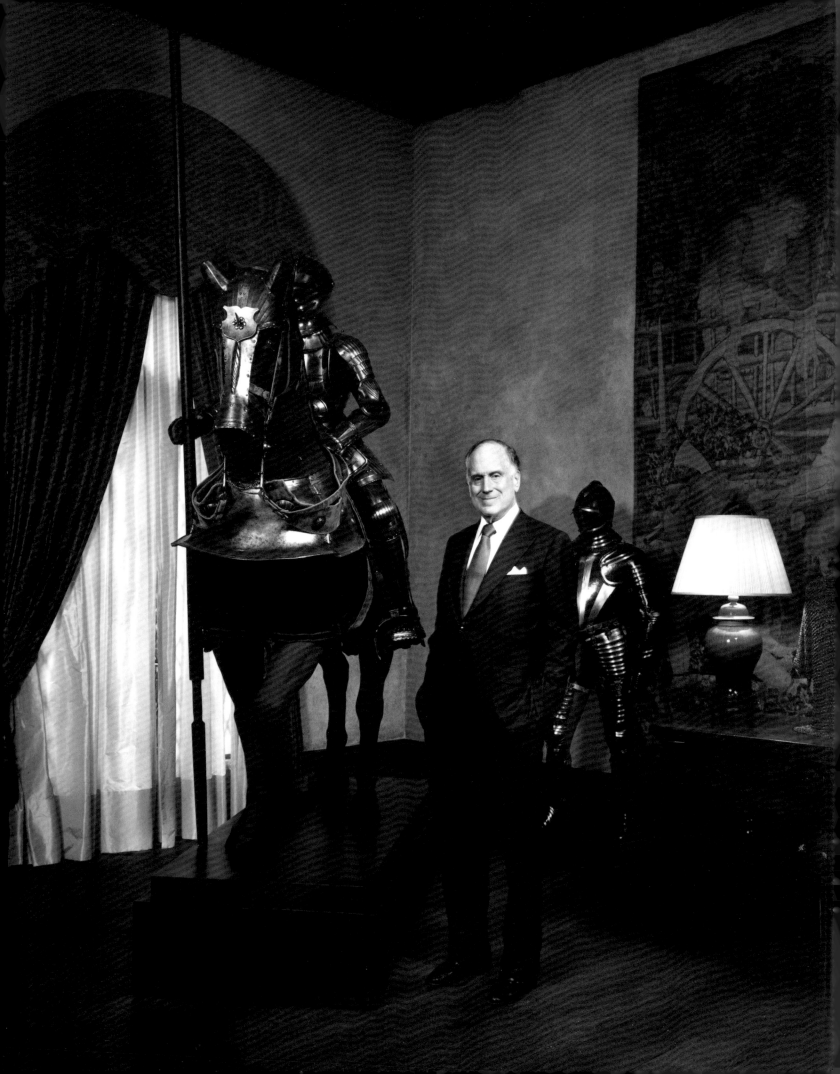

THE RONALD S. LAUDER COLLECTION

SELECTIONS FROM THE 3RD CENTURY BC TO THE 20TH CENTURY

GERMANY, AUSTRIA, AND FRANCE

With preface by Ronald S. Lauder,
foreword by Renée Price,
and contributions by Alessandra Comini, Stuart Pyhrr, Elizabeth Szancer Kujawski,
Ann Temkin, Eugene Thaw, Christian Witt-Dörring, and William D. Wixom

PRESTEL

MUNICH • LONDON • NEW YORK

This catalogue has been published in conjunction with the exhibition
The Ronald S. Lauder Collection: Selections from the 3rd Century BC to the 20th Century. Germany, Austria, and France

Neue Galerie New York, October 27, 2011 – April 2, 2012

Director of publications: Scott Gutterman
Managing editor: Janis Staggs
Editorial assistance: Liesbet van Leemput

Curator, Ronald S. Lauder Collection: Elizabeth Szancer Kujawski

Exhibition designer: Peter de Kimpe
Installation: Tom Zoufaly

Book design: Richard Pandiscio, William Loccisano / Pandiscio Co.
Translation: Steven Lindberg

Project coordination: Anja Besserer
Production: Andrea Cobré
Origination: royalmedia, Munich
Printing and Binding: APPL aprinta, Wemding

for the text © Neue Galerie, New York, 2011
© Prestel Verlag, Munich · London · New York 2011

Prestel, a member of Verlagsgruppe Random House GmbH

Prestel Verlag
Neumarkter Strasse 28
81673 Munich
+49 (0)89 4136-0 Tel.
+49 (0)89 4136-2335 Fax
www.prestel.de

Prestel Publishing Ltd.
4 Bloomsbury Place
London WC1A 2QA
+44 (0)20 7323-5004 Tel.
+44 (0)20 7636-8004 Fax

Prestel Publishing
900 Broadway, Suite 603
New York, NY 10003
+1 (212) 995-2720 Tel.
+1 (212) 995-2733 Fax
www.prestel.com

Library of Congress Control Number: 2011933700

British Library Cataloguing-in-Publication Data: a catalogue record for this book is available from the British Library; Deutsche Nationalbibliothek holds a record of this publication in the Deutsche Nationalbibliografie; detailed bibliographical data can be found under: http://dnb.ddb.de

Prestel books are available worldwide. Please contact your nearest bookseller or one of the above addresses for information concerning your local distributor.

ISBN 978-3-7913-5164-3

Verlagsgruppe Random House FSC-DEU-0100
The FSC-certified paper *Galaxi Supermatt* was supplied by Papier-Union, Ehingen.

FRONTISPIECE: Ronald S. Lauder in his home, autumn 2008, standing between a knight and charger in German armor, 1515–30 (left), and an Italian suit of armor, circa 1600–10. Also on the right is a detail of the *Les Bûcherons* tapestry, third quarter fifteenth century. Photograph by Mark Heithoff
PAGE 6: Ronald S. Lauder, Paris 1992. Photograph by Lillian Birnbaum

IN MEMORIAM

I would like to dedicate this publication
to the curators and dealers
who helped me develop my collection.

Ronald S. Lauder

Thomas Ammann
Alfred H. Barr, Jr.
Heinz Berggruen
Ernst Beyeler
Leo Castelli
Marianne Feilchenfeldt
Stephen Grancsay
Stephen Hahn
Leonard Hutton
Harold Joachim
Otto Kallir
Felix Landau
William Lieberman
Dorothy Miller
Edward R. Lubin
Peter Nathan
William S. Rubin
Kirk Varnedoe

and especially
Serge Sabarsky

ACKNOWLEDGEMENTS

Maria Altmann, Los Angeles †
Art Installation Design, New York
Paul and Stefan Asenbaum, Vienna
Peter Bacanovic, New York
Brett Dolin, New York
Melissa Chumsky, New York
Sari Goodfriend, New York
Alessandra Comini, Dallas
Jodi Hauptmann, New York
Reinhold Heller, Chicago
John Herring, New York
Paul Herring, New York
Max Hollein, Frankfurt am Main
Peter de Kimpe, Amsterdam
Hermes Knauer, New York
Hulya Kolabas, New York
Pamela Kort, Berlin
Elizabeth Szancer Kujawski, New York
Donald LaRocca, New York
Phyllis La Riccia, New York
Steve Lebron, New York
Liesbet van Leemput, New York
Steven Lindberg, Berlin
Chris Linnane, Cambridge, Mass.
Jill Lloyd, London
William Loccisano, New York
Susanne Metz, New York
Cassity Miller, New York
Vlasta Odell, New York
Richard Pandiscio, New York
Olaf Peters, Hanover
Ernst Ploil, Vienna
Alexandra Polson, New York
Stuart Pyhrr, New York
Howard Ricketts, New York
Jerry Rivera, New York
Eduard Sekler, Vienna
Peter Selz, Berkeley
Valentina Spalten, New York
Patty Tang, New York
Ann Temkin, New York
Eugene Thaw, Cherry Valley
Christian Witt-Dörring, Vienna
William D. Wixom, Pawling
Marilynn T. Van Dunk, New York
Bryonie Wise, Toronto
Tom Zoufaly, New York

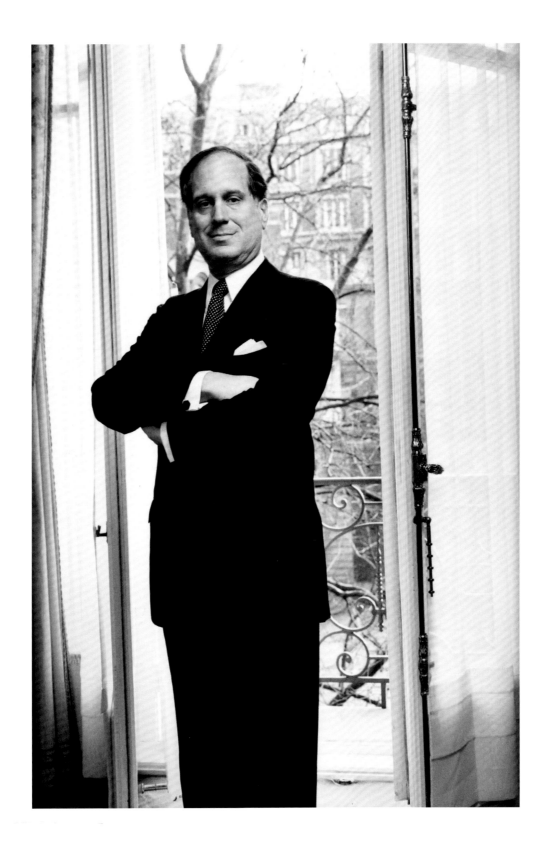

CONTENTS

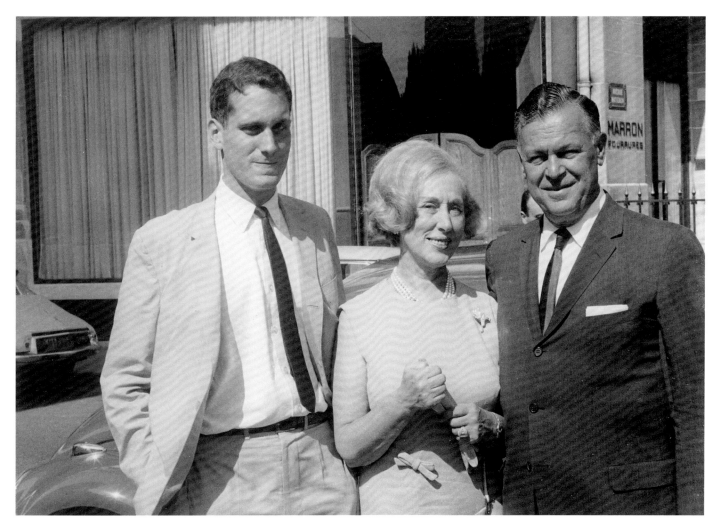

1. Ronald S. Lauder with his parents, Estée and Joseph Lauder, Paris, 1959

PREFACE

Passion. That is the one word that captures the absolute love and dedication I have had for collecting art throughout my life. A long time ago, I read a book by Pierre Cabanne about great collectors in which he describes collecting as a kind of addiction. And although he meant that in the most benign sense, I immediately recognized that I was afflicted with that addiction right from the start. It is impossible for me to imagine my life without my works of art.

People have always assumed that I inherited this trait from my family. Although my parents had many wonderful qualities as well as their own passions, collecting art was not one of them [Fig. 1]. But we tend to find like-minded people as we move through our lives—people who influence us, teach us, and guide us. These are people, I believe, who recognize in a younger person the same qualities they see in themselves. Mentoring comes naturally to them. I have been a very fortunate man, indeed, for I have had many extraordinary mentors in my life.

When I was a young teenager, I was invited to dinners at the home of Florence Gould [Fig. 2] in the south of France. Florence, along with her late husband, Jay Gould, had assembled a great collection of French Impressionist art. That was really the first time I understood the sheer joy that comes from living with pieces of extraordinary art around you every day. Their home, with all of its wonderful paintings, simply fascinated me. Florence spotted that interest and guided me as a friend and mentor.

Another life-changing experience occurred when I went to visit Lawrence Herring [Fig. 9], the father of my schoolmates, John and Paul Herring. Lawrence had arranged an entire wall filled with nineteenth- and twentieth-century drawings. That wall mesmerized me. It was the first time I realized just how wonderful drawings could be on their own and that one could be quite satisfied collecting just drawings. (Of course, someone could be satisfied collecting only drawings, but not me.)

The late 1950s and early 1960s in New York was one of those unique moments in time—a period when art and creativity simply explode. Vienna was like that fifty years earlier. That's the environment I was raised in—this is my New York. One glittering night, my parents brought me to a dinner at the

2. Florence Gould, 1936. © Laure
Albin-Guillot / Roger-Viollet

3. Bottom left: Jo Carole Lauder
with Constantin Brancusi *Fireplace*
and 1917 painting, *Suprematist
Composition (No. 31), Black
Trapezoid*, by Kasimir Malevich

4. Bottom right: Alfred H. Barr, Jr.,
Dorothy C. Miller, and James
Thrall Soby, The Museum
of Modern Art, New York

Metropolitan Museum of Art on the occasion of a Pierre Bonnard painting being gifted to the museum by Florence Gould. I sat at a table filled with the great collectors from 1950s New York. Their donations grace the walls of the Metropolitan, the Modern, and the National Gallery today. Just try to imagine a wide-eyed teenager sitting with that high-powered group and taking it all in. That night in that great museum, I just sat there and dreamed of being either a great art collector, a great drawing collector, or a great medieval collector. The next day, I ran into Florence Gould and told her my dream. I still remember her response. She freed me from my own self-limitations by simply asking, "Why not be all three?"

My one guiding principle to buying art is actually quite simple. I always purchase what I consider to be an artist's best work. This is my formula: I divide all art into three categories: The *Oh …* the *Oh my …* and the *Oh my God*. My goal from early on was to only buy the *Oh my God*.

But how do you know what is the best? Everyone talks about having a great eye but that's not a gift given out at birth. It is simply a combination of knowledge and passion—but still, you have to be willing to do the work. My method is to buy all the books about an artist that are available, including a catalogue raisonné, look at all the pictures, see the works in museums, and research the auction catalogues. Today, my art library is huge, but without it, I would never have been able to distinguish the *Oh my God* from the merely *Oh*. I have never gone wrong in buying the best. All of the mistakes I have made came when I thought that a work's rarity would make up for its not being great.

Regret is also unavoidable. Financiers look back at companies they should have bought. Stockbrokers think about IBM in the 1950s or Apple in the '70s. I wish I knew then what I know now, as I would have surely acquired many more masterpieces. But money and art are always intertwined. Growing up, I was always short of money because of my pas-

5. Ronald S. Lauder and William (Bill) S. Rubin at the opening for *Picasso and Portraiture: Representation and Transformation,* The Museum of Modern Art, New York, April 24, 1996. The Museum of Modern Art, New York. The Museum of Modern Art Archives, New York. Photograph by Patrick McMullan

sion to pay any price to obtain a work that I wanted. But this had its pluses and minuses. I always paid top prices, but at the same time, dealers knew that if they had the *Oh My God* piece, they would offer it to me first.

I will admit that, as a teenager, I was out of step with many of my friends. I spent many hours after school learning to recognize great works of art and the prices they were selling for. When everyone else went off to the movies or sports events, I spent most of my time at The Museum of Modern Art. I loved wandering through the galleries, looking at the great works, and trying not just to take it all in but to understand it. I developed my own system of educating myself. I would concentrate on one piece and one piece only during a visit—looking at it from all sides, studying it, knowing it. Even at that young age, I realized that everything I was viewing in that building was in the *Oh My God* category. I knew the galleries, the hallways, even the stairwells at MoMA as well as I knew

my own home. Spending time there was like visiting friends, except that the paintings spoke to me in a way that no human being could. It was at that institution that I was destined to spend the next fifty years of my life—first on committees, then as a young Trustee, and eventually as Chairman of the Board of Trustees, and now as Honorary Chairman, with David Rockefeller.

I had the honor of meeting some of the Modern's giants—Alfred Barr, the museum's brilliant first director; Dorothy Miller, one of the its great curators [Fig. 4]; Blanchette Rockefeller, who served as president and was the daughter-in-law of one of the three founders, Abby Aldrich Rockefeller; and the legendary Bill Rubin, the Chief Curator of the Department of Painting and Sculpture, who taught me so much [Fig. 5]. Later, I worked closely with his successor, Kirk Varnedoe [Fig. 6], especially on a great show of Viennese art.

Today, when I walk through the rooms of the

6. Kirk Varnedoe at the opening of *Vienna 1900: Art, Architecture, and Design,* Museum of Modern Art, New York, 1986

7. Eugene Victor Thaw. Photograph by Sari Goodfriend, October 2010. © Sari Goodfriend Photography

Modern, I see old friends, and I am transported back to my first glimpse of an Alberto Giacometti sculpture, an Edward Steichen photograph, a Paul Klee drawing, or the magic of Matisse and Picasso. I used to imagine what my ideal collection would be, and it was The Museum of Modern Art that set the standard.

Eugene Victor Thaw [Fig. 7] was not only a fabulous collector but also the first private art dealer I ever knew. He had a wonderful collection of Old Master and nineteenth-century drawings. Shortly after we met, Gene offered me a 1923 Vasily Kandinsky painting entitled *Black Form*. It had everything one could want in a Bauhaus Kandinsky. That was also the first work of art I purchased for my parents [Fig. 8].

One day, Gene called me and said he had a great painting to show me; he would not tell me what it was. After going to the theater, Jo Carole [Fig. 3] and I went to Gene's apartment and saw Paul Cézanne's *Man with Crossed Arms* [Fig. 1, p. 24]. I thought I had seen it originally at the Guggenheim Museum, as well as in Bill Rubin's great exhibition at the Modern about Cézanne's great late works. But Gene explained that this was a different painting. Cézanne apparently liked the subject so much, he painted two versions of it, each time solving different problems. The painting had once been called *The Clockmaker*. It was bursting with color, and the man it portrays seems to signify France, with all its layers of complexity. His face, although not broken into cubes, had five different planes. I was mesmerized, and of course bought it on the spot. Today, although there are several great Cézannes in my collection, *Man with Crossed Arms* still holds a certain mystery for me.

8. Joseph Lauder and Estée Lauder with Vasily Kandinsky's *Black Form*, New York, 1982

Harold Joachim at the Art Institute of Chicago, and Bill Lieberman, who was first at MoMA as Curator of Drawings and later at the Met, taught me how to look at drawings. Through them, I realized that drawings really allowed you to see what was in the artist's mind. They helped me to understand my works by Seurat, Cézanne, Vincent van Gogh, Edgar Degas, as well as modern masters such as Klee, Kandinsky, Picasso, and Matisse. I've never regretted any of the drawings I purchased.

The Middle Ages is another period that has always fascinated me. There is an interesting connection between the ancient world and the Renaissance. But to me, there is something unbelievably exciting about finding ivories from the eleventh and twelfth centuries, or bronzes or aquamaniles or works in gold or beautiful colored windows or parts of churches. These objects had a long history and were some of the greatest works ever made, done by nameless artists with a sense of beauty and timelessness. Ed Lubin was a private dealer who found me some of the greatest works of art of the last thousand years. Bill Wixom [Fig. 10], then Chief Curator of Medieval Art at the Metropolitan and at the Cloisters, taught me about this subject and made it come alive with all its excitement and history.

I received my first antique pistol and sword from a friend of my father when I was twelve. I was fascinated by all types of arms and armor, but it wasn't until Stephen Grancsay, Curator of Arms and Armor at the Metropolitan Museum, came to my office with Prescott Andrews to tell me about the Otto von Kienbusch Collection that was going to the Philadelphia Museum of Art that my interest was fully aroused. Howard Ricketts, a Lon-

don dealer, started finding me helmets and suits of armor from some of the finest craftsmen of the fifteenth and sixteenth centuries in France, Germany, Italy, and Spain. They told me that there were still a few pieces in private hands and that, although I would not be able to have as great a collection as von Kienbush, there were still great helmets and suits of armor. Although I find parade armor very beautiful, the armor that was used in battle is more striking in its simplicity.

Today, it is very rare to find great pieces of armor. Stuart Pyhrr [Fig. 11], who is now Curator of Arms and Armor at the Metropolitan Museum, has been an invaluable source of information about many of my pieces, and has done an amazing job at the Metropolitan displaying this work.

At the same time that I started collecting drawings and paintings, I also began to collect decorative arts. At first, it was Art Nouveau, and along with my acquisition of Toulouse-Lautrec posters, there were design examples by Hector Guimard. This was soon followed by my then developing interest in turn-of-the-century Vienna, especially in the works of Josef Hoffmann, Otto Wagner, Koloman Moser, and Adolf Loos. In this realm, I was fortunate to meet Paul and Stefan Asenbaum and Christian Witt-Dörring, all of whom continue to advise me on the Viennese additions to the collection. Concurrently, I became interested in Art Déco; the art of Emile-Jacques Ruhlmann; Jean Prouvé; and the Bauhaus masters. In recent years, key works by more contemporary designers such as Isamu Noguchi, Shiro Kuramata, and Alvar Aalto have entered the collection. I followed my instincts and collected each designer in depth, trying to get every great example they produced.

9. Lawrence (Larry) Herring and his wife Gladys Herring, Majorca, 1976

10. William D. Wixom

11. Stuart Pyhrr, Curator and Head of the Arms and Armor Department, Metropolitan Museum of Art. Photograph courtesy Metropolitan Museum of Art

Although there were many people who collected Matisse and Picasso paintings, there were very few who collected their drawings and sculptures. I have always looked for their drawings and sculpture made between 1904 and 1939. I feel that Constantin Brancusi [Fig. 12] was the greatest sculptor of the twentieth century. Over the last thirty years I have taken advantage of every opportunity I could afford to buy his works. I never tire of seeing his creations and each time I see something new.

One of the defining moments in my life came one afternoon when my brother, Leonard, brought me to meet Serge Sebarsky [Fig. 13]. I was only 25 and Serge was 56, but the two of us became immediate friends. Through Serge, there was a direct connection with a period of time that fascinated me the most—early twentieth-century Vienna, when the Expressionists cut the bonds that tethered art to the earth. Serge also had a breadth of knowledge that he was delighted to pass on to me. We became such close friends, spending many, many hours together talking about Schiele, Klimt, and Oskar Kokoschka. We would sit and debate about whose collection was better and whether a piece he had just purchased should be kept for him, made available to me, or sold. Many pieces in my collection bring back wonderful memories of those long afternoon discussions. The museum that bears this book's name was born of that friendship.

There were others, too. I found my way to the Galerie St. Etienne and its owner, Otto Kallir and his assistant, Hildegard Bachert, and later, his granddaughter, Jane Kallir. From them, I bought some of my finest Schiele paintings and Klimt drawings, as well as Oskar Kokoschka works. These artists

still give me the same thrill today as they did when I first laid eyes on them [Fig. 14].

Sometimes, when we take our steps in life, we don't always know why or where they are leading us. For me, this entire focus—from my education in art and my first purchases to my friendship with Serge Sabarsky, as well as my rekindled interest in the Jewish world—all came together with one painting, *Adele Bloch-Bauer I* by Gustav Klimt. This towering work carries with it the tortured history of Europe throughout the entire twentieth century—completed in Vienna in 1907 with its own personal intrigue, stolen by the Nazis, kept from its rightful owner, Maria Altmann, by the Austrians and, after decades of legal wrangling, finally repatriated. Adele Bloch-Bauer now resides as the crown jewel of the Neue Galerie, a fitting home for this enchanting woman.

In the last ten years before Serge Sabarsky died, we shared the dream of combining our two collections and creating a museum of German and Austrian art. Serge saw the ac-

12. Constantin Brancusi, Self-Portrait in his studio, Paris, 1933–34. Photograph by Georges Meguerditchian. Musée National d'Art Moderne, Centre Georges Pompidou, Paris, France

Most private collections are never seen in their entirety during the lifetime of the owner. If they are, it is limited to auction catalogues and magazine articles. But there is rarely the chance to actually see the collection as a whole. Although there are parts of my collection that are not on display here, most of the key works in every field are represented. It is my hope that a young collector out there will stroll into the Neue Galerie during this show and will be inspired as I was, such a long time ago in this great city.

Ronald S. Lauder
President, Neue Galerie New York

13. Left: Serge Sabarsky in his apartment at 110 Riverside Drive, ca. 1960

14. Below: Ronald S. Lauder with Egon Schiele's *Portrait of the Painter Karl Zakovsek*, New York, ca. 1995

quisition of the building that was to become the Neue Galerie, but sadly, he did not live to see the realization of our dream: the opening of the museum ten years ago. I know that what the Neue Galerie has become, with its quality and excellence, would fulfill his expectations and make him happy.

And none of this would have happened without the devotion of the Neue Galerie's first and only director, Renée Price, whom I first met in the 1970s when she worked as gallery director for Serge Sabarsky. Renée was there during those early discussions and has a clear understanding of the foundation of this institution like no one else.

A special thank you goes to Elizabeth Szancer Kujawski, who came to me first to catalogue my collection over two decades ago and has remained with me all this time as my curator. Her husband, Tom Zoufaly, and his loyal crew have moved these works a total of what must now be hundreds of miles. Their hard work and expertise brings this show to the public.

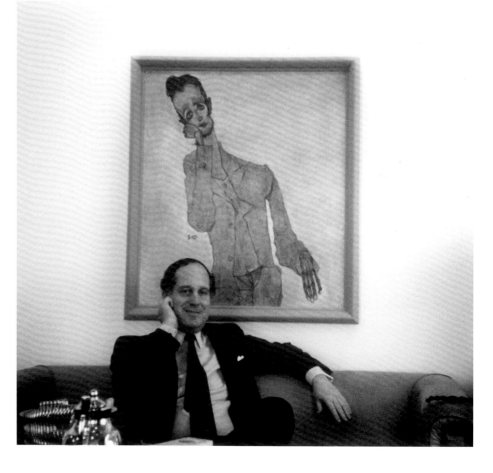

1. Neue Galerie New York. Photograph by Hulya Kolabas, 2009

FOREWORD

In November 2011, Neue Galerie New York [Fig. 1] celebrates its tenth anniversary. I remember well the excitement of installing our collection for the first time, and welcoming visitors into the newly renovated building after four arduous years of planning and construction. In fact, this journey really began in the mid-80s, when the Neue Galerie co-founders Serge Sabarsky and Ronald S. Lauder began to discuss creating a museum for German and Austrian art, with their collections as the foundation. I was honored to be part of those discussions, as I am now privileged to carry out their vision.

Serge Sabarsky played an important role in the development of the Ronald S. Lauder Collection. It started out in 1968 at the Sabarsky residence on Riverside Drive. Ronald and his brother Leonard came to view the large Egon Schiele drawings collection they had heard about and to have a Schiele drawing authenticated. That was the beginning of a thirty-year friendship between Serge and Ronald. Both men shared a passion for collecting art. Hardly a day passed during my seven-year tenure at the Serge Sabarsky Gallery without a phone call from Ronald to Serge. I witnessed Ronald calling

from all parts of the world, even—much to Serge's delight—while airborne [Fig. 2]. Serge, thirty-three years Ronald's senior, felt very proud of their close relationship.

Many a Sunday afternoon, the two men met at the Upper East Side gallery, in Serge's dim back office, to exchange views on works of art, politics, life, love and loss—often peppered with spicy jokes to keep things from becoming too serious [Fig. 3]. Art acquisitions were always a hot topic. After all, Serge was not only a collector, but also an art dealer and a shrewd businessman. He procured the finest works of Austrian and German Expressionism for himself and on behalf of his client and friend.

Among the masterpieces that passed through Serge's hands to the Ronald S. Lauder Collection was Gustav Klimt's *Forester House in Weissenbach on the Attersee* of 1914. In this bright canvas, which depicts the Attersee house where Klimt lodged during the summers of 1914–16, the artist pays tribute to the Post-Impressionist master Vincent van Gogh. Klimt focused on the elaborate painterly surface of the front garden and house façade, with the exception of one

square inch of impasto on the upper right window. There, the artist teases the viewer's eye to look through the house interior into a patch of green garden beyond. Ronald's mother, Estée, had a great fondness of this painting [Fig. 4].

The large *Jurisprudence* transfer drawing, dated 1902–03 [Fig. 5], from Klimt's doomed commission to decorate the ceiling of the University of Vienna's Great Hall, may be considered the most important Klimt work on paper in Ronald's collection. A naked old man with hands tied behind his back, surrounded by svelte sirens, is being judged, while an octopus menacingly spreads its tentacles. Vienna's conservative art establishment, including nearly ninety professors who signed a petition to thwart the commission, was not ready for Klimt's pictorial candor. After toiling away for ten years, the embittered artist withdrew from the disputed commission, and refrained from accepting further public assignments.

Serge had empathy for the plight of the artists he showed. He maintained a particu-

lar love for the younger Viennese modernists, especially Richard Gerstl, Oskar Kokoschka, and Egon Schiele. Among the many Schiele drawings and watercolors that came from Serge's private collection, three stand out: the 1910 *Portrait of the Painter Max Oppenheimer* [Fig. 6], depicting a fellow artist friend of Schiele, known then as Mopp. The distinct silhouette of Mopp's black coat, the seductive gaze at the viewer—with shadowed

eyelids and proud posture—epitomize the artist's exploration of self, coupled with the decadent attitude of the era. Schiele's 1910 *Reclining Male Nude* [Fig. 7], an emaciated, headless, contorted body—rendered in red and swiftly outlined with black chalk—is, in fact, a self-portrait. The artist made a series of these torsos with flayed skin, in which he excavates his inner core before his floor-length mirror.

Schiele's *Sturm und Drang* had subsided by 1917 in the *Portrait of the Composer Arnold Schönberg* [Fig. 8]. Although recruited into the Austrian army, Schiele had a desk job that allowed him to continue his artistic pursuits. Schönberg was already a prominent avant-garde composer, and Schiele captures the seated man's essence with black chalk outlines, omitting the armrest of the chair that the sitter's fingers are straddling. The cerebral intensity of Schönberg's gaze is eloquently played against the animated ripple of his creased vest and jacket sleeve.

Richard Gerstl was an academically trained painter who met Arnold Schönberg in 1906 and soon became part of the composer's inner circle. His *Portrait of a Man on the Lawn* [Fig. 9] was painted outdoors in 1907 while Gerstl summered with the Schönberg family. Gerstl's break with a naturalistic, academic style and his newly found open painterly technique was considered radical by his contemporaries. His stormy love affair with Schönberg's wife Mathilde, (who eventually returned to her husband and family), and his ensuing rupture with Schönberg and his circle, were contributing factors to Gerstl's suicide in 1908.

Both Ronald and Serge responded to the bold, raw nature of German Expressionist art,

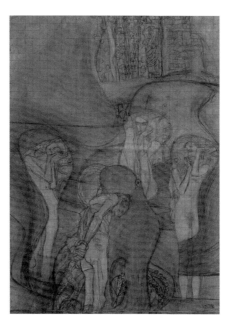

5. Gustav Klimt, Transfer drawing for *Jurisprudence*, 1902–03, black chalk and pencil on paper

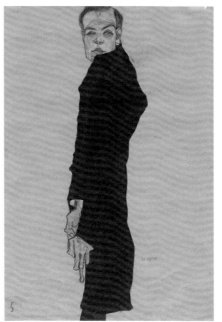

6. Egon Schiele, *Portrait of the Painter Max Oppenheimer*, 1910, watercolor, gouache, ink, and black crayon on paper

especially that of the Dresden architecture students who decided to become painters and formed the Brücke (Bridge) in 1905. But the endeavors of the more intellectual Munich-based artist group around Vasily

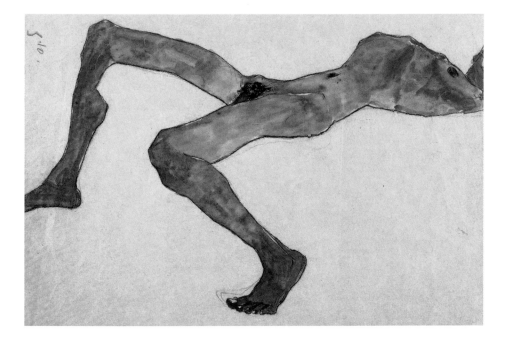

7. Above: Egon Schiele, *Reclining Male Nude*, 1910, watercolor and black crayon on paper

8. Right: Egon Schiele, *Portrait of the Composer Arnold Schön-berg*, 1917, watercolor, gouache, and black crayon on paper

August Macke, like Franz Marc, had a strong interest in French art, primarily Cubism and Orphism. He also absorbed the Impressionists' subject matter which was taken from daily life—street, café, and park scenes. *Strollers at the Lake II* [Fig. 11], of 1912, observes the lakeside activities of bourgeois burghers on the Bavarian lake Tegernsee. Ronald said he was drawn to Macke's Expressionist palette, combined with the faceless, abstract figures before the horizontal blue of the lake. Macke's heavy use of black and green add a powerful impact to the composition.

Serge, a Viennese émigré, related to the fact that Lyonel Feininger was considered an American in Europe and a German in America. Feininger, of German descent, was born and died in New York. But his formative artistic years, spent in Germany included visits to Paris, where he studied the work of the French Cubists. By 1906, Feininger had dis-

Kandinsky, Franz Marc, and August Macke, known as the Blaue Reiter (Blue Rider), also held their fascination and were often on view in the Serge Sabarsky Gallery. Gabriele Münter's *Kandinsky in Interior*, dated ca. 1912 [Fig. 10], captures the spiritual father of the Blue Reiter standing in the Munich living room he shared with Münter, holding his pipe. Originally the painting was larger and encompassed two couples, the art dealer who gave the Blaue Reiter their second exhibition, Hans Goltz, and his wife, along with Kandinsky and Münter. Dissatisfied with the composition, the artist cut away more than half of the canvas, leaving this fragment. Kandinsky's isolated in front of the table, which is set for *Nachmittagsjause* (afternoon tea). Two paintings hang on the wall behind him, a bold landscape above his head—possibly by Kandinsky—and, to his left, a still-life, probably by Münter. Serge would joke, "You get three pictures for the price of one!" That must have swayed Ronald to buy it.

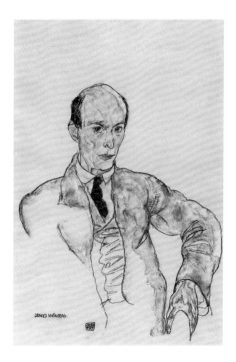

covered the small village church of Gelmeroda, a town outside of Weimar, which held an obsessive fascination for him for years to come. Feininger created a highly individual synthesis of Cubist and Expressionist pictorial language. The predominately yellow *Gelmeroda II* of 1913 [Fig. 12] is exemplary for this crystalline style, and was originally part of the Sladt Museum Dresden collection, until it was confiscated during the Third Reich. Serge relished the notion that the canvas was included in the *Entartete Kunst* (*Degenerate Art*) exhibition that toured Nazi Germany in 1937, yet survived the scorn and derision it endured and was placed into New York's finest private collection.

Of course, the Ronald S. Lauder Collection extends well beyond the realm of German and Austrian art, the areas in which Serge Sabarsky worked. As this tenth anniversary of the Neue Galerie approached, we began to wonder how we could do justice to the moment, and whether we ought to go beyond our core mission for the occasion. To date, we have mounted large-scale exhibitions devoted to Gustav Klimt and Egon Schiele, perhaps the two leading lights of our collection. We have shown the decorative arts of Josef Hoffmann and Dagobert Peche, as well as thematic exhibitions such as *Comic Grotesque: Wit and Mockery in German Art, 1870–1940* and our first photography survey, *Portraits of an Age: Photography in Germany and Austria 1900–1938*. We have traced entire art movements in *Brücke* and *Van Gogh and Expressionism*, and created shows focused on individual works, such as *Adele Bloch-Bauer I* by Klimt, *Self-Portrait with Horn* by Max Beckmann, and *Berlin Street Scene* by Ernst Ludwig Kirchner. We have also shown the collection of our late co-founder, Serge Sabarsky.

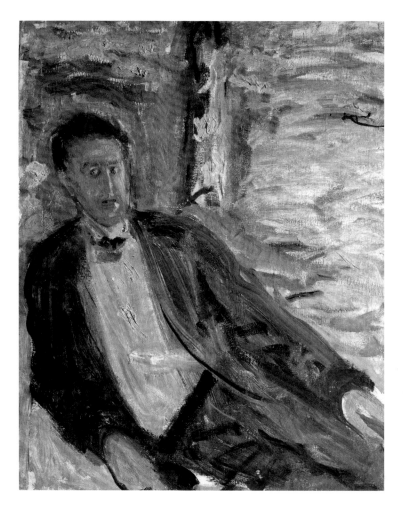

In the end, we did decide to go beyond our stated mission for this occasion, and turned to the entire collection of our other co-founder, the driving force behind the museum, Ronald Lauder. Having consistently displayed his German and Austrian art and design, we decided to show the broad spectrum of his collecting interests. Capturing this range is quite a challenge, as Ronald maintains a passionate interest in so many different kinds of art: arms and armor, medieval and renaissance painting, master drawings, and modern and contemporary art. We pay homage to our original mission by focusing on German and

9. Richard Gerstl, *Portrait of a Man on the Lawn*, 1907, oil on canvas

Austrian art and design in the modern and contemporary sections of the exhibition.

The main principle uniting all these broad collecting interests is an absolute, instinctual dedication to quality. Ronald has the vision and temperament to identify greatness in art very quickly, and he has the conviction and courage to follow through and acquire masterworks. The result is no less than one of the finest private art collections in the world. Ronald joins me in expressing our deep gratitude to special friends and colleagues who played important roles in helping the Neue Galerie reach this milestone occasion. Thanks go to our esteemed advisory board members—Reinhold Heller, Max Hollein, Jill Lloyd,

Ernst Ploil, Olaf Peters, Carl Schorske, Peter Selz, Eduard Sekler, and Christian Witt-Dörring—who have all contributed so much to setting the direction for our museum; five from this group have also organized exhibitions for the Neue Galerie. From the outset the brothers Paul and Stefan Asenbaum have been our valued Viennese partners. Wilfried Utermann remains a most loyal German confidant. Kurt Gutenbrunner has made the Café Sabarsky a sought-after destination through his rigorous dedication to Austrian cuisine. Special thanks are due to Alessandra Comini for her friendship and guidance.

Architect Annabelle Selldorf oversaw the magnificent building renovation with her team. It has been an honor to collaborate with guest curators Monika Faber, Josef Helfenstein, Annegret Hoberg, Pamela Kort, Roland März, and Tobias Natter. Every installation from the past ten years has been carried out under the guiding hand of Tom Zoufaly. He has expertly worked with our exhibition designers: John Vinci, Lawrence Kenney, Peter de Kimpe, Jerry Neuner, and Federico de Vera. We take our hat off to them all and thank them for their keen vision. For the tenth anniversary show in particular, exhibitions designers Peter de Kimpe and Tom Zoufaly discovered a way to present a tremendous amount of a material in a very elegant manner. Curator Elizabeth Szancer Kujawski used her extensive knowledge of the Lauder Collection to help cull the finest works from it, and to place them in a broader context. The designers of this catalogue, and in fact our entire graphic identity program, Richard Pandiscio and Bill Loccisano, brought their brilliant creativity to bear. The entire Neue Galerie family, including Scott Gutterman, our steadfast deputy director; Sefa Saglam, director of exhibitions and registrar; Janis Staggs,

10. Gabriele Münter, *Kandinsky in Interior*, ca. 1912, oil on canvas on panel. Private Collection

11. Left: August Macke, *Strollers at the Lake II*, 1912, oil on canvas. Private Collection

12. Right: Lyonel Feininger, *Gelmeroda II*, 1913, oil on canvas. Private Collection. © 2011 Artists Rights Society (ARS), New York / VG Bild-Kunst, Bonn

associate curator; Michael Voss, preparator; and Leah Ammon, communications manager helped bring this exhibition to life.

We have been fortunate to receive gifts of artwork from several important individuals: Leonard Lauder, who donated a complete set of Wiener Werkstätte postcards; the late Maria Altmann, who presented the museum with two George Minne sculptures, which proudly flank the portrait of Adele Bloch-Bauer; and the Manley family, which graciously donated to the museum a magnificent Egon Schiele landscape. All have contributed greatly to the legacy of the Neue Galerie.

My most profound thanks, though, are reserved for Ronald Lauder himself. I consider myself privileged to be a close friend of and to work with this fascinating, complex, and most generous man. In presenting his collection, we honor the endless quest to assemble and share works of art that exude strength and beauty. They give comfort and speak to the best qualities of human en-

deavor. They represent a gift and an inspiration beyond all measure.

The warmth with which the Neue Galerie has been embraced by the public is a blessing to all who have been involved in giving it shape. May it thrive for decades to come.

Renée Price
Director, Neue Galerie New York

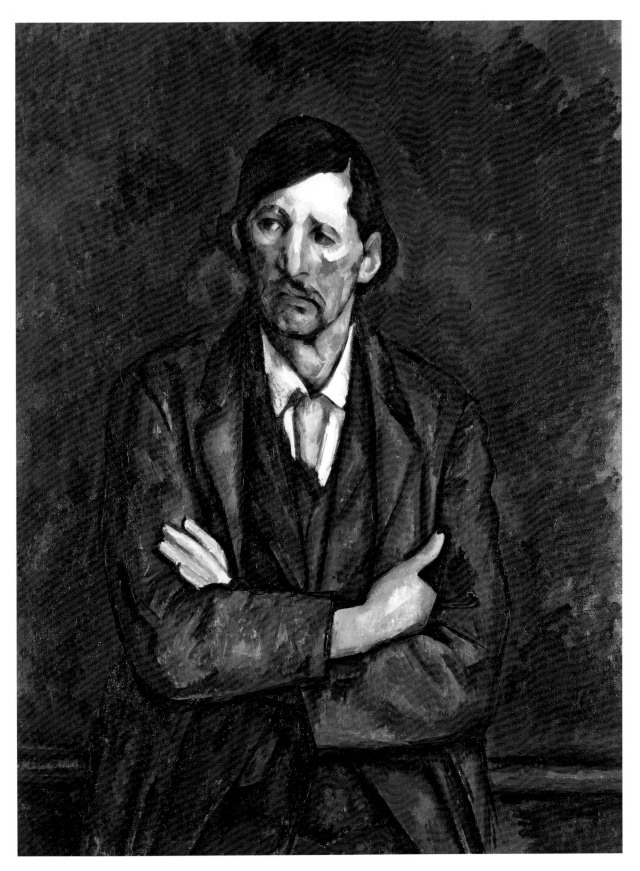

1. Paul Cézanne, *Man with Crossed Arms*, ca. 1899, oil on canvas

ELIZABETH SZANCER KUJAWSKI

From Wish List to Collection

The memory remains incredibly vivid of that November morning, some twenty-eight years ago. It was a Saturday, and Ronald Lauder had invited me to his family home to view his already notable art collection. I had been familiar with some of the extraordinary works, and we had been discussing the possibility of cataloguing the collection with a view to eventually writing and publishing a catalogue for scholarly purposes.

When I entered, I was introduced to Jo Carole Lauder and led past the imposing vitrines of medieval objects and a salon-style installation of Picasso drawings. I entered into the library, a room so visually engaging that I would remain forever awestruck. It was an art historian's dream. The works, spanning the centuries, encompassed early Netherlandish drawings, eighteenth-century works on paper by David, Gericault, and Delacroix, Cézannes and other major nineteenth-century artists, as well as arms and armor and furnishings, all brilliantly presented. A variety of European helmets were lined up on a shelf, opposite full suits of armor and horse helmets, or shaffrons. The mid-eighteenth century Combe Abbey Library Table, attributed to Thomas Chippendale, was placed upon an intricately designed Louis XIII Savonnerie carpet. As I toured the room, I was welcomed by Ronald's declarative statement, "I guess I don't have to tell you what you are looking at—you know these artists." A lively dialogue ensued, the first of what would soon grow into an ongoing daily exchange of ideas and rapport that we still share today.

Animatedly, Ronald introduced me to the latest addition to the collection, a magnificently rendered Cézanne, *Apples and Inkwell* (ca. 1902–06) [Fig. 2], a gift that he had recently received to mark the occasion of his fortieth birthday. This colorful watercolor and pencil drawing of Cézanne's last years hung in the library below a beautifully drawn work *Full-Length Portrait of The Artist's Son*, (ca. 1885–86) [Plate 172], executed during a period when the artist focused more on the contrasts of black and white rather than on a line as a definition of form. These were surrounded by a group of other equally significant works on paper by Degas, Seurat, Van Gogh and Toulouse-Lautrec. Today, this same wall, where I had gotten my first view of ten stellar pieces, displays twice as many works, and overall, the collection has grown twentyfold.

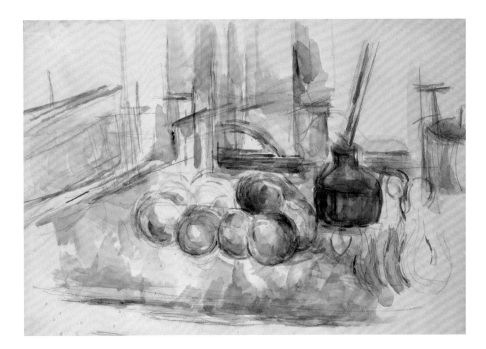

The tour continued into a small study, filled with prime examples of twentieth-century German and Austrian works on paper, complemented by Austrian furnishings of the Wiener Werkstätte. A tightly installed group of some twelve Schieles, including the highly emotive charcoal and wash of 1910, *Self-Portrait with Arm Twisted above Head* [Plate 223], surrounded by Klimt drawings on one wall, was juxtaposed with carefully chosen pieces by Klee, Grosz, and Heckel on another.

I have been asked many times if Ronald's interest in this area was borne out of his experience as the American Ambassador to Austria in the late 1980s, but it was in fact an early focus developed during his teenage years. With a passionate and instinctive appetite for art, Ronald Lauder had already concentrated on specific areas of collecting as a very young man. Not having descended from a family of collectors, as was the case with many other earlier art enthusiasts, inspirations about art came from his studies, as well as an interest in foreign languages and his frequent travels abroad, which included museum and private collection visits. Early on, he was aware of historically known collections as well as those of the later twentieth century formed by Florence Gould (1895–1983), Germain Seligman (1904–1978), and Nelson A. Rockefeller (1908–1979), to name just a few; he had even had the distinct privilege of viewing some of them. It has often been mentioned how Ronald purchased his first works of art as a teenager. It is true that, at age 14, he purchased a work by Schiele and another by Klimt, against his parents' wishes. The Schiele watercolor, of a girl with striped stockings, now belongs to The Leopold Museum; he still owns the Klimt drawing.

We proceeded to the living room, where Constantin Brancusi's marble *Bird in Space*, [Fig.

3] had recently been installed. The first of Ronald's ten Brancusi sculptures, including a mantelpiece, and the only one that he owned at that time, it had been familiar to him and to me from the collection of Governor Nelson A. Rockefeller. I had worked for Governor Rockefeller as an assistant curator and had long been inspired by this extraordinary sculpture, which I had seen earlier in the 1969 exhibition, "Twentieth-Century Art from the Nelson Aldrich Rockefeller Collection."[1] Its fascinating history has become part of the piece itself. Carved from a single block of white marble, and among the tallest of Brancusi's forty-one *Birds*, a theme that preoccupied the artist from 1908 through the 1950s, it captures the essence of flight in endless space. From 1923 on, Brancusi depicted his birds soaring in flight, and the concept of a solid weighty mass defying gravity, ascending upward, allowed for limitless possibilities.[2] Brancusi sold this sculpture directly to the collector, Mrs. Charles C. Rumsey, in 1929–30; it then went by descent to her son, Charles C. Rumsey. It was purchased by Lee A. Ault, the collector and art dealer, in 1948. In 1952, Nelson A. Rockefeller acquired this dynamic statuesque masterpiece through the dealer Curt Valentin and installed it at Kykuit, his home in Pocantico Hills. Later deaccessioned, it eventually found its way to the Lauder collection in 1982 through the art dealer and collector, Eugene Thaw.

Another vivid recollection from this first visit is the Cézanne, *Man with Crossed Arms* (ca. 1899) [Fig. 1], whose companion painting of the same subject, *The Clockmaker*, I had known well from the Guggenheim. In this portrait, which entered the collection in 1979, Cézanne presents a figure of contrasts and distortions, resulting in an expressive quality that has been likened to that of El Greco. In the facial features, there are upward movements on the right counteracted by downturning pulls on the left. Cézanne has created a spatial illusion as well. The head seems to rotate away from the background, allowing us to view it from several angles—an idea fully explored by the Cubists.[3] The man's pose, centralized and simple in manner, his wavy hair, parted and glowing in opposite directions, suggests a restlessness and tension in the figure.[4] There is also, however, a contrasting restraint in the figure's folded arms, a recurring theme in Cézanne's work. The crossed arms appear in Cézanne's work as early as the 1860s and later in works such as *Standing Peasant* (ca.1895), and in the standing figure of the larger version of *Cardplayers*, (1890–92), both in the Barnes collection. They suggest, perhaps, a melancholy resignation or a posture of self-restraint.[5] The symmetry and frontality of the figure are reminiscent of other Cézanne portraits such as *Portrait de M. Ambroise Vollard* (1899), Cézanne's dealer, in the Petit Palais, Paris. The unassuming attitude of the sitter is a quality that the artist also valued in himself.[6]

Cézanne depicted this sitter twice, a model who has never been identified. Although they are not identical, there is a great similarity in the portraits. The sitter may have been a farm worker at the Jas de Bouffan. Similar subjects served as models of other works by the artist.[7]

Ronald had been captured by this portrait when it was included in the 1977 exhibition, "Cézanne: The Late Work," and recalls that the owners had been noted on the label. A few months later, Eugene Thaw called to say that it was for sale, and that evening Ronald went

3. Constantin Brancusi, *Bird in Space*, ca. 1925, marble. © 2011 Artists Rights Society (ARS), New York / ADAGP, Paris

to see it. At the time, the price was the highest that Ronald had ever paid for a work or art, but he knew that it was a must for his collection.

As we slowly moved on to look at the arms and armor, Ronald took a moment to share his own personal grading system for works of art: *Oh…*, *Oh my…*, and *Oh my God*. He emphatically let me know that he was only interested in acquiring art that is in the *Oh my God* category, a philosophy and a passion that have guided him to this day. Before leaving, Ronald handed me the catalogue of the collection of Germain Seligman. The limited edition privately printed publication, with its full-page photographs, in-depth cataloguing details of historical significance, and aesthetically appropriate paper stock, was to serve as a reference guide for our endeavor. Ronald felt akin to this exemplary collector, with his broad range of interests, and over the years, he acquired two Seurat conté crayon drawings, a David drawing, and a late sixteenth century horseman's saddle ax from this collection.[8]

With Ronald's grading system in mind, I understood that I was about to embark on an exciting and challenging task to which I would be applying the same standards of excellence. We formulated our strategy, and I began by gathering and carefully researching whatever information and documentation was available on the collection. I would have access to the key figures who had influenced or mentored him on the acquisitions across multiple disciplines, including William D. Wixom and Edward R. Lubin, for Medieval art; Stuart Pyhrr and Howard Ricketts for arms and armor; William Rubin, Eugene Thaw, Ernst Beyeler, and John and Paul Herring for Modern Masters: and for German and Austrian works, Jane Kallir and Hildegard Bachert of the Galerie St. Etienne and, of course, Serge Sabarsky. Shortly thereafter, Christian Witt-Dörring and Paul and Stefan Asenbaum would begin to provide important advice regarding Austrian furnishings and decorations. Each work was studied, catalogued, and photographed, and we met on a regular basis to review the progress, whether in New York, Washington, or Vienna. Inevitably, our discussions would turn to pertinent exhibitions, upcoming auctions, recently received offers, and the wish list.

As I proceeded, an awareness of Ronald Lauder's discerning eye became increasingly apparent, though the distinct thread that has always run through his collections was also evident from the start. From our first discussions, I was captivated by Ronald's connoisseurship and keen visual memory and recognized his intellectual ability, as he possessed the knowledge to discuss and debate a work of art or concept with any art historian, artist, or critic. He only needed to view something once for it to become indelibly ingrained in his memory, and he could instantly recall when and where it had been seen. This kind of relationship to art— the ability to exist comfortably and knowledgably in the past as well as the present—is rare. His desire to work in a collaborative manner was a special opportunity for me, and I have been extremely fortunate to have participated in the development and expansion of one of the most important collections of our time. Through the years, we have created fine-tuned, synchronized methods of integrating the collection in terms of philosophy and growth.

Eclectic is a term often applied to this formidable collection. However, it is more a garner-

ing of collections across multiple disciplines to create something larger: a *Gesamtkunstwerk*. Ronald Lauder has successfully combined various art forms into a carefully orchestrated synthesis, resulting in a total artwork. Each personal space, from home to office, is like a declarative statement and understanding of art, design, and style, comprised of incredible art works complemented by specifically selected furnishings and decorations. He is the only person I know who has collected in so many different fields, amassing a collection spanning the centuries. From the earliest ivory or enamel medieval works to grand-scale contemporary examples by Bruce Nauman, Brice Marden, Gerhard Richter and Sigmar Polke, to work by the most contemporary video artists, it is a collection that rivals many that are housed in our most prominent institutions. Its furnishings are not only those of the Wiener Werkstätte or of the Bauhaus, but there are numerous examples of other noted designers in various media, including Alvar Aalto, Alberto and Diego Giacometti, Jean Prouvé, Jean-Michel Frank, Émile-Jacques Ruhlmann, Carlo Mollino, Gio Ponti, Carlo Scarpa, Isamu Noguchi, Shiro Kuramata, Fernando and Humberto Campana, Ron Arad, and many more.

Aside from a brief foray into the ancient world of Archaic Chinese bronzes, there has been, from the beginning, a devoted and consistent concentration in the collecting areas that we see today. Medieval art, arms and armor, the modern masters, the decorative arts, and German and Austrian works of art have been the main collecting areas for him. Each of the aforementioned areas has been approached with further qualification and specificity. The Medieval works are some of the finest in private hands; the arms and armor focus on European examples; the paintings of the Modern masters are supported by seminal drawings. According to Ronald, every artist has a special time in his or her career, especially in the case of the modern artists, and according to him, Picasso created his best works before 1935; therefore, there are no later works by him in the collection.

When we meet, I am usually greeted with the question, "OK, what've you got?" On any given day, we review auction catalogues that we have both marked, as well as any relevant offers. We compare and debate what lots should be researched and pursued. The follow-up steps have been performed countless times and do not have to be reviewed by us. New acquisitions is a topic that dominates many of our discussions, but there are other subjects that also come to the fore and typify how we interact: where to install newly purchased or framed pieces; conservation and storage issues; and how to respond to loan requests, to name just a few. From this range of details, there have been numerous outstanding memories and defining moments. What follows is a recounting of some of the most extraordinary experiences.

It was the fall of 1990. Ronald had been spending a good deal of time in Germany and Eastern Europe, focusing on various projects and aspects of The Ronald S. Lauder Foundation. Following our usual format, we each had reviewed the upcoming auction catalogues for the November sales. Having both targeted the extraordinary 1910 Kokoschka portrait of *Dr. Rudolf Blümner* [Fig. 4], we agreed that it was something to pursue. This painting of the lawyer turned actor had first been owned by Herwarth Walden, founder of *Der Sturm*, the Expressionist magazine and an art gallery that promoted young and unknown artists, Oskar

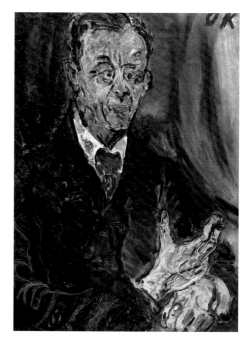

4. Oskar Kokoschka, *Dr. Rudolf Blümner*, 1910, oil on canvas. Private Collection. © 2011 Fondation Oskar Kokoschka / Artists Rights Society (ARS), New York / ProLitteris, Zürich

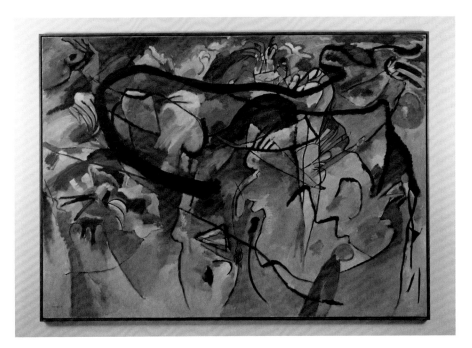

Kokoschka among them. (Note the bronze *Portrait of Herwarth Walden* designed by William Wauer in 1917 is also in the collection. [Plate 130]) I proceeded to follow up on this pursuit with all of the required due diligence prior to the sale date, and knowing that there would be great competition for this lot, we also discussed the estimate and assessed how high to bid in the hopes of being successful. After the sale, I phoned Ronald in Berlin to relay the positive results; however, I had concerns about how to convey that I had determined to go one bid above our agreed-upon price. I knew that ultimately Ronald wanted the work and would have been disappointed had he been the underbidder. I can still hear his silence on the other end of the line when I explained what I had done. And then his words: "I think that it's a great picture, don't you?"

The painting of Dr. Blümner was well-placed into the collection, which already featured other prime examples of Austrian art. Kirk Varnedoe's 1986 exhibition, at the Museum of Modern Art, "Vienna 1900, Art, Architecture and Design," included several of the earlier acquired works and a number of loans from other sources that would later join them. So, in 1990 when Ronald Lauder and Serge Sabarsky had begun to seriously discuss the idea of a German and Austrian museum of art for New York City, it was already with a certain vision in mind. From the 1960s, Serge had mounted monumental exhibitions in his Madison Avenue gallery, as well as traveling shows of German and Austrian Expressionist artists, so the concept of an American cultural institution that would promote scholarship in this field was something that they decided to make a reality. It was one of the usual phone calls from Ronald, but this time, in 1993, the request was quite different. "Elizabeth, I need to find a building. Serge has finally agreed to the museum project. Can you call a couple of brokers and find out

what's on the market?" By the end of the week, the three of us were headed on an expedition to find the perfect building. Up and down, as close to Museum Mile as we could explore, we visited a variety of available properties. 1048 Fifth Avenue had come to the market. This splendid 1914 edifice, designed by Carrère and Hastings, belonged to YIVO, the Institute for Jewish Research. The director gave us a tour of the building, explaining that it no longer fit the needs of his organization. We ascended to each floor, and by the time that we had exited onto the roof, I could see that Ronald and Serge both knew that this was to be their museum's future home, and the purchase was finalized in 1994. Serge's concepts have been thoroughly integrated into the Neue Galerie's design and exhibition programming. Although it is unfortunate that he was not able to experience the museum's final creation, as he passed away in 1996, Ronald Lauder has certainly made it a tribute to his memory.

The interest in post-war German and Austrian art developed as a parallel pursuit in the late 80s and early 90s. During those years, it was possible to acquire exemplary works in a variety of media by key artists of a certain generation: Georg Baselitz, Sigmar Polke, Gerhard Richter, Joseph Beuys, Anselm Kiefer, Markus Lupertz, Jörg Immendorff, Arnulf Rainer and Hermann Nitsch. These would soon be followed by additions from Martin Kippenberger and Albert Oehlen, among others. As it became more widely known that Ronald was now actively collecting in the realm, numerous offers came his way, and the selection was his.

Pursuit of the most sought-after pieces on one's wish list is the constant quest of a passionate collector, who keeps a steady eye on stellar works that could become available. The words "private collection" on an exhibition label or illustration reference engender hope that an acquisition might still be possible. For Ronald Lauder, some of these dreams have become realized through the years. Vasily Kandinsky's *Composition V* [Fig. 5] of 1911 was one such work on the wish list. Having first seen this extraordinary painting in 1983 in the collection of Josef Müller (1887–1977) in Solothurn, Switzerland, he knew that it was something to be

6. Henri Matisse, *The Backs I–IV*, 1909–30, bronze. © 2011 Succession H. Matisse / Artists Rights Society (ARS), New York

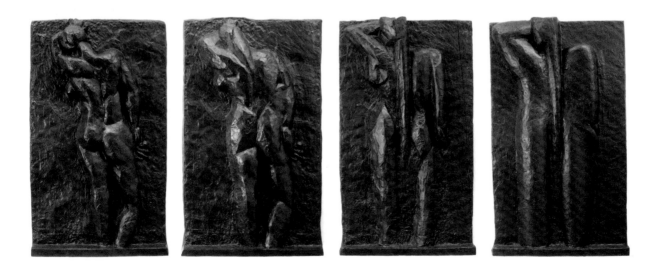

7. Max Beckmann, *Galleria Umberto*, 1925, oil on canvas. © 2011 Artists Rights Society (ARS), New York / VG Bild-Kunst, Bonn

coveted. By the time that Müller was in his early 20s, he had already amassed a number of significant works of art, and in 1913, he purchased *Composition V* directly from the artist. This painting, the most controversial of Kandinsky's oeuvre, had been rejected for inclusion in the 1911 exhibition of Neue Künstlervereinigung Munich, or Munich New Artist's Association, on the grounds that its dimensions were larger than the acceptable scale. Perhaps it was Kandinsky's experimentation with abstraction and pure painting that was the fundamental issue. Influenced by the Austrian composer Arnold Schönberg's (1874–1951) expressionistic music, specifically the Second String Quartet of 1908, Kandinsky discovered a new way to approach his developing aesthetic. Also known as *The Last Judgment*, *Composition V* is one in a series of seven compositions, but it is this composition in which the artist's transition from figurative painting to abstraction is most clearly evident. Although it continues the theme of the Resurrection, with its ethnographic motifs and symbolic references, the theme is veiled in abstracted forms and a dynamic color palette.[9]

In 1995, The Museum of Modern Art mounted the exhibition "Kandinsky Compositions," curated by Magdalena Dabrowski, and *Composition V*, then in a collection in Switzerland, was sent to New York for inclusion. Some four years later, Ronald was able to acquire this masterpiece, and soon after, I was on my way to Switzerland to accompany it to New York. Once again, its size posed a challenge, and in order for it to be installed, it had to be hoisted. We also used this opportunity to rig two acquired bronze states of *Nu du dos*, or "The Backs" by Henri Matisse [Fig. 6]. Numbers II and III, of 1913 and 1916–17 respectively, they had been in storage awaiting installation. The ultimate goal was to be able to acquire the two other backs in this series of four, and luckily, within two years, Numbers I and IV were offered to Ronald Lauder. Now, the viewer was able to experience Henri Matisse's manipulation of the female figure, from the more figurative depiction in *Back I* to its abstracted portrayal in *Back IV*. This monumental group of four Matisse *Backs* still remains as the only complete set in private hands. The others can be seen together in public institutions fortunate enough to have this sculptural group.

In curating this exhibition, I have researched my records of the last twenty-plus years. I also realized that we have made a number of yearly purchases in the "Oh my God" category and that Ronald has been able to regularly check off works from his wish list. For example, in 1991, a smaller auction house in France was selling the Brancusi *Fireplace* that the artist had created for Maurice Reynal, the art historian and critic. He had only made two examples of this sculpture. One of these is currently installed in the Atelier Brancusi, designed by Renzo Piano and located outside the Pompidou. Made of three very simple but weighty plinths of soapstone in 1933–34, this new purchase found no designated spot for installation. It remained in storage until 1996, when architectural changes in the Lauder home made it possible for it to be placed there among the other Brancusi sculptures that had been acquired by that time. For a collector to recognize a great work of art and to purchase it without having a designated placement, as in this case, takes determination and courage.

During this same five-year period, other key wish list pieces were acquired, including the

following paintings: Max Beckmann, *Galleria Umberto* (1925) [Fig. 7]; Joan Miró, *The Table* (*Still-Life with Rabbit*) (1920), exhibited in Miro's first one-man show in Paris in 1921 and well known from the Gustav Zumsteg collection in Zurich until its deaccession in 1995; Egon Schiele *Man and Woman I* (*Lovers I*) (1914) as well as the following sculptures: Marcel Broodthears, *White Cabinet and White Table* (1965) [Fig. 8]; Picasso's unique plaster bas-relief of Marie-Thérèse, *Head of a Woman* (1931) [Plate 107], and Richard Serra's *Intersection II* (1992) [Fig. 9], constructed of four Cor-ten steel massive curves, each 55 feet long and 13 feet high. Shown in 1993 at the Gagosian Gallery in SoHo, it has since been donated to The Museum of Modern Art and was installed in the museum's garden for a recent Serra exhibition.

The next five years brought the first two Matisse *Backs* and the Kandinsky *Composition V*, which were mentioned earlier. The amazing still life by Cézanne, *Still-Life with Drapery and Fruit* (1904–06) [Plate 101], where the artist clearly transitions to abstraction, had been a principal target on the wish list, and when it became available, we immediately entered negotiations. Soon afterward, Brice Marden agreed to sell his *Muses* (*Hydra Version*), 1991–97, with the intention that it go to a collection such as this. A mural-size canvas that the artist had reworked over a number of years in New York and in Hydra, it belongs to a body of work drawing on the theme of the Greek muses abstractly depicted with colorful lines and references to figures and places. Also acquired were the 1904 Picasso gouache and pastel on paper, *Woman*

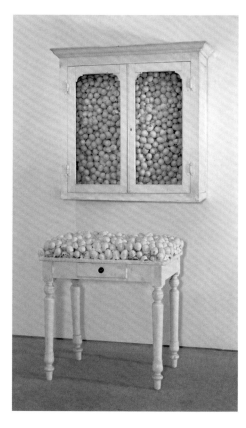

8. Marcel Broodthaers, *White Cabinet and White Table* 1965, wood, oil, and egg-shells. The Museum of Modern Art, New York. Fractional and promised gift of Jo Carole and Ronald S. Lauder. © 2011 Artists Rights Society (ARS), New York / SABAM, Brussels

9. Richard Serra, *Intersection II*, 1992, four plates of Cor-Ten steel. The Museum of Modern Art, New York, Gift of Jo Carole and Ronald S. Lauder. © 2011 Richard Serra / Artists Rights Society (ARS), New York

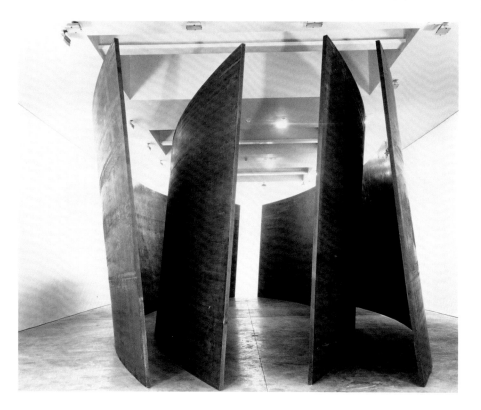

with a Raven [Plate 190], which clearly bridged the artist's evolution from the Rose period to the Blue, and the sofa with gilded feet by Jean-Michel Frank from the collection of Mr. and Mrs. Nelson A. Rockefeller.

Future additions included the exemplary Lighting Table (ca. 1953) by Jean Prouvé and Charlotte Perriand; an important group of arms and armor from the renowned Gwynn Collection; Alberto Giacometti's *Disagreeable Object*, an early Surrealist sculptural wood form from 1931 [Plate 115]; and Robert Rauschenberg's monumental painting, *Rebus*, of 1955 [Fig. 10]. Of all of the highlights that I could describe, and there are many, the acquisition of the restituted portrait painting *Adele Bloch-Bauer I* of 1907 by Gustav Klimt [Plate 116] was one that has no rival.

The most exciting thing for me now is to look ahead as to what might be added during these next 10 to 20 years. We have a wish list that, unfortunately, grows smaller each year, as more and more pieces become part of public collections, but just as this wish list seems to shrink, new works are added to it in more unusual fields. As I look back on the last twenty-eight years, with a realization of the fulfillment of so many objectives, I also look forward to the possibilities that lie ahead.

Most great collectors only come to light after they die and their collections are bequeathed to museums. Sometimes, the public has to wait for decades to see these extraordinary works of art. Through the years, we have shown many pieces in one exhibition or another, but it was Ronald's typically generous decision to share his collection all at one time on this special celebratory occasion of the tenth anniversary of the Neue Galerie. It is not only a question of what is in this collection, but also the philosophy behind it, as well as the relationship among the pieces. The works certainly speak for themselves, but the man whose collecting philosophy established this extraordinary melding of artistic disciplines is also a creative participant in the dialogue.

Every collector has a philosophy of what to acquire. Some buy only in one area; others are driven by monetary value. Still others reflect the contemporary art of their time. Some collections are inherited and then augmented as a means of having instant visual culture or a demonstration of wealth. It is extremely rare, however, that a true connoisseur's collection is created. In the French meaning of the word, Ronald Lauder is a true "amateur" in that he has assembled such an outstanding and diverse collection driven only by his passion for great art.

To work so closely with this extraordinary collection has been a unique adventure. To have been involved with some 4,000 objects covering a broad range of collecting areas, across a multitude of cultures, and dating from the 3rd century BC to the present, is a rare opportunity that few curators have. As I reflect on these years filled with a broad range of exciting experiences and interactions that have marked my career, it is the relationship with Ronald and Jo Carole Lauder that I most appreciate and for which I am forever grateful.

NOTES

1 William S. Lieberman, *Twentieth-Century Art from the Nelson Aldrich Rockefeller Collection,* The Museum of Modern Art, New York, Distributed by New York Graphic Society Ltd., Greenwich, Connecticut, 1969, p. 15, illus. p. 61.

2 Radu Varia, *Brancusi,* Rizzoli, New York, 1986, pp. 221–222.

3 E. Loran, *Cézanne's Composition,* University of California Press, Berkeley and Los Angeles, 1943, pp. 90–91.

4 William Rubin, ed., Theodore Reff, "Painting and Theory in the Fine Decade," *Cézanne The Late Work,* The Museum of Modern Art, New York, Distributed by New York Graphic Society, Boston, 1977, p. 21.

5 Ibid.

6 Ibid., p.22.

7 Ibid., p. 21.

8 John Richardson, ed., *The Collection of Germain Seligman, Paintings, Drawings, and Works of Art,* privately printed, 1979, nos. 16, 71, 72, 119.

9 John Golding, *Paths to the Absolute: Mondrian, Malevich, Kandinsky, Pollock, Newman, Rothko,* Still, Thames & Hudson, London, 2000, pp. 96, 98, illus. p. 66.

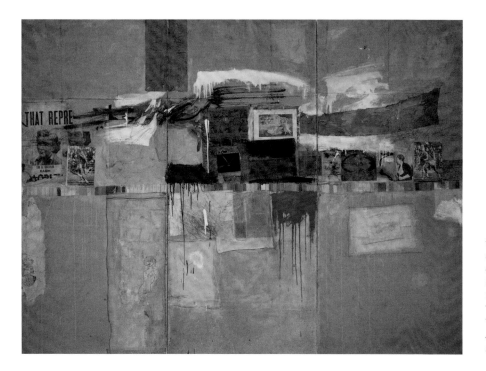

10. Robert Rauschenberg, *Rebus*, 1955, combine painting: oil, paper, fabric, pencil, crayon, newspaper, and printed reproductions on canvas (three panels). © 2011 Estate of Robert Rauschenberg / Licensed by VAGA, New York, NY. The Museum of Modern Art, New York. Partial and promised gift of Jo Carole and Ronald S. Lauder and purchase

ELIZABETH SZANCER KUJAWSKI

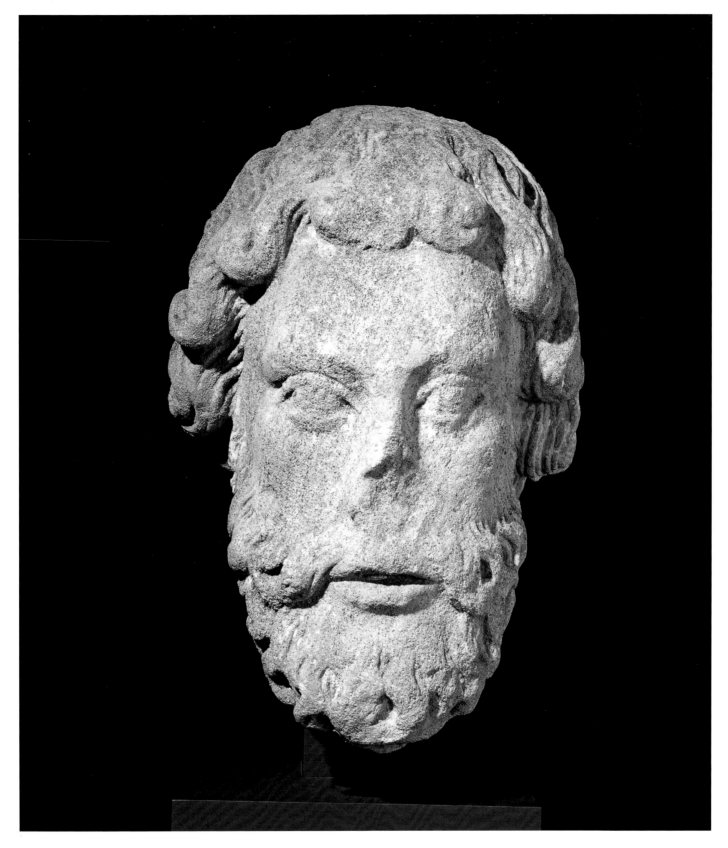

1. *Head of an Apostle*, Northeastern France, Thérouanne, ca. 1235, limestone

WILLIAM D. WIXOM

Medieval Art

The formative period during the youth of any major collector is not always known. In conversation with Ronald Lauder, my inquiries brought to light several significant facts in this regard. The cultural milieu of his parents led to his introduction in about 1964 to the collector Florence Gould (1895–1983). This occasion, at a dinner at The Metropolitan Museum of Art, led to an invitation to Mrs. Gould's home in the south of France near Cannes. Mr. Lauder acknowledges the major impact on him of this visit. The breadth of his host's collecting interests included Impressionist, Post-Impressionist, and early modern paintings and drawings, as well as French book bindings, period furnishings, jewelry, and a series of medieval works of art; some of the latter were clustered in a gothic room [Fig. 2].[1] Mrs. Gould's ensembles were a catalyst to learn more, and an extensive reading program ensued.

Perhaps a less dramatic formative influence, also cited by Mr. Lauder, were his visits to museums here and abroad. The Metropolitan, the Walters, the Wallace Collection, and the Belvedere each played a special role.

It has been my observation that acute perceptions and deeply felt aesthetic experiences underlie the most personally formed collections, and this applies to the medieval works of art assembled here. As acquisition opportunities are rarely predictable, the elements of choice and resolve are imperative when they do occur. Mr. Lauder has not been shy at these moments. While alert art dealers and experienced auction personnel are of great importance, the direction of interest and actual decisions depended on this collector's developed sense of the artistic integrity and quality of each work of art under review. On occasion, imperative art historical factors have also come into play. Over the years of active collecting, this medieval collection developed almost as a series of extremely worthy representatives and masterpieces of key periods in the evolution of Celtic, Migration, Early Christian, Byzantine, Ottonian, Romanesque, and Gothic art.

An expansion of this collector's taste and knowledge cannot be easily demonstrated because both attributes were highly notable from the beginning. For example, the monumen-

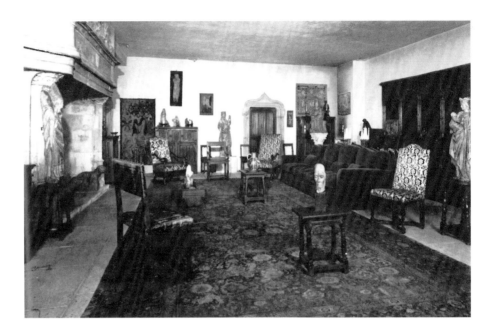

tal limestone *Head of an Apostle* [Fig. 1, Plate 34] from Thérouanne Cathedral was purchased in late 1978 when Mr. Lauder was only thirty-four. Just as significant acquisitions have followed during the decades since. As a result, the subsequent remarks will not focus on the dates of purchases, but will instead be framed within broad art historical categories or headings.

CELTIC METALWORK, THIRD CENTURY BC

The broad periods of Celtic culture, Hallstatt and La Tène, spread over the six centuries before the birth of Christ.[2] Elements of the culture continued during the late Roman period and into the early medieval period. The variety of surviving artifacts derive from a multiplicity of grave finds and other sites across the face of Europe and Britain and from discoveries from shipwrecks scattered across the eastern Mediterranean. A plethora of examples are undocumented.

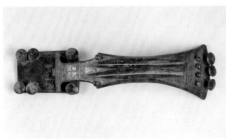

3. *Military Girdle Clasp or Buckle
with Arched Back*, Celtic,
third century BC, copper alloy

The two large copper alloy *Military Girdle Clasps* or *Buckles*, third century BC, make a dramatic introduction to the collection. The decoration on the attenuated and arched example [Fig. 3, Plate 4] includes narrowly engraved borders, large and small knobs, and two tapered strengthening ridges. The larger knobs are the terminals for the attachment dowels to the lost leather girdle or belt. The second example [Plate 4], apparently of high tinned bronze, also exhibits engraved borders, in this instance elegant rope twists at their centers. In bold contrast is the balanced orchestration of fourteen large knobs. The two plates of each work are secured together with a broad hook on the underside of one plate fitting into a rectangular open slot in the other. This mechanism is found in clasps from the Andalusian region of the Iberian peninsula.

ART OF THE GERMANIC MIGRATING PEOPLES, FIFTH THROUGH SEVENTH CENTURIES AD

The earrings, buckles, and radiate-headed bow brooches in worked gold, cast silver gilt and copper alloy are key representatives of the portable art of the migrating tribes of the early middle ages.[3] Colorful inlays of garnet and glass enhance many pieces. The Lauder collection provides a variety of examples, each exhibiting exquisite craftsmanship as well as tribal and geographical range. The Goths, initially from South Russia and northwest of the Black Sea, spread westward, the Ostrogoths (East Goths) to Italy and the Visigoths (West Goths) eventually to the Iberian peninsula.

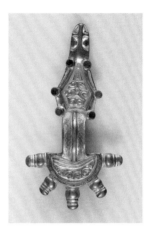

4. *Bow Brooch or Fibula*, Ostrogothic, second half of fifth century, silver alloy, gilt; garnets, niello

An Ostrogothic radiate-headed *Bow Brooch* [Fig. 4, Plate 5] initiates a group of garment fasteners, often called fibula. Made of gilt silver and niello[4] and inlaid with garnets, they date from the second half of the fifth century or first half of the sixth century. The center fields of the foot, positioned at the top, and the crescent shaped head below are fine examples of cast, chip-carved[5] design of faceted scroll work.

The Visigoths, having settled principally in the South of France and in the Iberian peninsula, also produced radiate-headed bow brooches as in a copper alloy pair cast with internal chip-carved geometric designs [Plate 7] which date from the first half of the sixth century. Comparable brooches were found in a cemetery of Castiltierra, Spain. Two impressive copper alloy women's buckles with inlays of glass, garnet, and shell [Plates 9, 10], of the sixth century, too, are also characteristic of Visigothic metalwork and thought to have come from the Castilian plateau. The plates of both buckles have cast chip-carved angular designs at their centers. The remains of prongs below the corners of the plates suggest the means of attachment to a leather belt.

From the Frankish people, residing in Gaul, have come another series of radiate-headed *Bow Brooches* [Plates 1, 2], also dating from the sixth century. All are cast silver gilt and some with inset garnets. Chip-work designs occur in the center fields of the crescent shaped heads and on the borders of the bars above the arched bows. Of a different order is a very bold and complete copper alloy Frankish *Buckle* [Plate 11] with two engraved plates bordered by a series of large knobs. This ensemble probably dates from the early seventh century.

EARLY CHRISTIAN AND BYZANTINE ART

The first of two objects in this section is an Early Christian *Pyxis*[6] [Fig. 5, Plate 12], a nearly circular ivory container cut from a portion of an elephant tusk.[7] The original tight-fitting lid that rested on the recessed lip is missing; the closure at the base is also missing. Such boxes, mostly dating from the fifth-sixth centuries, have been attributed to North Africa or to Syria-Palestine. Their function is unclear. Were they to hold healing medications, the Eucharistic bread or wine, or incense, as have been suggested?[8]

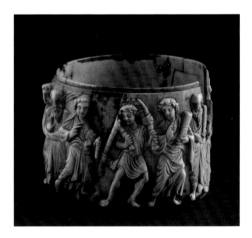

5. *Pyxis*, North Africa or Syria / Palestine, fifth to sixth century, ivory

One of more than forty carvings of this kind with Old and New Testament subjects, the principal figures here show Christ healing a paralytic, who carries away his sick bed[9] and Christ

healing a blind man.[10] Flanking apostolic and other witnesses, abbreviated architectural elements, and hanging knotted curtains complete the carving.

Some ivory pyxides had locks, now mostly lost, and many show evidence of frequent re-mountings, as in the present example. The faint remains of the date 1501 may indicate the time of one of the adaptive re-uses. Another change occurred in Paris in the nineteenth century, when the work was used as the sleeve of a tankard.

The imagery on the pyxis is arranged like a continuous frieze with nearly all of the figures of the same size and the heads mostly on the same level. The smooth rounded cheeks of the younger faces, the bald and bearded older ones, the piercing eyes, dramatic gestures, the bold stances of the fully draped figures of Christ, and the gathered witnesses combine to provide an engaging and narrative power. Unrecognized before 1986, this work is a major addition to the corpus of Early Christian ivory carvings.

The bearded apostle heads appearing on the ivory *Pyxis* find a clear echo in the large mosaic *Head of an Apostle* [Plate 17],[11] a Byzantine work that was removed from the late eleventh-century mosaic of the Last Judgment that covered the vast west wall of Torcello's Cathedral of Santa Maria Assunta. Despite the alterations of the twelfth century and repairs of the nineteenth century, this powerful image still suggests the majesty of the monumental mosaic mostly preserved at Torcello. The head also demonstrates the continuity of style and physiognomic types continued from the roots of Byzantine art in ancient Greek and Early Christian art.

OTTONIAN AND ROMANESQUE ART

Another ivory carving of great rarity and beauty dates from the Ottonian period about 968–970. This is the relief [Fig. 6, Plate 14][12] that depicts the Crucifixion flanked by Longinus, the lance bearer, and Stephaton, the sponge bearer, holding a situla or bucket. The figures of Mary and John mourn at each side while facing the cross. Christ, wearing a diadem, turns his head toward Mary. His loin cloth is knotted at the center, while his feet are placed squarely on a projecting shelf. The foot of the cross is encircled by a serpent.[13] Above and behind the cross-arms may be seen the Greek letters for alpha and omega,[14] together with medallions of the sun and the moon and the busts of two angels who tilt their heads toward the head of Christ.

The three-part rectangular frame is comprised of an inner narrow fillet, a regularized series of acanthus leaves, and a beaded strip between another two narrow fillets. This frame, the vertical format, and the subject suggest that the ivory was intended to be the central panel of a Gospel book cover.

It was carved by one of the principal creators of a series of ivory plaques thought to have once formed part of an altar frontal, chancel doors, or a throne in Magdeburg Cathedral.[15] This cathedral was an imperial foundation of Otto I (the Great), who reigned from 962 until his death

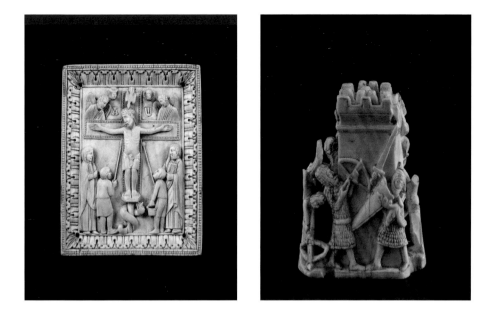

in 973. Another related ivory relief in this style has the subject of Christ's Mission to the Apostles.[16] This ivory, now in Cleveland, is probably also from a cover of a Gospel book and it shares a similar acanthus and beaded frame as the Lauder ivory. The Magdeburg ivories are located in museums in Berlin, Darmstadt, Liverpool, London, New York, and Paris. The entire series together with the two proposed book cover panels were probably carved by German artists working in the imperial workshop of Otto, possibly located in Milan.

Many details and stylistic features within the entire group are held in common, such as in the treatment of the bearded head of Christ and the smooth vertical folds of the standing holy figures. The intensity of gaze, the clarity of the narrative compositions, and the suggested monumentality are also shared. The high quality of the Lauder ivory is equal to that of the comparative plaques.[17]

The Lauder collection includes another early ivory, a rare English *Chessman* carved in walrus ivory [Fig. 7, Plate 13] that dates about 1140.[18] It was unknown before 1988. Carved in the round, it depicts an animated scene of the storming of a castle tower. Just visible over the crenellated parapet are the heads of several helmeted knights; the slightly larger one may be a king. The attackers around the base of the tower protect themselves by their long, straight-topped, and triangular shields. They wear either mail or gambesons, a defense garment of padded and quilted cloth or leather. Their helmets are tall, domed, and cross-banded. This intriguing chessman, possibly a king, has no exact parallels. Yet it is one of five English chess pieces, each dated to the second quarter of the twelfth century on the basis of the defense garments, shields, and helmets.[19] The five pieces are not from a common set even though they share some armor details as well as the style of the foliate ornamentation.

Also dating from the twelfth century are three important metalwork and enamel objects. The first is a Mosan *Book Cover Plaque*[20] [Fig. 8, Plate 22] with a champlevé enamel[21] image. This shows Abel at the right offering with cloaked hands a sacrificial lamb to the hand of God while his brother Cain proffers with uncovered hands a sheaf of grain.[22] The colors are deep and rich in the clothing of the two figures, the ground below, and the centered cloud; these range from a variety of blues, two shades of green, white, yellow, sealing-wax red, a translu-

6. Left: *Book Cover Plaque*, Ottonian, ca. 968-970, ivory

7. Right: *Chessman*, English, ca. 1140, ivory

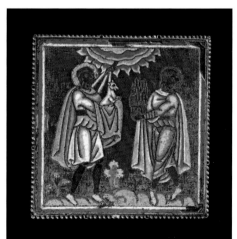

8. *Plaque with the Sacrifice of Cain and Abel*, Mosan, mid-twelfth century, copper alloy, gilt; champlevé enamel

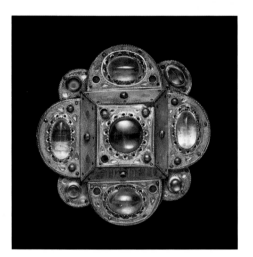

9. *Phylactery* (Reliquary), Mosan, ca. 1160-79, copper alloy, gilt; rock crystal

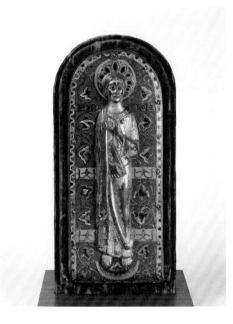

10. *Plaque with Saint John the Evangelist*, Limoges, ca. 1174–1213 (probably by 1188), copper alloy, gilt; champlevé enamel

cent golden green over foil (Abel's halo), and a semi-translucent purplish red-brown (Abel's leggings). Both faces, Cain's offering, the hand of God, and the inscribed capitals (Abel and Cain) are each engraved, the lines of which are filled with blue enamel. The gilding is worn away in these areas, as well as in portions of the background.

Abel is clean-shaven; Cain is bearded. In contrast to Abel's halo, Cain's head is outlined in blue enamel, a kind of false halo. Abel's gift, the lamb, is fully enameled in shades of blue with highlights in white, while Cain's offering is restricted to engraved lines filled with blue enamel.

This very striking enamel plaque, initially recorded in 1989, is one of a series of twelve related enamel plaques of similar style, format, borders, technique, and dimensions preserved in the museums of London, New York, and Paris.[23] Each member of the series is of high quality despite evident wear and losses. The epigraphy is identical in the eight enamels in the series that have inscriptions.

As examples of twelfth century Mosan enameling, the twelve plaques have several unique features that have led to the suggestion that they could have been the result of a commission for a monument during the rule of Henry of Blois, bishop of Winchester from 1129 to his death in 1171.[24] The basis for this is the stylistic and technical comparisons with two semi-circular enamel plaques, with inscriptions mentioning Bishop Henry as donor. (Henry is shown as a tonsured and kneeling nearly prostrate figure.) The series of twelve plaques, including the *Sacrifice of Cain and Abel*, and the two semi-circular examples may have been created by a Mosan enamellist working in England around the middle of the twelfth century.

A gilt copper alloy *Phylactery*, datable to about 1160–1170, is the second Mosan work of the Romanesque period in the collection [Fig. 9, Plate 23].[25] Polylobate in overall form, studded with five hog-back rock crystals, the face of this reliquary makes a dramatic yet self-contained statement. The raised square center with its circular crystal may have once held a relic of the saint named on one of the oblique framing panels, S. Jehan (Saint John). This inscription, the engraved cross-hatching, and tear-shaped petals contrast with the series of small circles that frame each of the large crystals. The smaller inset stones are either missing or possibly replaced. The reverse of the *phylactery* is patterned with elegant leafy vine scrolls in *vernis brun*[26] or *email brun*.[27] Two lobes have been partially cut back.

There are several other Romanesque phylacteries of this kind, from regions of the Meuse River Valley, the middle Rhine, and Lower Saxony.[28] Two examples originally contained a centrally placed relic visible through a rock-crystal cover. The basically quatrefoil form of these reliquaries established a kind of cross-reference between a central image or relic and Christ's death on the cross.

A gilt copper alloy *Plaque with Saint John the Evangelist* [Fig. 10, Plate 21] is another representative of the Romanesque period. The elongated proportion, smooth long folds of drapery, restrained gesture close to the body, and architectural stance are reminiscent of a

monumental jamb sculpture on the portal of a great church. Set against an arched and colorful enamel back plate and a product of one of the gifted workshops in Limoges, France, this imposing work probably dates prior to 1188 because it seems to have come from an altar and altar frontal in the Cathedral of Saint Martin of Tours in Orense (Galicia), Spain.[29] The donor was Alphonso, bishop of Orense between 1174 and 1213. Apostles, saints, and symbols of the evangelists are the subjects of the extant reliefs, each of which was backed by an enamel plaque.

The relief of *Saint John the Evangelist*, like the rest of other figures from the ensemble, was worked in the techniques of repoussé, chasing, scraping, engraving, and gilding. The copper alloy background plates were all enameled in the champlevé technique. Three horizontal bands in the exhibited example include both the capital letters identifying Saint John at the top and the reserved pseudo-Kufic inscriptions against an intense turquoise enamel below. A narrow arched border with an undulating pattern frames these bands, as well as the elegant foliate vine tendrils filling the remaining fields above and below. Gilt lines and backgrounds, several blues, including turquoise, green, yellow, red, and white repeated and varied throughout, provide a striking setting for the gilt relief figure at the center.

The last Romanesque work in this section is a *Double Capital* carved in the round in grey marble [Fig. 11, Plate 44].[30] Undoubtedly originally part of a double columned arcade of a monastic cloister, allegedly Saint-Bertrand-de-Comminges in southwest France, this carving exhibits an intricate lattice network interspersed with foliate vine tendrils. The rounded molding at the bottom conforms in plan to the double columns originally fitted below. Related capitals in this style from the Collegiate Church of Saint-Gaudens (Haute-Garonne) have been dated to the middle or the third quarter of the twelfth century.[31]

ROMANESQUE AND GOTHIC AQUAMANILIA AND PRICKET CANDLESTICKS

In the middle ages, hollow cast copper alloy water vessels known as aquamanilia were at first used for liturgical hand-washing, in time in relation to both Christian and Jewish services. In the later middle ages, aquamanilia were adapted for secular purposes at the tables of princes and other members of elite society. The earlier Romanesque examples, preserved from the late twelfth century, utilized lions and dragons for their subjects, probably for symbolic reasons. The later Gothic pieces, favored for the secular table, seem to reflect the taste and preferences of their aristocratic owners: equestrian knights and courtiers, dogs, centaurs, unicorns, griffons, and other subjects.[32]

A focal point of the Lauder medieval collection is the group of seven aquamanilia, probably the largest such group in private hands. Like all other aquamanilia, the present examples are cast in the lost wax method.[33] Several are subsequently burnished and some details are engraved.

The earliest piece [Fig. 12, Plate 26],[34] probably dating from late twelfth century, is entitled *Samson and the Lion*.[35] It was made in northern Germany, possibly in or in the vicinity of

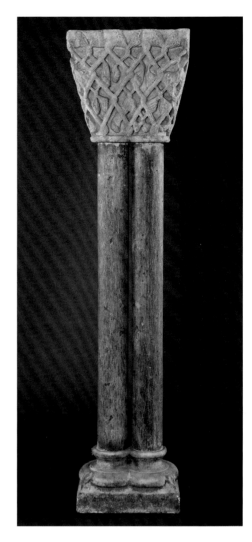

11. *Double Capital*, Southwest France, Saint Bertrand de Comminges (?), mid-twelfth century, marble

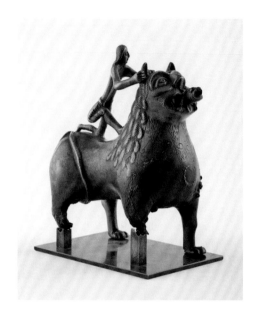

12. *Aquamanile of Samson and the Lion*, Magdeburg (?), late twelfth century, copper alloy

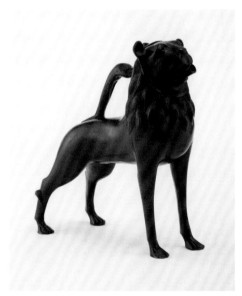

13. *Aquamanile of a Lion*, North German, probably Hildesheim, mid-thirteenth century, copper alloy

Magdeburg. Stout, with upturned head, heavy arch brows, bulging eyes, full and curly mane, this lion seems to grimace as he spits out a frog-fish that grasps the lower jaw with both hands. The lion's tail completely encircles his rump. The handle above is the stick-like figure of Samson, bare-chested and wearing loose pantaloons ending at the knees.

Samson grasps the lion's pricked ears with each hand. His legs spread widely, Samson's left foot rests near the tufted end of the lion's tail, while the right foot pushes firmly at the back of the lion's neck. Several post-casting details are engraved, especially as seen in the four symmetrically placed curls on the chest. Damaged by fire since it left the collection of J. Pierpont Morgan, this aquamanile is supported on a modern copper alloy base. A complete and comparable aquamanile was recorded in 1935 as in the Schlossmuseum in Berlin.

An imposing *Aquamanile of a Lion* [Fig. 13, Plate 27],[36] also from northern Germany and almost certainly Hildesheim, is a clear and dramatic reflection of the nearby monumental copper alloy *Lion of Duke Henry the Lion* of 1166, formerly set up in the Cathedral Square in Brunswick. The modeling, casting, and details of the aquamanile have close parallels in the *Lion Candelabra* for the altar in the Cathedral at Hildesheim and in lion aquamanilia in Florence, Bremen, Berlin, Schleswig, and Cleveland.[37] A mid thirteenth-century date has been assigned to all these works.

Dating around 1300 or a little before are three other north German *Aquamanile*: a handsome unicorn [Plate 29],[38] a sturdy saddled horse [Plate 28], and a perky stag. Each of these represented animals stands firmly on splayed legs and each has a widely arched handle. The unicorn may be unique while the saddled horse has a close cousin in Cleveland.[39] The stag, the earliest of only three extent examples, bears a post-medieval saddle blanket and chest strap.[40]

The final two aquamanilia were made in southern Germany in Nuremberg. The first represents a bridled and erect horse with an arching dragon handle [Plate 30].[41] It may be dated about 1400 and it is a fine example of a type represented in Frankfurt, New York, Nuremberg, and elsewhere.[42] The second work, an equestrian group [Plate 31], is dateable to around 1430–40.[43] A stocky, short-legged horse supports here a tightly costumed rider with a page boy coiffure and droopy mustache. The pointed slipper-shoes are firmly fitted into the stirrups. The raised right arm and hand may have supported a separately cast sword or lance.

While each of these aquamanilia have enormous appeal as dramatic three-dimensional sculptures, their surfaces are far darker than they were originally. This has resulted from post-medieval applications of black lacquer and/or tinted wax. Unencumbered surfaces have a natural brown patina (copper oxide). Some of these darkened surfaces may have resulted from nineteenth-century tastes and a desire to have these remarkable works resemble Renaissance bronzes.

Two cast copper alloy *Pricket Candlesticks* are included in the collection. The earliest, an animated Mosan example dating from the mid-twelfth century, presents a barely clothed youth with a comical cap or helmet astride a winged and feathered dragon [Fig. 14, Plate 24].[44] The figure leans forward to thrust his spear into the dragon's mouth, an action allowed by the backward curve of the dragon's head and neck. The dragon's tail becomes a vine tendril support for the kite-shaped shield attached to the combatant's right arm. The lost pricket and supporting drip pan for a candle formerly extended from the side of the cap and adjacent tendril. The ensemble is supported on the dragon's two claw feet, the tips of his wings, and a short volute branching out from the dragon's neck. Notable for the pervasive wear from long use, the patina is now mostly dark brown (copper oxide). Similar works reside in the museums in New York and Paris.[45]

The second *Pricket Candlestick* is made in the shape of a harnessed elephant bearing a howdah or small pavilion [Plate 25]. The latter supports a crenelated rectangular drip pan. A crouching man blows his horn over one corner of the parapet. The chiseled details show significant wear; these are partially obscured by the natural brown patina. Comparable picturesque examples of this type are found in Hanover and Nuremberg, each attributed to west Germany, late twelfth to thirteenth century.[46]

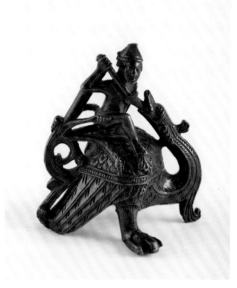

14. *Pricket Candlestick*, Mosan, ca. 1150, copper alloy

GOTHIC ART OF THE THIRTEENTH CENTURY

The cathedral of Thérouanne in northeast France was destroyed with the surrounding city by the Hapsburg Emperor Charles V in June of 1553. A series of five heads of apostles were found in 1923 built into the wall of a house in the rue Sainte-Croix in nearby Saint-Omer. The over life-size *Head* [Fig. 1] comes from this group, now divided among the museums in Cleveland, Houston, and London.[47] It is thought that the five heads came from either the south or the west portal at Thérouanne. They clearly share the same limestone, as well as the gently eroded surfaces that resulted from natural weathering. The chief losses are in the nose regions and in the lips.

Related to the sequence of stylistic and iconographical developments in French High Gothic cathedral portal sculpture of the first third of the thirteenth century, the five heads may be dated specifically around the time of the dedication of the cathedral at Thérouanne in 1134.

Together the exhibited head and the other four are individually heroic not only in size but also in form. The hair and beards are carved irregularly, presenting a variegated texture, substance, and richness. The symmetrical, linear, and planar character of late Romanesque and early Gothic jamb sculptures is abandoned. A more organic conception of human face has taken hold. In this style and in these heads, the human physiognomy is ennobled, and the apostles represented are rendered in terms of a simplified naturalism and a restrained expression of spirituality.

The Thérouanne *Head of an Apostle* [Fig. 1] makes clear a significant early phase of High Gothic sculpture. In this work, the interest in the structure of the human head and the fram-

ing texture of hair and beard embodies a creative and expressive use of stone and chisel; the sculptural result is both imposing and subtle.

Contemporary with these two French Gothic works are two massive limestone carvings of *Seated Knights* [Plate 41].[48] Major secular high relief sculptures, they were originally placed high on the upper story of the façade of the fortified Bye Street gate at Hereford, Herefordshire, England. This structure was demolished in 1798. Drawings of 1784 depict them individually as well as in their original positions.[49] While pre-industrial natural weathering has softened their surfaces, it is clear that both knights wear protective mail and heavy surcoats. The knight wearing a flat topped helmet with visor grasps the hilt of his sword in his right hand while holding his left over his chest. His companion is accompanied by a small dog who licks one of his paws. Dating around 1230–50, these powerful sculptures are carved in the late so-called transitional style often referred to as the "ca.1200 style," with their frontal emphasis and accent on the looping folds over the very prominent knees. They are rare survivors from a lost architectural civic monument. They also illustrate the characteristic military armor of their period.

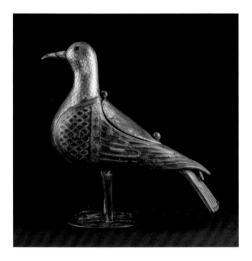

15. *Eucharistic Dove from the Marienstift of Erfurt*, Limoges, ca. 1215-35, copper alloy, gilt; champlevé enamel

Roughly contemporary with the foregoing sculpture are three fine enamel objects from the workshops of Limoges. The first is the handsome *Eucharistic Dove* [Fig. 15, Plate 18] that originally belonged to the Marienstift of Erfurt (Thuringia), Germany.[50] Along with similar examples, it may be dated about 1215–35. The body is constructed of two copper alloy sheets, shaped, engraved, gilt, and riveted together. The hinged lid, also engraved and gilt, covers the Eucharistic cavity. The ridged beak is intact, while the filling for the eyes is missing. The glory of such works resides especially in the champlevé enameling of the separately worked wings and tail, with three to four blues and white in the horizontal feathers and imbrications of the shoulders. A middle band of enamel on the wings has been seen as suggesting a row of inset cabochons.

The second Limoges work is the large footed architectural *Chasse of Saint Ursula* [Fig. 16, Plate 19],[51] an oblong, gabled, pitch-roofed reliquary casket with champlevé enamels said to have once belonged to the church at Lezoux (Puy-de-Dôme), a Cluniac priory of Thiers in France. Despite a few losses and replaced portions, this object is impressive not only for its size. The wood core is overlaid with copper alloy sheets that are chased, engraved, and gilded. There are five pairs of mounted low relief enameled figures on the principal face. These depict the martyrdom of Saint Ursula (applied to the projecting transept[52]) and her companions (left and right and above on the roof). Each figure is riveted to the gilt and stippled background with engraved stars supplemented by a whole array of cabochons of glass and semi-precious stones. The gilt panels on the reverse of the chasse have a different scheme of engraving and enameling in which all of the figures and portions of the settings are without enamel. Other areas are enameled, as in the waves of the sea or river.

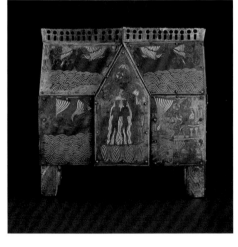

16. *Chasse of Saint Ursula*, Limoges, ca. 1235-45, copper alloy, chased, engraved, and gilt; champlevé enamel, glass, semi-precious stones, oak core

The chasse as a whole effectively tells the story of the life and martyrdom of Saint Ursula, most of which is repeated in Jacobus de Voragin's Golden Legend, written around 1260.[53]

The scene at the center of the reverse represents the baptism of Ursula and Etherius, her fiancée, a subject not repeated in the Golden Legend. The relics of Saint Ursula and the 11,000 virgins, are said to have who traveled with her, were widely venerated in the later middle ages. This chasse, along with a few stylistically related ones, has been dated around 1235–45.

A second, smaller yet roughly contemporary footed Limoges *Reliquary Chasse* [Fig. 17, Plate 20][54] also utilizes the materials and techniques of chased, engraved, gilded copper alloy and champlevé enamel. All elements are attached to a hollowed-out oak core. The center of the front panel is dominated by a relief figure of Christ on the Cross. The mourning figures of the Virgin and Saint John are on either side. They are completed in reverse, except for the applied relief heads, as in all of the remaining figures. To the left and right are book-bearing saints, each seated under a round arch supported by pilaster columns. The roof panel above displays a Christ in Majesty within a mandorla[55] accompanied by scroll-bearing busts of angels framed by trilobed arches and columns. The end panels of the *Chasse* depict standing saints also holding books. The enameled backgrounds for the figurative panels are notable for the series of multi-colored rosettes against light blue. Decorative bands of pseudo-Kufic inscriptions appear behind the figures of the front panel and roof. The reverse panels and roof are covered by an overall pattern of closely spaced rosettes and intervening small quatra-lobe motifs. This fine reliquary casket boasts its original engraved open-work crest set with three enameled medallions.

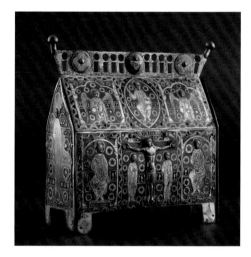

17. *Reliquary Chasse*, early thirteenth century, copper alloy, gilt; champlevé enamel, oak, paper lining

The last work of the thirteenth century in the Lauder collection is a group of four double-sided half-page miniatures cut from an Apocalypse manuscript [Plates 36–39 and Fig. 18]. Each of the more than seventy miniatures removed from this volume were painted in tempera on vellum, with haloes and other details rendered in burnished gold. Examples are now in the museums in Cleveland, Detroit, and possibly elsewhere. At the time of their sale in 1983, England (York) about 1270 was proposed for the origin.[56] More recently the miniatures were attributed to Eastern France (Lorraine) ca. 1295.[57] Such a reassessment acknowledges cross-channel (Anglo-Lorraine), Netherlandish, and Parisian interconnections in the field of luxurious illuminated manuscripts commissioned for members of the aristocracy.

The original biblical text in Latin of the parent manuscript was in the tradition of apocalyptic literature, a class of Jewish and Christian texts produced from about 250 BC to later in the early centuries after Christ. These works were intended to assure the faithful of God's righteousness and the future triumph of Israel, or the messianic kingdom. The Book of Daniel in the Old Testament, parts of the Dead Sea Scrolls, and the last book of the New Testament, the Apocalypse or Book of Revelation, are each prominent examples.

18. *Miniature from an Illuminated Manuscript*, English, ca. 1270, Recto: Apocalypse 20:7-9, tempura and burnished gold on vellum

The succession of chapters of this last text offer prophecies, visions, cataclysmic events, destructions, end of the world and the triumph of the heavenly Jerusalem. Actual wars, plagues, and other calamities over the centuries have prompted various commentators to find correlations with the Apocalypse text in their own world.

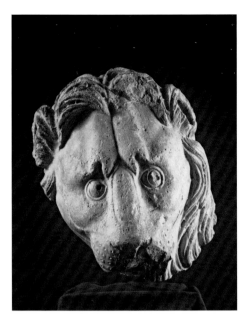

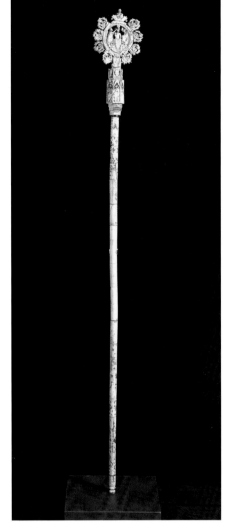

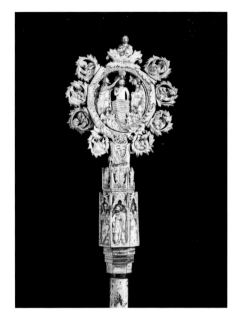

19. Assistant or workshop of
Giovanni Pisano, *Head of a Lion*,
Italian, ca. 1250-1315, marble

20. Left and above: *Crozier*,
Volterra, second quarter of the
fourteenth century, ivory

GOTHIC ART OF THE FOURTEENTH CENTURY

The first of two Italian works that initiate this section is an imposing *Head of a Lion* [Fig.
19, Plate 35], approximately life size, carved in marble, and a portion of a larger work. De-
spite the weathered surface and losses of the lower jaw and some of the edges of the mane,
this powerful remnant calls for a comparison with the pulpit sculptures by the great Italian
Gothic sculptor Giovanni Pisano (ca. 1250–1315) and his workshop. For example, the carv-
ing of the lion's furrowed brow, cleft forehead, high cheekbones, and drilled pupils and
whiskers each find early parallels in the heads of the three lions and the lioness of the dated
1301 pulpit by the sculptor and his workshop in S. Andrea in Pistoia in northern Tuscany.[58]
These details as well as the flowing but drill-interrupted grooves of the mane recall the man-
ner of the two lions supporting the pulpit of 1302–10 in the Duomo in nearby Pisa.[59] These
collective comparisons are such that the exhibited lion head may be assigned to an assis-
tant of Giovanni Pisano who was active in his workshop in the early fourteenth century.

A remaining issue that needs further study is the unknown context: was this lion head a frag-
ment of a trial carving or was it broken off from a larger work? It seems less likely that it
came from a three-dimensional column-supporting lion; rather, and depending on comparative

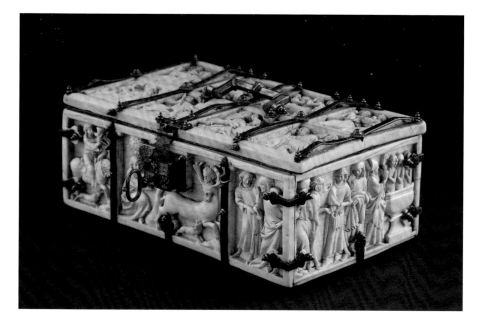

21. *Casket depicting the Legend of Saint Eustache*, Paris, ca. 1325–50, ivory

measurements, a possible context might have been as either part of a portal lion in high relief at S. Quirico d'Orcia[60]; or, as a tetramorph[61] group of a column base or parapet pilaster.[62]

No such queries arise in relation to the second Italian work, a partially painted and gilded ivory *Crozier* [Fig. 20, Plate 16],[63] Tuscan, second quarter of the fourteenth century. Extraordinarily complete, it shows the volute fully carved on both sides, with the Baptism of Christ at the center. This scene, framed by a foliated wreath, is surrounded by eight busts of prophets bearing identifying banderoles all of which are held in place by scrolling foliage. At the top, the bust of God the Father rises above splayed leaves. The volute is supported by a toothy-mouthed dragon. Below in succession are hexagonal sections with upright acanthus leaves, standing apostles and saints beneath trilobed arches supported on twisted columns, and finally three matching horizontal and scaled borders stepping down to the smaller thickness of the staff proper. The painted and gilt decoration of the shaft includes rabbits, dragons, and plants. Of the seven or eight complete or fragmentary Italian ivory croziers, this one and the crozier in Siena are the finest and most complete.[64]

Contemporary with the Italian *Crozier* is an exquisite ivory *Casket* made in Paris around 1325–50 [Fig. 21, Plate 15][65] Seventeen scenes of the legend of Saint Eustache are depicted. All of these are closely based on Jacobus de Voragine's Golden Legend of about 1260.[66] These are distributed in the successive compartments on sides and lid. One of the most familiar subjects appears below the later enameled lock plate, where the saint kneels before a vision of the head of Christ set between the antlers of a stag. The cult of Saint Eustace, especially popular in the fourteenth century, eventually declined and seems to have been replaced in the fifteenth century by the legend of Saint Hubert, who was said to have had a similar vision.

The quality of the carving places the casket in its entirety among the finest ivory relief carvings of any subject that were produced in the workshops active in fourteenth century Paris. The well-crafted silver gilt and enamel fittings, while not medieval, seem to be from the seventeenth century. The enameled lock plate bearing the arms of England underscores the distinguished provenance, a descendant of the Stuarts and James I.

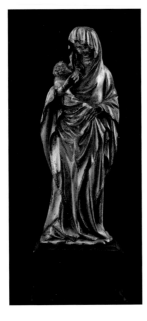

22. *Madonna and Child*, French or Netherlandish, ca. 1420, copper alloy, gilt

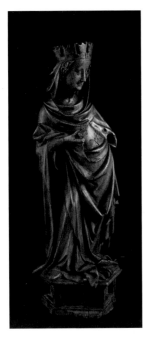

23. *Standing Madonna*, Upper Rhine Valley, ca. 1420–30, walnut

The cast, gilt and burnished copper alloy relief of *Saint Thaddeus* [Plate 32][67] from northern Germany (Lower Saxony or Westphalia) dates around 1350. It was once part of a series of such appliqué figures of the twelve apostles, some of which are distributed among museums in Chicago, Detroit, and New York.[68] While the original concept is uncertain, it is possible that they could have been part of a shrine with a figure of Christ at the center. Each apostle turning his head slightly to the side may have been in orientation to this central image. Full and heavy drapery folds envelop each statuette, revealing only the general body mass. Cap-like hair, strongly rolled around the edges of the faces, ends in loose falling locks over the shoulders. Each apostle clutches a Gospel Book. The exhibited statuette is identified with capital letters along the upper border of the rounded bracket-base. It shares a sense of quiet, solemn dignity with the rest of the series.

GOTHIC ART OF THE FIFTEENTH CENTURY: 1420–30

Two sculptures fall within this time frame. The first is a diminutive statuette of the *Madonna and Child* [Fig. 22, Plate 33][69] of cast, gilt, and burnished copper alloy and attributed to either Netherlandish or French areas. Modeled in the round, this group may have been the centerpiece intended to be viewed frontally of a small tabernacle or shrine for a house altar and chapel. It was secured by means of a small attachment ring between the Madonna's shoulders. The tender reciprocal relationship of the two figures is found in many works in the Burgundian and Franche-Comte areas, especially in full-size stone sculptures attributed to Claus de Werve. The modeling of the Madonna's mantle also points in this direction as in the framing multiple heavy folds hanging at her sides; the horizontally curving folds drawn across her torso and back, and the folds over her head and forehead. The naturalism and drama of this style is especially paralleled in the sculptures of the *Madonna and Child* attributed to Claus de Werve in Poligny and Bézoutt.[70]

The second work, probably dating from the same decade, is the walnut *Standing Madonna* [Fig. 23][71] attributed to Upper Rhine Valley around 1420–30. She is veiled and crowned; she holds a pear in her right hand, while her left, holding the Christ Child, is missing. The ample folds of this Madonna's mantle fall in a sharper configuration than those of the gilt *Madonna and Child*. This is clear especially in the deep V fold at the lower center of the larger sculpture. The crumpled folds resting over the hexagonal base tend towards angularity, as do those held above the walnut Madonna's right elbow.

GOTHIC ART OF THE SECOND HALF OF THE FIFTEENTH CENTURY AND EARLY SIXTEENTH CENTURY

The important limestone *Saint John the Baptist* [Fig. 24, Plate 42][72] is one of the largest French sculptures of the period portraying the messenger of Christ.[73] The saint is shown presenting a lamb who sits on a thick book, references to both the fulfillment of the Old Testament prophecies and to Christ whom John hailed as the Lamb of God.[74] This sculpture may be attributed to Burgundy, perhaps the Eastern region of Franche-Comté some time in the third quarter of the fifteenth century.

For a limestone sculpture of its size of over five and a half feet tall, it is not surprising the work was broken in two places, across the neck (through the lower locks of hair and beard) and across the lower waist well below the rope belt. Tinted and carved plaster was used to fill and repair some of the adjacent losses. Only widespread traces remain of the original polychromy; this includes the suggestion that the hair and beard were originally gilded. The use of chisels with spaced teeth, common in many late medieval stone sculptures, is evident throughout, thus adding to the conviction of the integrity of the whole despite the breaks.

Although a three-dimensional carving, this sculpture was conceived to be seen primarily from the front or from three-quarter viewpoints, as well as from below. It was probably planned for a high console against a pier or column of a church. The orientation of the Baptist's gaze not only directed to the Lamb but also to the worshipper supports this suggestion. The deep multiple vertical folds of the richly textured camel-hair coat contribute to the three-dimensional strength of an otherwise tall and slim figure. The weight is borne over the bare left leg, leaving the right leg, also bare, slightly extended, and the head turns a bit to the other side, so that a figural torsion is created, a late Gothic version of the classical contrapposto[75] stance. Key to the overall impact of this work are the elongated proportions with a relatively small head and the several textured contrasts. These are found in the long camel-hair coat, the strands of hair and beard, the nodular wool of the lamb, the twisted rope belt, and the smooth flesh areas of the face and legs. Even the linear edges of the pages of the book participate in these sequences of contrasts.

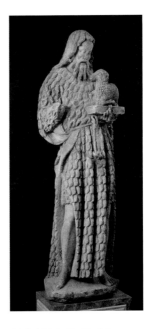

24. *Saint John the Baptist*, Burgundy, third quarter fifteenth century, limestone

Reflections of early Franco-Netherlandish sculptural traditions, of Claus Sluter (ca. 1360–1406) and Claus de Werve (ca. 1380–1439), for example, may be seen in the carving of the features of the Baptist's face. The firm brow, the rounded high cheek bones, the parted lips, and the curly and long strands of hair and beard are part of this debt to the past.

There are at least ten probably contemporary statues of the Baptist still preserved in or recorded as coming from greater Burgundy, but only a few of them are so convincingly monumental as the present work. Perhaps the best known is the modest but charming example in the Musée Rolin in Autun that also utilizes the saint's full-length camel-hair coat and his bare extended right leg.[76]

A work of outstanding importance and beauty is the large South Netherlandish wall hanging, *The Woodcutters Tapestry* [Fig. 25, Plate 40].[77] Dateable to the 1460s, this great work, wool with silk threads, is to be admired for the overall pictorial composition, the firm drawing throughout, and the rich naturalistic details of both flora and fauna. Set before a thick forest of English oak trees, holly bushes, and other species are four woodcutters chopping, trimming, and gathering the wood of the felled oaks. A fifth worker in the middle distance bends forward to receive several logs to add to those already in the open large-wheeled cart. A white horse, positioned in front of the cart, pauses while he nibbles on a fruited leafy branch offered by a youthful groom. (That the animal is ready to move forward is evident by the taut chain links of the trace.) A second horse beyond lowers his head to chew on another

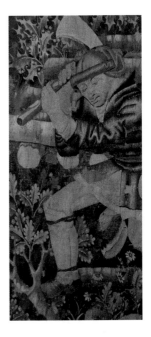

25. *The Woodcutters Tapestry* (detail), South Netherlands, probably Tournai, third quarter fifteenth century

portion of foliage. A partly hidden leopard cub crouches below the cut branches near the center foreground.

A variety of birds appear across the upper reaches of the trees; these may be tentatively identified as a pheasant, several hawks, and a pair of swans feeding their nested young. Almost hidden in the branches just below sits a fat squirrel, who ignores the surrounding activity, and a watchful owl.

A tapestry hanging depicting woodcutters in the Musée des Arts Décoratifs in Paris may depend on closely related cartoons for two of the major woodcutters.[78] While cropped, the Paris hanging still bears the coat of arms of Nicolas Rolin, chancellor of Burgundy from 1422 to 1461. This work has been associated with the Tournai producer-merchant Pasquier Grenier (ca. 1425–1493).[79] Hangings assigned to the 1470s with similar genres such as grape gatherers and rabbit hunters have been related to the French designer and miniaturist known as Maître de Coëtivy.[80] Large colored drawings in the Louvre illustrating scenes from the Trojan Wars have been attributed to this artist, who has also been associated with another colored drawing in the Bibliothèque National de Paris.[81] Certain details in these drawings suggest the possibility that several of the workers in the two tapestry hangings with the woodcutters could depend on lost inventions of the Maître de Coëtivy. The concordance of the active half-crouching figures and their broad, short-bearded, long-nosed, and tight-lipped facial types is unmistakable.[82]

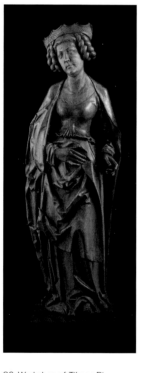

26. Workshop of Tilman Riemenschneider, *Female Saint*, Franconia, early sixteenth century, lindenwood

Tapestry hangings with woodcutters at work as the principal subject was the focus of a seminal article by Aby Warburg published in 1907.[83] While the Rolin tapestry example cited above is the springboard for his discussion, Warburg mentioned documentary evidence for three occasions when woodcutters at work were "recorded as the sole subject of whole cycles of tapestries" in 1461, 1466, and 1505. Such cycles could include not only wall hangings, but also bed covers, canopies, cushions, and bench covers for an aristocratic bedroom. The first two commissions were instigated for the Burgundian duke, Philip the Good. The hanging with the arms of Chancellor Rolin may have been part of the commission of 1461. It is tempting to relate the Lauder hanging to the commission of 1466 even lacking a coat of arms, documentation, or any other proof. However, the shallow space positioning of the workers, the cart, and the horses suggests an exploration of the cartoon designer beyond that for the Rolin hanging. This provides some support for the 1466 date.

Certainly the subject of woodcutters relates these two works to Warburg's continuum of late medieval interest in rustic subjects for court tapestry art. One may speculate how such subjects anticipate some of the animated illustrations in the Housebook of the early 1480s to early 1490s that was exhibited at The Frick Collection in 1999.[84] This preference seems to pre-figure the paintings and graphics of 100 years later of the great Netherlandish artist, Pieter Breugel, the Elder (ca. 1525–1569).

A fine relief carved in lindenwood of a *Female Saint* [Fig. 26][85] comes from the workshop

of the renowned German late Gothic sculptor, Tilman Riemenschneider (ca. 1460–1531). This gifted artist and his large workshop were principally active in Franconia creating a number of altarpieces, statues, tomb monuments, and reliefs. Employing lindenwood or stone (alabaster, sandstone, and limestone), the workshop had a very large production.

The *Female Saint* wears a long dress, tight over the chest, with radiating pleats at the waist, and covered below by the sweep of her mantle held in place by her right hand. The suspended, broken folds at the center are echoed at the saint's right side. A variety of angled folds cascade over her feet and the base. The shallow crown, now missing its finials, extends broadly over the massive braids framing the face, which is inclined to one side. The subject is uncertain because of the loss of the saint's attribute formerly held in the left hand. The heartwood has been removed from the back of the figure.[86]

There are several related carvings of female saints by Riemenschneider and by members of his workshop. The example in Raleigh, by the master himself and dating around 1490, represents the more volumetric character of his early style.[87] The present sculpture is more broadly conceived and gives a flatter impression, reflecting the stylistic change found in much of sculptor's work of the early sixteenth century. It is instructive to observe this evolution in the standing Virgin at the center of the great altarpiece at Creglingen of 1505–10 and a brilliant autograph carving by the master.[88] Some of the Riemenschneider altarpieces such as this were never meant to be polychromed. Without a detailed technical study it is difficult to ascertain the intentions on this issue in the case of the *Female Saint*.

The original context was probably within the deep central shrine of a large altarpiece. A few companion saints and a central figure of the Virgin and Child or of Christ may have completed the imagery. Movable wings with low reliefs would have been hinged at the sides. Such composite works were widespread in the late fifteenth and early sixteenth centuries in German-speaking regions and other Central European areas; they were often produced by the greatest masters and their workshops. This moving sculpture of a *Female Saint* constitutes a fitting closing subject for this survey of Ronald Lauder's excursion into the broad field of medieval art.

NOTES

1 Florence J. Gould, sale, Sotheby's Monaco, June 25, 1984, illus. p. 157. Lot 956, the large five seat choir stall against the right wall is now in Ronald Lauder's collection.

2 The general public was first introduced to this subject in a major way in the large exhibition held in the Palazzo Grassi in Venice: *The Celts*, Milan, Bompiani, 1991, pp. 1–795; see also, *Mirror of the Medieval World*, exh. cat., edited by William D. Wixom, New York, MMA, 1999, pp. 12–17, especially no. 10, Girdle Clasp, Celto-Iberian (Spain), second century BC, illus. I am indebted to Pete Dandridge for examining the Celtic and all other metalwork mentioned in this essay.

3 For an introduction to this subject, see the essays in the symposium volume, *From Attila to Charlemagne*, edited by Katharine Reynolds Brown, Dafydd Kidd, and Charles T. Little, New York, MMA and Yale University Press, 2000.

4 Niello: A black alloy of silver, sulphur, and lead used as an inlay in the engraved designs cut into the base metal.

5 Chip-carved: Faceted or angular cut designed carved in the original wax before casting.

6 Pyxis: Greek word for small box.

7 Sale, Sotheby's, London, December 11, 1986, lot 9, illus.

8 *The Oxford Dictionary of Byzantium*, edited by Alexander P. Kazhdan et al, New York and Oxford, Oxford University Press, 1991, vol. III, pp. 1761–1762.

9 NT, Mt 9:6-7.

10 Of the several Biblical references, see especially Vulg. Bible, NT, Mk 10:46-52, and OT, Is 35:5.

11 Sale, Sotheby's, London, July 9, 1987, lot 64, illus. For a detailed discussion, see *The Glory of Byzantium: Art and Culture of the Middle Byzantine Era, AD 843–1261*, edited by Helen C. Evans and William D. Wixom, exh. cat., New York, MMA, 1997, pp. 452–453, cat. no. 293B, entry by Irina Andreescu-Treadgold.

12 Phillips, London, December 4, 1989, lot 28, illus.

13 OT, Nm 21:8, 9 and NT, Jn 3:14.

14 NT, Apoc. 1:8, 21:6, 22:13.

15 Adolph Goldschmidt, *Die Elfenbeinskulpturen aus der Zeit der karolingischen und sächsischen Kaiser VIII-XI Jahrhundert*, Berlin, Verlag Bruno Cassirer, 1918 (1970 reprint), pp. 17–20, nos. 4–16, pls. IV–VI.

16 Goldschmidt, pp. 20–21, no. 18, pl. VI; for a recent discussion, see *The Glory of Byzantium*, p. 490, cat. no. 324, entry by Wixom, bibl., illus., cf. N.T. 28: 18–20.

17 Goldschmidt, p. 20, no. 17, pl. VI, represents a copy.

18 Hotel Drouot, Paris, June 10, 1988, lot 76, illus.

19 Richard H. Randall, Jr., *The Golden Age of Ivory: Gothic Carvings in North American Collections*, New York, Hudson Hills Press, 1993, p. 120, no. 176, illus.; *Age of Chivalry, Art in Plantagenet England, 1200–1400*, exh. cat., edited by Jonathan Alexander and Paul Binski, London, Royal Academy, 1987, pp. 252–254, cat. nos. 145, 146–148, bibl., illus.

20 Sotheby's, London, July 6, 1989, lot 11, illus.

21 Champlevé enamel: This method of enameling entails gouging out the base metal to create a series of troughs or cells to receive the vitreous enamel. After firing and cooling, the enamel surfaces are polished. In Medieval examples, the exposed areas and ridges are mercury gilded.

22 OT, Gn 4:3-5; OT, Heb 11:4.

23 *Catalogue of Medieval Enamels in the British Museum*, vol. II, *Northern Romanesque Enamel*, by Neil Stratford, London, British Museum Press, 1993, pp. 58–67, color pl. II, black and white plates, 9–20.

24 Stratford, pp. 53–58, 65, nos. 1–2, color pls. I, III–V, black and white plates 1–2.

25 Thomas F. Flannery, Jr.., Collection, Sotheby's, London, December 1, 1983, lot 10, illus. (obverse and reverse).

26 *Vernis brun* or *email brun*: This technique entails coating a copper alloy sheet with linseed oil and painting the decorative motifs with powdered gold in solution with mercury. Firing causes the mercury to burn off leaving the gilt pattern. The surrounding surfaces are left a rich brown color.

27 The backs of a mandorla-shaped hanging reliquary in Boston and two *polylobate* hanging reliquaries in Cleveland and Saint-Petersburg are also prime examples of this type of Mosan *vernis brun* decoration. See Hanns Swarzenski and Nancy Netzer, *Catalogue of Medieval Objects, Enamels and Glass*, Boston, MFA, 1986, pp. 5, 48, 49, illus; *Sacred Gifts and Worldly Treasures: Medieval Masterworks from the Cleveland Museum of Art*, edited by Holger A. Klein, Cleveland, CMA, 2007, pp. 136–137, illus.; H.W. van Os, *The Way to Heaven: Relic Veneration in the Middle Ages*, Amsterdam, 2002, pp. 119–121, illus.

28 See *Treasures of Heaven, Saints, Relics, and Devotion in Medieval Europe*, exh. cat., edited by Martina Bagnodi, et al, Cleveland (CMA), Baltimore (WAM), London (BM), 2010, p. 180, cat. no. 88, illus.; van Os, pp. 118–119, illus., Swarzenski and Netzer, pp. 40–41, illus.

29 *Enamels of Limoges, 1100–1350*, exh. cat., New York, MMA, 1996, cat. no. 51, entry by Barbara Drake Boehm, includes a detailed discussion of this context.

30 Sotheby's, April 3, 1984, lot 78, illus.

31 Jane Hayward and Walter Cahn, et al, *Radiance and Reflection, Medieval Art from the Raymond Pitcairn Collection*, exh. cat., New York, MMA, 1982, pp. 67–69.

32 For the best survey on this subject in English, see *Lions, Dragons, and Other Beasts, Aquamanila of the Middle Ages, Vessels for the Church and Table*, exh. cat., edited by Peter Barnet and Pete Dandridge, New York, The Bard Graduate Center and The Metropolitan Museum of Art, 2006.

33 Lost wax cast: An artist's original work modeled in wax is lost in the casting process.

34 Otto von Falke and Erich Meyer, *Romanische Leuchter und Gefässe, Giessgefässe der Gotik*, Berlin, Deutscher Verein für Kunstwissenschaft 1935 (reprint 1983) (*Bronzegeräte des Mittelalters*, vol. I), p. 110, no. 354, pl. 146, fig. 330, ex colls: A. Pickert, Cologne, 1881; Baron A. v. Oppenheim; J. Pierpont Morgan, New York.

35 OT, Jgs 14:5-6.

36 Sotheby's, London, 1984, private sale.

37 V. Falke and E. Meyer, pl. 176, fig. 417; nos. 442, 443, 444, figs. 415, 416, 419; *Schloss Gottorf und seine Sammlungen, Mittelalter*, Schleswig, Schleswig-Holsteinisches Landesmuseum, 1994, no. 64, illus.; William D. Wixom, "A Lion Aquamanile," *The Bulletin of The Cleveland Museum of Art*, LXI, 8, October 1974, pp. 260–270, figs. 1–2, 8, 9.

38 V. Falke and E. Meyer, p. 116, no. 553, pl. 207, fig. 510; Sotheby's, London, December 1, 1983, lot 129, illus. The unicorn is well represented in bestiary texts and illustrations. Such manuscripts are notable for their moralizing accounts of natural history, fables, myths, and travelers' descriptions. For example, see T.H. White, *The Book of Beasts*, New York, 1954, pp. 20–21 for the unicorn.

39 V. Falke and E. Meyer, pp. 86, 117, no. 560, pl. 208, fig. 514; Wixom, "Late Medieval Bronzes," *Renaissance Bronzes from Ohio Collection*, exh. cat., Cleveland, CMA, 1975, cat. no. 1, illus.

40 V. Falke and E. Meyer, p. 118, no. 585, pl. 216, fig. 536 and no. 597, pl. 219, fig. 545.

41 V. Falke and E. Meyer, pp. 88, 117, no. 578, pl. 214, fig. 531, ex colls.: Fürst Hohenzollern, Sigmaringen; Baron Robert von Hirsch, Frankfurt and later Basel, sale, Sotheby's, London, June 22, 1978, lot 207, illus.

42 For examples in New York, see *Lions, Dragons…*, exh. cat., 2006, cat. nos. 21, 22, 23, illus.

43 Von Falke and E. Meyer, pp. 90, 118, no. 602, pl. 221, fig. 550, ex colls.: Fürst Hohenzollern, Sigmaringen; Baron Robert von Hirsch, Frankfurt and later Basel, sale, Sotheby's, London, June 22, 1978, lot 205, illus.

44 Von Falke and E. Meyer, pp. 29, 104, no. 212, pl. 77, fig. 177, ex. coll.: Baron Robert von Hirsch, Frankfurt and later Basel, sale, Sotheby's, London, June 22, 1978, lot 212, illus.

45 *Lions, Dragons, …* exh. cat., 2006, cat. no. 43, illus.; v. Falke and E. Meyer, pp. 29, 104, no. 211, pl. 77, fig. 176.

46 *Mittelalter I, Bronze, Email, Elfenbein* (*Bildkataloge des Kestner Museums, Hannover VIII*), Hannover, 1966, pp. 33–34, cat. no. 23, illus., bibl. The example in the Lauder collection was formerly in the collection of Hyatt Mayor (1901–1980), the distinguished curator of prints at The Metropolitan Museum of Art. Depictions of howdah bearing elephants appear in contemporary bestiaries, e.g. T.H. White, pp. 24–28.

47 Ex colls.: [Audomarois, France]; [René Gimpel, London]; [Artemis, London and New York, 1978]. For further discussion and bibliography, see *Set in Stone, The Face of Medieval Sculpture*, exh. cat., edited by Charles T. Little, New York, MMA, 2006, pp. 35–38, cat. no. 9, illus., entry by Dorothy Gillerman.

48 Ex colls.: Hampton Court, Herefordshire; [Sidney Burney, London]; [Roy Grosvenor Thomas, London and New York]; [Brumner Gallery, New York]; Sir Charles Close, London, his sale, Christie's, London, December, 13, 1985, lot 67 and 67A, illus.

49 London, British Library, Add. Ms. 29926, folios 139 and 138 respectively. This library contains two additional illustrations of the Bye Street Gate: an Indian ink drawing by S. Fisher dating ca. 1770–1800 and an aquatint print also by S. Fisher of 1785. The British Museum owns a watercolor by Thomas Herne of 1794, four years prior to the demolition. I am indebted to Christina Alphonso and Christine Brennan at the MMA for research assistance.

50 Ex colls.: Marienstift, Erfurt; Fürst Hohenzollern, Sigmaringen; Baron Robert von Hirsch, Frankfurt and later Basel, sale, Sotheby's, London, June 22, 1978, lot 239, illus.; Sotheby's, London, December 1, 1983, lot 128, illus.

51 Ex colls.: Mme. Camille LeLong, Paris; M. La Rouchefoucauld, Paris; [Brimo de Laroussilhe, Paris]; [Simon Seligmann, Paris (ca. 1909–12)]; Georges Seligmann, New York. *Enamels of Limoges, 1100–1350*, exh. cat., New York, MMA, 1996, pp. 332–333, cat. no. 114, illus., entry by Barbara Drake Boehm.

52 Transept: The transversal part of a Romanesque or Gothic cruciform church, which crosses at a right angle to the greatest length, and between the nave and the apse or choir.

53 Jacobus de Voragine, *The Golden Legend, Readings on the Saints*, translated by William Granger Ryan, Princeton, University Press, 1993, vol. II, pp. 256–260; van Os, pp. 28–31.

54 Ex colls.: Jacon Astley, 16th Baron Hastings; Emil Levy, sale, Paris, December 14, 1928, lot 51; Paul R.G. Horst, Robert Horst, sale, Christie's, London, November 28, 1961, lot 67; Jack and Belle Linsky, New York, Sotheby's, New York, May 21, 1985, lot 66, illus.

55 Mandorla: This Italian word for nut refers in Christian art to the almond shape or pointed oval. This shape, often gilded, was primarily used to frame the images of Christ and the Virgin.

56 Ex coll.: Daniel Burckhardt-Wildt (1752–1819), Basel; sale by descendants, Sotheby's, London, April 25, 1983, lots 37, 45, 55, 66, illus.

57 Patrick M. de Winter, "Visions of the Apocalypse in Medieval England and France," *The Cleveland Museum of Art Bulletin*, 70, 1983, pp. 396–417, color pls. 1–4 (Cleveland, CMA), figs. 18, 19 (New York, PMLM), fig. 20 (Detroit, DIA).

58 For example, see Enzo Carli, Giovanni Pisano, Pisa, Pacini Editore, 1977, figs. 80–82, 95.

59 Carli, figs. 108, 112–117.

60 Heinz Klotz, "Ein Bildwerke aus der Hütte des Giovanni Pisano," *Jahrbuch der Berliner Museen*, vol. 7, 2, 1965, pp. 166–178, fig. 9.

61 Tetramorph: This term coming from the Greek was used in Christian art to represent the four winged symbols of the Evangelists: Matthew (a man), Mark (a lion), Luke (an ox), and John (an eagle). This imagery originated in the Old Testament book of the prophet Ezekiel. It recurs in the New Testament book of Revelation (Apocalypse).

62 Carli, fig. 82; Lisbeth Castelnuovo-Tedesco and Jack Soultanian, *Italian Medieval Sculpture in The Metropolitan Museum of Art and The Cloisters*, New York, MMA, and New Haven and London, Yale University Press, 2010, pp. 166–170, cat. no. 37.

63 Ex coll.: Lord Astor of Hever, Hever Castle, Kent, sale, Sotheby's, London, May 6, 1983, lot 233, illus.; Richard H. Randall, Jr., *The Golden Age of Ivory…*, p. 135, cat. no. 205, illus., bibl.

64 Danielle Gaborit-Chopin, *Ivoires du Moyen Age*, Paris, Office du Livre, 1978, pp. 162–163, ill. 252.

65 Collections of the Stuart family since the accession of James I in 1603; Henry Stuart, Cardinal of York before 1807; dowager duchess of Cleveland, 1807; Hollingworth Magniac, Coleworth House, Bedfordshire, before 1857–1892; Lord Astor of Hever, Hever Castle, Kent, sale, Sotheby's, London, May 6, 1983, lot 230, illus.; Randall, Jr., *The Golden Age of Ivory…* pp. 121–122, illus., bibl.

66 Jacobus de Voraigne, *The Golden Legend…*. Transl. By William Granges Ryan, 1993, vol. II, pp. 266–271.

67 Ex coll.: Thomas F. Flannery Jr., Chicago, sale, Sotheby's, London, December 2, 1983, lot 15, illus.

68 *Lions, Dragons…*, exh. cat., 2006, cat. nos. 51, 52, illus.

69 Ex. coll.: Thomas F. Flannery J., Chicago, sale, Sotheby's, London, December 2, 1983, lot 15, illus.

70 See Sabina Witt, "The Statuary of Poligny: Foundations and Court Art in France-Comte," in *Art from the Court of Burgundy*, exh. cat., Dijon, Musée des Beaux-Arts and Cleveland, CMA, 2004, pp. 274–275, cat. nos. 105–106, illus. In the same publication, see Véronique Boucherat, "A New Approach to the Sculpture of Claus de Werve," pp. 322–323, fig. 8.

71 Ex coll.: Henri Garnier, Paris; [Rosenberg & Stiebel, Inc., New York].

72 Ex coll.: [Wildenstein and Co., Inc. New York].

73 NT, Mk 1:2-9.

74 OT, Is 16:1; NT Jn 1:29, 36.

75 *Contrapposto*: This Italian term is used in the visual arts to describe the human figure standing with most weight borne over one leg and foot forcing the torso, shoulders, and arms off-axis. This derives from the canon of the Classical fourth century BC Greek sculptor Polykleitos.

76 Jacqueline Bocador, *Statuaire Médiévale en France de 1400–1530*, Paris, 1974, vol. I, fig. 360. The extended bare right leg, the positioning of the lamb above the horizontal edges of the book pages, and the carving of the eyes, high cheek bones, and mouth may be compared with those of the limestone sculpture of the Baptist of the same period and localization in The Metropolitan Museum of Art, see William D. Wixom, *Late Medieval Sculpture in the Metropolitan, 1400 to 1530* (reprint: MMA Bulletin, LXIV, 4, Spring 2007, pp. 18–19, illus., 48 bibl.).

77 Private collection, Paris, sale, Galerie Georges Petit, Paris, November 22, 1920, lot 109, illus.; [Trinity Fine Art, Inc., Vaduz, 1986.] I am indebted to Florica Zaharia for her examination of this tapestry.

78 *Burgund im Spätmittelalte 12. bis 15. Jh.,* exh. cat., Ingelheim am Rhein, 1986, pp. 142–43, cat. no. 105, illus.

79 For a discussion of Pasquier Grenier, see Adolfo Salvatore Cavallo, *Medieval Tapestries in The Metropolitan Museum of Art*, New York, MMA, 1993, pp. 58–59, 66–67, 243.

80 Fabienne Joubert, *La tapisserie médiévale au musée de Cluny, Paris, Éditions de La Réunion nationaux*, 1987, pp. 98, 103.

81 François Avril and Nicole Reynaud, *Les manuscrits à peintures en France, 1440–1520*, exh. cat., Paris, Flammarion, 1993, pp. 58–59, 64–67, cat. now. 26 and 27, illus.

82 See Margaret B. Freeman, *The Unicorn Tapestries*, New York, MMA, 1976, illus. 268–272.

83 Aby Warburg, "Peasants at Work in Burgundian Tapestries," in *Aby Warburg, The Renewal of Pagan Antiquity*, transl. By David Britt, Los Angeles, Getty Research Institute for the History of Art and the Humanities, 1999, pp. 315–323, 484–485 (this article was called to my attention by Elizabeth A. H. Cleland).

84 Collection of the Princes of Waldburg-Wolfegg at Schloss Wolfegg near Ravensburg, Germany; Timothy B. Husband, *The Medieval Housebook and The Art of Illustration*, exh. cat. New York, The Frick Collection, 1999, pp. 18, 31, 39, 46, figs. 2 (fol. 11r), 10 (fols. 19v–20r), 14 (fols, 23v–24r), 16 (fol. 35r).

85 Private collection, 1805–1983, Kizigtal, Germany, sale, Sotheby's London, December 13, 1984, lot 76, illus.

86 For a recent discussion about the hollowing out of the heartwood, see Michael Baxandall in *Tilman Riemenschneider, Master Sculptor of the Late Middle Ages*, exh. cat., by Julian Chapuis et al, Washington, DC, NGA and New York, MMA, 1999, pp. 94–96.

87 Ibid., p. 196, cat. no. 10, illus., entry by Julian Chapuis.

88 Ibid., p. 33., fig. 7 and back cover.

1. Stairway and Armory at Strawberry Hill, 1784

STUART W. PYHRR

Arms and Armor

Collectors of European arms and armor are an endangered species. The heyday of collecting was the nineteenth century, when an intense interest in the European Middle Ages, manifest as the Gothic Revival, and an abundant supply of arms and weapons, dislodged from castles and arsenals on the Continent as the result of the French Revolution and Napoleonic Wars, coincided to make armor collecting both practical and fashionable. Among the great private collections formed in that era were those of Sir Samuel Meyrick and Sir Richard Wallace in England, Napoleon III and the Comte de Nieuwerkerke in Paris, Carlo Alberto of Savoy in Turin, and Czar Nicholas I and Prince Peter Soltykoff in Saint Petersburg. The majority have since passed into the public domain. A second golden age of collecting occurred during the years between the two world wars. It especially benefited American collectors and museums, whose wealth attracted to our shores large numbers of antique arms that had for centuries remained in European aristocratic armories and national museums. The best of these also entered public collections, with the result that few first quality arms remained on the art market.

Ronald Lauder faced a formidable challenge when he set out in the 1970s to form a collection of European arms and armor, one that he hoped would emulate and perhaps also complement that of the Metropolitan Museum of Art. The great objects he dreamed of acquiring were likely to appear for sale seldom, if ever. Yet his collection today, arguably the finest in private hands, includes a number of exceptional and beautiful armors and weapons of museum quality.

Ronald is a modern version of the eclectic nineteenth-century collector, having the same wide-ranging interest in the art of different periods and media. However, unlike the Victorian collectors, with their preference for highly ornamented and elaborately worked objects (the Rothschilds come to mind), Ronald has been guided by a different aesthetic that favors bold forms, clean lines, and spare decoration. It is no surprise that his favorite period of armor is the fifteenth and early sixteenth century, corresponding to the late Middle Ages and early Renaissance, armor characterized by functional design, strong profiles, and smooth, largely unornamented surfaces. Indeed, many of the pieces in his collection share the same abstract qualities as modern sculpture.

ARMOR COLLECTING IN CONTEXT

The history of past ownership, that is, the establishment of provenance or "ex collection," is an important aspect of collecting. Tracing the earlier owners of a work can lead us back to the aristocratic family or historic castle from which it came. And there is also considerable satisfaction for the modern collector in learning that he owns pieces that were formerly in the hands of famous collectors and discerning connoisseurs of the past. The provenances of Ronald's arms and armor holdings are as distinguished as they are diverse. They include examples from a number of national collections such as the former imperial armory in Vienna, the Zeughaus in Berlin, and the royal armory in Dresden, as well as Churburg Castle (Castle Coira), in the north Italian Tyrol, the only surviving medieval armory still owned by the original family. Many of the most important private collections formed in the modern era, after 1750, are also represented, including those of Horace Walpole, Samuel Meyrick, Robert Curzon (Baron Zouche), and Edwin Brett in England, those at Grafenegg Castle and Burg Kreuzenstein in Austria and Erbach Castle in Germany, and the twentieth-century collections formed by Bashford Dean, Clarence Mackay, William Randolph Hearst, and Stephen Grancsay in the United States, and Peter Gwynn in England.

The history of arms and armor collecting is centuries old and has aristocratic roots[1]. The first specialized collector was Archduke Ferdinand II of Tyrol (1529–1595), younger brother of Holy Roman Emperor Maximilian II, who governed the transalpine regions of Austria from his castle at Ambras, near Innsbruck. Beginning in the 1570s, Ferdinand systematically collected the armors of the leading military figures of his century, friend and foe alike. He displayed them in a splendid paneled gallery, with niches to house the armors, each set up on a lifelike mannequin. More than one hundred steel harnesses filled the archduke's "Armory of Heroes." Ferdinand also prepared a deluxe folio-sized publication featuring a woodcut illustration of each armor, with accompanying text recounting the biography and military exploits of the armor's owners. Published posthumously in Latin in 1601 (a German edition followed in 1603), this volume is now considered the first museum catalogue. But Ferdinand's collecting interests do not seem to have inspired succeeding generations, and throughout most of the baroque age, arms and armor, when collected at all, was relegated to the cabinet of curiosities, where it was displayed for its technical or mechanical peculiarities, its exotic origins, or its purported historical associations.

In the second half of the eighteenth century, with the advent of the Gothic Revival and a renewed interest in the Middle Ages, armor became the object of antiquarian collecting. Horace Walpole (1717–1797) led the way, installing an armory in his new Gothic-style "castle" at Strawberry Hill as early as 1753[2]. For Walpole the specific contents of his arms collection were less important than the picturesque display of the ensemble, an armory considered both a requisite part of any castle and evidence of the chivalric roots of an aristocratic family. Walpoles's guidebook to his house, *A Description of the Villa of Mr. Horace Walpole...at Strawberry Hill* (1784), includes an illustration of the staircase leading up to the armory, a modest affair limited to a landing arranged with panoplies of armor and weapons, with heraldic arms above and a stained glass window to one side [Fig. 1]. A niche on the staircase housed an

embossed and gilt French parade armor dating around 1600 that Walpole mistakenly believed to have belonged to Francis I of France (ruled 1515–1547). At the foot of the armor, though not visible in the illustration, was an associated etched and gilt French shaffron (armor for the horse's head) of about the same date, that is today in Ronald's collection [Plate 56][3]. It is one of only a few items identifiable from Walpole's once famous armory and therefore is a precious relic of this important early collection.

Strawberry Hill's Gothic-inspired interiors and its prominent armory very likely inspired other collectors, both in England and abroad. By the 1780s, for example, Count Franz I zu Erbach-Erbach had begun to assemble a collection of arms and armor in his ancestral home, Schloss Erbach, in the Odenwald near Darmstadt, while at the same time transforming the baroque manor into a medieval-style castle. A new armor hall, the Rittersaal, or Hall of Knights, was constructed and furnished with shields of arms and stained glass to complement the display of two dozen harnesses, each identified as belonging to a distinguished warrior or historic figure [Fig. 2][4]. Count Erbach had an advantage over Walpole in that he had access to the well-stocked armories and arsenals in Germany and Austria. He acquired, for example, several armors from the city arsenal of Nuremberg. One of these, an armor dating to about 1500–1510 and bearing the later engraved arms of Kunz Schott von Hellingen (d.1523), the famous "robber knight" of Rothenburg, is now in Ronald's collection [Plate 49].[5]

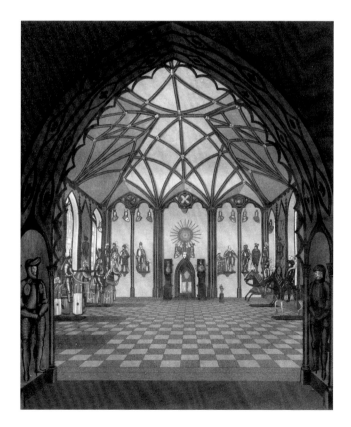

2. Schloss Erbach, showing armory and Kunz Schott armor in the niche at the right, 1832

During the nineteenth century the continuing influence of the Gothic Revival and the romantic taste for tales of knighthood and chivalry, as exemplified by the novels of Sir Walter Scott, heightened public awareness of arms and armor and fueled interest in antiquarian research and collecting. The dispersal of many dynastic armories and municipal arsenals during the French Revolution and Napoleonic Wars resulted in quantities of historic arms becoming widely available to collectors.[6] London and Paris became the principal cities in which arms and armor were on public display and were regularly sold at auction and by specialized dealers. Arms and armor came to be recognized as a valid area of the applied or decorative arts and found acceptance both in the private salon and public museum. Arms and armor collecting became fashionable. Great Victorian collectors like Sir Richard Wallace and various members of the Rothschilds family, whose vast wealth allowed them to acquire the very best examples in any field, regularly displayed highly decorated armor and weapons with their Old Master paintings, bronzes, porcelain, and furniture. In France, the two greatest armor collectors during the Second Empire were Napoleon III and the Comte de Nieuwerkerke, Director of French Museums and Superintendent of Fine Arts, men at the very pinnacle of society and thus influential trendsetters.

Early armor collecting was dominated by aristocrats, artists, and antiquaries.[7] The nobility sought to rebuild and decorate their ancient seats in the medieval style, complete with armories their forebears had long since discarded or perhaps never had in the first place. In England, for example, the earl of Warwick refurbished his ancestral castle, one of the oldest in the realm, and began to collect armor anew. History painters and artists of the Romantic Movement not only studied ancient armor to aid their depiction of historic costume, but they also collected examples of their own. In London, the painters Richard Cosway, Philippe-Jacques de Loutherbourg, and Johann Zoffany had collections; in France, Géricault and Delacroix studied museum collections (the former sketched in Samuel Meyrick's collection in London in 1821), and Anne-Louis Girodet owned a considerable number of arms. The growing interest in armor also inspired the publication of specialized studies, most importantly Sir Samuel Meyrick's *Critical Inquiry into Antient Armour* (1st ed. 1824; 2nd ed. 1842), an ambitious pioneering work by a lawyer-turned-antiquary who looked to documented sources as the foundation for his history of the evolution of European armor. Meyrick also formed an extensive private collection of over one thousand arms. Many of these he published in 1830 in a lavishly illustrated two-volume catalogue of his collection, thus pioneering in the arms and armor field a new genre, the private collection catalogue.[8] Thanks to the detailed illustrations in Meyrick's catalogue, at least two works from his collection can be identified in Ronald's: an Italian shaffron of etched and gilt steel, ca. 1550–60 [Plate 55]; and a horseman's saddle ax, possibly an Italian work of late sixteenth-century date, which has an elegantly shaped steel head pierced and inlaid with an openwork copper alloy rosette [Fig. 3].[9]

Arms and armor collecting in the United States was inspired by European examples and first manifests itself in the decades following the end of the Civil War, when new fortunes were made and Americans became increasingly more cosmopolitan and well traveled.[10] Among the most important early collectors was Oliver Belmont (1858–1908), son of the

international financier August Belmont, who in the 1890s added a Gothic-style armory to his Newport home, Belcourt Castle. The armory was furnished with a selection of armors and equestrian equipment purchased from Tiffany's, that fashionable firm having recently acquired a portion of the collection of Richard Zschille, a German collector who had displayed his arms in 1893 at the Century of Progress Exhibition in Chicago. In 1916 a new collector in the field, Clarence Mackay, acquired the Belmont armory. One of the Zschille-Belmont-Mackay armors is now in Ronald's collection [Fig. 4].

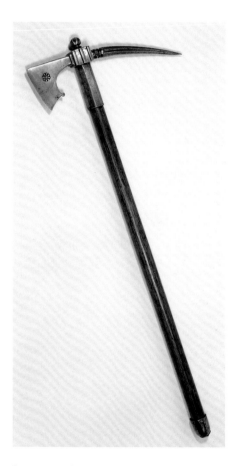

3. Horseman's Saddle Ax, possibly Italian, late sixteenth century, steel, copper alloy, wood

4. Armor, Nuremberg, ca. 1515– 25, steel, leather

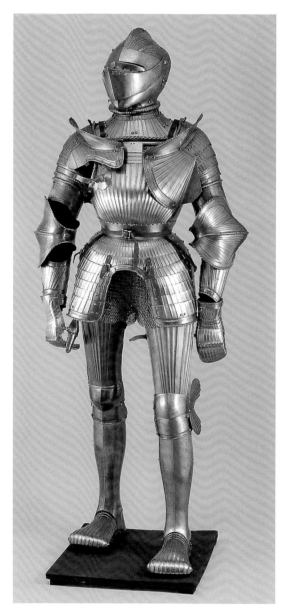

Rutherfurd Stuyvesant (1842–1909), descendant of the peg-legged Dutch governor of New York, was another active armor collector of the time, who, in this case, was less important for the objects he gathered than for his influence in directing the Metropolitan Museum of Art to collect in that field. A trustee of the Metropolitan Museum since its founding in 1870, Stuyvesant persuaded the Metropolitan in 1904 to purchase the collection of Maurice de Talleyrand-Périgord, Duc de Dino, reputedly the finest private collection of arms and armor of its day, for the extraordinary sum of $250,000. This purchase established armor as a significant facet of the museum's collection and led to the hiring of a Columbia University professor, Dr. Bashford Dean (1867–1928), as honorary curator.[11] Dean's energetic and inspired work in displaying, publishing, and promoting the collection, and expanding it through loans, gifts, and purchases, caused the museum to establish in 1912 a separate Department of Arms and Armor, with Dean as its full-time curator.

From that time on, the Metropolitan assumed a leading role in the arms and armor field. Dean's primary mission was to build up the Museum's collections. In 1913 he secured the donation of the William H. Riggs collection, comprising about 2,000 European armors and weapons, which established a solid foundation for the department's collection. Dean could not have anticipated at the time that in the following decade the Museum—and American collectors in general—would have unprecedented opportunities to secure historic pieces from some of the most important European collections. Acquisitions in coming years would transform the Museum's collection into one of world-class status.

The ravages of World War I and the years of social and financial turmoil that followed caused a number of European museums and aristocratic collectors to offer for sale significant parts of their art collections, including arms and armor. American collectors and museums, enjoying a strong peacetime economy, were at the ready. In the armor field, Dean actively pursued curators, collectors, and dealers in every country in Europe. He was not alone, however, having two principal competitors, Clarence Mackay and William Randolph Hearst. Competition for the same objects was intense and prices rose to unprecedented heights.

The success of these three collectors, Mackay, Hearst, and Dean, is made evident by the photographs of their private collections. The architectural settings, period furnishings and tapestries, and displays of armor successfully evoked the medieval castles and Renaissance chateaux that were their models.

Clarence Mackay (1874–1938), son of one of the original miners of the Comstock Lode silver fortune in Nevada and himself director of the Mackay Telegraph Company, lived in a palatial chateau, Harbor Hill, in Roslyn, Long Island.[12] Its vast spaces, designed by the architectural firm McKim, Mead, and White, were filled with Old Master paintings, sculptures, and tapestries [Fig. 5]. But Mackay's first love was armor. His acquisitions were highly selective, as he was interested in quality rather than quantity. Only the best would do. This emphasis on quality, backed up by a willingness to pay almost any price to secure the rarest objects, accounts for such prized possessions as the embossed parade armor of Henry II of France,

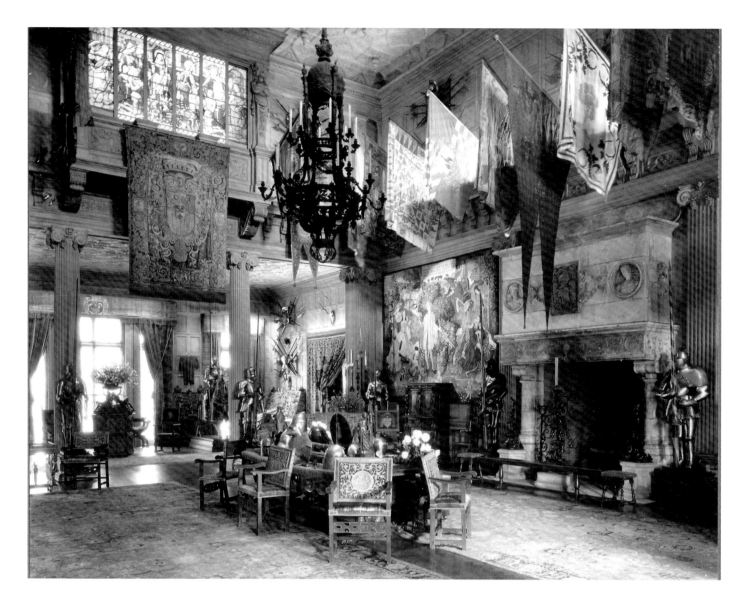

5. Mackay collection, Harbor Hill, Long Island, ca. 1930

and the harnesses of two great Elizabethan courtiers, George Clifford, Earl of Cumberland, and Henry Herbert, Earl of Pembroke, both extremely rare decorated examples from the English royal workshops at Greenwich. All three are now in the Metropolitan.

William Randolph Hearst (1863–1951) was a larger than life figure in American history.[13] He was famous not only as the creator of the nation's largest newspaper empire, but also as an omnivorous collector who filled his many homes with the art treasures of Europe. His collections were so large, and grew at such an alarming rate, that many pieces never left their warehouses. Perhaps less selective than Mackay, Hearst nevertheless had the wealth and influence to secure great armors, many of which came from German armories, and even from national museums such as those in Dresden and Berlin. Hearst's armor collection was largely displayed in his triple-height living room in the Clarendon apartment house on West End Avenue in New York [Fig. 6] and in his castle, St. Donat's, in Wales [Fig. 7]. A third armory seems to have been planned for his castle of San Simeon in California, but was never completed.

Bashford Dean built a private collection of arms and armor while taking care to balance his

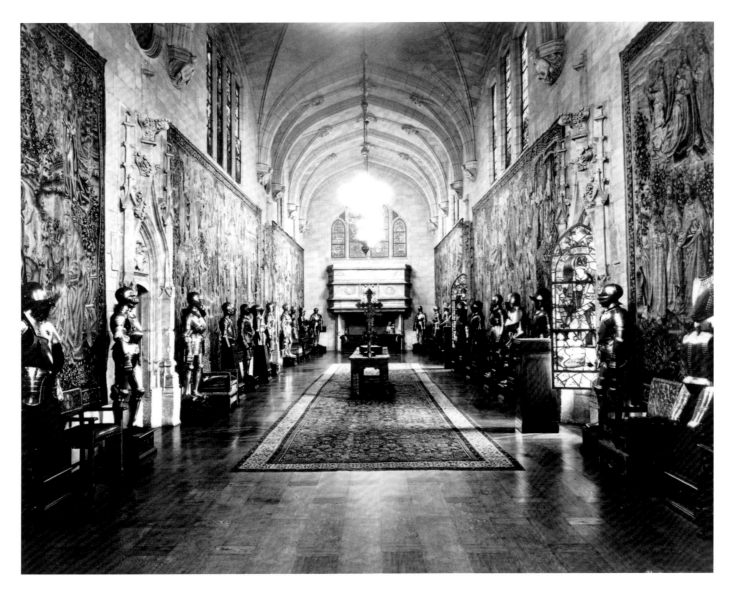

personal acquisitions with those he made for the Metropolitan. At the same time he also tried to stay on friendly terms with his rivals Mackay and Hearst. While he sought masterpieces for the Metropolitan, Dean built his private collection along educational lines, with the intent of telling the story of the evolution and development of arms and armor. In 1927 he set about adding an armor hall on to his home at Wave Hill, in Riverdale, overlooking the Hudson [Fig. 8]. Dean's choice of a traditional medieval-style setting for his collection demonstrates the legacy of the Gothic Revival and the powerful romantic tradition that still enshrouded arms and armor collecting in the early twentieth century.

The stock market crash of 1929 and the Great Depression that followed put an end to the armor boom. Dean died in 1928, after which his collection was dispersed, about half of it being acquired by the Metropolitan Museum through bequest, gift, and purchase. By 1930 Mackay had ceased collecting and in 1932 he was forced by debt to sell some of his finest items to the Metropolitan. After his death in 1938, his holdings were scattered by public auction and private sale through the firm of Jacques Seligmann in New York. Hearst's collecting continued unabated until the mid-1930s, when he too found himself and his news-

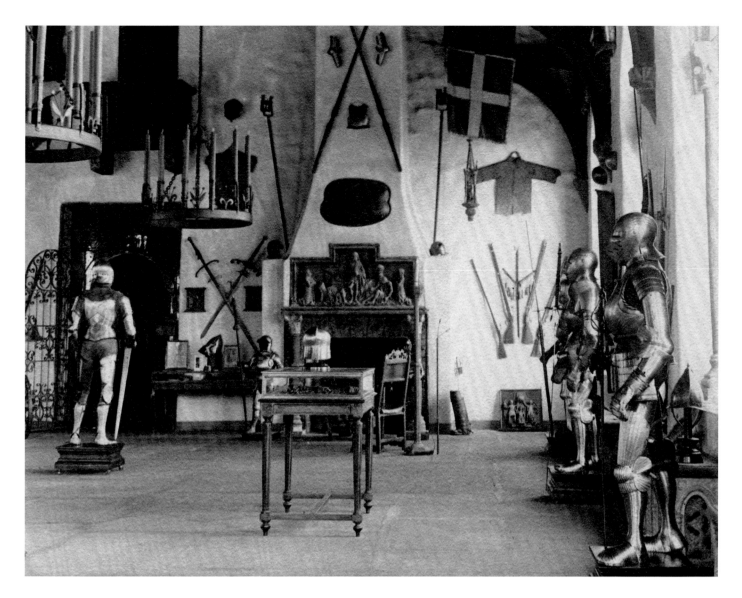

papers deep in debt. Much of his armor collection was sold in the late 1930s, by auction and, most famously, at Gimbel's Department Store in New York, where historic armors, Old Master pictures, and period furniture bore retail price tags, marking the ignominious end to the greatest period of American armor collecting.

In the post-World War II period arms and armor collecting in the United States and Europe seemed to have lost its momentum. Prices were low, wealthy collectors were few. Two notable exceptions, however, were Carl Otto von Kienbusch (1884–1976) in New York and Reginald T. ("Peter") Gwynn (1905–2001) in Epsom, England. Each had a sharp eye for quality and, despite budgets much more limited than those of Hearst or Mackay, was able to take advantage of the opportunities presented by the postwar dispersals of armor collections. Both profited especially from the sale of the residue of Hearst's collection, beginning in 1951 following the collector's death. Von Kienbusch, whose wealth derived from the family tobacco importing business, was a friend and disciple of Bashford Dean's and his collection emulated Dean's in its comprehensive scope.[14] He bought selectively and well at the Hearst auctions and privately from the Bronx warehouse where the bulk of Hearst's American ar-

6. Opposite top: Hearst collection, New York, 1920s

7. Opposite bottom: Hearst collection, St. Donat's Castle, Wales, 1930s

8. Above: Dean collection, Riverdale, New York, 1930

mor holdings were stored. Hearst material forms the largest single source for Kienbusch's twelve hundred piece collection, which until his death was displayed on the second floor of his townhouse at 12 East 74th Street [Fig. 9]. The collection was bequeathed to the Philadelphia Museum of Art, where it was installed in specially designed galleries in 1977.

Peter Gwynn, an executive with the Woolworth Company in Britain and later partner with the art dealer R.A. Lee, formed the other great postwar collection of armor.[15] Like von Kienbusch, his acquisitions came largely from the Hearst collection, though selected mostly from the contents at St. Donat's Castle. Much smaller and less comprehensive than von Kienbusch's collection, Gwynn's focused primarily on early armor and included several prized pieces from the former imperial armory in Vienna and from Churburg Castle. The collection was displayed

9. Kienbusch collection, New York, 1960s

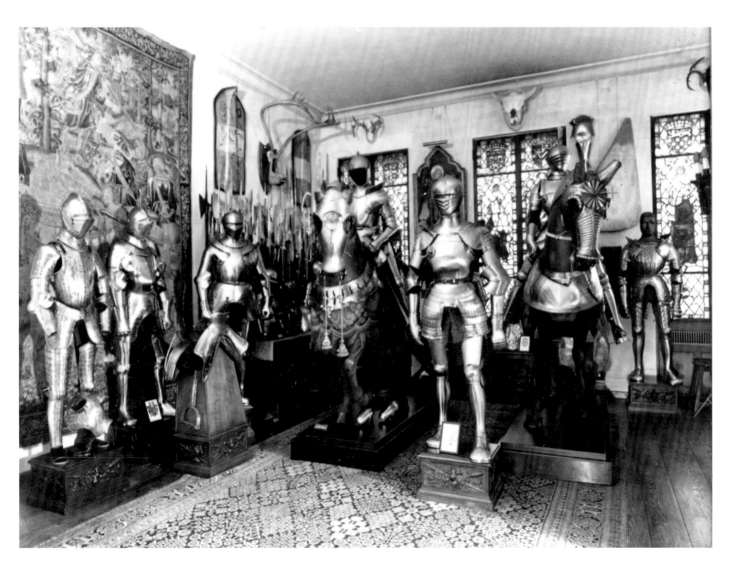

on the ground floor of his small but charming Elizabethan house, Dame Annis Barn in Epsom, and was complemented by two other equally select collections, medieval oak furniture and early clocks. When he died in 2001, Gwynn left an armor collection of fewer than one hundred pieces. The best of these Ronald acquired by private treaty; others were purchased at Christie's, where the remaining Gwynn pieces were sold.

FORMING A COLLECTOR AND A COLLECTION

Like most arms and armor collectors, Ronald traces his interest in the subject to his youth. At age 9, he was given a gift of several pistols and edged weapons by a friend of his father. It would be another two decades, however, before Ronald purchased his first piece of armor.

As with other specialized fields of fine arts and antiques, the collecting of arms and armor requires careful navigation through the many fakes, pastiches, and overly restored artifacts that populate the art market. Around 1976, before he had bought a single item, Ronald sought the expert advice of Stephen V. Grancsay (1897–1980), curator emeritus of the Metropolitan Museum's Department of Arms and Armor and dean of American arms studies.[16] Retired from the Metropolitan since 1963 after fifty years of dedicated service, Grancsay devoted his remaining years to the research and cataloguing of the collections at the Metropolitan Museum and the George F. Harding Museum in Chicago. The well-traveled curator knew every important public and private collection in the United States and abroad and, a seasoned collector himself, Grancsay had a good sense of the art market. In Grancsay, Ronald found himself an authoritative guide and advisor without equal.

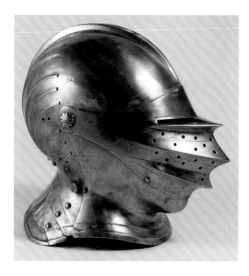

10. Close-helmet, German, early sixteenth century, steel

Planning sessions with Granscay informed the neophyte collector about the principal dealers and collectors he should visit, the important objects hidden away in European castles that he might eventually acquire, and a host of fakes he must avoid. By this time Grancsay had also made the acquaintance of Prescott Andrews, a young businessman with a similar passion for antique arms who had sought the curator's acquaintance. Grancsay introduced him to Ronald. Prescott's energy and enthusiasm were infectious and soon he was acting on Ronald's behalf, scouting for the most desirable objects in collections and dealers here and abroad.

Ronald's collecting began cautiously. His first purchase, made at a Christie's auction in 1977, was an early sixteenth-century German close-helmet of fluted (so-called Maximilian) type [Fig. 10]. It is still in Ronald's collection, where it anchors an impressive series of almost thirty helmets.

In addition to offering sage advice, Grancsay also offered Ronald three of the most important pieces in his personal collection. Grancsay came from a generation of curators who actively collected in their own field (the practice is discouraged today), putting their personal income and expertise to the test. Once the owner of more than five hundred arms, Grancsay retained in his later years only the very best. Ronald's purchase of the Grancsay pieces set the standard of quality that would become the measure of acquisitions to follow.

The most important item acquired from Grancsay was a complete armor, head to foot, homogenous in all its parts [Plate 51].[17] Complete and unrestored armors are rare even in museums, so Grancsay must have considered himself exceptionally fortunate to have discovered this harness in a dealer's shop in Paris in 1934. It has all the features of a traditional "field armor," that is, one intended for mounted use with a lance: a close-helmet, breastplate with a lance-rest on the right side (now missing, though a single hole for a special type of lance-rest is present), right pauldron (shoulder defense) cut out to accommodate the couching of the lance beneath the right arm; and complete arm and leg defenses. The steel plates are rough from the hammer and blackened; the principal surfaces are decorated with vertical bands formed of narrow, brightly polished channels, with similar recessed bands following the edges of the principal plates. The sober black and white coloring is relieved only by gilt rivets and buckles. The armor seems to have an intriguing provenance: when acquired by Grancsay it was lined with Japanese silk, indicating that it had once been in Japan, where perhaps it had been sent as a diplomatic gift. Unfortunately the lining has since been removed and with it has been lost all evidence of the armor's earlier peregrinations.

Grancsay believed his armor to be French, dating about 1550. New research, on the other hand, indicates that it is Italian and of much later date, about 1600–1610; indeed, it is also a much rarer and more important piece, as it can be attributed to the Florentine grand ducal workshops in the Uffizi. Details of the armor's form and construction, particularly the compact shape of the helmet, closed vambraces, short-waisted breastplate shaped with a small point at the bottom-center, and rounded sabatons, point to this later dating. Identical fluted bands are found on several armors made for members of the Medici court in the same years, armors most likely produced in the grand ducal workshops. The most complete and beautiful of these is the half-armor for foot-combat at the barriers made for young Cosimo II de' Medici (1590–1621, ruled from 1609), now in the Detroit Institute of Arts.[18] The common decoration suggests a Florentine origin for the group. The Grancsay armor appears to be the only surviving field armor created in the Florentine workshops, and an unusually archaic one at that, as by 1600 field armors were seldom fitted with greaves and sabatons (defenses for the lower legs and feet). It too may have been made for one of the Medici princes, possibly Cosimo II.

The second Grancsay piece, and a particular favorite of Ronald's, is a triple-combed burgonet (open-faced helmet) of about 1540–50 [Plate 66].[19] It is struck on the brim with the town mark of Augsburg and the maker's mark (a Stech-helm surmounted by a star) of Desiderius Helmschmid (1513–1579), the most distinguished and famous Augsburg armorer of his generation. The armorer's famous clientele included Emperor Charles V, his son, the future Philip II of Spain, and a host of German and Spanish knights and nobility. The skill of raising three tall ridges, or combs, from a single plate of steel attests to the armorer's mastery of his material and makes this a particularly prized possession. The Lauder example is one of a small number of identical burgonets, some bearing the Helmschmied mark and others unmarked, which suggests that the series may have been made by several different armorers, with Helmschmid marking only those forged in his workshop. Seven examples (only one of them marked) are preserved today in the former imperial armory (Hofjagd-

und Rüstkammer) of the Kunsthistorisches Museum in Vienna, where they are tentatively suggested as having been made for the imperial guard of Charles V.[20]

The third acquisition from Grancsay is an Italian falchion, a distinctive type of curved sword [Plate 80].[21] Despite the fact that curved swords were not commonplace in ancient Rome, falchions were worn in the sixteenth century with *all'antica* costume. The Grancsay example has a gold-damascened iron hilt chiseled with grotesque harpie-like creatures forming the grip and quillons, with an openwork shell guard fashioned from two symmetrically opposed dragons. The superb blade, probably a Brescian work, is chiseled overall with parallel rows of recessed panels, an ostentatious demonstration of the bladesmith's mastery. The falchion reputedly passed in the nineteenth century from the dukes of Pastrana in Spain to the private collection of the Conde de Valencia de Don Juan, director of the Real Armería in Madrid, who exhibited it in the Madrid exhibition of 1892. After Valencia's death the falchion entered the art market and later appeared in the Whawell sale at Sotheby's, London, in 1927, when it was acquired by William Randolph Hearst. In 1939, Grancsay bought several Hearst pieces for his private collection, including the falchion.

Grancsay bequeathed his library and professional papers to the Metropolitan Museum, with the understanding that the duplicate books not needed by the Museum should go to Ronald. In honor of this great armor scholar and his valued advisor, Ronald sponsored the reprinting of Grancsay's 115 articles on arms and armor originally published in the Metropolitan's *Bulletin* between 1920 and 1964.[22] He thus perpetuated the curator's legacy by making available to a new generation of collectors and museum professionals these important but often overlooked armor studies.

In the 1980s Ronald emerged publicly as a serious armor collector ready to compete internationally for the very best examples on the market. Much of his success can be attributed to his trusted buying agent and advisor, Howard Ricketts. One of the leading British dealers in arms and armor, Ricketts had worked for Sotheby's from 1959 to 1972, specializing in arms as well as medieval and Renaissance works of art and objets de virtu. His education in the art world was greatly stimulated and informed by his Sotheby's colleague, John Hayward, one of the legendary experts in Renaissance metalwork and arms and armor, especially firearms. After leaving Sotheby's, Ricketts opened a gallery a few steps away at 180 New Bond Street, where he specialized in arms and armor of both European and Islamic origin, as well as selected works of art. Ronald was introduced to Ricketts in the late 1970s by a mutual acquaintance, Adrian Ward-Jackson, a London dealer working at Colnaghi's, who was assisting Ronald in collecting Old Master drawings. Ricketts's auction house experience and the reliance placed on him by such distinguished American firearms collectors as Frank Bivens and Clay Bedford earned Ronald's respect and trust.

Ricketts's knowledge of private collections immediately yielded several important acquisitions for Ronald. Most notable among these were two superb items from the Paul collection in Berlin. The collection had been formed between the two world wars by Dr. Werner Paul,

11. Cape of mail (so-called "Bishop's Mantle") from the armory of the electors of Saxony, German, ca. 1580, silver, gilt; steel

who, like his American collector rivals, had the opportunity to acquire directly from the Berlin Zeughaus and the Dresden Rüstkammer. During World War II the collection was hidden in the basement of Paul's house and was saved from discovery and certain looting by the Russians when the collector distracted a visiting Russian officer with the bribe of a gold watch. The collection was inherited and expanded by his son Frank, from whom Ricketts acquired one of the most delicate and beautiful late-fifteenth century German crossbows known [Plate 69].[23] The wood stock, or tiller, is stained black and veneered in white bone with delicate foliate scrolls; the bow, of composite type, constructed of a flexible laminate of horn and sinew, is wrapped in birchbark decorated with colorful diagonal stripes. On the top of the tiller are the carved and painted arms thought to be those of the Fügen family of Tyrol. Elaborately ornamented crossbows of this kind served the aristocracy as sporting weapons for the hunt.

The second item is a so-called Bishop's Mantle, a deep collar or cape of mail that covered the wearer's neck and shoulders to the mid-chest [Fig. 11]. The Paul example was one of several sold by the Historical Museum in Dresden after World War I. The Dresden examples are distinguished by having two distinct areas of mail, very fine, dense links in the neck region, and larger, looser links below; the upper chest area has a slit that allows the mantle to fit over the head and which is closed with large decorative silver-gilt buckles. Originally worn by the German infantry *Landsknecht* in the early to mid-sixteenth century, bishop's mantles of this luxurious type were strictly court wear.

The 1980s began auspiciously with the unexpected reappearance at Christie's in London, on November 18, 1981, of a famous armor long thought to have been lost in World War II.[24] This is the magnificent Greenwich armor ordered in 1610 by Henry, Prince of Wales (1594–1612), son and heir of King James I of England, as a gift for his German cousin Prince Friedrich Ulrich of Brunswick-Wolfenbüttel (1591–1634), who was visiting England. The armor was shipped to Germany in 1613 and remained a prized possession of the dukes of Brunswick for two centuries. The armorer's symbolic value for the ruling house is evident from its frequent appearance in ducal portraits, notably in that of Friedrich Ulrich's brother, Duke Christian (d. 1626) (a version is in Ronald's collection), and in several representations of his successor, Duke August (1579–1666). The armor was last recorded in the ducal arsenal at Wolfenbüttel in 1732. Sometime afterward it passed into the possession of the noble Veltheim family, loyal subjects of the dukes, and remained in their castle, Schloss Harbke, until World War II. Nothing further was known of the armor's fate, as the castle was located in Russian-occupied East Germany. Unknown to specialists, the armor had traveled to West Germany after the war with a member of the Veltheim family. At the Christie's sale it was described as an armor whose "quality, condition, documentation and historical associations make it unquestionably the most important complete armour of any period to be offered at public auction in either Europe or the United States for half a century." Competition was sure to be stiff. Ricketts, bidding for Ronald, successfully acquired it for the world record price of €418,000 ($800,000) [Plate 52].

This example occupies a place of special importance in the study of armor made in the royal workshops at Greenwich. As the English armor specialist Claude Blair wrote in the sale cat-

ARMS AND ARMOR

alogue, "This is the only documented product of the Greenwich Armouries known to survive and is therefore a key piece for the identification and study of the whole group." He also noted that "it is also the only surviving Greenwich armour to retain any polychrome decoration," referring to the accompanying half-shaffron bearing the full Brunswick arms [Plate 53]. The armor is the last richly decorated example from the Greenwich workshops, which were established by Henry VIII in 1515 and closed at the outbreak of Civil War in 1642 [Fig. 12, Plate 52]. The brilliantly blued surfaces of the armor are decorated with wide recessed bands of etched and gilt strapwork and, between the bands, with a gilt rose and knot design, a decorative scheme known from several earlier Greenwich armors, including the Metropolitan Museum's armor of George Clifford, Earl of Cumberland, dating some thirty years earlier. The Brunswick armor preserves much of its original color, as well as its original leather straps and textile linings, rare survivals indeed. Unfortunately the extra pieces for the tilt that probably accompanied the armor to Germany have long since disappeared. The gauntlets, however, which were missing from the armor at the time of the sale, have not been lost: they belong to the Metropolitan Museum and are now reunited with the armor as a long-term loan.

On the most import arms and armor auctions of the post-World War II era was held at Sotheby's in London on May 5, 1983, that of the Hever Castle collection. The Hever collection was assembled in less than a decade, 1900–10, at the behest of the American anglophile William Waldorf Astor, who had acquired Hever, a genuine medieval castle, at the end of the nineteenth century, and who set about furnishing in an authentic manner. The collection of arms and armor, an essential element for the interior decoration of any self-respecting castle, was formed in a short time by the leading dealers in London and Paris. The quality of the pieces, almost two hundred in number, varied considerably, as did their condition, but the collection contained many rare and beautiful items of museum quality.

Ronald was particularly fortunate to acquire two exceptionally rare and important Italian daggers of *cinquedea* type [Plate 68].[25] Made about 1500 as ceremonial arms rather than practical weapons of self-defense, cinquedeas are characterized by their shaped grips faced with white bone or ivory plaques pierced by openwork brass rosettes, cast bronze pommels, inverted u-shaped guards of steel, and broad triangular blades with channeled surfaces. The best examples have blades etched and gilt with Renaissance ornament and figural scenes from ancient history or classical mythology, and occasionally also include the heraldic arms of their owners. Several bear the cognizances of the Gonzaga, dukes of Mantua, the Este, dukes of Ferrara, and the Bentivoglio, rulers of Bologna, attesting to the elevated social status of cinquedea owners. Ronald's two examples, in addition to the classical scenes on each blade, display the Bentivoglio arms and those of the Piccolomini of Siena. The collection also includes a smaller cinquedea-style dagger without decoration, an example evidently intended for more utilitarian purpose.

A collection is shaped not only by what is acquired, but also by what is missed or passed over. At the Hever sale Ronald was the successful bidder for three important lots with distinguished English provenance: a gauntlet belonging to an armor of Henry VIII, made about

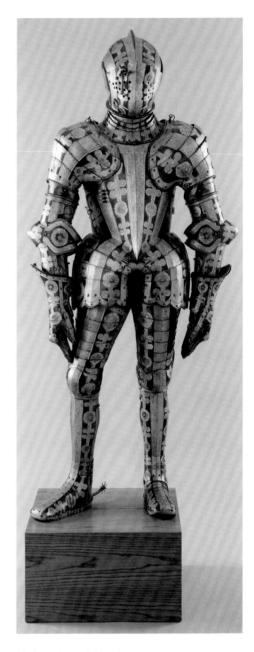

12. Armor for the field and tournament, made for the Duke Friedrich Ulrich of Brunswick, Greenwich, 1610–13, steel, etched, blued, and gilt; leather, textile. Pair of gauntlets lent by The Metropolitan Museum of Art, gift of William H. Riggs, 1913

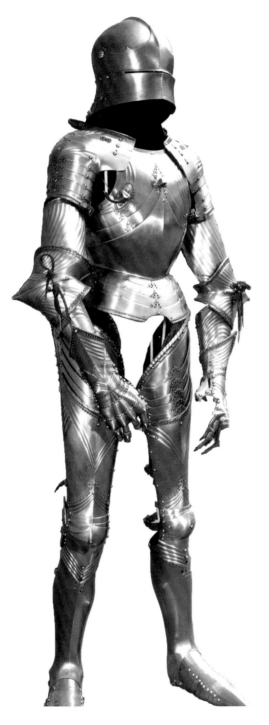

13. Visored sallet mounted with armor A60 from the Kunsthistorisches Museum Vienna, made for Maximilian I, as Archduke of Austria, ca. 1480

1544; an etched and gilt French armor made around 1590 for the Earl of Southampton; and an early seventeenth century English sword with gold and silver damascened decoration, the finest surviving example of its type. The three were deemed of national importance and and export licensees were denied; they were subsequently acquired by the Royal Armouries at the Tower of London. Ronald was also the underbidder for the centerpiece of the Hever collection, the embossed parade armor made about 1540 for the young Henry II of France, when Dauphin, a work attributed to Giovan Paolo Nagroli of Milan. The sting of these losses was compensated for during the second day's sale of the Hever collection, comprising the works of art, in which Ronald acquired several magnificent medieval ivories, of which two fourteenth century examples are included in the present exhibit [Plates 15, 16].

COLLECTION HIGHLIGHTS

Ronald Lauder's collection of arms and armor was shaped by his personal taste, his likes and interest, as much as by the availability of fine arms in the art market. His collection focuses principally on armor and includes six full armors (or "suits" to use a familiar collector's term), twenty-nine helmets, nine shaffrons, one armored saddle, and three painted wood shields. One of his armors, of early sixteenth century German fluted type, is an equestrian figure mounted on a horse manikin with matching shaffron, peytral (breast defense), and saddle [Plate 48]. There are also two mail shirts and, as already mentioned, a bishop's mantle. Weapons, fewer in number but of equally distinguished quality, include fifteen swords (ten medieval examples and five dating to the sixteenth century), four daggers, and five shafted weapons (mostly maces), as well as two crossbows and four firearms. Numbering fewer that one hundred items, about one third of the collection is represented in this exhibition.

The majority of pieces in the Lauder collection date from the fifteenth century, a period that witnessed the final flowering of the Gothic style north of the Alps and the birth of the Renaissance in Italy. This has been called the "great period" or "golden age" of European armor. As the century progressed, distinct differences in armor fashion became discernible north and south of the Alps. The Lauder collection clearly demonstrates these changes.

Only about a dozen more or less complete and homogenous armors of fifteenth century date survive today, none in the United States. Most collections have to suffice with "Gothic" armors made up in modern times of disparate elements, genuine or otherwise, in an attempt to approximate a fifteenth-century harness. The Lauder collection includes no composite Gothic armors but focuses instead on genuine elements of the period that have a sculptural integrity of their own. This is amply demonstrated by several of the helmets exhibited here.

The earliest is a basinet [Plate 63], the most popular and ubiquitous form of helmet worn by the mounted knight and man-at-arms throughout much of the fourteenth century.[26] Ronald's is of later western European type, dating about 1390–1400, characterized by a tall bowl, or skull, rising to a sharp point set toward the back and reaching down the sides and back of the head; the face-opening is protected by a pointed visor, pierced with slots and holes for sight and breath, that is pivoted at the sides of the bowl. The neck is protected by a curtain

of mail (aventail) suspended from the helmet rim and held by a leather cord passing through pierced staples (vervelles).

As the American ambassador to Austria in the late 1980s, Ronald had ample opportunity to study the armory in the Kunsthistorisches Museum, the most important and comprehensive of its kind. At the time he probably never anticipated that his collection would eventually include several helmets from the former imperial armory, which he acquired with the Gwynn purchase. The finest of these, perhaps one of the handsomest examples of the late Gothic period, is a visored sallet [Plate 62].[27] Its construction, with three articulated neck lames at the back that dramatically extend the helmet's profile, is unusual and distinctive. Although without an armorer's mark, the helmet's overall design, quality of forging, and decorative details, such as the cusped edges and pierced foliate ornament on the lames of the neck, support an attribution to Lorenz Helmschmid (1445–1515/16) of Augsburg, the greatest armorer of this day. Indeed, the sallet is thought to belong to armor A.60 in Vienna, a Helmschmid masterpiece made about 1480 for Archduke (later Emperor) Maximilian I of Austria. The armor and helmet share the same distinctive motifs, including the pierced foliate ornament on the edges and the applied brass borders with crocketed edges that encircled the helmet's lower edge. The borders on the Lauder helmet are now missing, with only the copper-alloy rivets that formerly secured the appliqués still present. The armor and sallet, the latter then in the Gwynn collection, were reunited and photographed at an exhibition in Ghent in 1955 [Fig. 13], allowing us to envision this superb armor as originally composed.

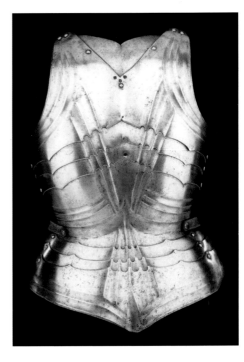

14. Backplate, German, ca. 1480, steel, leather

The Helmschmid example is but one of six German-style sallets in the Lauder collection. A second example in the exhibition rivals the Helmschmid sallet in graceful design and virtuoso forging [Plate 64].[28] This is a visored sallet with one-piece skull (without the articulated neck of the Helmschmid sallet discussed above) of sweeping horizontal profile. Its distinctive feature of design is the comb, which consists of three low ridges along the top extending front to back. No other combed sallet of this type is recorded. The masterful forging of the steel, and the similarity of the visor with its cusped sides to that of the Helmschmid example, suggest to some armor specialists that here too we have another work by Lorenz Helmschmid.

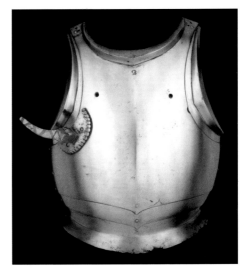

Ronald's sallets are complemented by two late fifteenth century armor elements: a backplate from a German armor of about 1480, with a shaped waist, ridged, light-catching surface, and cusped edges so characteristic of late Gothic fashion [Fig. 14];[29] and a breastplate [Fig. 15] by Hans Prünner of Mühlau (Innsbruck), ca. 1490, which illustrates the Italian influence in the north at the end of the fifteenth century.[30] The armorers at Innsbruck, so close to Italy, were particularly receptive to Italian fashion. Prünner's breastplate, originally part of a heavy field armor for mounted use, has broad polished surfaces, articulated gussets (moveable plates at the armholes), and bold angular turned edges, features that will become commonplace in the next century. In addition to Prünner's personal mark (a helmet), the breastplate is also incised with the mark of the Ottoman arsenal, evidence that it was probably taken in battle by the Turks and subsequently deposited among the trophies in their arsenal in Istanbul.

15. Hans Prünner of Mühlau, Breastplate, Innsbruck, ca. 1490, steel, copper alloy

Armor-making in Italy in the fifteenth century was concentrated in the north, principally in Milan, in territories ruled by the Visconti and Sforza dukes of Milan, and in Brescia, under Venetian suzerainty. Armor manufacture was one of Milan's most famous and lucrative industries and employed numerous armorers, many of whom worked in large *botteghe* in which each craftsman had a specialty (helmets, breastplates, etc.). This explains the different stamped marks found on various elements comprising a homogenous Milanese armor. The highly productive Milanese armorers were valued for the quality and beauty of their workmanship at all levels. Milan was thus the center of choice when outfitting an army, as hundreds of "off the peg" armors were kept in stock for just such needs. Monarchs and nobles throughout Europe ordered specially designed and personally fitted armors for war and tournament use from the leading workshops, especially that of the Missaglia, Milan's most esteemed dynasty of armorers. Good businessmen, Milanese armorers adapted their wares to foreign markets, making armors in the German, French, or Spanish fashion as needed and Milanese merchants, traveled throughout Europe and even the Levant promoting their products. Ronald's collection includes a rare north Italian "export" sallet made in the German style, dating about 1450–60.[31]

Differing considerably in construction, form, and fashion from German armor, Italian armor of the Quattrocento, with its emphasis on smooth rounded forms, is better characterized as Renaissance than Gothic. Helmets in the Lauder collection make evident some of the differences.

The most important of the Italian examples is an early form of armet [Plate 59], the type of closed helmet worn by mounted knights throughout the century.[32] The armet is characterized by a bowl fitted with two hinged cheekpieces shaped around the sides of the face that overlap at the chin and are secured by a turning pin; the face-opening is typically closed by a pivoted visor. The Lauder example is the earliest known armet, dating about 1410–20. The bowl has a strong central comb rising to a slight point at the back; the cheekpieces are very deep, covering much of the neck, and extend like a prow away from the face; no pivoted visor was intended, but instead there is a staple at the front of the cheekpieces, which indicates that some form of face defense could be attached. Additional protection was provided by an aventail, the mail curtain attached by vervelles around the base of the helmet, an example of which is preserved with the Lauder basinet [Plate 63]. Struck at the back is an unidentified armorer's mark, a square enclosing the letters PC, PG, or PE beneath a crown. This unique headpiece was preserved until the 1960s as part of the historic armory at Schloss Churburg, in the Italian Tyrol, which was the seat of the Matsch family since the late thirteenth century and their kin, the counts Trapp, since the sixteenth century. The Trapps still own the castle and its armory. The Lauder helmet is thought to belong to one of the armors still at Churburg, which is earliest more or less complete Quattrocento armor preserved. The collection includes a second armet of more developed type [Plate 61].[33] Dating to ca. 1470, the Lauder example is fitted with a brow reinforce, pivoted visor, and a short stem supporting a disk at the back. This last feature seems to have served as an aid for the attachment of a bevor, a reinforcing face and neck defense that fit over the front of the hel-

met; the bevor was secured to the armet by means of straps buckling at the back of the helmet, the stem offering a more secure tension to the straps and the disk providing protection for the closure. Similar armets are illustrated in Italian Quattrocento painting, as in the famous battle scenes of Pisanello and Uccello.

Another common type of Italian helmet of the period is the Venetian sallet, or barbute, a deep, one-piece open-faced helmet that often extends down to the shoulders. Helmets of the type could be worn by both the cavalry and infantry. There are three examples in the collection, each with a differently shaped face-opening: one with a wide opening, the others with T- or Y-shaped openings. All three are struck with armorer's marks. The finest is particularly handsome, with a prominent keel-shaped comb across the top, the sides and back of the skull shaped to the head, and the face-opening reinforced with an applied steel band of flat section [Fig. 16, Plate 60].[34] Sallets of this type are often compared to the Greek Corinthian-style helmet of the fifth century BC, though there is no proof that this helmet type was a conscious early Renaissance revival *all'antica*. Although now darkened with centuries-old corrosion, the sallet was probably originally brightly polished. Stamped at the back of the skull on the right are three armorers' marks of Milanese type, the upper one with letters beneath a crown. An indistinct mark on the cheek is presumably the winged lion of St. Mark, symbol of Venice, which suggests that the helmet may once have been in the Serenissima's arsenal.

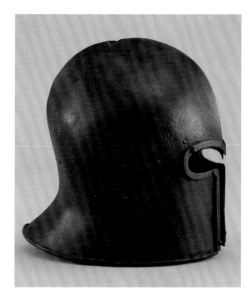

16. Sallet, Milan, ca. 1450, steel

While the armor-making centers of Germany and Italy were the most prolific in the fifteenth century, their wares readily recognizable thanks to armorers' marks or distinctive stylistic features. Comparatively little is known about armor making in Spain, England, France, or the Netherlands in the same period. Armor made in these regions is sometimes identifiable because of its distinctive form or style, historical or geographical associations, or marks. Among the Lauder helmets, for example, is a late fifteenth-century Spanish capacete, or war hat, of a type amply documented in Spanish painting and sculpture of the period.[35] The war hat—a one-piece open-faced defense shaped like a brimmed hat—was common throughout Europe and was particularly favored by the infantry or light cavalry. The Lauder example is typical of the Spanish type, having a tall pointed skull, the point turned slightly to the back, with a downturned brim pointed at front and back. It is accompanied by an associated bevor, a defense covering the lower face and neck that was customarily worn with these open-faced helmets. The bevor is struck with two stamped "crows-foot" marks found on numerous elements of Spanish armor. The collection also includes a rare example of the early sixteenth century English close helmet.[36] The term "close-helmet" defines a type having a visor and bevor (chin defense) pivoting together at the sides of the bowl. The close-helmet became popular at the beginning of the sixteenth century and gradually replaced the armet as the standard cavalry helmet. The early English version, is recognizable owing to its bluntly pointed visor and the separate plate riveted to the bevor that protects the lower edge of the visor.

The turn of the sixteenth century witnessed dramatic changes in armor fashion. Robust, rounded Italian forms were adopted by German armorers, who often embellished the surfaces

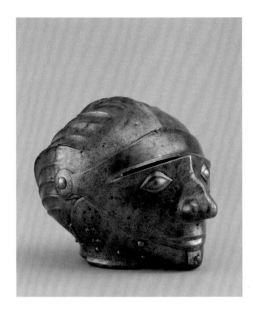

17. Attributed to Konrad Seusenhofer or Hans Seusenhofer, Close-helmet with "mask" visor, Innsbruck, ca. 1515–20, steel and copper alloy

with parallel fluting, a surface treatment developed from the channeled and ridged surfaces of Gothic armor. Fluting was in turn adopted on occasion by Italian armorers for their German-style (*alla tedesca*) harnesses, and armorers everywhere began to embellish the steel surfaces with etched decoration.

Ronald's Nuremberg armor with the arms of Kunz Schott, mentioned above, a work dating around the turn of the sixteenth century, captures this moment of transition. The globose breastplate and rounded forms of the helmet, arms, and legs demonstrate the adoption of Italian fashion by German armorers. Intended as a working armor for a man–at-arms, this harness probably never orginally had greaves or sabatons (armor for the lower legs and feet), as the knee defenses end with long plates with lining rivets, suggesting that the legs harness was lined and ended just below the knee. The more characteristic form of German armor of the period, with fluted rather than smooth surfaces, is represented by two full-length armors in the collection [an equestrian ensemble, Plate 48],[37] and portions of a third (helmet, gorget, and breastplate], as well as several helmets [Fig. 10, Plate 65], and two shaffrons.

Changes in armor fashion in the early sixteenth century took a whimsical turn. Entire armors were embossed and etched in emulation of the exaggerated puffed-and-slashed textile costumes worn by the German *Landknechte* mercenaries, and helmets were fitted with visors shaped as humorous or grotesque faces or even as animal or bird heads. These imaginative armors of exaggerated form must have challenged the skill of even the best armorers and presumably were such a costly extravagance that only the wealthiest clients could afford them. They have a theatrical quality that suggests they were intended primarily for court ceremonies, but several contemporary representations of tournaments show helmets with mask-shaped visors in use, indicating that they had some practical use. A helmet with a mask visor acquired for the collection in 1987 is an outstanding example of the type [Fig. 17, Plate 65].[38] It has been convincingly attributed to the Imperial Court workshop at Innsbruck under the direction of Konrad Seusenhofer (recorded 1500; died 1517) and his brother Hans (1470-1555). The Innsbruck workshop was established by Emperor Maximilian I in 1504 to produce armors for himself and his court, and as gifts to foreign sovereigns and nobles. Dating to about 1515–20, the Lauder helmet may be the work of either Seusenhofer brother, both innovative masters. Constructed as a conventional armet, with hinged cheekpieces closing at the chin, the helmet appears to be unique in the unusual form of its fluted skull, which has three low combs, and the presence of a deep brow reinforce covering the front of the skull. The visor is embossed with a prominent human nose and smiling mouth and has applied eyes riveted below the actual vision slit. Although now worn and difficult to see, the surfaces are etched with a variety of ornament including eyelashes, a mustache, bells, and the sacred monogram IHS on the visor, with overlapping scales and clouds and rays on the reinforce. The bells (*schelle* in German) may be a punning reference to the noble von Schellenberg family.

Little is known about the helmet's early provenance. It was apparently bought by the Earl of Meath at an important early sale of armor at Brooks of Bond Street in London on June 21, 1827. The collection being sold was advertised as having come "from the castles of

Staremberg, in Bavaria, and Ambrose, in Tyrol," the latter referring to Schloss Ambras, which housed Archduke Ferdinand's famous "Armory of Heroes." This extraordinary helmet thus very likely came from a German or Austrian castle. Lord Meath, like many other nineteenth century collectors, probably acquired it merely as decoration for the new Gothic-inspired interiors that had been introduced into his house in Ireland. We appreciate the helmet quite differently today, as a work of imagination and great armor making, and as one of the most intriguing and eye-catching objects in the Lauder collection.

The production of armor made in the court workshop in Innsbruck was, by definition, limited to the patronage of the imperial family and members of the court, with the result that relatively few examples are likely to appear on the art market. The rediscovery of a fairly complete Innsbruck armor [Fig. 18, Plate 50] at an antiques fair in Germany in the 1980s was therefore a noteworthy event.[39] Dirty and at first considered to be a fake, the armor was acquired by a private German collector who recognized it as the work of the Innsbruck armorer Michael Witz the younger (active ca. 1529, died by 1588), whose personal mark, a W is stamped on the helmet, breastplate, and gauntlets. The armor comprises elements for field and tournament use, that is, for war and sport, and originally possessed additional pieces of exchange and reinforcement, now missing. The armor is one of the Witz's early works. The armor's burly form, its breastplate with a strong medial ridge and protruding profile, the oversized couters (elbow defenses), deep fauld (skirt), and large pointed tassets suggest a dating to the 1530s. The etched decoration, probably by the Innsbruck specialist Leonhard Meurl (d. 1547), consists of foliate ornament inhabited by putti, sirens, and marine monsters, all set against a dotted and blackened ground. The raised vines and etched frond-like elements on the elbows, tassets, and knees are decorative flourishes rarely encountered on Innsbruck armor.

The collection boasts some outstanding Renaissance parade armor. Notable among these is an early form of morion, a hat-like, open-faced helmet, which dates about 1540.[40] The large raised and gilt acanthus leaves that cover the sides of the bowl and of the raised panels on the tall comb and brim recall the work of the Mantuan armorer, Caremolo Modrone (ca. 1489–1543), who worked for most of his career for Duke Federico II Gonzaga of Mantua (1500–1541). The helmet has a refinement that belies its humble origin as an infantryman's headpiece. The strong form and the boldly conceived but subtle embossed decoration reveals a talented armorer's hand.

Even more elaborate is an embossed and damascened burgonet, a rare Milanese work of about 1560 [Plate 67].[41] Embossed parade armor of this type was the specialty of Milanese armorers, though embossed burgonets are rare (more numerous are embossed cabassets, tall pointed hat-like helmets with very short brims). Ronald's example is original in design and very well preserved; it is especially noteworthy for its tall arched comb, imitating a Roman centurion's helmet, with a small leonine mask at the front. Exactly this kind of helmet comb is known from archeological examples, though none was specifically recorded in the sixteenth century. The burgonet retains its original plume-holder at the back, its decoratively shaped

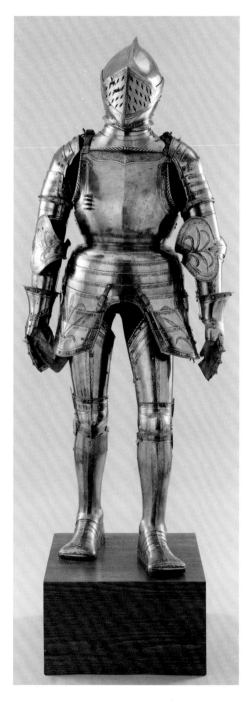

18. Michel Witz the Younger,
Armor for the field and tournament,
Innsbruck, ca. 1530–35, etched
steel, copper alloy, leather

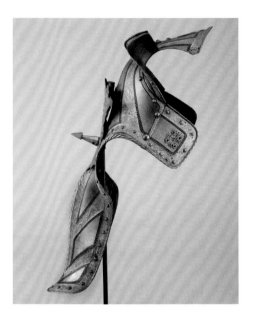

19. Matthäus Frauenpreiss the Elder. Shaffron from the "King's Garniture" of the future Emperor Maximilian II, Augsburg, ca. 1548–50, steel, etched and gilt, enhanced with black wax and pigment; leather and copper alloy

20. Opposite: Sword, European, late twelfth to early thirteenth century, steel

cover-plate engraved and gold-damascened with the letters F and C beside two columns. It suggests that the helmet was made for a member of the noble Colonna family of Rome, whose arms include the canting device of a column. The Colonna association is reinforced by the presence, at the front of the helmet, of a personification of Fortitude, who holds her attributes, two columns. The embossed decoration is enhanced by engraved details and rich coloring, imparted by means of gold and silver damacening. While embossed armor has never been one of Ronald's primary interests, this rare and magnificent Renaissance headpiece is a notable exception and adds significantly to the breadth and quality of the collection.

Among the ten shaffrons in the Lauder collection two exceptional examples must be singled out. Each has a strong sculptural and decorative presence, not to mention august provenance. The larger shaffron [Fig. 19, Plate 54] was made by the Augsburg armorer Matthäus Frauenpreiss the Elder (ca. 1505–1549) and etched by Jörg Sorg the Younger (1522–1603).[42] It forms part of the so-called King's Garniture (*Königsgarnitur*) made for the Archduke Maximilian (1527–1576), who ruled as Emperor Maximilian II from 1564. The armor was probably ordered from Frauenpreiss in 1548 in anticipation of Maximilian's election as King of Bohemia the following year. The escutcheon in the center of the shaffron bears the crowned Bohemian arms (though Maximilian did not officially succeed to the title until the death of his father, Emperor Ferdinand I, in 1564).

The Frauenpreiss armor-garniture is considered one of the largest and most beautiful German armors of the mid-sixteenth century. The term "garniture" refers to the fact that armors of the period were often made for multiple uses, for the field and for various forms of tournament such as the joust or tourney (melée) on horse and the foot–combat, and therefore were constructed with reinforcing or exchange pieces that could be added or subtracted as needed. The Frauenpreiss garniture originally comprised dozens of pieces, including several shaffrons. The Lauder shaffron is the most impressive of these owing to the superb quality of etching (the wide gilt bands are filled with foliage, trophies, and grotesques of the most varied and inventive kind), the visual impact of the oversized escutcheon with its prominent raised crown, and its remarkable state of conservation.

The shaffron, like several other elements of the Königsgarnitur no longer in Vienna, may have been stolen during the Napoleonic wars; nothing further is known of its history before it appeared in the collection of Baron Alphonse von Rothschild in Vienna in the late nineteenth or early twentieth century. After World War II it was given by the Rothschilds with many other works of art to the Kunsthistorisches Museum, a collection the Austrian State returned to the family in 1999. The shaffron was acquired at the famous Rothschild sale at Christie's in London, on July 8, 1999. Another element from the same garniture, a helmet-reinforce for foot-combat use, is in the Metropolitan Museum.[43]

The second shaffron [Plate 58], a royal piece, also has a Rothschild provenance.[44] A Flemish work, it belongs to one of a series of deluxe armors made for King Philip IV of Spain (r. 1621–1665) between 1624 and 1626. The armors were ordered as a gift by Philip's aunt,

the Infanta Isabella Clara Eugenia, governor of the Netherlands, and were made by local Brussels armorers, one of whom used as his personal mark the letters MP flanking a crowned shield bearing three fleurs-de-lis. This shaffron matches portions of a field armor in the Real Armería in Madrid, the elements of which are engraved overall with foliate scrolls, silvered against a dark-patinated stippled ground. The shaffron's form is distinctive, particularly the shaping of the lower portion to a point terminating with a gilded spiral knob, and the decorative gilt rondel with spiral knob set between the eyes. This exquisitely decorative piece of armor is unusual for the period, when the use of shaffrons had largely been abandoned. The shaffron is also one of the rare examples of armor known to have been made in Brussels, an armor-making center still awaiting study.

The Lauder shaffron is one of many pieces of armor that disappeared from the Real Armería in the 1830s and are now scattered among museums and private collections in Europe and the United States. It was subsequently acquired in the second half of the nineteenth century by Baron James de Rothschild (1792–1868), who installed it with other decorative arms in his neo-Renaissance Château de Ferrières, outside Paris. The chateau was donated to the French government by Guy de Rothschild in the 1970s and its small collection of arms was sold at Sotheby's in 1976. By that date the shaffron's royal provenance had been forgotten and its beauty, obscured by a thick layer of dirt and tarnish, went unappreciated. Its true importance was recognized only when it came to the Metropolitan Museum for examination and conservation.

Among the weapons in the Lauder collection is a small but important group of medieval swords. Unlike medieval armor, of which little survives today, medieval swords exist in large numbers, though the majority are in excavated condition. Discovered buried in the ground or in river beds, the iron swords usually have heavily corroded surfaces and have lost their grips and scabbards, which, made of organic materials like wood and leather, deteriorate more readily than ferrous metal. The exhibition includes one excavated weapon, the earliest sword in the collection, a handsome twelfth-century example said to have been found in France [Fig. 20, Plate 74].[45] The medieval sword is a relatively simple weapon: it typically consists of a wide double-edged blade intended for cutting rather than thrusting, and a cruciform hilt composed of a straight or slightly curved cross-guard (quillons) set at a right angle to the blade, a grip, and a pommel at the top. Sword design changed slowly during the Middle Ages, though pommel shapes varied considerably and are often a useful dating feature. The "brazil-nut" shaped pommel on the Lauder sword points to a twelfth- or early thirteenth-century date. The sword's blade has a central groove on each side bearing an iron-inlaid Latin inscription—on one side, a version of IN NOMINE DOMINE (In the Name of God), an on the other, NISO ME FECIT (Niso made me). Although the surfaces of this weapon are corroded and the grip is missing, it has a powerful presence. Perhaps more than any other object in the collection, it evokes images of the medieval European knight.

Not all medieval swords, however, came from excavations. There is a large and important group of late medieval European swords bearing Arabic inscriptions which were originally

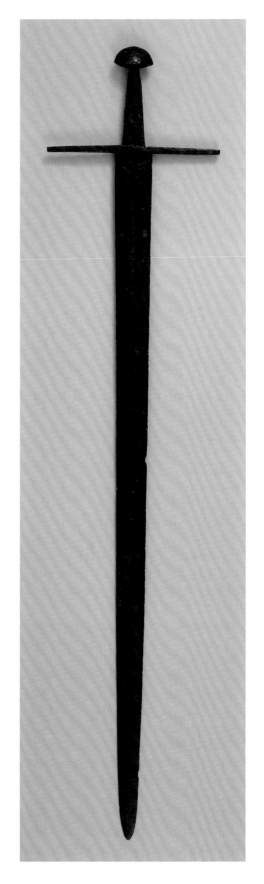

preserved in the Mamluk arsenal at Alexandria, Egypt.[46] The inscriptions, engraved on the blade near the hilt, give the name of the donor, usually a sultan or emir, and the date of the donation to the arsenal. The dates cover a seventy-year period ranging between 1367/8 and 1436/7. The swords are thought to have come into Mamluk possession either as war booty or as diplomatic gifts from European powers such as the kingdom of Cypress or the republics of Venice and Genoa. At some time after 1517, when the Ottomans conquered Mamluk Egypt, the contents of the Alexandria arsenal were transferred to the Ottoman arsenal in Istanbul, which was housed in the former Byzantine church of Hagia Eirene, part of the Topkapi Palace complex. The swords remained there, largely unknown to historians and collectors, until the late nineteenth or early twentieth century, when many appear to have been sold. These weapons are especially important as they are in relatively good condition, and provide specific dating information and documentation for European swords of the fourteenth and fifteenth century. Among Ronald's five Arabic-inscribed swords is a handsome example of the earliest type, with a broad, almost spatulate blade, flat quillons toward the tips, and a copper-alloy pommel [Plate 76]. The inscription on the blade gives the Mamluk emir's name and date as A.H. 769 (1367–68 A.D.).

The collection has few post-medieval swords. One exceptionally rare type is a fine Italian example dating around 1500 [Plate 78],[47] which has the robust and powerful form that distinguishes most of the weapons in the collection. The wide triangular blade tapers to an acute point and is given increased rigidity by a raised rib down the center on each side, indicating that it was intended as a thrusting weapon. The hilt is of particularly graceful design, having spare but subtle decoration: the scrolled quillons are chiseled with roped ribs and a shaped molding at the center; the pommel is chiseled with lobed faces and roped ribs around the sides. The grip is missing. The sword also retains its original scabbard of tooled, black leather: few examples survive from this period. Only a handful of comparable swords are known, the closest examples in the Doge's armory in the Palazzo Ducale in Venice. This sword is contemporary with, and forms a perfect complement to, the aforementioned cinquedeas [Plate 68].

Ronald is not a collector of firearms, the area of antique arms most avidly pursued by Americans. He owns, however, two extraordinary seventeenth-century wheellocks that rival those in any princely armory or public museum. They were made by members of the Sadeler family, specialized iron-chiselers who worked for the dukes of Bavaria in Munich.[48] The so-called Munich school of iron chiseling was established by Emanuel Sadeler (d. 1610) in 1594; it was continued by his brother Daniel (d. 1632), and then carried on after the latter's death by a member of the Sadeler workshop, Caspar Spät (d. 1691). These three craftsmen specialized in the decoration of iron gun barrels, locks, and firearms mounts and accessories, sword and dagger hilts, and small furniture mounts, the surfaces chiseled in low relief, the ornament heat blued and the recessed ground gilt for contrast. The wooden stocks, often veneered in exotic materials, such as ebony, Brazil wood, or bleached bone, were inlaid with wood or bone of contrasting colors, the decoration consisting of Mannerist ornament and figural scenes depicting the hunt or episodes from classical mythology. Most of the ornament was

copied after, or at least inspired by, late sixteenth-century prints. Small ornamental engravings by the French goldsmith and printmaker Étienne Delaune (ca. 1518–1583), as well as Flemish Mannerist prints by Collaert and other members of the Sadeler family, were favorite graphic sources. Arms decorated by the Sadelers rank among the most sophisticated in design, refined in execution, and most colorful ever made. Created as luxury arms for the personal use of the dukes of Bavaria, Sadeler firearms and edged weapons were frequently chosen as representative gifts from the Munich court; hence Sadeler arms came to be widely distributed and prized throughout Europe.

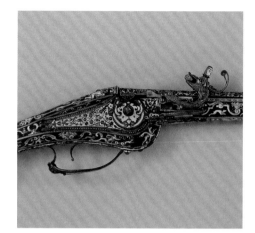

21. Emanuel Sadeler and Adam Vischer, Wheellock pistol (detail), ca. 1600–10, iron barrel, lock, and mounts, chiseled, blued, and gilt; wood stock, inlaid with engraved bone

The earlier of the two wheellocks is an long, slender and elegantly proportioned pistol of contemporary French form (German wheellocks of the time were considerably bulkier), arguably one of the most beautiful of all Sadeler arms [Fig. 21, Plate 82].[49] Dating about 1600–1610, it can reasonably be attributed to Emanuel Sadeler, whose style of chiseling is rounder, the figures smaller and more attenuated in the Mannerist style, than that of his brother Daniel. The early dating is further confirmed by the initials AV engraved on a plaque behind the barrel tang, the monogram of the Munich gunstocker Adam Vischer (recorded 1599–1610). The decoration of the stock and its iron mounts exhibits a refinement and delicacy rarely found in German firearms. The narrow, small-caliber barrel is chiseled with a delicate web of tendrils, flowers, and fruit inhabited by three tiny female figures (among them Judith with the head of Holofernes), the blued iron ornament set off by the gold ground. The lock is similarly chiseled with tendrils; the cock takes the form of a dragon's head, a characteristic Sadeler feature, and the rear end of the lockplate also terminates with dragon's head. The stock is inlaid in white bone with dozens of minute figures, including hunters, hounds, and their prey (birds, hares, and foxes), satyrs, monkeys, insects, fruit and flowers, even small oval vignettes of cityscapes, an almost encyclopedic array of late Mannerist ornament.

The second wheellock is a hunting rifle dating to about 1620 [Plate 81].[50] It can be attributed to Daniel Sadeler, who is recorded in imperial service in Prague from 1602, but who seems to have come to Munich in 1610 to take over his late brother's workshop. Unlike the earlier French-inspired pistol, the rifle is of typical German fashion, with a heavy rifled barrel and a thick butt shaped on the left side to fit the cheek, against which the gun was held when firing. The barrel and lock are richly chiseled in the characteristic Sadeler style, the raised ornament blued against a gilt ground. Trophies and foliate scrolls with fruit and flowers adorn panels at the breach and muzzle ends, the remaining barrel surfaces longitudinally grooved, blue against gold. As appropriate for a sporting arm of this type, the lock is chiseled with the figure of a hunter holding a rifle and blowing a horn while his dogs chase a stag and a doe. The present cock replaces the original one, which like most Sadeler cocks would have been chiseled with a dragon's head. The ornament-laden stock is a virtuoso demonstration of the cabinetmaker's and engraver's art. Though unmarked, it may be the work of the Munich gunstocker Hieronymous Borstorfer the Elder (active 1599–died 1637), who regularly worked with the Sadelers. Every inch of the surface is inlaid with engraved white staghorn in large figural compositions, as well as delicate strapwork and grotesque ornament. The Sadeler workshop's regular use of Delaune's ornamental prints is

22. Tula Workshops, Flintlock holster pistol (detail), Tula, ca. 1745–55, steel barrel and lock, chiseled and partly gilt; wood stocks with cast silver mount, horn

evident on the top of the butt, where tiny figures of Atlas and a personification of Astronomy are depicted; on the butt is a seated figure of an antique warrior after an engraving by Adrian Collaert. On the left side of the stock, where the large uninterrupted surfaces offered ample space for figural groupings, there are scenes from classical mythology, including the sleep of the hunter Endymion and of Mercury and Argos set in wooden landscapes, the elaborately engraved staghorn plaques looking exactly like the Flemish mannerist prints from which they must have been copied. This rifle is one of the most remarkable of the Sadeler-Borstorfer firearms because of its superabundant ornament and the prominence of large engraved figural scenes.

Works of the eighteenth century are rare in the Lauder collection. A notable exception, however, a pair of flintlock pistols made in the imperial Russian arms factory at Tula around 1750 [Fig. 22, Plate 83]. The Tula factory was established in 1712 by Czar Peter the Great (ruled 1682–1725). Staffed by Russian and foreign-trained craftsmen, the factory's principal purpose was to produce firearms and edged weapons of modern design and technology for the Russian armies. The factory also was called upon to provide deluxe sporting arms for the czar, his family, and the court. The finest of these courtly weapons were made in the period 1740–60, corresponding to the reign of Empress Elizabeth Petrovna (r. 1741–61), when the factory employed large numbers of émigré German gunmakers who introduced up-to-

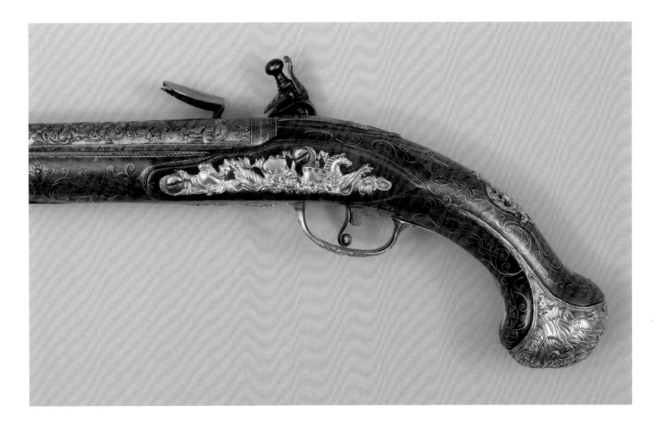

date European firearms design and ornament. For the first time Tula arms rivaled their western competitors.

Ronald's pair ranks among the best of Tula arms outside Russia. Technically they are little different from mid-eighteenth century French or German pistols, though the presence of a double pan cover (a safety device that kept the priming powder securely in the pan) is a favorite Tula innovation. The barrels and locks are chiseled overall in low relief with figural and foliate ornament on a gold ground. Many of the motifs derive from the late seventeenth-century gunmaker's patternbook published by Nicholas Guérard of Paris, which was probably transmitted to Russia in the form of the German facsimile issued by Johann Christoph Weigel of Nuremberg in the early eighteenth century. Several motifs on the barrels, a mounted kettle-drummer and confronted demi-figures blowing trumpets derive from the patternbook, whereas naive figures with pointed hats and siren-like birds betray native Russian design elements. At the breech end is a female figure, fashionably attired for the hunt with a tricorn hat and full skirt, holding a gun and accompanied by her dogs, a reminder that aristocratic ladies also enjoyed the hunt. On the lockplates the chiseled figures of Diana in a chariot pulled by dogs, and Cupid with his bow, were inspired by ornamental engravings in the firearms patternbook of Delacolombe, published in Paris in 1730. The walnut stocks of these pistols are inlaid with delicate silver tendrils; the mounts are of cast and chased silver decorated with figures seated among trophies, classically inspired profile heads, and on each buttcap a leonine mask. The barrels retain their original velvet-covered wood storage rods (tampions) which kept them clean. Although they are unmarked and bear neither the heraldic arms nor the monogram of their owner, these pistols are nevertheless fit for a czar and serve as a magnificent coda to Ronald Lauder's collection of arms.

My sincere thanks go to Marilyn Van Dunk, Stephen Bluto, and Lois Granato for help in preparing this essay.

NOTES

1 For an introduction to the history of arms and armor collecting, see Francis Henry Cripps-Day, *A Record of Armour Sales 1881–1924* (London 1925), pp. xxi–lxviii.

2 On Walpole as an armor collector, see Stuart W. Pyhrr, "The Strawberry Hill Armoury," in *Horace Walpole's Strawberry Hill*, exh. cat., Yale Center for British Art, New Haven, and Victoria and Albert Museum, London, 2009, pp. 221–233.

3 Pyhrr in New Haven and London 2009, p. 229 and 286, cat. no. 52, fig. 307.

4 The Erbach armory is discussed in detail by Wolfgang Glüber, "Franz I. und der Rittersaal im Schloss zu Erbach," *Kunst in Hessen und am Mittelrhein* nF2, 2006, pp. 35–62.

5 The earliest published illustrations of the Erbach armory are found in G.L. von Kress, *Rittersaal im Schloss zu Erbach im Odenwald* (Offenbach, 1832); the Kunz Schott armor, then painted black and gold, is described on p. 20 and illustrated on plates 2 [fig. 2 in this essay] and 9 of the unnumbered series of acquatints.

6 For the consequences of the Napoleonic wars on the redistribution of arms and armor in Europe, see Stuart W. Pyhrr, "From Revolution to Romanticism: France and the Collecting of Arms and Armour in the early 19th Century," in Robert Douglas Smith, editor, *ICOM 50: Papers on Arms and Military History 1957–2007* (Leeds, 2007), pp. 106–135.

7 Pyhrr 2007, pp. 116–123.

8 Joseph Skelton, *Engraved Illustrations of Antient Arms and Armour: from the Collection of Llewelyn Meyrick at Goodrich Court, Herefordshire: after the Drawings, and with the Description of Dr. Meyrick*, 2 vols. (London, 1830).

9 Skelton 1830, vol. 2, pl. 128, fig. 5, and vol. 2, pl. 91, fig. 8, respectively.

10 For an introduction to arms and armor collecting in the United States, see Donald J. La Rocca, "Carl Otto Kretzschmar von Kienbusch and the Collecting of Arms and Armor in America," *Bulletin of the Philadelphia Museum* 81, no. 345 (Winter 1985), pp. 1–24.

11 Dean's life and career are amply treated in the biographical essays by Carl Otto von Kienbusch in *The Bashford Dean Collection of Arms and Armor in the Metropolitan Museum of Art* (Portland, Maine, 1933), pp. 3–47.

12 Stuart W. Pyhrr, "Clarence H. Mackay as an Armour Collector," *The Nineteenth Park Lane Arms Fair* (London, 2001), pp. 20–32.

13 Mary L. Levkoff, *Hearst the Collector*, exh. cat., Los Angeles County Museum of Art, Los Angeles, 2008.

14 La Rocca 1985.

15 J.F. Hayward, "A Notable Private Collection: XVth and XVIth Century Armour and Swords in the Collection of R.T. Gwynn, Esq.," *The Connoisseur Year Book*, 1954, pp. 34–44; and J.F. Hayward and C. Blair, "The R.T. Gwynn Collections," *The Connoisseur*, June 1962, pp. 78–91. Many Gwynn pieces are exhibited in *The Art of the Armourer: An Exhibition of Armour, Swords and Firearms*, exh. cat., Victoria and Albert Museum. London, 1963.

16 Stuart W. Pyhrr, "Stephen V. Grancsay (18897–1980)," in *Arms and Armor: Essays by Stephen V. Grancsay from the Metropolitan Museum of Art Bulletin 1920–1964* (New York 1986), pp. 9–12.

17 *Arms and Armor: A loan Exhibition from the Collection of Stephen V. Grancsay, with Important Contributions by the Metropolitan Museum of Art, New York, and the John Woodman Higgins Armory, Worcester, Massachusetts*, exh. cat. Allentown Art Museum, Allentown, Pennsylvania, 1964, cat. no. 71.

18 Lionello Boccia, "Arms and Armor from the Medici Court," *Bulletin of the Detroit Institute of Arts* 61, nos. 1/2 (Summer 1983), pp. 59–61.

19 Allentown 1964, cat. no. 54.

20 Inv. nos. A 357, 358, 397, 476–479, of which only A 358 bears the Helmschmid mark; see Ortwin Gamber and Christian Beaufort, *Kunsthistorisches Museum, Wien. Katalog der Leibrüstkammer, II. Teil, der Zeitraum von 1530–1560* (Vienna and Milan, 1990), p. 111.

21 Allentown 1964, cat. no. 102.

22 See n. 16.

23 Ex collections: Richard Zschille, Grossenhain, Saxony; Henry Griffith Keasbey, Eastbourne, England; his sale, part 2, American Art Association, New York, November 27–28, 1925, lot 277.

24 Lot 132; the catalogue entry was written by the foremost English armor authority, Claude Blair.

25 Sotheby's, London, May 5, 1983, lots 1 and 2.

26 Ex collections: Richard Zschille, Grossenhain, Saxony; Sir Edward Barry, Ockwells Manor, Bray, Berkshire; S. H. Barnett, Ockwells and Clarendon Hall, Warwickshire; his sale, Sotheby's, London, July 5, 1965, lots 43 (bascinet) and 103 (associated visor); R.T. Gwynn, Epsom.

27 Ex collections: Schloss Grafenegg, Austria; William R. Hearst, St. Donat's Castle, Wales; Raymond Bartel, St. Donat's Castle, Wales; his sale, Sotheby's London, Dec. 12, 1952, lot 13; R.T. Gwynn, Epsom. See London 1963, no. 28.

28 Ex collections: Prince Carl of Prussia, Berlin; Berlin Zeughaus; Galerie Fischer, Lucerne, August 28, 1934, lot 20; William R. Hearst, St. Donat's Castle, Wales; R.T. Gwynn, Epsom. See London 1963, no. 29.

29 Ex collections: Counts Solm-Braunfels; Sotheby's, London, May 26, 1933, lot 81; William R. Hearst, New York; Galerie Fischer, Lucerne, June 24, 1963, lot 63; R.T. Gwynn, Epsom.

30 Ex collections: Robert Curzon, Baron Zouche, Parham, Pulborough, Sussex; Sotheby's London, November 10–11, 1920, lot 58; S. J. Whawell, London; his sale, Sotheby's, London, May 3–6, 1927, lot 212; Major H.D. Barnes; his sale, Sotheby's, London, April 21, 1955, lot 110; R.T. Gwynn, Epsom. See London 1963, no. 8.

31 Ex collections: The Cranbrook Academy of Arts, Bloomfield Hills, Michigan; Sotheby's, London, May 15, 1972, lot 206; Herschell Boyd, Seattle; his sale, Christie's, London, December 12, 1997, lot 300.

32 Oswald Graf Trapp, *The Armoury of the Castle of Churburg*, translated, with a preface, by James Gow Mann (London, 1929), cat. no. 57.

33 Ex collection: Frédérick Spitzer, Paris; his sale, Galerie Georges Petit, Paris, June 10–14, 1895, lot 34; Baron C. A. de Cosson; Christie's, May 2–3, 1893, lot 233; Sir Edward Barry, Ockwells Manor, Bray; S. H. Barnett; Ockwells and Clavendon Hall, Warwickshire; his sale, Sotheby's, London, July 5, 1965, lot 42; R.T. Gwynn, Epsom.

34 Ex collection: Lt.-Col. Sir Raymond Boileau, Ketteringham Park, Wymondham, Norfolk; R.T. Gwynn, Epsom. See London 1963, no. 26.

35 Ex collections: (by repute) Imperial Armory, Vienna; S.J. Whawell, Sir Henry Farnham Burke, London; Christie's, London, May 5, 1931, lot 49 (in part); William R. Hearst, St. Donat's Castle, Glamorgan, Wales; R.T. Gwynn, Epsom.

36 Ex collections: Sir Archibald Lamb, Beauport Park, Battle, Sussex; his sale, Christie's, London, May 15, 1922, lot 64; W.H. Fenton, London; Raymond Bartel, St. Donat's Castle, Glamorgan, Wales; R.T. Gwynn, Epsom; Herschell Boyd, Seattle; his sale, Christie's London, December 12, 1997, lot 297.

37 Composed in the Metropolitan from elements from, among others, the Dino, Riggs, and Radziwill collections; sold at Sotheby's, New York, January 31, 1997, lot 412.

38 Ex collections: Earls of Meath, County Meath, Ireland; Christie's, London, October 21, 1987, lot 222, catalogue entry by Claude Blair.

39 Petra Vincke-Koroschetz, "Der Plattner Michel Witz der Jungere und seine Werke- neue Forschungsergebisse zum Lebenwerk des Plattners, Teil I," *Waffen- und Kostümkunde* 45 (2003, Heft 1), pp. 8–11.

40 Claude Blair, "A Morion by Caremolo Modrone of Mantua," *Arms & Armour at the Dorchester*, London, 1983, pp. 11–17; Christie's, London, April 18, 1985, lot 41.

41 Ex collections: Karsten Klingbeil, Berlin; Eric Vaule, Bridgewater, Conn. See José A. Godoy and Silvio Leydi, *Parures Triomphales: Le Maniérisme dans l'art de l'armure italienne*, exh. cat., Musées d'art et d'histoire, Geneva, 2003, cat. no. 45.

42 Ex collections: Imperial Armory, Vienna; Alphonse de Rothschild, Vienna; Kunsthistorisches Museum, Vienna, inv. no. A2236; Rothschild heirs; Christie's, London, July 8, 1999, lot 78.

43 Acc. no. 04.3.218; see Stephen V. Grancsay, "A Pate Defense of the Emperor Maximilian II," in *Metropolitan Museum of Art Bulletin* 26 (May 1931), pp. 125–127 (reprinted in Grancsay 1986 [n. 16], pp. 80–81).

44 Ex collections: Real Armería, Madrid; Henri Lepage, Paris; Baron James de Rothschild, Château de Ferrières, Seine-et-Marne, France; by descent to Guy de Rothschild; his sale, Sotheby's, London, October 12, 1976, lot 293; Peter Finer; David Alexander, Titusville, New Jersey and Puicelsi, France. Regarding the shaffron's early provenance, see Stuart W. Pyhrr, "'Ancient Armour and Arms Recently Received from Spain': Eusebio Zuloaga, Henry Lepage, and the Real Armería in Madrid," *Gladius* 19 (1999), p. 285.

45 Ex collections: Morgan S. Williams, St. Donat's Castle, Glamorgan, Wales; his sale, Christie's, April 26–28, 1921, lot 17; Dacre K. Edwards; his sale, Christie's, London, April 25, 1961, lot 147; R.T. Gwynn, Epsom. See London 1963, no. 54.

46 This group of swords was studied in detail by David G. Alexander, "European Swords in the Collections of Istanbul, Part I, Swords from the Arsenal of Alexandria," *Waffen- und Kostümkunde* 27, 1985, pp. 81–118; Part II, ibid. 29 (1987), pp. 21–48.

47 Ex collections: Counts von Khevenhüller; Counts von Giech, Schloss Thurnau, near Bayreuth; Sotheby's, London, November 19, 1974, lot 234.

48 The Sadeler/Spät workshop was studied in detail by Hans Stöcklein, *Meister des Eisenschnittes: Berträge zur Kunst- und Waffengeschichte im 16. Und 17. Jahrhundert* (Esslingen, 1922); for an English summary, see John F. Hayward, *The Art of the Gunmaker: Volume one, 1500–1660,* 2nd ed. (London, 1965), pp. 175–187.

49 Ex collections: Christie's, London, July 8, 1980, lot 70 (no earlier provenance recorded); Frank Bivens, West Los Angeles.

50 Ex collections: London art market, late 1960s; Eric Vaule, Bridgewater, Conn.; Frank Bivens, West Los Angeles.

51 Ex collection: Lord Cunard.

1. Vincent van Gogh, *Portrait of Joseph Roulin*, 1888, reed pen, brush, ink, and graphite on paper

EUGENE THAW

The Collector as Connoisseur

What Ronald Lauder has achieved in his vast and splendid collection of art—paintings, drawings, and objects—is both evidence and proof that art collecting is not only an emotional and compulsive activity, but it is an intellectual exercise—an ordering of material to create structure. For those of us lucky enough to see the results, it is a true learning experience.

For certain artists—Paul Cézanne for example—Ronald's holdings constitute a small retrospective of the artist's career, including iconic major works on paper and three great paintings, which are certainly among the finest still in private hands anywhere in the world.

No Georges Seurat painting of quality has surfaced on the art market in many years, but Ronald Lauder has managed to obtain seven remarkable conté crayon sheets, which any great museum would be proud to show. Edgar Degas is another artist here present in several superb examples. This kind of collecting, rather than the "one of each" assortment of names, shows the kind of depth and commitment to favorite artists that is the pulse of true collecting.

The shock of recognition—an experience of sheer quality—shouts out from the series of five major Vincent van Gogh drawings including the *Garden with Flowers* [Plate 180], *Souvenir of Saintes-Maries-de-la-Mer* [Plate 178], and the *Portrait of Joseph Roulin* [Fig. 1, Plate 179], all drawn in reed pen at Arles in his greatest period. The fifth Van Gogh reed pen sheet is *Olive Trees with Les Alpilles in the Background* [Plate 181], drawn near the hospital at St. Rémy.

But the collecting in depth of a major artist's work reaches a pinnacle in the Lauder collection of its holdings of Picasso. There are twenty important works on paper, including self-portraits, portraits of Igor Stravinsky and Guillaume Apollinaire, Cubist collages and famous early sheets of the Blue and Rose periods.

Henri Matisse also seems superbly at home in the Lauder collection. Two famous and extremely

rare fauve drawings [Fig. 2]—one for a woodcut, the other for *The Joy of Life* of 1906 now in The Barnes Foundation—are the early examples. These are followed by a great pen and ink interior and a masterwork of the series *Reclining Nude in the Studio* of 1933. An honest and amusing self-portrait and a couple of late cutouts round out the holdings in this area, while not as well-represented as Picasso, Matisse is still seen to brilliant effect.

For those artists in this collection not represented in multiple examples, the collector has found single characteristic works that express the essence of the artist's style. The single, incomparable Antoine Watteau *trois crayons* drawing of *Four Studies of a Woman's Head* embodies everything we look for in this artist's best work. It is a masterpiece by an artist who seems to be a favorite of every lover of drawings. A couple each of fine Théodore Géricaults and Eugène Delacroix, a superb Théodore Chassériau pencil portrait, and two Jean Auguste Dominique Ingres do justice to the nineteenth century. A circus drawing by Henri de Toulouse-Lautrec, just on the verge of the twentieth century, is so good it needs to be cited.

In the category of absolute icons of modernism, the Lauder collection includes three extraordinary sculptures by Constantin Brancusi, an absolutely major late Piet Mondrian painting, as well as a key 1913 (*Gemalde No. 1*) / *Composition No. XII* [Fig. 3] composition, Mondrian's bow to Cubism.

As further proof of Ronald Lauder's wide-ranging and inquiring open mind, he has acquired

an interesting and challenging selection of works by post-war artists who are somehow maintaining the tradition of the history of art up to our own days. Some of the names of artists with characteristic works are: Anselm Kiefer, Brice Marden, Ellsworth Kelly, Robert Rauschenberg, Gerhard Richter, Robert Ryman, Jackson Pollock, and Joseph Beuys, among others.

It is not in my competence to discuss or to recommend medieval objects, but I must say how powerfully I am drawn to them. The sculptural high point of many medieval collections are the metal lions or other animal figures for pouring water or wine. They are called aquamaniles and are quite rare. Lauder has at least five, as well as pricket candlesticks, reliquaries, and painted leaves from an apocalypse manuscript. But my total amazement was aroused by the extensive Migration Period objects – fibulas, belt buckles, and other barbarian jewelry. These objects of Merovingian, Ostrogothic, Frankish and other tribal origins of the so-called "Dark Ages" are astonishing. The great art historian at Columbia University with whom I studied more than sixty years ago demolished the designation "Dark Ages," showing this transitional period between the decline of Rome and the rise of Charlemagne as a very rich period in the history of design. One sees the reinvention of motifs, which extended the "animal

3. Piet Mondrian (*Gemalde No. 1*) / *Composition No. XII*, 1913, oil on canvas. © 2011 Mondrian / Holtzman Trust c/o HCR International Washington, DC

style" of the Asian steppes, influencing the vocabulary of the illustrated manuscripts of the Romanesque and Gothic eras: think of the book of Kells, which is, after all, from the eighth century. I thought I was alone in recently collecting this Merovingian material and proud of searching it out in the art market, since it is quite rare. It was favorite material for J.P. Morgan, whose extensive collection of it was given to the Metropolitan Museum in about 1918. (Other than the Metropolitan Museum of Art, the Städl Museum in Frankfurt, the Walters Art Gallery in Baltimore, and the British Museum have extensive holdings in this field.) My own group, which I apparently assembled at the same time as Ronald Lauder, was gathered for the Morgan Library and now resides there in a beautifully installed new gallery called the North Room. But again, this is one of so many areas in which Ronald collections widely and well. His wide-ranging eye has been focused on masterworks of arms and armor, Limoges enamels, ivories and glorious carved limestone heads from some of the gothic cathedrals destroyed in the French Revolution.

All in all, what I am trying to bring out more clearly is that there is an art collection that is totally personal in its interests and enthusiasms, but yet is so wide-ranging over the history of art as to take its place among the very best of the major American collections, such as those of J. Pierpont Morgan, Henry Clay Frick, Duncan Phillips, Henry Walter, Charles and Jayne Wrightsman, Grenville Winthrop, Stephen L. Clark, and Norton Simon.

Here, in this amazing Lauder assemblage, are works of art bought for recognition of their quality, not for investment, not for profit. It is a very refreshing and old-fashioned kind of art collecting, one so unlike most art buying in our culture of today. Today's collectors often have paid advisors and seldom look at or personally choose the pieces they are buying. There is an overwhelming influence of the art market, of what's hot and what's not. So many collections look the same and so many acquisitions are nearly immediately for sale if the price is right. The Lauder collection is worlds away from those currently following the trends of the market, and the players in these two different avenues seldom ever meet or understand each other.

I must return to the subject of Picasso drawings and works on paper. It is an extraordinary group that Ronald Lauder has assembled. The *Woman with a Raven* [Fig. 4] has been reproduced so frequently and exhibited so widely that it has become an icon from 1904, a Blue Period master work radiating magic and emotion. Several truly major, even monumental Cubist sheets are as strong a representation of this crucial style as can be found in any private collection that I am aware of. Two great cubist collages, two early self-portraits, a unique carved plaster classical sculpture and you have some idea of the richness of this group.

This is the first time Ronald has permitted a large part of his now legendary art collection to be exhibited in all its power. Works of art change in different contexts and in different arrangements. I look forward to seeing many of the works collected by Ronald Lauder in a new light. Even individual pieces that I have known for years, and that are already famous, will assume new identities and teach us new ways of seeing as they take their places in this new context and this new catalogue.

It occurred to me many years ago when I first got to know Ronald Lauder that he could have become the greatest art dealer of our era, had he chosen that path. He forgot nothing and, although busy in his family's business, he knew more about what I was offering him than I did. He began to search out major pictures by some expressionist artists who, while they may have produced a few very interesting works, were in no way household names. Only a Lauder type of collector knew enough to search out and find the best pieces, with a future museum like the Neue Galerie already in mind.

4. Pablo Picasso, *Woman with a Raven*, 1904, gouache and pastel on paper. © 2011 Estate of Pablo Picasso / Artists Rights Society (ARS), New York

1. Josef Hoffmann, Writing table for Katharina Biach, 1902-03, wood, painted white, leather, metal

CHRISTIAN WITT-DÖRRING

Decorative Arts

Ronald Lauder's path and mine first crossed in 1987, when he was serving as American ambassador in Vienna. At the time I was the curator of the furniture collection at MAK—Österreichisches Museum für angewandte Kunst in Vienna, and he asked me to give the International Council of the Museum of Modern Art a survey tour of Viennese architecture and arts and crafts from around 1900. That was my first opportunity to meet Ronald Lauder personally [Fig. 2]. The encounter would become a determining factor on my future path, not only professionally but also personally. Life is full of surprises, and one is repeatedly confronted with unanticipated situations that bear the seeds of new possibilities. When they fall on fertile, well-tilled soil, and the climate is favorable, a rich harvest can be expected.

These prerequisites were met in two respects at the time, and hence they led to new, increased access to an area of research in the history of Austrian art and culture that had already been familiar to me for years: the production of art in Vienna around 1900. On the one hand, there was the acquaintance and interchange with a private collector of decidedly selective and subjective taste, which contrasted with my accustomed encyclopedically trained historian's appreciation of art and thus opened up a new context for looking at art. On the other hand, and of much more lasting effect on my view of things, were our discussions in the wake of the Waldheim Affair from 1986 onward, of Austria's share in the responsibility for the Holocaust. In this process, I became aware of the possibility of radically reevaluating my own Jewish heritage, to which I had previously paid little attention. The priorities in my work began to shift. The traditional art historical and stylistic approach that had dominated when I was a student and during my early years as a collection curator in Vienna receded into the background in favor of a perspective based on cultural history.

Answering the questions of who, when, and where were no longer ends in themselves but rather aids to an understanding the how and why. Craft objects were no longer simply reduced to their stylistic classification but suddenly acquired a language that could provide information about the motivations and fates of their creators and consumers alike. Thus it was like a small revolution in the late 1980s, when the Austrian Museum for Applied Arts

2. Christian Witt-Dörring and Ronald Lauder at the opening of the exhibition *Vienna 1900: Style and Identity*, Neue Galerie New York, February 23, 2010. Photograph by Daniel Kukla for André Maier Photography

in Vienna included in the description of its objects not just the usual information about the design, execution, period, and materials but also about the provenance of the objects. The statement about the society was suddenly just as important as the art historical information. The craft object was no longer located in the vacuum of objective stylistic criteria but rather integrated into the subjective spheres of human lives. The former approach was roughly comparable to suppressing the name of the sitter for a portrait and determining the identity of the painting solely by the name of the painter. That very approach was employed with conscious political intention by the Nazis, for example, when Klimt's portrait of Adele Bloch-Bauer was exhibited at the Viennese Secession in a large retrospective of the artist's work in 1943 as *Portrait of a Woman in front of a Gold Background*.[1]

When Ronald Lauder took up his position as American ambassador to Austria in April 1986, Viennese art of the turn of the century was by no means an unknown field to him. Already since his youth, and thanks especially to his friendship with Serge Sabarsky, he had long been familiar with it as a collector of Egon Schiele and Gustav Klimt, and it represented a central interest of his passion for collecting. For example, his and Sabarsky's support made it possible to acquire Gustav Klimt's painting *Hoffnung II* (Hope II) [Temkin Fig. 1, p. 124] for the Museum of Modern Art in 1978. Finally, his love and zeal for the aesthetics of turn-of-the-century Vienna met with official affirmation and enthusiastic public response in New York in July 1986 thanks to his tireless advocacy and financial assistance. His own Jewish roots in the cultural sphere of the former Austrian-Hungarian monarchy had not previously been a top-priority theme for him. In March 1986, the World Jewish Congress demanded that Kurt Waldheim, at the time a candidate for the presidency of Austria, should be placed on the watch list, as was ultimately done by United States Attorney General Edward Meese in April 1987. This made it impossible for Waldheim to travel to the United States and led to a new blossoming of anti-Semitism in Austria. It was only in the wake of these events that Lauder began to pay more attention to his own Jewish heritage and started to explore it. He became aware of the fact that the Jewish life that had flourished in Central and Eastern Europe at the time had by no means been extinguished by the Holocaust, but merely required financial support to find its way back to its former self-confidence. This ultimately led to the founding of the Ronald S. Lauder Foundation in 1987.

In light of the events and experiences of his years in Vienna, the material evidence of a once culturally highly evolved Jewish population of Central Europe had not only aesthetic value but also an additional emotional significance and began to occupy a new, determining place in Lauder's self-definition. Collecting generally offers such an opportunity for self-definition. Strict criteria of quality and selection are necessary to achieve it. It is through them that one's own priorities can be conveyed to others and hence become a means of communicating a profession of belief. From this discussion, it is clear that Lauder's collection of art produced in Vienna was never intended to be an encyclopedic museum presentation of an era but was primarily a way of integrating specific outstanding artistic achievements into his private daily life. This clear priority also provides the personal point of contact between Vienna around 1900 and Ronald Lauder. On the one hand, his activity as a collector and his

philanthropic commitment placed him within the American civic tradition of art patronage, which feels a responsibility to the general welfare that derives from its self-image as a democratic culture. On the other hand, he is at home in the tradition of the wealthy European Jews who were striving for cultural integration and social assimilation in the latter half of the nineteenth century. Sustained by a new self-confidence, wealthy Jews who until the middle of the nineteenth century had played only a subordinate role in the social life of Austria-Hungary employed, the progressive fine arts and performing arts around 1900 as a vehicle for social recognition and presence. In contrast to the established Austrian aristocracy, wealthy Jews were the primary supporters and patrons of artists of the Viennese Secession, the Wiener Werkstätte, and the likes of Adolf Loos and Oskar Kokoschka, and hence were largely responsible for making Vienna one of the new creative laboratories of modernism. With the opening of the Neue Galerie New York in November 2001, a museum for German and Austrian modern art, Lauder's private passion for collecting and his philanthropic ambitions came together. It was the logical expression and clear manifestation of his love and affection for and his identification with a pioneering cultural aspect of human history and with his native city, New York. Private motivation and public responsibility acquire here their purest symbiotic form and represent an enduring legacy for future generations. The opportunity to contribute to that opened up new dimensions of human and scholarly experience in my career as an art historian. I had the good fortune to be involved as early as 1999 in the museum's development phase and hence to play a role in the aesthetic and substantive conception from the beginning as a future curator for the applied arts. It was the beginning of a very close personal collaboration with Ronald Lauder, which continues to be a fruitful history of mutual give and take and of growth. As already noted above, the challenge lies in a constant interplay between subjective soundness in matters of taste and objective, and scholarly criteria. The focus was not on established norms that call for safety, not on tried-and-true solutions from the traditional activities of American museums, but rather the more hazardous enterprise of finding a new audience for personal convictions by providing a solid scholarly basis for them. I am greatly indebted to Ronald Lauder for taking that risk and continuing to do so. Without his belief and his commitment, which often stretches the limits of what is financially feasible, a whole series of exhibition projects, publications, and acquisitions could never have been achieved. For example, the Neue Galerie presented, among other exhibitions, *Dagobert Peche and the Wiener Werkstätte* in 2002, which was awarded second prize for the best architecture and design exhibition by the United States section of the International Association of Art Critics (AICA), and *Josef Hoffmann: Interiors, 1902–1913* in 2006 [Fig. 1]. Both exhibitions explored new terrain in their elaborate temporary presentations in the spirit of a didactics of the sensual. In the approach of experiencing the craft object as primarily sensory and aesthetic information and only secondarily as art historical information, I found a kindred partner in Ronald Lauder.

Alongside a series of individual pieces, two coherent areas of collecting stand out in Ronald Lauder's private collection of the applied arts. Whereas the individual pieces demonstrate Lauder's subjective, individual preferences for specific designers, the latter form the backbone, so to speak, of the Neue Galerie's permanent collection. They are the two large com-

plexes of Viennese applied arts around 1900 and objects from the sphere of influence of the Bauhaus. In contrast to the individual pieces, both these groups stand almost programmatically for the materialization of his process of consciousness about his roots and his identity. As described above, the significant factors in this context are, on the one hand, their local, Central European origins and, on the other hand, the background in cultural history and design theory that are subsequently explained in greater detail. This background tells of the individual's search for identity in order to become a responsible, democratically inclined, modern citizen. The design of turn-of-the-century Vienna was no longer conceived in imitation of role models from the court and aristocracy but within a broader logic of the creation of a new human being suited to the challenges of the twentieth century—a logic the reforms of the Bauhaus then put into action. In formal terms, these two areas of collecting—turn-of-the-century Vienna with Adolf Loos and the protagonists of the Secession and the Wiener Werkstätte, on the one hand, and the members of the Bauhaus, on the other—send extremely different aesthetic signals. In terms of the history of art's evolution, however, they are logically connected. They share an absolute faith in formal and craft quality.

The nature of Ronald Lauder's far-sighted collecting decisions, which ran counter to current fashions and market tendencies, is demonstrated by the acquisition of two early vitrines based on designs by Otto Wagner (1841–1918). Created in 1886 for the dining room of the

Heckscher home and in 1892 for the boudoir of Wagner's home and studio on Rennweg [Fig. 3] respectively, they correspond neither to the formal concepts of a Wagnerian modern functional style nor to the stereotypical ideal image of avant-garde Viennese design around 1900. In my opinion, however, these two vitrines are capable of much more than satisfying a preconceived expectation. They embody that exciting moment in design history when the old aesthetic concepts are still present but their validity is already being called into question by subtle changes in their traditional look. At first, superficial glance, viewers are confronted with something familiar, but their eyes are left somewhat perplexed by the object, without being able to find a clear explanation for that. It is that subtle moment when evolution can be experienced by the senses, when evolution becomes motion in the truest sense of the word. "Something moves," in contradiction to the static final result of a mature stylistic solution. The familiar and hence unspectacular aspect of looking at Wagner's two vitrines is their use of historical styles. The piece from 1886 is in the Renaissance style and the one from 1892 in the style of Louis XVI, and hence both are indebted to historicism, in keeping with contemporaneous taste. At the end of the nineteenth century, Wagner would criticize that style as fundamentally inadequate to the modern bourgeois. Both Renaissance and Louis XVI are styles that employ classical formal elements and emphasize the tectonics of load-bearing. This latter quality of emphasizing construction is what Wagner argued was one of the fundamental premises for the development of a modern style. He believed it could be realized in a so-called free Renaissance, which in conjunction with satisfying the function of an object, necessarily led to a functional style. Wagner saw how abstraction and a tectonic reevaluation of historical stylistic elements of the two vitrine bases could clear a path that would lead away from historicism. The actually functional parts of the furniture that make up the structure of the vitrines is, apart from the slight profile on the cornice that forms the upper termination, free of any decorative elements and formed of simple, smooth metal rods. This represented an aesthetic that was completely new at the time, making possible a self-evident harmony between the upper-middle-class need for status objects and a modern functional way of thinking. Lauder understands, moreover, who these a priori seemingly unmodern pieces of furniture can be given the modern context they deserve in the context of his collection. Wagner's creative period between 1902 and 1918 is also represented by important unique pieces in the collection, as well as industrially produced pieces. Primary among these are the reception desk and armchair model he designed in 1902 for the dispatch bureau of the daily newspaper *Die Zeit*. It already points to striking features of his mature "functional style" that are unobtrusively modern, which derive their justification from Wagner's maxim "Nothing impracticable can be beautiful." His designs just a few years later, 1904–06 and 1910–12, for the furniture for the Österreichische Postsparkasse, derive logically from these earlier designs and are rightly present in the collection as design icons of ambitious seating furniture, étagères, cabinets, and lamps.

The next generation of architects and designers responsible for the evolution of the modern era in Vienna is represented in the collection above all by Adolf Loos (1870–1933), Josef Hofmann (1870–1956), and Koloman Moser (1868–1918). They stand for two different paths that the discussion of modernism took in Vienna after Wagnerian ideas of reform had been accepted. In essence, the loner Loos stood for developing a modern attitude

4. Adolf Loos, Chair for the Café Museum, 1899. Execution: J. & J. Kohn, beechwood, stained red, partly bent, caning. Neue Galerie New York. © 2011 Artists Rights Society (ARS), New York / VBK, Vienna

according to the needs of individuals, which calls for a modern human being, not a modern form, while Hoffmann and Moser, as representatives, of the Vienna Seccession and the Wiener Werkstätte, slip a modern dress over old content. The architect Loos saw himself not as a designer of craft objects but as a competent adviser, thanks to his architectural training, on how to approach the products offered by the market. Objects that had proved their worth for generations were identified and recommended by him or objects available on the market were redesigned to conform to new demands. Correspondingly inconspicuous in terms of form, and dispensing with the stamp of the designer's personality, Loos's creations embody the quality of the timelessly up-to-date, dismissing the tyranny of fashion. For example, the Neue Galerie collection includes, among other works, one of the rare Café Museum chairs of 1899 [Fig. 4] still in its original state, as well as the table from the study of the apartment of Emil Löwenbach of 1913. It is thus not surprising that the living environment created by Ronald Lauder can include one of the masterpieces of English cabinetmaking, the so-called Combe Abbey library table from around 1754, which is attributed to Thomas Chippendale, without creating any aesthetic contradiction.

Ronald Lauder's great love and collection passion, however, is the work of the Wiener Werkstätte. This workshop was founded in 1903 as a cooperative of artists and artisans, based on the ideology of the Arts and Crafts movement and faith in the artistic ambition of complete design held by two founding members of the Wiener Secession, the architect Josef Hoffmann and the painter Koloman Moser, along with the Jewish textile industrialist Fritz Waerndorfer. Its goal was to produce modern functional objects designed according to individual artistic perspectives and executed according to the highest craft standards. It was an attempt to save the world by means of the *Gesamtkunstwerk*, or "total work of art." Although the ideological argument for this concept originally called for a broad basis in society, the economic and design realities limited the target audience of the Wiener Werkstätte to financially powerful bourgeoisie of large industry and high finance. They are thus absolutely luxury items produced as unique pieces or in very small series. On the one hand, this enabled designers to realize their artistic ideas completely and, on the other hand, offered consumers the sense of achievement of owning a unique, irreplaceable object—not unlike the consumer behavior of court and aristocratic society of the seventeenth and eighteenth centuries. In that sense, owning such works contributes to individuality and ensures one will be noticed in the context of social competition.

Ronald Lauder's collection has the largest holdings of works of the Wiener Werkstätte outside Vienna, which not only covers the spectrum of the various products and periods but also their documentation. The furniture includes a group of seating furniture for Ladislaus Rémy-Berzenkovich von Szillás and Margarete Hellmann, Fritz Waerndorfer's sister-in-law, designed by Koloman Moser in 1904 on the occasion of their wedding [Fig. 5]. They are among the few furniture items produced in the Wiener Werkstätte's own cabinetmaking workshops and reflect the early canon of forms of Viennese modernism that had achieved maturity by this period. This canon was in principle limited to the use of geometric basic forms and volumes, assembled to produce abstract, minimalist forms. The sofa, for example, plays with a rectan-

gular module that, on the one hand, establishes the frame for the entire piece and, on the other hand, provides the framework for the panels of the backrest, which consist in turn of individual rectangles. The latter are inscribed with ovals, in which sits in turn a rhombus composed of four oval segments. Thus the sharp-edged, rigid, rectangular outer frame is countered by a soft and curved inner structure, uniting their contradictory messages into a fascinatingly harmonious whole. The basic structure of the sofa can be traced back to Viennese furniture from the period around 1800–10. The proportions and the way the individual elements are combined into a new whole is, however, typical of the twentieth century. The furniture thus conveys tradition and modernity at once and hence embodies the Viennese Secession's ideal of achieving artistic innovation by reviving a concept of quality that had been lost. Another ensemble of furniture in the collection—this one slightly earlier: from 1902, thus slightly predating the founding of the Wiener Werkstätte—designed by Josef Hoffmann for the bedroom of seventeen-year-old Katharina Biach,[2] is one of only very few sets of furniture for a room that survives in its entirety. On the occasion of the exhibition *Josef Hoffmann Interiors, 1902–1913* in 2006, it could be exhibited in the Neue Galerie as a *Gesamtkunstwerk* in the context of the reconstructed room. Also worthy of mention for its provenance is a vitrine [Fig. 6] for the presentation of Wiener Werkstätte jewelry that Koloman Moser designed for the fashion salon of the Flöge sisters in 1904.[3]

5. Koloman Moser, Group of seating furniture, 1904. Execution: Wiener Werkstätte, black stained wood and upholstery

In 2008 the Neue Galerie dedicated an entire exhibition to Wiener Werkstätte jewelry, largely consisting of objects from the Lauder Collection.[4] The brooches based on designs by Josef Hoffmann that are presented here form a special group. They enable us to appreciate his genius as a designer able to form ever new small works of art by exploiting the possibilities of diverse materials and craft execution. With these pieces, Hoffmann liberated the idea of jewelry from its established dependency on the value of the raw material being worked. For the most part made of silver and semi-precious stones, their value derives not from the preciousness of the materials but from the way he employs artistic invention to lend a new language to the beauty of nature. Hoffmann produces creative fireworks of abstract nature, each inscribed in a square or rectangular frame. The formal limitation of the frame results in a concentrated effect on the content depicted, from which Hoffmann derives ever new possibilities of expression.

Another category of holdings in the Lauder Collection, much larger in terms of the number of objects, was the point of departure for another Neue Galerie exhibition. In 2003 it presented *Viennese Silver: Modern Design, 1780–1918*.[5] It traced the roots of modern design using the example of Viennese silversmiths' work from the late eighteenth century to the end of the First World War, juxtaposing it with classics of international modernism from the Bauhaus to the 1960s. The Wiener Werkstätte began production in 1903 with just two workshops: one for metal and one for leather. Concentrating on these two materials during the early, experimental phase of the Wiener Werkstätte resulted in several products that prepared the way for its most astonishing future developments, particularly in metalwork. Much as we saw with Wiener Werkstätte jewelry, the material value of an object is not emphasized a priori, but rather the artistic idea executed with high-quality craftsmanship. The

6. Koloman Moser, Display case for the Schwestern Flöge (Flöge Sisters) Fashion Salon, 1904. Execution: Wiener Werkstätte, maple, stained black, glass, white metal

7. Josef Hoffmann, Tray, 1904.
Execution: Wiener Werkstätte,
silver-plated alpacca, glass

most remarkable example of this is the tray of silver-plated alpacca with glass stones designed by Hoffmann in 1904 [Fig. 7]. Despite their original high sale price, the form and material are not typical of the usual status objects of the time. That they nevertheless managed to produce a craft product able to persuade a wealthy clientele was then and is still astonishing. Therein lies the quality of this tray, which even today captivates our senses. The proportions of the individual structural elements of the tray are problematic. They are even more problematic in their interplay, in the attempt to achieve a functioning, harmonious coexistence. Last but not least, the hammered surface treatment that was chosen is problematic, suggesting more a primitive functional object than a luxury product. Above all it is the determination and matter-of-factness with which Hoffmann pursues the aesthetic direction he has taken, even though it is not easily understandable, and brings it to its conclusion that is paramount. By doing so he took a complex, ambiguous situation and created an autonomous, fascinating, and new harmonious unity. Many of the silverworks presented here have this quality in common, which distinguishes them clearly from other Arts and Crafts products.

The objects in the Lauder Collection based on the design philosophy of the Bauhaus take a completely different direction. Whereas the Austrian designers and architects placed the implementation of aesthetic reforms primarily into the hands of artisans through the second half of the twentieth century, in Germany standardized, industrially mass-produced products of high formal quality began very early on, already the context of the founding of the Deutscher Werkbund in 1907. This is connected to a far more self-confident bourgeoisie in Germany and to a more effective democratic movement. Although teaching at the Bauhaus was based on the workshop system of the crafts, this served merely to increase understanding of a cultural point of departure. It was not an end in itself but rather a useful tool to clarify a process of development that calls into question craft production as a determining criterion of quality and sees the future in the standardized industrial product. Like the Wiener Werkstätte, the Bauhaus also pursued the idea of architecture as a *Gesamtkunstwerk*. The

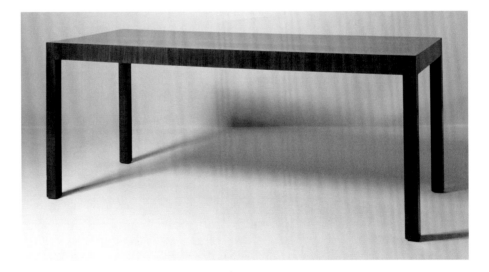

8. Ludwig Mies van der Rohe and Lilly Reich, Dining room table for the apartment of Philip Johnson in New York, Berlin, 1930. Execution: Richard Fahnkow (?), Berlin, rosewood, veneer. © 2011 Artists Rights Society (ARS), New York / VG Bild-Kunst, Bonn

9. Marcel Breuer, ti 114 Man's armoire, 1927. Execution: Möbelwerkstätte Bauhaus, Dessau, cherry veneer over wood-core plywood, wood painted black.

Gesamtkunstwerk of the Bauhaus emphasized not the realization of artistic individuality, but rather constructive clarity as a stage for the modern democratic human being. Individuality is no longer achieved with the help of an object. People were supposed to break free of superficial aesthetic stimulation in order to completely express their inner individuality. The functional object recedes into the background because its material is in perfect harmony with the space. From this harmony, whose goal is dematerialization, the object develops its aesthetic appeal. Liberated from superficial individuality, it becomes capable of international acceptance. This is particularly clear, and well represented in this collection, by the quality of the furniture developed in the Bauhaus circle. Three rare examples from this collection will be emphasized here. The table designed by Ludwig Mies van der Rohe (1886–1969) in 1928–29 for the Barcelona Pavilion, which was a gift from Ronald Lauder to the Neue Galerie collection; a dining table from the apartment of Philip Johnson of 1930, also by Mies van der Rohe with the collaboration of Lilly Reich [Fig. 8]; and finally the ti 114 Man's armoire by Marcel Breuer (1902–1991) of 1927 [Fig. 9], from the Bauhaus program of standardized furniture. All three pieces of furniture share the qualities discussed above. Whereas

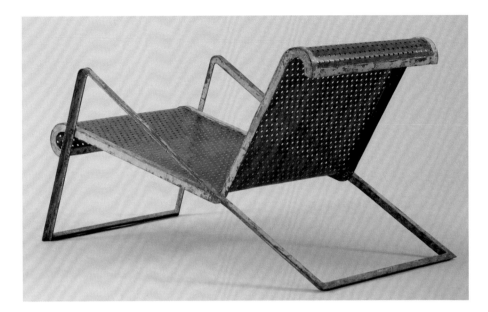

the two tables—which feature legs that leave lots of free space and frames that are either invisible or integrated into the tabletop—take up only the space of the material absolutely necessary for the construction, the man's armoire becomes, thanks to the planar design of its front, almost a piece of the wall, behind which he could withdraw in his mind. It seems to lack any of the tectonic details of a three-dimensional body. It has neither its own base or cornice zone nor an emphatic tectonic termination on the sides that could serve, not just visually but also mechanically, to absorb the forces of the door hinges. The hinges are continuous, integrated invisibly within the narrow frame that results from the width of the side walls. This frame, which is emphasized with black paint, surrounds the wardrobe only on the sides and floor. The upper end of the wardrobe seems to run into the space with no demarcation. The visual message of this wardrobe is hence that of a mobile surface, not of static material blocking out space.

One separate, very heterogeneous part of the collection consists of furniture designed by French and Italian decorators and architects from the 1920s to the 1950s and postmodern furniture of the late 1970s to the 1990s. In the context of Ronald Lauder's passion for collecting, the heterogeneity of these holdings is not the least bit surprising. With his great sensitivity to the aesthetic, he recognizes its creative potential and draws from it inspiration for a creative approach to the rest of his collection. This results in a constant dialogue of possibilities that leaves the collection open to constant reevaluation. This makes it possible to test the validity of his own standards of value and to get closer to answering the question of his own position in life. We mention here only a few examples to give a sense of the diversity of Ronald Lauder's interests. The great achievements of French interior design are represented by, among other works, a stool by Serge Roche (1898–1988), a three-legged side table by Émile-Jacques Ruhlmann (1879–1933), and an armchair by Jean Royère

(1902–81). The first two pieces demonstrate one of the many possible paths French interior designers took in the 1920s and 1930s to translate the achievements of the classicism of the late eighteenth and early nineteenth century into the twentieth century. Roche's stool, acquired in 1934 for the apartment of the American interior designer Elsie de Wolfe, employs the form of a *tabouret pliant* (folding stool) from the period around 1800 and places mirrors, one of the designer's favorite elements, on its frame. Ruhlmann's side table is based on a Louis XVI creation, and Ruhlmann transformed it again and again in very distinct variations. Lauder's version gets by with a minimum of decorative details, thereby laying bare the essence of the classical load-bearing system. Royère, who is known for his flexible approach to all stylistic varieties, is represented by a very modern creation. His armchair [Fig. 10] was designed for the furnishings of the Pavillon de la Céramique et de la Verrerie at the International Exhibition of the Arts et Techniques dans la Vie Moderne in Paris in 1937 and is limited to only the most necessary structural elements. It is essentially composed of three staggered pieces of bent metal, one of which forms the seat and the backrest, while the two others, placed in parallel, make up the front and back legs and the supports for the armrests. This metal frame supports the seat and backrest, both formed from one continuous piece of perforated metal.

Italian design is represented by the Turin-based architect Carlo Mollino (1905–1973). He is grounded in the tradition of individual pieces of furniture designed for specific projects and executed with the highest craftsmanship, but also being open to the latest aesthetic developments. Mollino's furniture, such as the chair [Fig. 11] designed in 1940 for the home of his daughter Lisa and the one for his own apartment in Turin, designed from 1956 to 1959, demonstrate his mature style, which was inspired by Surrealism and organic design. They are more than just seating furniture. Their forms are consciously associated with the human body, lending them a sculpture-like quality. This same sculptural character is radiated by the small version of the roll-top desk for Molino's own home (1946–47) from 1948–49 and the adjustable daybed for the Turin home of the Marchese Vladi Orengo of 1949–50. In these cases, the legs, which are clearly distinguished from the body by color, seem to give Mollino's creatures the ability to walk. His designs result in an individualistic yet timeless elegance.

The sculptural character of objects is also emphasized by the seating furniture of Alessandro Mendini (b. 1931) and Shiro Kuramata (1934–1991), which is indebted to postmodern design theory. The Lauder Collection includes a number of pieces of important furniture by the latter designer. After modernism had lost its vitality, postmodernism took the stage in the 1970s, redefining the established concept of function. The subjectivity of emotion was given a voice in design alongside the objectivity of function. In a democratic spirit, individual bad taste was given rights equal to neutral good taste. The designer is no longer satisfied to be neutral and indifferent toward his creation but demands an individual emotional reaction from the consumer. The entire history of design is available for reevaluation in the context of the outgoing twentieth century. This is often done with humor and sarcasm. Mendini's Proust reinvents the epitome of bourgeois comfort and status-oriented thinking, puts good taste to the test, and in the process gives birth to an icon of postmodern design. The theme

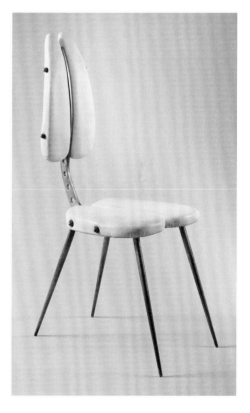

11. Carlo Mollino, Side chair for Lisa Licitra Ponti, Milan, 1940, brass, Resinflex

of Kuramata's 1990 stool of acrylic resin with cast feathers is immateriality and timelessness [Fig. 12]. The light, colorful feathers signal movement and hence the passing of time. Seeming weightless, captured in solid yet transparent block of acrylic resin, this expectation is not fulfilled.

Apart from the collection of the MAK—Österreichisches Museum für angewandte Kunst, Ronald Lauder's collection can best represent the most important positions of the artistic spring of Vienna around 1900, with selected objects that serve as high points of its reflections on design theory. Beginning with Otto Wagner's logical process of evolution from a free Renaissance style to a functional style by way of Adolf Loos's fascinating path from designer to rejecter of design and on to the luxury products of the likes of Josef Hoffmann and Koloman Moser for the Wiener Werkstätte, it is possible to follow in individual masterpieces the complex evolution of Viennese applied arts during this period. When selecting objects from his collection, Lauder often shows an individual taste independent of the mainstream, one that the market often follows only years later. Because these things primarily obtain meaning for him as part of his own self-definition, and thus embody emotional values, a crucial role in the process of acquisition is played by how they can be positioned within his personal taste. I became aware of this approach only gradually. It triggered in me a learning process, which represents, in a sense, a new freedom in my approach to my expert knowledge. Finally, in contrast to an object within the context of a museum, it guarantees that an object will live on, and thus retain its qualities within the reality of everyday life. An object is born in the context of very specific social, cultural, and economic circumstances, subject to the trials of changing taste, and repeatedly required to prove itself anew and offer its raison d'être. The logical consequence of this is a continuous process of reevaluation. Static classification within a linear process of art historical development may seem to offer superficial certainty, but it is no substitute for the exciting, living, uncertain positioning of the object within the coordinate system of personal values. The quality of the result proves he is right, and is nothing less than the expression of his creative potential. A painter uses a brush to given expression to his world. Lauder selects and brings together in order to lend his world a face. Whereas in the initial phase of our collaboration on the project of the Neue Galerie, when the goal was to develop an identity for this new private institution that was open to the public, he repeatedly stated the maxim that the museum had to represent both a home and an exhibition at once. As his model he mentioned the Frick Collection, with its atmosphere, unique in New York, of a private ambience made public in the form of a museum. The museum visitor is a guest in Ronald Lauder's home and not in some neutral institution indebted to chimeras of the objective communication of knowledge. Any selection, no matter what objective criteria it may be based on, remains subjective. The more clearly this fact becomes evident, the more honest and just the intended communication of knowledge and creation of awareness will be. Whether Lauder's private collection of craft objects or the one he has assembled for the Neue Galerie, both are motivated by the same personal intention, and hence each supplements the other.

Translated from the German by Steven Lindberg

NOTES

1 Sophie Lillie and Georg Gaugusch, eds., *Portrait of Adele Bloch-Bauer* (New York: Neue Galerie, 2007), 72.

2 Christian Witt-Dörring, ed., *Josef Hoffmann Interiors, 1902–1913: The Making of an Exhibition*, exh. cat. (Munich: Prestel, 2006), p. 150–73. Christian Witt-Dörring, ed., *Josef Hoffmann Interiors, 1902–1913: The Making of an Exhibition*, exh. cat. (New York: Neue Galerie, 2008), 16–28.

3 Renée Price, ed., *New Worlds: German and Austrian Art, 1890–1940* (Cologne: DuMont, 2001), fig. on p. 444, cat. III.48.

4 Janis Staggs, ed. *Wiener Werkstätte Jewelry* (Ostfildern: Hatje Cantz, 2008).

5 Michael Huey, ed., *Viennese Silver, Modern Design, 1780–1918* (Ostfildern: Hatje Cantz, 2003).

12. Shiro Kuramata, Stool, 1990, acrylic, aluminum, feathers

CHRISTIAN WITT-DÖRRING

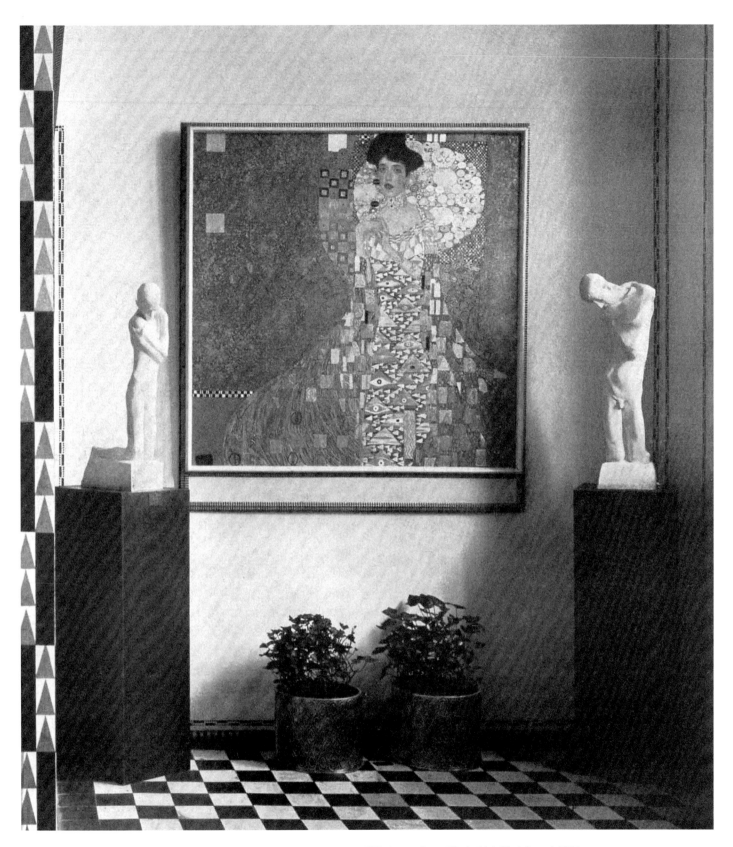

View of the *Internationale Kunstausstellung* exhibition, Mannheim 1907 showing Gustav Klimt's *Adele Bloch-Bauer I*, 1907, and George Minne's *Kneeling Youths*, 1898

ALESSANDRA COMINI

German and Austrian Expressionist Art

"You are doing God's work," a straight-faced Ronald Lauder commented gravely one evening in November of 2005. Bound for Vienna the next day, my travel companion and I had encountered Ronald by chance in a New York restaurant near the Neue Galerie. I knew this piquant observation was meant as a wily acknowledgement of the impetuous rush of Gustav Klimt and Egon Schiele information I had directed his way, and I came to treasure the remark as a prime example of Lauder diplomatic drollness. This was perhaps the same measured, discerning quality that had served him so well during his stint as American ambassador to Austria in the mid-1980s.

Egon Schiele was the subject of my dissertation when I was a PhD student and later instructor at Columbia University in the mid-1960s. In 1963 I had, by good fortune, discovered the neglected Austrian prison cell in which the artist was incarcerated in 1912 (now a museum). One of the first persons in New York to whom I showed my photographs of that basement cell was the dedicated Schiele collector Serge Sabarsky, later owner of his own art gallery and finally co-conceiver with Lauder of what was to become the Neue Galerie New York. To know Sabarsky was to hear engrossing narratives about the avid acquisitions of Lauder, but Ronald and I did not meet face to face until shortly after my book on Schiele's portraits was published and nominated for a National Book Award in 1974. I was curious to meet this knowledgeable collector of Austrian and German art so admired by Sabarsky, and at Lauder's invitation gladly went to visit him in an office building overlooking the venerable Plaza Hotel. We had a lively discussion that touched upon not only artists and collectors, but upon some of the difficulties facing one in Vienna, where the bureaucratic motto appeared to be "*Warum einfach wenn es komplizierter geht*?" (Why simple when it could be more complicated?)

To see jewels from the formidable holdings of the Lauder Collection on display at the finally realized Neue Galerie was akin to having a well-written textbook on German and Austrian art of the early twentieth century spring to life. In addition to the main text of genuine masterworks such as those on view in this exhibition, the footnotes to that history—lesser-known artists and artifacts—also take on compelling dimensional presence when viewed alongside

the gems of the collection. Lauder's far-flung interests in this vibrant field, which was one of the triggers of modern art, range from precious Wiener Werkstätte household items to sculptured busts to rare posters and placards to art photographs and the graphic arts. The didactic stamp of a conversant connoisseur is everywhere present.

It is therefore with the keen gratification of having watched a vast collection come to life that the essay below utilizes treasures from the Lauder holdings to present and illustrate the history of an exceptionally rich and decisive decade in the arts, the period of 1907 to 1917. It was a decade agreed upon by the collector and the author as both strive to do "God's work" of preservation and education here on earth.

■

Seven years into the dawning twentieth century, the Viennese master of Art Nouveau, Gustav Klimt (1862–1918) created a mesmerizing gold and silver Byzantine style portrait of Adele Bloch-Bauer [Plate 116]. Seventeen years into the same century, a prematurely white-haired Käthe Kollwitz (1867–1945) [Fig.1], began work on a sculptural memorial to her son. Peter had been killed in the early months of World War I. She wrote in her diary: "To know that the longing for peace is so fervent everywhere in Europe, the same everywhere, and yet the war *cannot* stop and goes on day after day, and every hour young men must die!"[1]

During that dazzling Klimt year of 1907, in the face of virulent anti-Semitism, the beleaguered composer-conductor Gustav Mahler resigned from his post as director of the Vienna Court Opera. In 1917, in the midst of the horrific trench warfare of World War I, Hans Pfitzner premiered

1. Above: Photograph of Käthe Kollwitz at the age of fifty, Berlin, 1917

2. Left: Vasily Kandinsky, *Red and Blue*, 1913, watercolor, India ink, and pencil on paper. © 2011 Artists Rights Society (ARS), New York / ADAGP, Paris

3. Right: Ludwig Meidner, *I and the City*, 1913, oil on canvas

his backward-looking opera *Palestrina* in Munich. What had promised to be the best of times had become the worst of times. It could not be sidestepped by invoking the past, as had Pfitzner, nor could it be ignored, as Kollwitz's private agony-turned-universal incessantly testified.

And yet the emerging twentieth century—one in which all things had seemed possible and all dreams attainable—was greeted with huge enthusiasm by artists. In cultural circles, a widely held belief at the time was that the materialism of the nineteenth-century machine age would be supplanted by a new spiritual epoch. By 1910, the Westphalian painter and future Blue Rider member August Macke (1887–1914) felt confident enough to pose for the camera eye in a mock ceremony celebrating the "planting of the tree of modern art." In our own new twenty-first century— the tradition-shattering art created in German-speaking lands during the decisive decade of 1907–1917 can now be recognized for what it was: an unprecedented, intuitive declaration of collective emotion—the movement of Expressionism. In a very real sense, artistic form followed personal feeling as two polarities of mood were invoked by artists in Germany: exultation [Fig. 2] and apprehension [Fig. 3]. In Austria, intuitive, strangely invasive portraiture paralleled Freudian forays into the very psyche of the person portrayed, whether sitter or self.

The genealogy of Expressionism—later, a special target of Adolf Hitler's aesthetic wrath— embraced the somewhat neurotic Norwegian Edvard Munch (1863–1944) as the movement's spiritual father and passionate Prussian pacifist Käthe Kollwitz as its compassionate mother. Another artist, the tragically short-lived Paula Modersohn-Becker, who died at the age of thirty-one in 1907, anticipated the Expressionist quest for pictorial equations of essence in a sophisticated search for what she called "the naïve in line" [Fig. 4].

Expressionism's physical geography corresponded to the patterns of political power in central Europe. The two most violent epicenters of the movement were close to the imperial households of Hohenzollern Prussia in the north and Habsburg Austria-Hungary in the south. The former, North Germany, became associated with the aggressive, impetuous Brücke (Bridge); the latter, Vienna from 1907, attracted the painters Richard Gerstl, Egon Schiele, and Oskar Kokoschka. A third geographical center of Expressionism was in less turbulent, slower-paced southern Germany, where Bavaria's art-obsessed "mad" King Ludwig II and his liberal successor, Prince Regent Luitpold, had made the capital city of Munich a magnet for a varied group of artists. A certain directness, austerity, or harshness distinguishes the North German artists' work from the more lyrical and often pictorially more luscious imagery produced by those artists whose daily lives were warmed by the Bavarian sun.

As for intensity, it was as though the closer artists lived to Kaiser Wilhelm—of withered left arm and compensatory expansionist appetite—the more probable it was that the artists' perception of the materialism of Bismarck's industrialized German Empire would lead to spiritual despair. And the nearer an artist was drawn into the orbit of Vienna's waltz with the past, the more likely the urge to slash through the stubbornly maintained splendiferous façade of aging Kaiser Franz Josef's crumbling, multi-racial empire. For six decades the emperor had weathered simmering national tensions, but on June 28, 1914, with the assassination of the

4. Paula Modersohn-Becker, *Seated Woman*, 1900, pastel and charcoal on paper

heir apparent to the Austrian throne at Sarajevo, the "shot heard round the world" would precipitate World War I.

The two cells of Expressionism in Germany were markedly distinct from one another. The earlier Brücke group was self-consciously a fraternity of German painters. Their leader was the radical Ernst Ludwig Kirchner (1880–1938), an architectural student at Dresden's Königliche Technische Hochschule, where he earned a degree in 1905. That same year he, along with Erich Heckel (1883–1970), Karl Schmidt-Rottluff, (1884–1976) and Fritz Bleyl (1880–1966) founded Die Brücke, a label intended to do homage to Dresden's venerable Augustus Bridge and to convey the idea of passage from old art to new art. However a glance at the poster designed by Kirchner for the Brücke's last exhibition in Dresden before regrouping in Berlin in 1911 reveals the transition was not to be a harmonious one. We can imagine the shock experienced by Dresden's inhabitants when, one morning in September of 1910, they awoke to find their beautiful Baroque town plastered with a poster of unparalleled ostentation. In a brutalized semi-African style, the placard, brazenly printed in Germany's national colors of red, gold, and black, presented an angular adolescent female whose jutting heels, knees, and elbows supported a massive, smirking head. The head, in turn, served as platform for an audacious black legend: KG Brücke (The KG standing for Künstler Gruppe, or Artists' Group) spelled out in thick, splintered, purposefully crude lettering. The poster was scandalous: a pubescent little girl who leered out from a blood-red background, like a yellow puppet jerked

by invisible wires. Critics and public alike felt threatened by the eroticism and figural deformities flaunted by this aggressive poster. (Now, of course, we recognize the image's indebtedness to Munch's well-known, disturbing lithograph *Puberty* of 1894.)

In cosmopolitan Berlin, where the long-lived German Impressionists Max Liebermann (1847–1935, [Fig. 5]) and Lovis Corinth (1858–1925, [Fig. 6]) held sway at the Secession, each of the Brücke artists' individual style and thematic preferences began to jell. Kirchner's development, with sources ranging from Cranach to Gauguin, to Indian and African examples in non-Western art, was the most complex in its several redefinitions of the ambiguities of two- and three-dimensional picture space and its increasing subjectivity of color choice. A dynamism based on jagged kinetic strokes gives his brittle Berlin scenes of men and women stalking each other a tremendous tension. Kirchner's special zigzags would be imitated to achieve the claustrophobic effects so important to German Expressionist cinema in the 1920s. Heckel and Schmidt-Rottluff, although still handling similar themes, began to express themselves differently. Heckel's angular portrait heads and splintered landscapes were a structured emotional response to the motif. Schmidt-Rottluff—the most drastically reductive of the Brücke painters (and the most impressed by African sculpture) packed his figures, buildings, and landscapes [Fig. 7] with compelling tonal saturations and linear contrasts.

Other Brücke members were the more lyrically inclined Max Pechstein (1881–1955, [Fig. 8]), who, as founder of the Berlin Neue Secession, had already achieved independent artistic success, and the dour but refulgent colorist from near the Danish border, Emil Nolde (1867–1956). After a brief association with the group (his 1906 oil portrait of Schmidt-

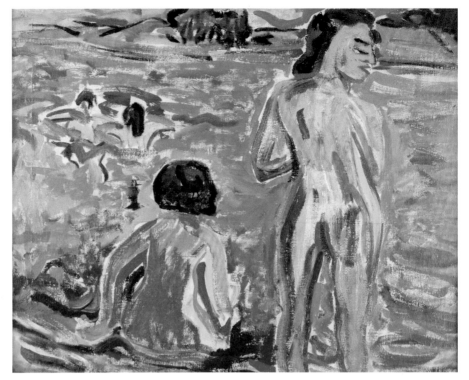

9. Left: Ernst Ludwig Kirchner, *The Russian Dancer Mela*, 1911, oil on canvas

10. Right: Erich Heckel, *Bathers in a Pond*, 1908, oil on canvas. © 2011 Artists Rights Society (ARS), New York / VG Bild-Kunst, Bonn

11. Below: Photograph of Mary Wigman dancing by the shore of Lake Maggiore, ca. 1914. From Hans Brandenburg, *Der moderne Tanz* (1921; reprinted 1930)

Rottluff painting outdoors is a turbulent contrast of bright and dark impasto slashes), he accused them of having too much of a look-alike style. This was actually the aim of the Brücke in its initial period, when members often shared and traded the jobs of design and execution of brightly colored, angular woodcut prints.

Nolde traveled his own lonely path of Expressionism, joining an imperial German ethnographic expedition through Russia, Japan, and New Guinea, before retiring to the North Sea marshes of his native Schleswig-Holstein to record with glowing color the brooding intensity of nature. Exercising the single-mindedness of a William James without the objectivity, Nolde collected the varieties of religious experience and compressed them into a keg of emotional gunpowder, which he exploded in a series of scenes from the life of Christ that outraged viewers by their sheer audacity. In his *Christ among the Children* of 1910, with its grotesquely exaggerated Semitic features and crowd-level view of Christ from the back, the painter presented an unheard-of familiarity, as shocking to its generation as the contemporaneity of the rock opera *Jesus Christ Superstar* was to Americans in the 1970s.

The mild, by contrast, Otto Mueller (1874–1930) joined the Brücke group in 1910. He was of Romany extraction, a fact that influenced his choice of enigmatic gypsies as subjects, with their sometimes insolent grace and proud aloofness from Western civilization. In a group portrait, *Painters of the Brücke*, created by Kirchner in 1926–27, Mueller is shown seated at the left, with Kirchner standing behind him in profile before an open window. Heckel faces us in the center, his eyes turned toward a goateed, bespectacled Schmidt-Rottluff, shown in three-quarter profile to the right. As self-appointed chronicler of the Brücke (he holds illustrated text pages in his hands, possibly a manifesto), Kirchner revenges himself upon dissenters and unwelcome competitors by striking acts of omission: Fritz Bleyl, the fourth original member (who returned to architectural studies to support his family in 1909), Pechstein, and

12. Alfred Kubin, *Jungle*, 1911, pen and ink on paper. © 2011 Eberhard Spangenberg / Artists Rights Society (ARS), New York / VG Bild-Kunst, Bonn

Nolde. Only the pipe-smoking Mueller is deemed loyal enough to Brücke aims to merit inclusion, albeit at literally a lower level.

Aside from a penchant for portraiture, the Brücke artists tended to address themselves to two aspects of the human condition in Wilhelmine Germany: the soul-destroying city and the spirit-expanding country. By employing startling distortions of form and angular strokes, they strove to give, in Kirchner's words, "pictorial form to contemporary life." They showed anxiety-ridden urban streets (elaborating upon Munch's avenues of alienation and anticipating Bertolt Brecht's erotic alleys) and the garish night life of Berlin's dance halls, brothels, circuses, and cabarets [Fig. 9]. Their female models served to illuminate the other great Brücke motif: unfettered life in nature. Male and female nudes were shown against lush forest backgrounds or sparkling lakes in ecstatic canvases, such as Heckel's bathers [Fig 10].

13. Paul Klee, *Self-Portrait, Full Face, Hand Supporting Head*, 1909, watercolor on paper mounted on cardboard. © 2011 Artists Rights Society (ARS), New York

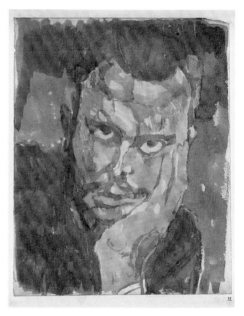

Such cathartic scenes had much in common with the liberating breakthroughs of contemporary dance, ushered in by Rudolf von Laban in Berlin and his most famous student, Mary Wigman [Fig. 11]. A friend of both Kirchner and Nolde, Wigman, from about 1913 on, created a dance method of her own that remarkably parallels the Brücke branch of Expressionism. Both dancer and artists discovered new visual languages through their employment of violent gestures and kinetic symbols; both utilized a psychic self indulgence to dramatize emotions more universal than their own feelings; and both demolished traditional structure to build a new form in which content—the human figure—expressed not only the pathology but the cultural torment of their era.

In contrast to the exclusively German and all-male makeup of the Brücke, the Blue Rider, in addition to having a strong Germanic representation reaching as far as West Austria's strange visionary Alfred Kubin (1877–1959, [Fig. 12], attracted a diverse international membership.

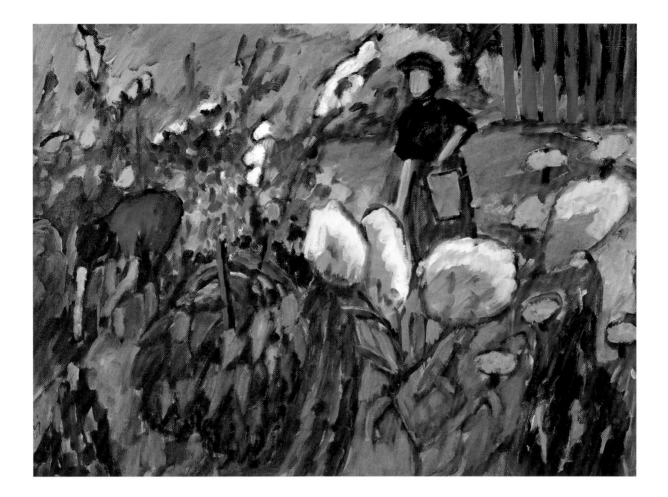

14. Gabriele Münter, *Woman in Garden*, 1912, oil on canvas. © 2011 Artists Rights Society (ARS), New York / VG Bild-Kunst, Bonn

From Russia, most notably, came Vasily Kandinsky (1866–1944), Alexei Jawlensky (1864–1941), and David Burliuk (1882–1967); from Holland, the Fauve painter of pure color and daring line, Kees van Dongen (1877–1968); from Switzerland the wry, poetic contemplator of all phenomena great and small, Paul Klee (1879–1940, [Fig. 13]; from Italy, Emma Barrera Bossi (1882–1952), whose canvases were bathed in colors; and from France, Robert Delaunay (1885–1941), who, with his Russian wife Sonia Terk Delaunay (1885–1979), developed what Apollinaire termed Orphism, a colorful variation of Cubism.

Prominent female members of the Blue Rider included the Russian Marianne von Werefkin (1860–1938) and Berlin-born Gabriele Münter (1877–1962). Along with former law professor Kandinsky and former theology student Franz Marc (1880–1916), Münter was a founding member of the Blue Rider in 1911. It was Münter who in 1909 bought the large yellow house in the country town of Murnau where she and Kandinsky spent fruitful summers [Fig. 14] until the outbreak of World War I. Ironically, it became known as the Russenhaus, partly because the villagers presumed Kandinsky owned it, and partly because of visits from his compatriots, Werefkin and Jawlensky. And it was Münter, rather than Kandinsky, who first began to collect local examples of Bavarian votive glass painting, the brilliant colors and thick black lines of which led to their both painting with pure colors on the back side of plates of glass (*Hinterglassmalerei*). Comparison of their efforts bears out a difference in painterly goals, with Münter opting for a close vantage point, simplification, and patternization, and Kandinsky preferring greater distance from his subject, pictorial scope, and diversity.[2]

"Marc loved blue and horses, I loved blue and riders" explained Kandinsky regarding their 1912 co-publication of the important *Blaue Reiter Almanac*. This 190-page compendium of the Munich group's work and artistic affinities contained almost 150 illustrations, notable for their astonishing variety. Included were early German woodcuts, Russian broadsides, Bavarian folk paintings on glass, and children's drawings; textiles, masks, or sculptures from Egypt, Mexico, Brazil, New Caledonia, Easter Island, Benin, and Alaska; Japanese and Chinese paintings and woodcuts; medieval and folk sculptures as well as Byzantine mosaics. Also represented pictorially were El Greco, Henri Rousseau, Van Gogh, Gauguin, Cézanne, Robert Delaunay, Matisse, Picasso, Goncharova, Münter, and Klee. There were two paintings by Arnold Schönberg, as well as a facsimile of his song "*Herzgewächse*" (Foliage of the Heart) and an essay, "The Relationship to the Text." Three essays were contributed by Franz Marc, one by David Burliuk, and one by August Macke, entitled simply "Masks" and asking, "Is life not more precious than food and the body not more precious than clothing? His answer: "Man expresses his life in forms. Each form of art is an expression of his inner life. The exterior of the form of art is its interior."[3] One of the longest essays, "On the Question of Form," was provided by Kandinsky concerning "colored tones." There followed his stage composition *The Yellow Sound*, comprised of stage action, music, and choir directives, and ever-changing lighting commands for five selected pictures.

How different from the purposeful primitivism of the Brücke poster of 1910 was the effect produced by the Blue Rider almanac's cover of 1912 [Fig. 15], with its velvety flowing of forms that give the impression of a fairy-tale horse and rider in a magical world of expanding color and space. And yet the public was no more cordial to this more lyrical branch of Expressionism:

15. Vasily Kandinsky, cover for the *Blaue Reiter Almanac*, 1912, colored lithograph. Neue Galerie New York

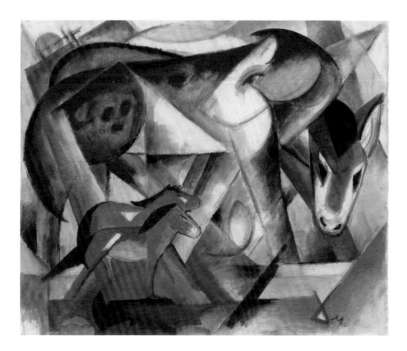

16. Franz Marc, *The First Animals*, 1913, gouache and pencil on paper

17. August Macke, *Two Men on a Bridge*, 1912-14, watercolor on paper. Private Collection

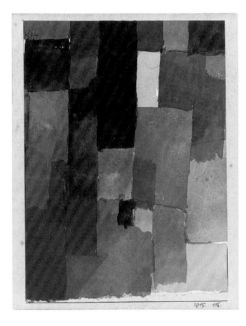

18. Paul Klee, *Small Black Door*, 1915, watercolor on paper mounted on cardboard. © 2011 Artists Rights Society (ARS), New York

Franz Marc's pictures of cows were actually spat upon by indignant gallery visitors. In contrast to the sharp staccato passages of the Brücke, the tempo of the Blue Rider painters before the outbreak of World War I was primarily andante cantabile. Marc's *The First Animals* [Fig. 16] and Kandinsky's *Composition V* [Plate 127] are characteristic examples of canorous rhythms that address an exalted subject matter such as an untouched-by-man world of noble beasts, or of synesthetic, nonobjective (Kandinsky's term) response to the swirling drives and poignant intersections of nature, animals, and human beings.

Another important Blue Rider member was the lanky American-born Lyonel Feininger (1871–1956), who went to Germany as a teenager to study music, but who switched to painting, soon exhibiting, in a work like *Gelmeroda II* [see illustration p. 23], his own original and poetic version of Picasso's analytical cubism. Invited to join the Blue Rider by Marc in 1913, he would later become, along with Kandinsky and Klee, one of the most revered of the master teachers at the Bauhaus.

Both groups of German Expressionists prized pictorial reduction—representation stripped of all nonessentials. This resulted in self-conscious primitivism for the Brücke and instinctive abstraction for the Blue Rider. But just as his friend Schönberg never used the term "atonal" for his pantonal music, so Kandinsky did not use the word "abstract" for his nonobjective art. Marc's initial mastery of and then his deliberate turning away from naturalism in his search for quintessential character typifies the Blue Rider's desire to, in his words, "show the mighty laws that surge behind the beautiful appearance of things," something that the Austrian Expressionists would divine in the work of Klimt. The apparent childlike simplification of the Blue Rider and the Brücke in their shift from what Kandinsky, the inveterate theorist, called the "superfluous to the necessary," from the naturalistic to the archetypal, was the result of intellectual decision and artistic intention, and certainly not of meager talent or inability to draw.

In the decisive decade of 1907–1917, August Macke was the first of the Blue Rider members to be cut down in the flowering of his career [Fig. 17]. He was killed at the front in the second month of the Great War at the age of twenty-seven. Uncharacteristic dark forms and somber premonitions haunt his final painting of 1914, a railway station scene entitled simply *Farewell*. In a eulogy for his friend, Franz Marc declared, "Compared to us he gave color the brightest and purest sound, as clear and bright as his whole being."[4]

The second Blue Rider artist to lose his life at the front, one who had initially perceived the war as a sort of spiritual purification, was Marc himself. He perished at Verdun on the 4th of March, 1916. Paul Klee, who remained in Germany during the war, was spared having to serve at the front. His dismay at the death of colleagues was hinted at in a few rare works, such as *Small Black Door* of 1915 [Fig. 18], in which, amid a color forest of vibrant rectangles, a single black rectangle looms incongruously, sounding a minor chord and disturbing the surrounding major key of colors.

Of the major Brücke artists, Kirchner was the one most affected by the Great War. Assigned

to a field artillery regiment, he soon suffered a nervous breakdown, one abetted by alcoholism and drugs, and entered a sanatorium. In 1915 he painted the gruesome *Self-Portrait as Soldier* in which he portrays himself with his painting hand cut off and reduced to a bloody stump. This did not actually happen to the artist, who ultimately moved to Switzerland outside a village near Davos. But his body of work was indeed cut off when Hitler pronounced it degenerate in 1937. A year later, hearing the Swiss militia at practice and believing it was a German invasion, Kirchner committed suicide.

Yet another suicide in the Expressionist art world occurred in Vienna in 1908. Richard Gerstl (1883–1908, [Fig. 19]) was the son of a wealthy Hungarian Jew, and he had reason to feel—as did his idol Mahler—an intruder in Kaiser Franz Josef's Catholic Vienna. Extremely gifted and fiercely impatient with the artistic status quo, Gerstl dismissed the laborious craftsmanship of Klimt's ornate façades. He developed an agitated, painterly style based on Velázquez, Van Gogh, and the recent Fauve color explosions [Plate 124]. The painter's empathic response to the long, willowy figure takes the shape of a lounging banana-like form placed diagonally against a backdrop of galvanized brushstrokes that charge both the picture plane and the portrait subject with high-voltage energy. Very quickly the emotional smears of Gerstl's oil pigment became themes in themselves, anticipating the abstract expressionism of De Kooning.

Gerstl also set himself on a collision course with what would ultimately trigger the tragedy of his death: a brief affair with the wife of his other musician god, Arnold Schönberg. When Mathilde returned to her husband and children—all of whose life-size portraits Gerstl had recently painted—the artist, isolated from the emotional haven he had found within the composer's family, became unhinged. The pathology of his despair culminated in a double destruction: on November 4, 1908, the twenty-five-year-old artist set fire to all the personal papers and paintings in his studio, then put a rope around his neck, and, in front of the mirror he had used for his self-portraits, plunged a butcher knife into his heart.

Voyeuristic self-portraiture [Fig. 20] was an obsession that dominated Egon Schiele's (1890–1918) portraits and allegories. It abated in urgency only slightly during the few years of marriage and artistic recognition he enjoyed. In 1917 he essayed a new medium, sculpture, and created a three-dimensional bust of himself. The taut facial features and charged hair radiate intensity, energy, and control. Schiele died eleven days before the end of World War I, not on the battlefield, but from influenza at the age of twenty-eight. His wife Edith, six months pregnant with their first child, had succumbed three days earlier in his arms to the same illness—she was the subject of his final, desperate drawings.

Death and sexuality played prominent roles in the artist's short life and were featured aggressively in his prodigious output. As a boy Schiele had witnessed the syphilitic deterioration of his father, who died when he was fourteen. The *Weltwehmut* (world melancholy) with which the young artist invested his anthropomorphic trees, autumnal landscapes, and "dead town" views sprang from a childhood clouded by shameful tragedy. His own sexual curiosity was enor-

19. Richard Gerstl, *Self-Portrait*, ca. 1907, pen and ink on paper

20. Egon Schiele, *Triple Self-Portrait*, 1913, gouache, watercolor, and pencil on paper

mous and, before his full-length, black-framed mirror,[5] he explored himself and others rapaciously, leaving trenchant pictorial accounts of his findings. The grotesque Doppelgängers reflected by Schiele's mirror in some of his self-portraits are more than narcissistic doubles. Often the emotion-racked torsos display lower limbs or arms that appear amputated—a shocking and pictorial displacement for the sin of masturbation. The then-taboo activity (sententiously referred to by Freud, who had difficulty discussing it with his own sons, as the "primal addiction") both attracted and terrified the artist. His thematic narcissism dealt with masturbation, guilt, and self-inflicted symbolic punishment with the same unsparing relentlessness as that applied by Freud in his pursuit of the unconscious. The hypocrisy and repression of Viennese society provoked both the artist and the physician into penetrating beyond the façade to the psyche. Twentieth-century angst, with its twin furies of eros and death, was being laid bare.

It was an acute sense of anxiety that was exhibited by both Gerstl and Schiele, who had caught sight of an existential nil just beneath the surface of the disintegrating façade of turn-of-the-century aestheticism. In spite of its last gay efflorescence, a sense of impending disaster imbued the operetta world of the senescent monarchy. A cult of pathos was born. The psyche under stress, whether from longing or repression, offered a beckoning terrain for Viennese Expressionism. At first glance, Schiele's oil *Portrait of Gerti Schiele* of 1909 appears to have imbibed its vibrant contour line at the fountain of Jugendstil (Art Nouveau), still so prevalent in Vienna's magazines and posters. There is a kinship between the elegant silhouetting of Schiele's dreaming girl and the pensive woman with raised hand supporting head and huge, latest-fashion hat depicted a year later by Klimt [Plate 117], *The Black Feather Hat*. Even the stepped angles of hair on the left of Gerti's head and defining black feather hat and brim seem consonant. Klimt's woman is generic and anonymous, however, whereas Schiele's sister is an identifiable person with a specific biography.

But when we know that biography, the Gerti portrait takes on a different and taboo meaning. The sexual curiosity aroused in the artist by the venereal origin of his father's illness had propelled Schiele to explore not only himself, but his favorite sister. Four years younger than her brother, Gerti was easily persuaded to pose in the nude for him and this led to other secrets. When Schiele was sixteen and his sister twelve, they duplicated the itinerary of their parents' wedding trip and journeyed by train all the way to Trieste, where they stayed overnight in a hotel.[6] By the time he was nineteen and had a studio of his own, Schiele began work on a large portrait (now lost) of Gerti, one in which she would appear completely nude. The watercolor study for the work is a sympathetic yet chilling unmasking of the adolescent psyche as well as body. The artist's unhealthy relationship with his adolescent sister was of temporary duration. His precocious attachment, however, was replicated in dozens of cases that came to the attention of Freud. Not necessarily always aware of Freud, yet often instinctively paralleling him, Schiele chartered a previously neglected sexual terrain of torments and taboos.

As for style, we can see how quickly Schiele moved from the still Klimt-influenced—Art Nouveau in line, decorative in detail, with head and closed eye in elegant profile of the Gerti portrait—to the exposed frontal, frozen, self-clutching, knobby-fingered *Portrait of Dr. Erwin*

von Graff of 1910 [Plate 121]. The ring finger of Graff's right hand is actually bandaged at the tip and, without any prop of chair or unifying background, he is chillingly set in empty existential space.

Intuitively echoing contemporary explorations by the young science of psychology, Expressionist artists, writers, and even composers plumbed their own and collective anxieties and made the soundings public. Thus an awesome parade of troubled psyches began to form. It began with Hugo von Hofmannsthal's vampiric, blood-lusting drama *Electra* of 1903, continued with Robert Musil's 1906 novel of adolescent awakening and group sadism at a military boarding school, *Young Törless* (*Die Verwirrungen des Zöglings Törless*), and reached a zenith with Schönberg's hallucinatory musical monodrama *Expectation* (*Erwartung*) of 1909, articulating the inner thoughts of a woman who frenziedly searches for and discovers the dead body of her unfaithful lover in a forest.

The Austrian Expressionist painters added their own poignant images of psyches under stress to this horrific public display, and assured themselves of the widest possible audience through the poster medium. Both Schiele and Oskar Kokoschka (1886–1980) utilized this multiple art form to broadcast urgent messages of pathos or persecution. In 1909 Kokoschka tossed in the face of the public a grim summer theater advertisement for his bloody play, *Murderer, Hope of Women*, in which, posited between the polarities of moon and sun, a battle of the sexes takes place as a crazed woman tears at a flayed man.

That same year, 1909, he also created a stunning half-length oil portrait of Vienna's quixotic coffeehouse poet, fifty-year-old Peter Altenberg [Plate 123]. Born Richard Engländer in 1859, he opted for the bohemian life and achieved local celebrity for his rhapsodic sketches of nature and everyday scenes in the city. In particular he idolized young girls, collecting hundreds of photographs of pubescent urban *grisettes*, and contributed unabashed aphoristic outpourings to the popular, non-threatening concept of the *Kind-Mädchen* (child-woman) then prevalent in Vienna. Kokoschka's portrait of the walruslike Altenberg of purposeful derelict appearance is arresting: he has caught the poet with hooded prurient eyes wide open under raised eyebrows, blood rushing to his neck, his outspread hands grasping at what eludes him. "Child-girl, I loved you *immensely* and I suffered for you, most loved one,"[7] he scrawled in spidery handwriting on a photograph of the young mistress of his famous architect friend Adolf Loos. Loos was also painted by Kokoschka that year (recognizable from his "malicious gorilla pupils," opined a visitor to his studio[8]).

A strange, spectral intensity emanates from the "nervously disordered" (Kokoschka's phrase) oil, portrait of *Dr. Rudolph Blümner*, of the following year, 1910 [Plate 122]. The sitter was a thirty-seven-year-old lawyer turned actor and he shared poverty and an attic room with the painter during his first stay in Berlin in 1910. The image of Blümner is commanding and compelling. This is due partly to the emphatic gesture of his open right hand, but also because of the simultaneous inward (crossed right eye) and outward stare of his eyes. His hands are streaked with red and blue blood vessels and the tornadic background spins upward.

Blümner would also become the portrait subject for Kokoschka's older colleague in Berlin, the film director and sculptor William Wauer (1866–1962), who in 1917 designed an extraordinary portrait bust of Herwarth Walden [Plate 130]—one every bit as original as his unforgettable illustrations of "Odol" mouthwash fame had become. Walden was the crusading founder of Der Sturm (The Storm) magazine in 1910 and a gallery of the same name soon followed in 1912. Works by Blue Rider members as well as Kokoschka were featured, and the latter's 1910 lithographic image [Fig. 21] and oil portrait of the long-necked radical publisher with the Liszt-length haircut confirm the veracity of Wauer's eel-like, upward-thrusting head of Walden.

By 1912 Kokoschka was back in Vienna and had initiated the love affair with Mahler's widow Alma that held Vienna's scandalized attention for three years. "There has been nothing like it since the Middle Ages, for no couple has ever breathed into each other so passionately," he wrote her decades later.[9] But by the time war broke out, jealousy had torn the lovers apart and Kokoschka eagerly enlisted in the Austro-Hungarian army. On the Ukrane front he was severely wounded in the head by a Russian machine gun and, left for dead, was then bayoneted in the chest, leaving him with a pierced lung. He survived the war but never lived in Vienna again. Over a long career the artist's paintings became milder but never lost the imprint of his personal brand of Expressionism.

Through the medium of their Expressionist portrait presence by Gerstl, Schiele, and Kokoschka, we could view the disparate individuals as in attendance at what might be called Adele Bloch-Bauer's "fantasy salon" in the Neue Galerie. There, a veritable galaxy of Expressionism hails Klimt's mosaic-embedded version of Art Nouveau. The beguiling, finger-wringing hostess Frau Bloch-Bauer—that compressed victim of Klimt's horror vacui—emerges triumphant as both precursor and instigator of Viennese Expressionism.

NOTES

1 Hans Kollwitz, ed., The Diary and Letters of Käthe Kollwitz (Evanstown, Ill: Northwestern University Press, 1988), diary entry for February 1917, p. 77.

2 I have written about Münter and Kandinsky at length in "State of the Field 1980: The Women Artists of German Expressionism," Arts Magazine, New York, Nov. 1980, pp. 147–153.

3 August Macke in his essay "Masks," as translated in The Blue Rider Almanac (London: Thames and Hudson Ltd., London, 1974), p. 85.

4 Ibid., p. 264.

5 Schiele had taken this life-size mirror from his mother's home when he got his first studio, and this constant companion, so vital for his work, was in the artist's last studio at the time of his death. It passed into the ownership of his older sister Melanie Schuster-Schiele, who kindly allowed me to photograph it on my very first visit to her apartment on September 6, 1963.

6 This unusual story was related to me by Schiele's sisters Gerti and Melanie in personal interviews during
 the 1960s;, see my book *Egon Schiele's Portraits* (Berkeley: University of California Press, 1974), p. 192, n. 13.

7 What modern observers would recognize as patent pedophilia was left to gather dust by Freud himself, since
 his interests flowed only one way: in the direction of oedipal ambivalence of children toward their parents.
 The changing perception of woman that obsessed Vienna's writers and painters at this time is discussed at
 length in my chapter "Toys in Freud's Attic: Torment and Taboo in the Child and Adolescent Themes of Vienna's
 Image-Makers," in *Picturing Children: Constructions of Childhood between Rousseau and Freud*, ed. Marilyn R.
 Brown, (Farnham: Ashgate Publishing Ltd., 2002), pp. 167–188.

8 Else Lasker-Schüler, as quoted in Edith Hoffmann, *Kokoschka Life and Work*, (London: Faber and Faber [194]),
 p. 82.

9 Quoted in Alma Mahler Werfel, *And the Bridge Is Love*, (New York, Harcourt, Brace and Co., 1958), p. 304.

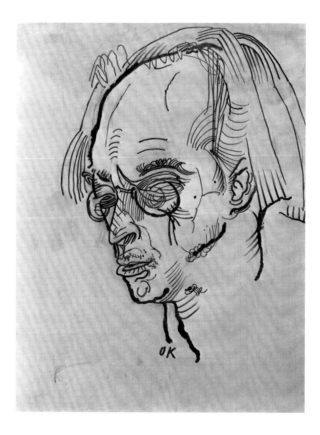

21. Oskar Kokoschka, *Portrait of the Poet Herwarth Walden*, 1910, black ink over graphite on off-white wove paper, printed with a grid. Harvard Art Museums / Fogg Art Museum, Friends of Art, Archaeology, and Music at Harvard Fund, 1949.37. Photo: Imaging Department © President and Fellows of Harvard College. © 2011 Fondation Oskar Kokoschka / Artists Rights Society (ARS), New York / ProLitteris, Zürich

1. Gustav Klimt, *Hope II* (*Vision*) 1907–08, oil, gold, and platinum on canvas. The Museum of Modern Art, New York. Jo Carole and Ronald S. Lauder and Helen Acheson Funds, and Serge Sabarsky

ANN TEMKIN

Modern Art

The Blue Rider, Galerie Thannhauser, Munich, 1911. *The First German Autumn Salon,* Galerie Der Sturm, Berlin, 1913. *Brancusi*, The Brummer Gallery, New York, 1926. *Cubism and Abstract Art*, The Museum of Modern Art, New York, 1936. *Fantastic Art, Dada and Surrealism*, The Museum of Modern Art, New York, 1936. *Living with Pop: A Demonstration for Capital Realism*, Berges furniture store, Düsseldorf, 1963. *Documenta 5*, Kassel, 1972...

The modern works of art now on display at the Neue Galerie made their first appearances in these landmark exhibitions and others of their kind. Such occasions mark turning points in the history of modern art, events at which a small coterie of devotees as well as a number of accidental witnesses encounter radical experiments in artistic practice. Several were artist-organized, such as the 1926 Brancusi show for which Marcel Duchamp served as curator. All of these exhibitions presented theretofore unimaginable work being done by individual artists, or groups of them, and made it impossible for art to return to what it had been previously.

The twentieth-century paintings, sculptures, prints and drawings that Ronald Lauder has collected hold interest for him in part because of their roles in this history. It is a narrative as compelling as any in Western art, and the individual works in the collection attest to its power. Lauder cannot provide the comprehensive chronicle that a textbook would allow, due to the simple fact that he tells the story with original objects rather than reproductions. Nor is mere historical *bona fides* sufficient; superlative quality must accompany it. Lauder's quest, over the course of five decades, has been to assemble a corpus of works that traverse the artistic heights of the twentieth century.

This narrative lens is indebted to that of Alfred H. Barr, Jr., the first director of The Museum of Modern Art. Soon after the museum's founding in 1929, Barr devised an ambitious plan by which the institution would map the art of its own time through a strategic program of exhibitions and acquisitions. He articulated his vision in much-revised diagrams that outlined the development of modern art in the systematic manner of a genealogical or evolutionary chart.

2. Cover of the exhibition catalogue, *Cubism and Abstract Art*, The Museum of Modern Art Archives, New York, 1936, showing Alfred H. Barr, Jr.'s chart of the progression of modernism. Alfred H. Barr, Jr. Papers, The Museum of Modern Art, New York

Unlike the art of other historical eras, the art of the twentieth century presented a cacophony of styles, or 'isms, that Barr strove to organize harmoniously. His work was immensely influential, shaping perceptions for decades to come. The chart reproduced on the dust jacket of the catalogue for *Cubism and Abstract Art* [Fig. 2] in 1936, one eminent art historian later recalled, "took on an authority verging on the Old Testament's."[1]

Lauder points out that The Museum of Modern Art has served as an important model for him both in terms of the works of art that hang on its walls and the acquisitive wiles of its curators. In 1974 he joined the acquisitions committee of the drawings department at the age of thirty, and at thirty-two became the Museum's youngest-ever trustee. Temperamentally historically minded, Lauder sought to acquire not the newest art, but works that were already modern masterpieces. In contrast, the art that was most coveted by other new collectors in the 1960s was contemporary, and overwhelmingly American. By looking at the work of the European avant-garde created a few decades earlier, he had the field much more to himself. His peers—great collectors such as Victor and Sally Ganz, Florene Marx Schoenborn, Louise Reinhardt Smith, the Rockefeller family—were one or two generations his senior.

Like any private collection—and, far more than is generally realized, the holdings of any museum collection—the Lauder collection of modern art developed not in a vacuum but on the basis of opportunity. Most startling is the mere fact that it was possible for works of this extraordinary caliber to become available to a private collector as late as the final third of the twentieth century. The group includes many objects that could be considered signature examples of a given artist's work, but it often provides access to more eccentric sides of a career. In some cases this is a result of happenstance, while in others it attests to Lauder's eye for not-obvious beauty, and his happy obliviousness to pedagogical duty. Thus for MoMA's *Girl before a Mirror* of 1932, for example, Lauder's *Bather with Beach Ball* [Plate 108] of the same year.

Lauder also has ventured into territory that Barr had not covered earlier. Figuring most prominently in this way, of course, is the modern art of Germany and Austria. Just a few years short of its fiftieth anniversary in 1979, the museum did not yet own paintings by the Austrian artists Gustav Klimt or Egon Schiele, although Barr had collected the work of portraitist Oskar Kokoschka. With Lauder's help curator William Rubin acquired for the museum Klimt's *Hope II* (*Vision*), 1907–08 [Fig. 1], in 1978 and Schiele's *Portrait of Gerti Schiele*, 1909, in 1982. His deep commitment to this field now has made the narrative at the Neue Galerie a necessary complement to the story told on West 53rd Street.

Lauder's approach echoes Barr's initial choice of Post-Impressionism as the starting point for the history of modern art as the new museum would tell it. In part this was a pragmatic decision on Barr's part (Impressionism was already being collected by established museums in the 1920s), but it also reflected a wide consensus of opinion among modern artists that attributed to Cézanne a uniquely generative role. Matisse famously insisted that "Cézanne is the father of us all," one of many similar proclamations by other artists.[2] No fewer than three

paintings in the Lauder collection acknowledge this distinction. Cézanne's *Still-Life with Drapery and Fruit*, 1904–06 [Fig. 3], concentrates upon a vertiginous cascade of fabric, anticipating Matisse's own interest in the compositional potential of patterned textiles. The entire scene of such a painting, as the British art critic David Sylvester noted, is constructed more like a landscape than a tabletop arrangement. The curtain's floral pattern provides the atmosphere of a dense forest. When Cézanne elaborated the topography of the curtain and nestled the bowl amidst its folds, he was inventing a place, while nonetheless proving the painter's loyalty to an observed subject. But the space is unstable, rejecting academic conventions of perspective. Were one looking at the painting with nineteenth-century eyes, the fruits in the shallow bowl would seem to be sliding down the front of the canvas—one would be tempted to reach out to push the dish back up on its tabletop. The painting suggests, on the one hand, monumentality and grandeur, and, on the other, precariousness and contingency. All are held in equilibrium on the canvas, with what Cézanne's admirers praised as a truth to his painting rather than to any external reality or standards of representation.

Cézanne's patriarchy is decisively present in the art movements soon to follow: Fauvism, Cubism, and abstraction in all its forms. For all of these artists in successive generations, what mattered as much as Cézanne's pictorial approach per se was what they viewed as his matchless originality. Any single painting by Cézanne takes care explicitly to reveal a painter at work in his job of painting, due in part to the areas or aspects of the picture that seem

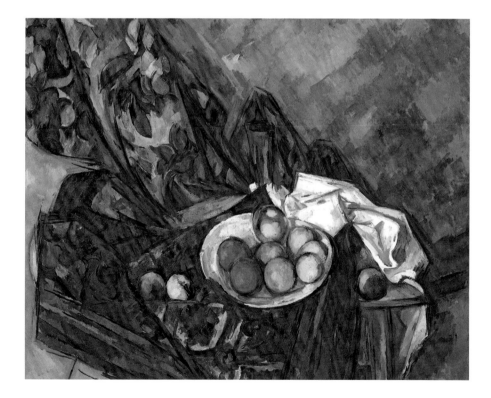

3. Paul Cézanne, *Still-Life with Drapery and Fruit*, 1904–06, oil on canvas

unfinished. His heirs ascribed to Cézanne not just a need to invent a style or a manner, but a yearning for the very reinvention of the task of painting. This same impulse released a rapid-fire succession of avant-gardes within the span of half a century, each declaring newness all over again.

Kandinsky's *Composition V*, 1911 [Plate 128] is one of the great landmarks of this era. It is one of seven Compositions that Kandinsky produced between the years of 1910 and 1913; only four survive today, as three were lost or destroyed during World War II.[3] This particular painting carries the distinction of having been responsible for the public debut of the The Blue Rider in Munich. Kandinsky had submitted *Composition V* to a juried exhibition of the Neue Künstler-Vereinigung München, an artists' group he had co-founded; when it was not accepted, he, Gabriele Münter, Franz Marc, and Alfred Kubin quit and organized the first Blue Rider exhibition, held at the Galerie Thannhauser in rooms adjacent to those displaying the NKV works. It was a time of famous rejections: the following year the Salon des Indépendants in Paris refused Duchamp's *Nude Descending a Staircase*.

The source of the Munich jurors' displeasure was surely the illegibility of *Composition V*. Although Kandinsky later identified its theme as the biblical scene of the Resurrection, this would have been no more apparent to its viewers in 1911 than today. Vestiges of descriptive details such as trumpeting angels are small elements within a monumental six-by-nine-foot canvas of sweeping black lines that travel through and atop explosive passages of color. The forceful impact of the generally somber tones is essential to Kandinsky's ideal of "pure painting."

4. Piet Mondrian (*Gemalde No. 1*)/
Composition No. XII, 1913,
oil on canvas. © 2011 Mondrian/
Holtzman Trust c/o HCR
International Washington, D.C.

"Symphonic" is a word that comes to mind when looking at this picture. Not coincidentally, Kandinsky's model for pure painting was music, an art in which sounds that have no mimetic function manage to transport the listener to another realm. Like symphonies, the Compositions were titled by number, and rehearsed over a long period of time with many sketches and studies; these stood in contrast to the more spontaneous forms of painting he termed Improvisations and Impressions. In all, color would replace musical tone as the carrier of expression—color in a pure form that was freed from descriptive obligations, freed to release what Kandinsky called a painting's inner sound.

A universalizing ambition similar to that of Kandinsky underlies the art of Piet Mondrian, although ultimately realized by the latter via a stark reduction rather than indulgence of color. Like the Russian-born Kandinsky and most of the key artists of this period, Mondrian was an émigré: he left his native Holland for Paris in 1912, when he was 40. There he became friends and neighbors with the Cubist artists who inspired him to set aside the naturalistic standards that governed his earlier work and instead create an independent visual language.

Composition XII, 1913 [Fig. 4], was made at a point when, like Kandinsky, Mondrian abandoned descriptive titles, though he did not ascribe to the word "composition" the same programmatic meaning as his Russian contemporary. As we know from pencil sketches, this

painting and others of its sort take as their point of departure the façades of Montparnasse, where Mondrian lived in a new building at 26, rue du Départ. The painting's cool palette stems from the Analytic Cubism of Picasso and Braque, but its degree of abstraction exceeds that of their paintings, which always preserve clues to the empirical subject of the painting.

Indeed, by the time Mondrian painted *Composition XII*, Picasso and Braque had begun to make collages that imported pieces of reality such as wallpaper or newsprint, not wishing to extend the path of Cubism into abstraction. Mondrian, like Kandinsky, was indifferent to the quotidian Cubist world. Although *Composition XII* is in fact an urban scene, its delicacy and ethereality utterly belie its roots. Rather than a view of a particular modern neighborhood, it feels like an excerpt of a universal order, as its scaffolding of horizontal, vertical, and occasionally arching lines continue to all four edges, though fading to foggy softness at the perimeter and especially at the foot of the composition.

Lauder's second painting by Mondrian hails from nearly thirty years later, made at another key point of transition in his work. *Composition X*, 1939-42 [Fig. 5], was painted in London in 1939 (the artist had fled the coming war in Paris a year earlier) and he had considered it finished at that time. But Mondrian emigrated to New York in 1940, and in preparation for an exhibition at the Valentine Gallery in January 1942, he modified the painting in a way that reflects the jazzy turn his art had taken during his stimulating months in Manhattan. Although we have no record of the painting's appearance in 1939, we can infer from documented changes in some of the other paintings that Mondrian reworked and double-dated that he would have added more lines and blocks of color. For the first time, Mondrian might place these blocks in the white field rather than necessarily bordering them by a black line or the canvas's edge. While it may seem a minor distinction, these open color blocks add a palpable sense of free play to the artist's compositions.

5. Piet Mondrian, *Composition X*, 1939-42, oil on canvas. © 2011 Mondrian/Holtzman Trust c/o HCR International Washington, D.C.

As was true for the 1913 *Composition XII*, a new urban environment dictated the path of Mondrian's painting. The purity of his abstraction was not indifferent to circumstance, and the seemingly steady trajectory of Mondrian's entire body of work does not refute the fact that it developed over a period bracketed by two World Wars. *Composition X* is a moving testimony to a life that was marked by a series of involuntary dislocations. Change itself is encompassed by compositions in which the relativity of every block of color and length of line is at the service of absolute painting.

Mondrian's closest parallel in the field of sculpture is Constantin Brancusi. Although Mondrian worked from a fundamental basis in landscape painting, and Brancusi in figural sculpture, their motivations were closely allied. In sculpture as well as painting, the rejection of naturalism as a measure of an artist's skill challenged the individual artist to set criteria of his or her own. Brancusi's apprenticeship with Auguste Rodin soon after he arrived in Paris from Romania provided the model against which he could react: a vision of sculpture that adopted the classical ideal of a naturalism that could almost bring a statue to life, Pygmalion-style. Internalizing a variety of sources such as the art of his native Romania, ancient art of the Mediterranean

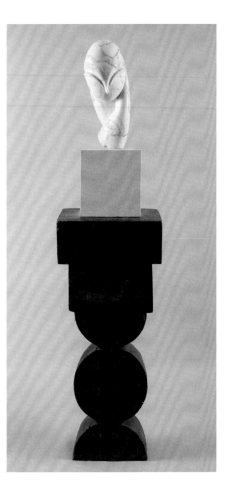

6. Constantin Brancusi, *Mademoiselle Pogany II*, 1919, veined marble on limestone and wood bases. © 2011 Artists Rights Society (ARS), New York / ADAGP, Paris

7. Constantin Brancusi, *Mademoiselle Pogany II*, undated photograph taken by Constantin Brancusi. Musée national d'art moderne, Centre George Pompidou, Paris. © 2011 Artists Rights Society (ARS), New York / ADAGP, Paris

and Africa, and the work of painter friends, Brancusi envisaged sculpture that conveyed a subject's inner essence rather than superficial accuracy.

Brancusi's sculptures thrive in the plural. The rhymes and oppositions that characterize the element of any one piece are extended across a group of them. Brancusi devoted immense effort to arranging his sculptures in a variety of groupings. Much as he would position a wood base with a limestone cylinder with a marble "head," he would rehearse combinatory groupings that linked diverse sculptures both thematically and formally. This interplay is amply visible in Lauder's group of ten magnificent works by Brancusi, at present the largest such assembled in private hands.

Mademoiselle Pogany II [Fig. 6] dates from 1919, when Brancusi had already been at work for a decade on his abstracting of human form in progressively more daring ways. Whereas a young acquaintance had posed for the first *Mademoiselle Pogany*, made in 1912, this work was made only with that first sculpture as its reference. By this point Brancusi has journeyed much farther in challenging the equation between a model and a sculpture. Rather than pure white marble, Brancusi chose a dramatically veined stone, emphasized in his high-contrast black and white photographs of the work [Fig. 7]. The two hands are merged into one, the eyes and nose have been stylized into two sweeping arcs that meet in the center, and the mouth is altogether gone. Most dramatically, the chignon at the back of the head merges with the neck and shoulders into a proto-Art Deco scalloped abstraction.

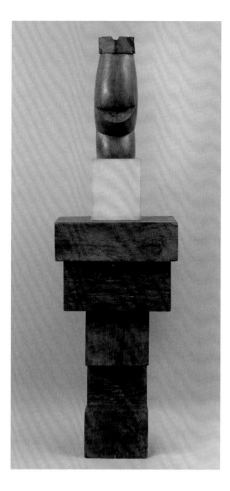

8. Constantin Brancusi, *The Chief*, 1925, wood and iron on limestone and wood bases © 2011 Artists Rights Society (ARS), New York / ADAGP, Paris

The Chief, 1925 [Fig. 8], presents an altogether different side of Brancusi's enterprise, and a more unusual one. Primarily a creation in wood, it is as close to amusing as sculpture tends to get, with a broad grin that reminded an early critic of a Halloween jack-o' lantern. Together with its title, the sculpture suggests a jovial and benign potentate, a character at far remove from Brancusi's regular cast of elegant women and sleek birds. And while its smoothly carved volumes and polished surfaces relate closely to those of his sculptures in marble and bronze, the work's whimsical spirit is underscored by the thin iron crown, no more imposing than something a child might have made out of newspaper.

The Chief sits atop a limestone cube on a base composed of three oak sections. As is also evident in the base supporting *Mademoiselle Pogany II*, Brancusi's bases are integral parts of the work, an innovation fundamental to modern sculpture to be made in the following decades. The strategy was as much philosophical as physical. For centuries a pedestal declared a boundary between the fictional world of art and the reality of the viewer's environment. Brancusi's wooden bases reject that task and instead play a far more active role. Their colors, materials, and shapes—all dramatic contrasts to the smooth forms above—engage in strong dialogue with what they support, as well as with the surrounding space. Although Brancusi often referred to the simplicity of his work, it is more accurately and wholly understood as a complex reconciliation of opposites: a totalizing view of the world that deliberately integrated modern and primitive, culture and nature, object and space.

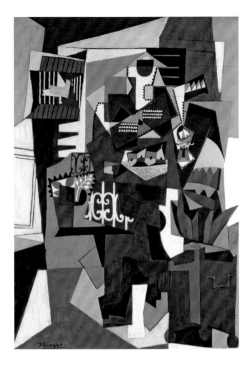

9. Pablo Picasso, *The Birdcage*, 1923, oil on canvas. © 2011 Estate of Pablo Picasso / Artists Rights Society (ARS), New York

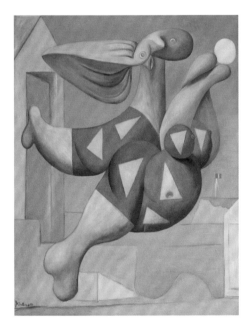

10. Pablo Picasso, *Bather with Beach Ball*, 1932, oil on canvas. The Museum of Modern Art, New York. Partial gift of an anonymous donor and promised gift of Jo Carole and Ronald S. Lauder. © 2011 Estate of Pablo Picasso / Artists Rights Society (ARS), New York

The modes of originality developed by Kandinsky, Mondrian, and Brancusi share an aspiration toward a pure or absolute painting and sculpture. As chimerical as such a goal might be, and as much as the actual construction of their works of art in fact denies the purity or absoluteness of these works, this goal nevertheless guided their hands. Nothing could be further from the interests of Picasso. Stylistic self-contradiction not merely from decade to decade but from one hour to the next makes impossible any notion of art that harbors an essential truth. The astounding variety of the twenty drawings in Lauder's collection reveals an artist ricocheting among visual languages in a manner that openly contrasts with his peers' slow and systematic elaboration of their styles. Whereas nobody could produce a Mondrian, Kandinsky, or Brancusi but themselves, all three artists sought a depersonalized universal that transcended reality. But Picasso was always specific to himself; his desires and circumstances were universe enough.

Lauder's two paintings by Picasso, *The Birdcage*, 1923 [Fig. 9], and *Bather with Beach Ball*, 1932 [Fig. 10], date from the middle of his career. *The Birdcage* hails from the moment in the early 1920s when the artist was simultaneously pursuing styles based on a timeless neo-classicism and, as in this painting, on his own Synthetic Cubism of a decade before. *The Birdcage*, like the famous *Three Musicians*, 1921 [Fig. 11], translates the flat planes of papier collé into paint as it raises them to monumental scale. The picture's domestic interior is a composed of overlapping colored shapes mapping an open window, wainscoted walls, a tabletop still life with a stringed instrument and bowl of fruit, and in the upper left, the element that gives the painting its title. Motifs such as the sawtooth contours and the balustrade's curlicues enliven the rhythm as they provide a unifying sense of pattern to the panoply of forms.

Bather with Beach Ball at first seems much simpler an image: a girl leaping in the air to catch a small white ball, in a comical transformation of a balletic arabesque. Her femininity is emphatic: Picasso brings to frontal view 360 degrees worth of female curves and private parts, not forgetting to leave a puff of pubic hair on one of the swimsuit's yellow triangles. The girl's wing-like hairstyle merges into a head that contorts as needed to provide a field for its surprised-looking eyes, nose, and mouth/vagina. Complete with playful purple-and-yellow surface, the round bather is far more of a beach ball than the flat circle she catches. The significant toy, one is made to see, belongs not to the model but to the artist.

Picasso painted the bather's head and body the grayish non-color of plaster. In fact the painting is closely informed by the sculptures Picasso was making at his chateau in Boisgeloup that year, bulbous concoctions in which undifferentiated heads, arms, and legs intertwine. The inspiration for these heads and bodies, and the *Bather*, is Marie-Thérèse Walter, also the model for the plaster bas-relief *Head of a Woman* [Plate 107], made one year earlier. The bas-relief, while a naturalistic portrayal, shares the solid fullness of the abstract works. Here the woman is cast in a heroic light, her straight neck and eyes steadily gazing outward almost as if she were the figure on the prow of a seagoing ship.

The remarkable erotic force of Picasso's work of the early 1930s has sources in his personal

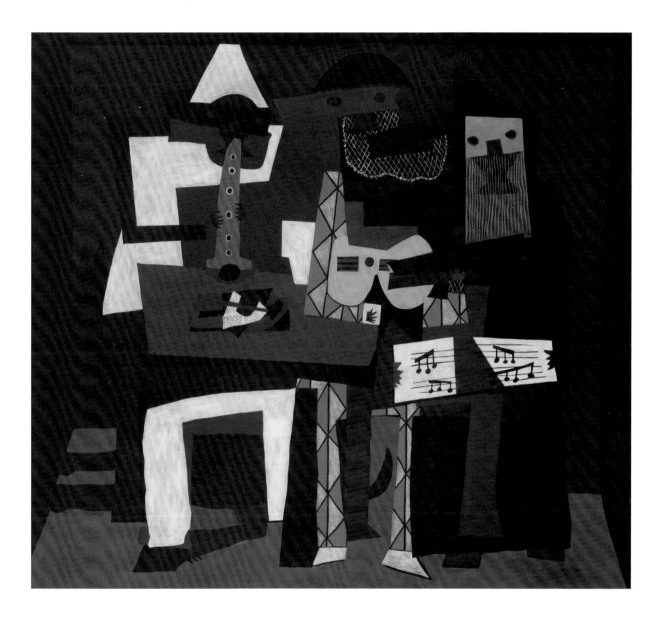

11. Pablo Picasso, *Three Musicians*,
1921, oil on canvas. The Museum
of Modern Art, New York.
Mrs. Simon Guggenheim Fund.
© 2011 Estate of Pablo Picasso
/ Artists Rights Society (ARS),
New York

12. Top: Alberto Giacometti, *Disagreeable Object*, 1931, carved wood. Promised gift to The Museum of Modern Art, New York, in honor of Kirk Varnedoe. © 2011 Succession Giacometti / Artists Rights Society (ARS), New York / ADAGP, Paris

13. Bottom: Man Ray, *Woman Holding the Disagreeable Object*, 1931, gelatin silver print. Musée national d'art moderne, Centre George Pompidou, Paris

life, but was also part of the zeitgeist. That moment was Surrealist, in particular, the Surrealism of around 1930, in which the dangerous play of Eros and Thanatos replaced the more benign Surrealism of the mid-1920s. Alberto Giacometti's *Disagreeable Object* of 1931 [Fig. 10] epitomizes this intensely charged climate. The motif is unidentified but unambiguously phallic. The object presents itself as simultaneously menacing and alluring. Whereas its pointed end produces five sharp spikes, its rounded end has two circular indentations on one side, and a set of long ovoid grooves on the other, all of which invite touch.

With no base or backing, the nineteen-inch-long object is left to balance unanchored on whatever surface it is given. Preferably, *Disagreeable Object* is to be picked up and handled; its raison d'être is interaction. Giacometti indicated this when he drew it as one of six "mobile and mute objects" for the journal *Le Surréalisme au service de la révolution*, and outlined a hand touching the object's spiked tip.[4] The point was dramatized in Man Ray's photograph of 1933 [Fig. 13], in which a sultry model gazes intently at the object as she cradles it close to her bared chest.

Like all of Giacometti's work at this time, the sculpture concisely links sex and danger, the innocent and the forbidden. As is true for the African or Oceanic objects that may have inspired its form, *Disagreeable Object* is indifferent to the category of art. In fact this wooden version was made by a professional cabinetmaker, hired by Giacometti to replicate his original plaster. The *Object*'s value is closer to that of an instrument, important less for its aesthetic qualities than for its function as a tool to liberate psychic drives.

Disagreeable Object is a haunting presence, full of foreboding. Although this was not its intent, it speaks vividly to the moment that was approaching, one that abruptly ended the efflorescence of the European avant-gardes. When *Disagreeable Object* was made, the Nazis were shuttering the Dessau Bauhaus, and by the close of the decade the circumstances of

all vanguard artists in Europe had changed. Whether the impetus was political or personal, for most artists the 1930s interrupted or redirected the trajectory their art had been following. Giacometti himself stopped making sculpture in 1935, and spent a full decade working his way to an entirely new approach. Picasso temporarily ceased painting that year, but his small ink drawing *Taureau et Chevaux* of 1936 [Plate 204] evokes the turbulence of a time at which worldwide catastrophe was imminent.

Henri Matisse, safely ensconced in Nice, was the artist whose work may have seemed most untouched by the historical climate. Between 1937 and 1939, working for the Ballets Russes de Monte Carlo, he designed the set, curtain, and costumes for *Rouge et Noir*, a ballet by Léonide Massine set to Shostakovich's First Symphony. Studies for the project [Plate 210] take up the technique of cut paper Matisse had first used for the *Dance* mural at the Barnes Foundation in Pennsylvania several years earlier; they look forward to the large-scale cut-outs of a decade later. But here we find a striking austerity, and even sobriety, in Matisse's designs. The curtain presents the black character—the force of evil—in an ambitious leap, while the poetic hero in white falls helplessly to the ground.

The Lauder collection's history of the avant-garde resumes—in France—a long decade later. The young American artist Ellsworth Kelly, who had gone to France with a World War II camouflage battalion, returned there in 1948 to continue his art education. Unlike the artists in postwar New York, who were determined to forge an entirely new style, Kelly nurtured a desire to extend the legacy of European modernism into the second half of the twentieth century. *Meschers*, 1951 [Fig. 14], is named for the place in which it was made, a southwestern village on the Gironde River, near the Atlantic coast. Like all of Kelly's work at this time, it has a basis in observed reality: here, the blue of sky and water seen through green foliage together produce a lyrical atmospheric flickering.

14. Ellsworth Kelly, *Meschers*, 1951, oil on canvas. © Ellsworth Kelly

Kelly's judicious employment of chance effects governed the creation of *Meschers*. While the painting's colors and patterns bring to mind the example of Matisse (whose chapel at Vence would be completed soon after), the method of its making owed more to Jean Arp, an artist Kelly visited in Paris and from whom he received meaningful encouragement. Like the black-and-white *Cité* of 1951, the first painting in the series to which it belongs, *Meschers* was based on a two-color striped painting on paper. Kelly then cut that painting into twenty-five squares, disrupting the continuity of his blue and green stripes, and redeployed them in a new layout. He translated the new composition into oil on canvas, covering a surface of twenty-five square feet.

Cité was based on a dream in which Kelly saw the students to whom he taught art in a Paris school all standing on a scaffolding, painting large bands of color. When it was originally shown in Paris in the autumn of 1951, *Cité* was entitled *Le Rêve I* and *Meschers*, *Le Rêve IV: Meschers*.[5] Kelly later abandoned the direct allusion to the paintings' source, perhaps finding it too self-referential or romantic. Three years later he would return to New York City, and embark on a career firmly based on the foundations established in France. The

15. Joseph Beuys, *The End of 100 Days of Documenta*, 1972, wood board, felt marker, red paint, plastic wrap, cardboard, and battery. © 2011 Artists Rights Society (ARS), New York / VG Bild-Kunst, Bonn

Lauder collection includes eighteen works Kelly made during the course of the next five decades, in a career that continues apace as the artist approaches ninety years of age.

Lauder's deepest commitment to the artistic history of the last fifty years has focused on art made in Germany. It was in Germany that the most drastic assault on the avant-garde occurred in the 1930s, and most of the modern artists whom Hitler labeled degenerate fled the country. The extraordinary progression of figures such as Kandinsky, Paul Klee, Max Beckmann, Max Ernst, Kurt Schwitters, and many others came to an abrupt halt, replaced by Nazi-sanctioned realist painters and sculptors. How was Germany to become a country of modern artists again? It is a question that this collection answers with breadth and acuity.

For a decade after the war, artists in the economically and spiritually ravaged country turned to international-style abstraction that strictly avoided any sign of Germanness. Their efforts were for the most part uninspired. But by the start of the 1960s, the situation began to change, most notably and notoriously with the work of the Düsseldorf artist Joseph Beuys. Beuys asserted that the rebirth of art in Germany needed to be a German art, recognizing

as inherent the tragedy of its recent past. Although not stated as such, Beuys's art paralleled the *Trauerarbeit* (mourning work) being done by German novelists in the 1960s.

A protean creator of sculptures, installations, drawings, prints, and multiples, Beuys often insisted that his greatest work of art was his teaching. This encompassed his role as a professor of monumental sculpture at the Düsseldorf Art Academy (from 1963–72) but also as a political activist and a creator of legendary performances, or "actions." The wall-mounted assemblage *The End of 100 Days at Documenta*, 1972 [Fig. 15], much like Beuys's free-standing vitrine sculptures, serves as the permanent record of one of Beuys's actions. It memorializes the daily activity of the office of the Organization for Direct Democracy during the course of the hundred-day-long exhibition Documenta 5 in Kassel, Germany.[6]

The ODD, which Beuys co-founded, advocated "politics structured from below to above," a non-party system that would operate through citizen initiatives. Beuys spent the time in Kassel engaging visitors in wide-ranging discussions about educational systems, environmental practices, and political initiatives. The leftover materials gathered in *The End of 100 Days at Documenta* prominently include a battery, one of the key symbols within Beuys's theory of sculpture. The work also features a crumpled multiple of 1971 entitled *How the Dictatorship of the Parties Can Be Overcome*, a plastic shopping bag that Beuys and his co-workers distributed to passersby at Documenta. The side of the bag visible here replicates a handwritten text by Beuys, while the reverse depicts a printed chart outlining the process for citizen referenda [Fig. 16]. The bag contained a poster and information sheets, as well as a membership form for the Organization for Direct Democracy, signed and stamped by Beuys.

Beuys galvanized the atmosphere of the Düsseldorf Art Academy. His example inspired even those pupils who did not study directly with him, and spawned a new generation of German artists who quickly gained worldwide stature. Many of them became painters, a choice that Beuys never would quite understand given his political goals for art. During the last quarter of the twentieth century, having survived the annihilation of its modernist legacy, Germany became, with the United States, the most important center for the visual arts. Lauder's interest in this material grew especially during the late 1980s, the years he resided in Vienna as U.S. Ambassador to Austria. His collection includes the work of key figures ranging from Georg Baselitz to Martin Kippenberger.

The two artists in this group who have had the greatest impact on the late modern redefinition of the task of painting are Gerhard Richter and Sigmar Polke, both émigrés from East Germany who studied painting at the Düsseldorf Art Academy during the early 1960s. At once challenged by Beuys to return German art to the forefront of innovation, and inspired by recent developments in New York, each took on the task of recalibrating painting for its time. Their work of the 1960s, when Richter and Polke were simultaneously friends and rivals, derived in large part from interrogating the relationship between painting and photography. In many ways, they were taking up a key question posed since the turn of the century: what was the job of painting now that the photograph was able to record the appearance of people and places?

16. Joseph Beuys, *How the Dictatorship of the Parties Can Be Overcome*, 1971, multiple of plastic shopping bag containing printed sheets, some with rubber stamp additions, and felt object. The Museum of Modern Art, New York. © 2011 Artists Rights Society (ARS), New York / VG Bild-Kunst, Bonn

17. Gerhard Richter, *Stag*, 1963, oil on canvas

While much of the twentieth-century avant-garde found its answer in abstraction, the confrontation of issues of representation would prove to be as fruitful a response for painting as avoidance. The head-on collision of photography and painting witnessed in the very different work of Polke and Richter offers a prime case study. Richter's *Stag*, 1963 [Fig. 17], is based on a snapshot of a stag in a forest, taken by the artist as a child.[7] The stag was a longtime symbol of the German nation, and therefore taboo in the postwar years. (Consequently, it was one of the animals that Beuys adopted as an alter-ego, in an effort to air rather than silence questions of national legacy.) Similarly taboo was the depiction of something as banal as a stag in a forest as a subject of high art; by 1960 such a subject read as pure kitsch, fodder for bad paintings found above the sofas in middle-class homes. Postwar painting had avoided the specifically German legacy of nineteenth-century Romantic artists such as Caspar David Friedrich. Richter sought a way to draw upon that heritage while both acknowledging the intercession of the photograph and renewing the power of painting qua painting. There is a strange disjunction between the blurry technique that invokes the young Richter's photograph of the stag, and the linear silhouetting of the dense tendrils surrounding it in the forest. A discomfiting hybrid, the painting asks whether an invalid subject and an invalid medium together can be recuperated.

The initial presentation of the painting intensified these issues, as it was installed in a model living room—indeed, above a sofa—in the Berges furniture store in downtown Düsseldorf. Richter and his fellow student Konrad Lueg (later to become the eminent art dealer Konrad

Fischer) rented the entire store for a night, installed paintings of their own (and sculptures by Beuys) within the model room settings filling the store, and staged neo-Dada events for onlookers. The event was mystifyingly entitled "Living with Pop: A Demonstration for Capital Realism." Where does art belong and who is it for? American artists such as Andy Warhol and Roy Lichtenstein were asking the same sort of questions, without the tragic history of Romanticism inscribing itself so plainly on the paintings.

Polke's painting *Japanese Dancers*, 1966 [Fig. 18], speaks directly to those of his American peers in its allusion to the process of photomechanical reproduction. It belongs to the body of work by Polke known as Raster paintings, referring to the enlarged spots that signal the presence of a printing screen. As is generally the case with Polke's work, the newspaper or magazine source of the image is unknown. It stands in dramatic contrast to the clarity and quick comprehensibility of the mass media sources chosen by the Americans, selected instead for its ambiguity. A vaguely unsavory exoticism replaces the wholesome eroticism of a pop icon or comic strip blonde. In elaborate costumes and headdresses, the two dancers parade across a stage in an indeterminate location. Obviously meant to attract and hold the hungry eyes of a male audience, they remain inaccessible on the elevated stage. Similarly, Polke's painting commands attention as it refuses one's normal desire to see it: no matter what a viewer does, the interference of the hand-painted Raster mesh keeps it stubbornly out of focus. It is as if the fishnet stockings that might plausi-

18. Sigmar Polke, *Japanese Dancers*, 1966, Dispersion on canvas. © 2011 The Estate of Sigmar Polke / ARS, New York / VG Bild-Kunst, Bonn

bly cover the dancers' legs have migrated to the rest of their bodies and beyond, growing to engulf the whole of the painting. No amount of looking will liberate the image from its blurry field, just as no amount of cleansing can purify a contaminated history, whether political or artistic.

The work of most American contemporary artists has kept at far remove the trauma of modern history. A decade younger than most of the Pop artists, Brice Marden gravitated back to abstraction, believing its potential to be not yet exhausted. Like Polke, Marden was born a few years before Ronald Lauder, a member of his generation. Though their biographies differ in almost every respect, the collector and the painter share a profound regard for the tradition of modernism. Marden is reverential toward Cézanne and a keen observer of his paintings, as well as an ardent student of the modern painting that followed. *Study for "The Muses" (Hydra Version)* 1991-95/97 [Fig. 19], embeds references to the painting of Jackson Pollock and late de Kooning, at the same time as it draws from the Chinese calligraphy about which Marden had become passionate and knowledgeable during the previous decade. And as the title implies, there is also a nod to Classical antiquity: one does not need to stretch the imagination far to read in these large-scale dancing lines the delicately outlined female figures on a Greek vase. As is true for the work of Cézanne and Matisse, the painting's surface reveals the time and the indecision that went into it. One sees beneath the skeins of vividly painted lines the ghosts of rejected pathways below. Rather than mistakes, they are vital elements of the finished work.

Marden titled the painting "study" although *The Muses*, begun at the same time, was finished in 1993. In so doing he adopted a particularly Cézannian stance, rendering every painting part of a perpetual striving, and devaluing the distinction between preparatory and final, and even finished and unfinished. The protracted date reveals the stop-and-go aspect of the painting, echoing the ongoing preoccupation evident in the late paintings of Cézanne, which the artist left undated.

Marden admired in Jackson Pollock "his conviction that each work is part of a continuing quest."[8] The same characterization could be applied to Ronald Lauder; in this sense he is a quintessential modernist, extending the still-resonant Romantic tradition. In his work as a collector, he has nobody to please but himself (which he contrasts, with satisfaction, to the myriad obligations and opinions at an institution such as MoMA), and no requirement for fairness or objectivity. Lauder's achievement is the sum of the hundreds of objects fortunate enough to ignite his curiosity and then to pass the collection's entrance examination. It is administered by a stern if compassionate judge with an unnerving eye, weighing nothing as much as his own instinctive response to the work in question.

NOTES

1 Robert Rosenblum, 1986, quoted in *Art in Our Time: A Chronicle of The Museum of Modern Art* (New York, 2004), p. 45. Although in recent decades these charts have been the subject of much debate and critique, they remain a central reference point.

2 Alfred H. Barr, Jr., *Matisse: His Art and His Public* (New York: The Museum of Modern Art, 1951), p. 87.

3 *Compositions I, II*, and *III*, all 1910, were destroyed in World War II. *Composition IV*, 1911, is in the Kunstsammlung Nordrhein-Westfalen, Düsseldorf. *Composition VI*, 1913, is in the State Hermitage Museum, St. Petersburg and *Composition VII*, 1913, is in the State Tretyakov Gallery, Moscow.

4 *Le Surréalisme au service de la révolution*, no. 3, December 1931. p. 19.

5 Nathalie Baudet, "Chronology" in Yve-Alain Bois, Jack Cowart, Alfred Pacquement, *Ellsworth Kelly, The Early Years in France, 1948–1954* (Washington, D.C.: National Gallery of Art, 1992), p. 191.

6 Documenta, a series of summer exhibitions held every five years in Kassel, was established in 1955 in an effort to restore Germany's central role in international contemporary art. Harald Szeemann, Jean-Christophe Ammann, and Arnold Bode organized the 1972 exhibition, subtitled "100 Days of Inquiry into Reality – Today's Imagery."

7 The photograph is included in Richter's *Atlas*, an ongoing archive of source material that he has maintained since the beginning of his career. See Helmut Friedel, ed., *Gerhard Richter: Atlas* (New York: D.A.P., 2006), p. [11].

8 Brenda Richardson, *Brice Marden Cold Mountain* (Houston: Houston Fine Art Press, 1991), p. 41.

19. Brice Marden, *Muses* (*Hydra Version*), 1991–94 / 97, oil on linen. © 2011 Brice Marden / Artists Rights Society (ARS), New York

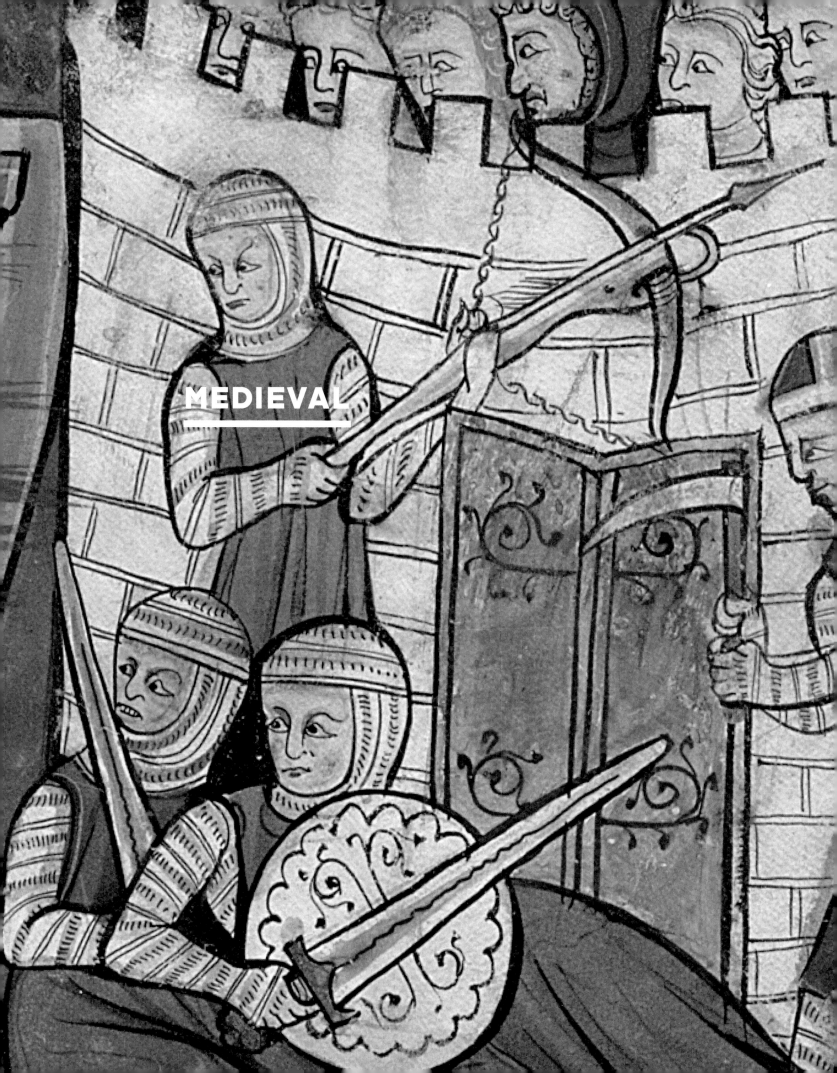

MEDIEVAL

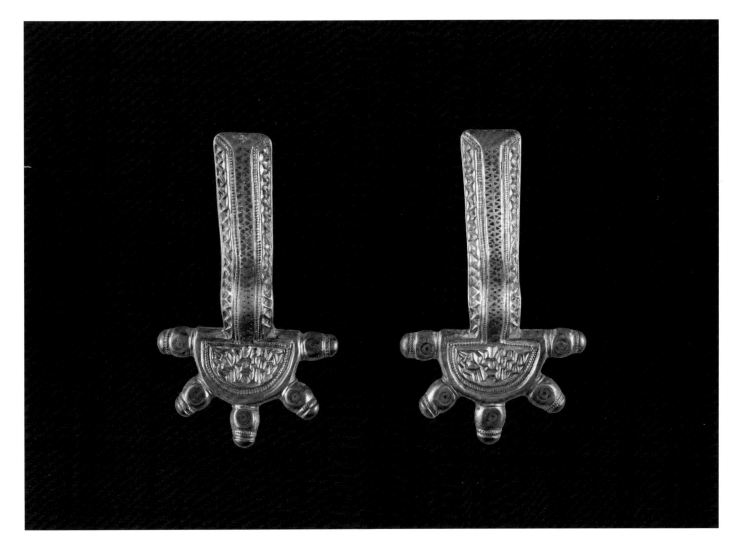

1. PAIR OF BOW BROOCHES OR FIBULAE, FRANKISH, SIXTH CENTURY

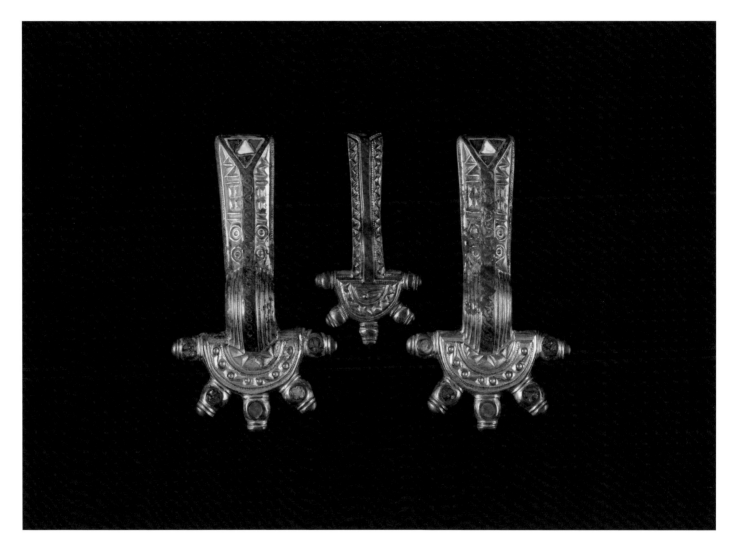

2. THREE BOW BROOCHES OR FIBULAE, MEROVINGIAN, SIXTH CENTURY

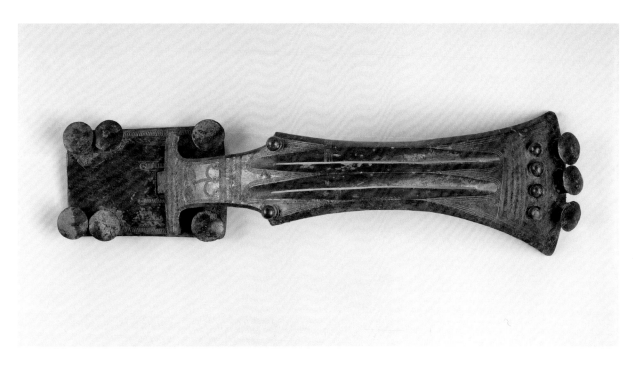

3. MILITARY GIRDLE CLASP OR BUCKLE WITH ARCHED BACK, CELTIC, THIRD CENTURY BC

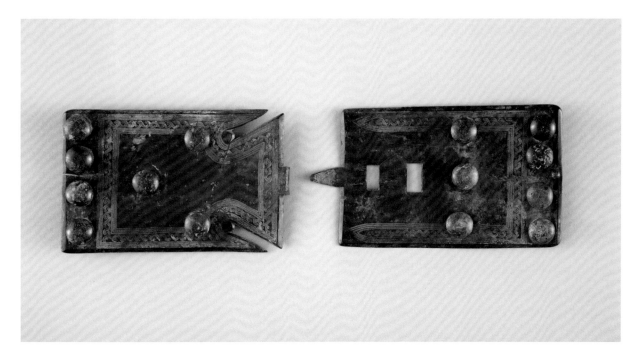

4. MILITARY GIRDLE CLASP OR BUCKLE WITH OVERLAPPING PLATES, CELTIC, THIRD CENTURY BC

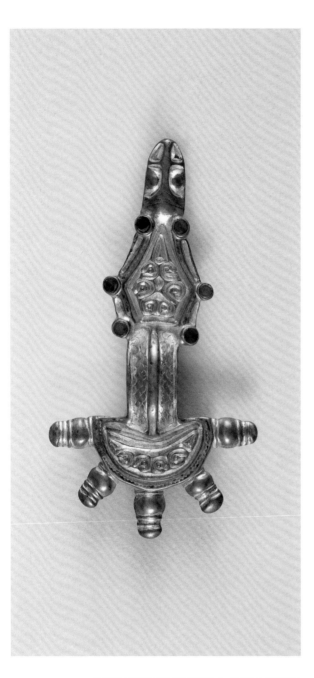

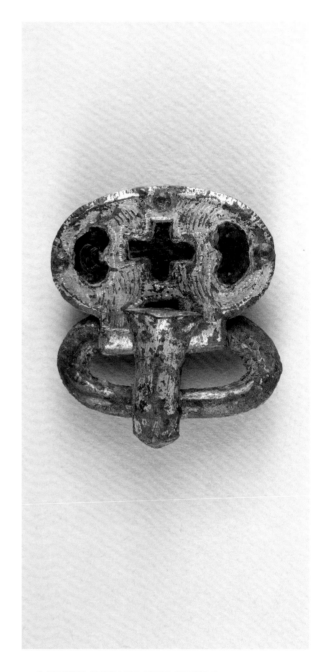

5. BOW BROOCH OR FIBULA, OSTROGOTHIC,
SECOND HALF FIFTH CENTURY

6. BUCKLE, GERMANIC, FIFTH CENTURY

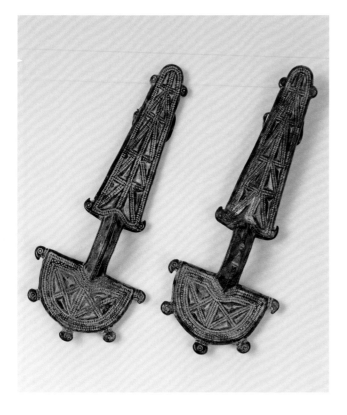

7. PAIR OF FIBULAE, VISIGOTHIC, SIXTH CENTURY

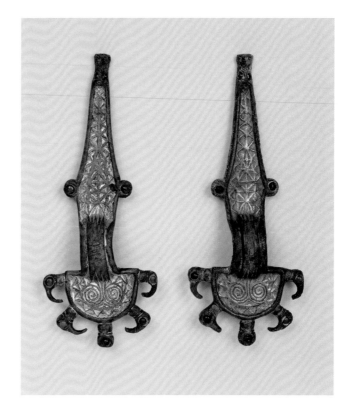

8. PAIR OF BOW BROOCHES OR FIBULAE WITH EAGLE'S-HEAD TERMINALS, OSTROGOTHIC, SIXTH CENTURY

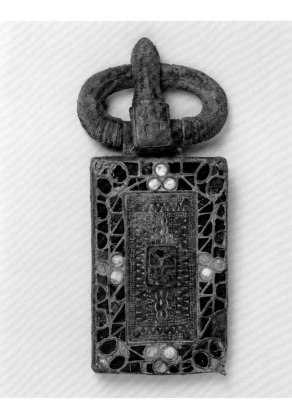

9. BUCKLE, VISIGOTHIC, SIXTH CENTURY

10. BUCKLE, VISIGOTHIC, SIXTH CENTURY

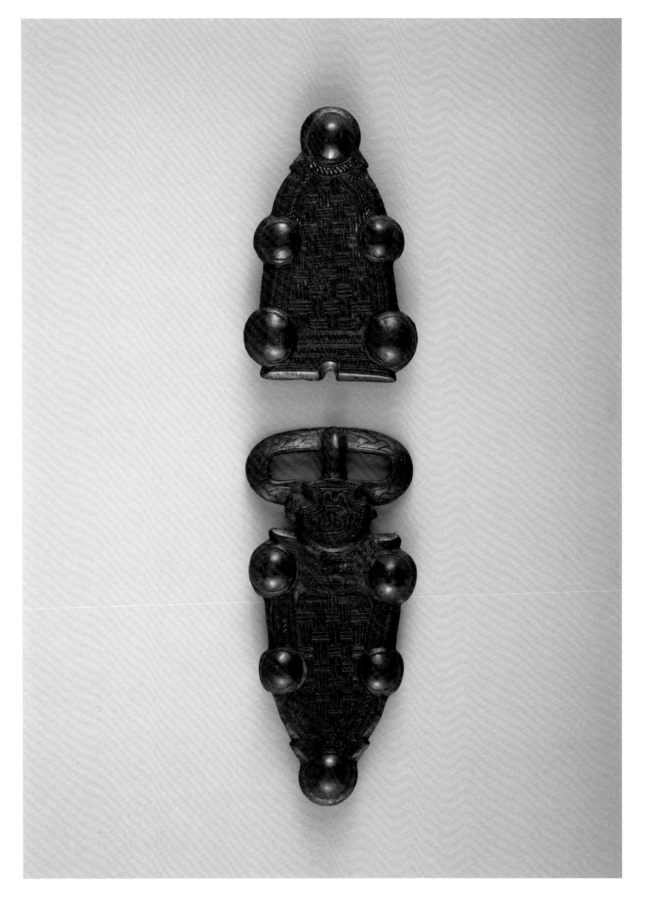

11. BUCKLE, FRANKISH, EARLY SEVENTH CENTURY

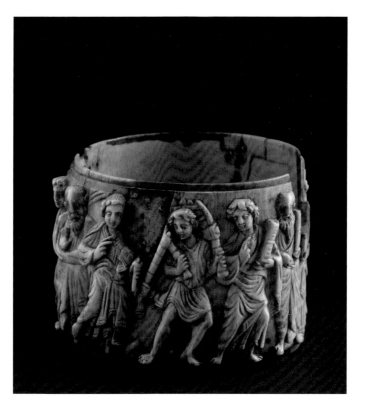

**12. PYXIS, NORTH AFRICA OR SYRIA/PALESTINE,
FIFTH TO SIXTH CENTURY**

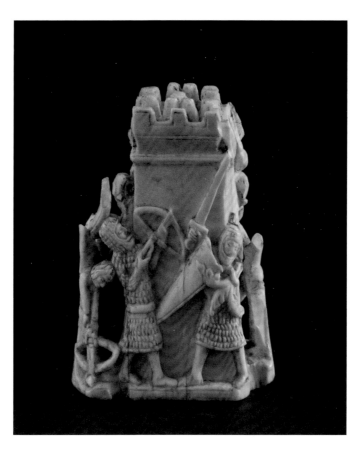

13. CHESSMAN, ENGLISH, CA. 1140

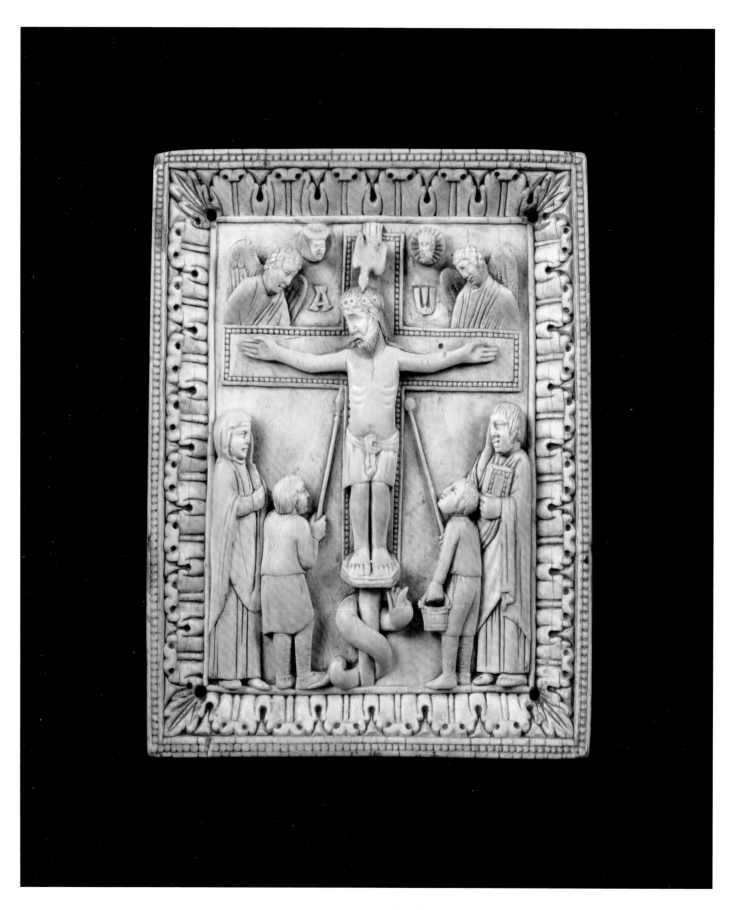

14. BOOK COVER PLAQUE, OTTONIAN, CA. 968–970

15. CASKET DEPICTING THE LEGEND OF SAINT EUSTACE, PARIS, CA. 1325–50

16. CROZIER, VOLTERRA, SECOND QUARTER FOURTEENTH CENTURY

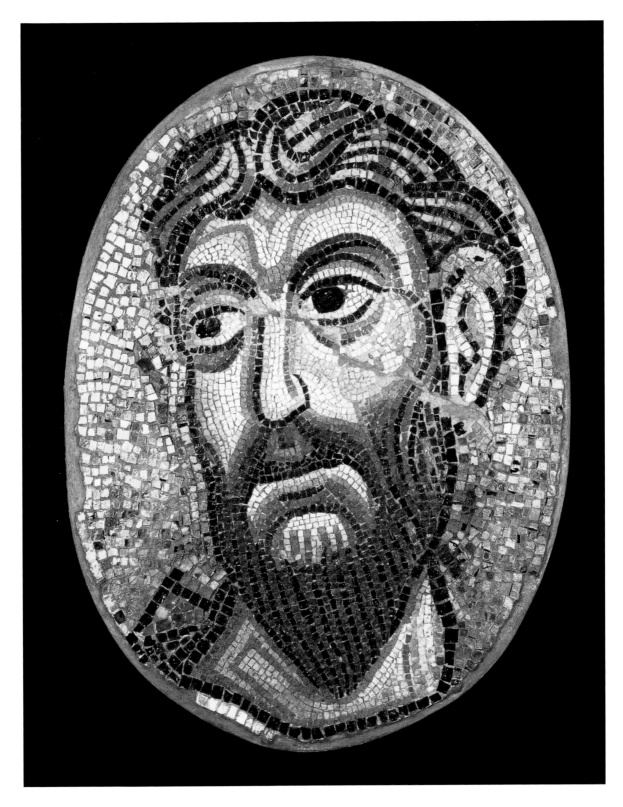

17. HEAD OF AN APOSTLE MOSAIC, BYZANTINE, LATE ELEVENTH CENTURY

18. EUCHARISTIC DOVE FROM THE MARIENSTIFT OF ERFURT, LIMOGES, CA. 1215–35

19. CHASSE OF SAINT URSULA, LIMOGES, CA. 1235–45

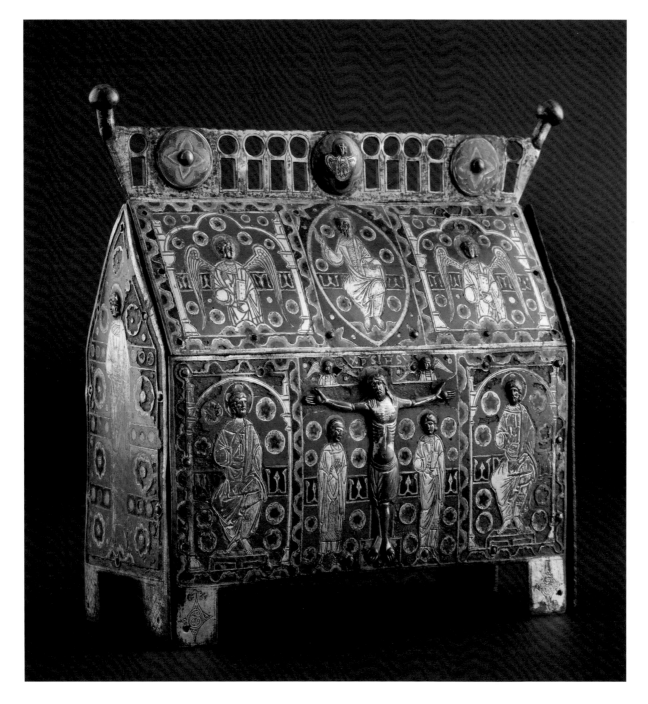

20. RELIQUARY CHASSE, LIMOGES, EARLY THIRTEENTH CENTURY

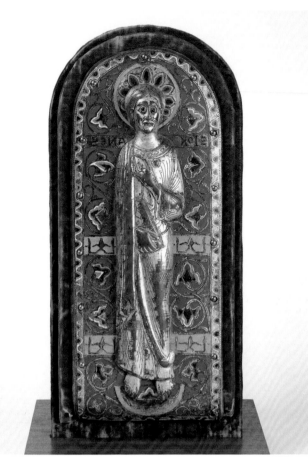

21. PLAQUE WITH SAINT JOHN THE EVANGELIST, LIMOGES, CA. 1174–1213 (PROBABLY BY 1188)

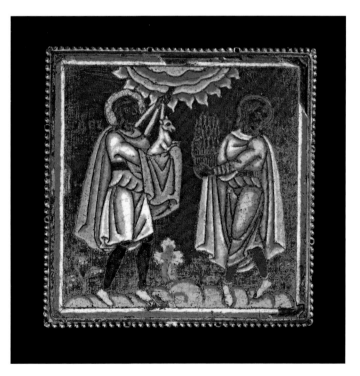

22. PLAQUE WITH THE SACRIFICE OF CAIN AND ABEL, MOSAN, MID-TWELFTH CENTURY

23. PHYLACTERY (RELIQUARY), MOSAN, CA. 1160–70

24. PRICKET CANDLESTICK, MOSAN, CA. 1150

25. PRICKET CANDLESTICK, GERMAN, LATE TWELFTH TO THIRTEENTH CENTURY

26. AQUAMANILE OF SAMSON AND THE LION, MAGDEBURG(?), LATE TWELFTH CENTURY

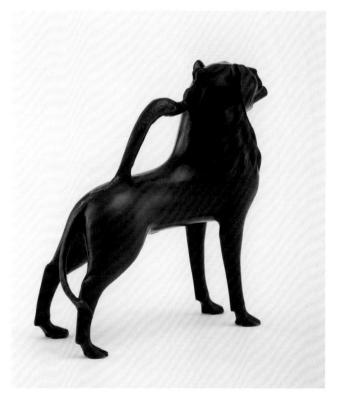

27. AQUAMANILE OF A LION, NORTH GERMAN, PROBABLY HILDESHEIM, MID-THIRTEENTH CENTURY

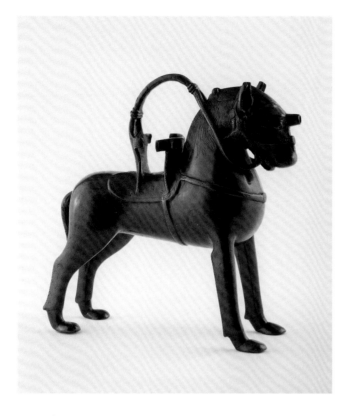

28. AQUAMANILE OF A SADDLED HORSE, NORTH GERMAN, CA. 1300

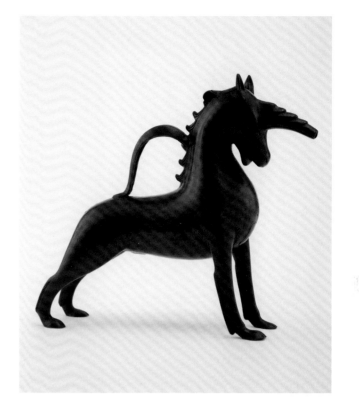

29. AQUAMANILE OF A UNICORN, NORTH GERMAN, CA. 1300

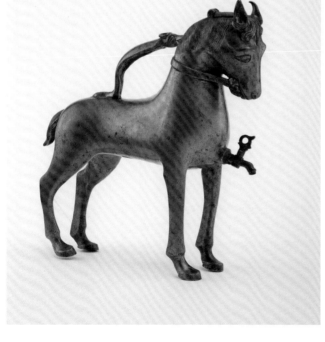

30. AQUAMANILE OF A HORSE, NUREMBERG, CA. 1400

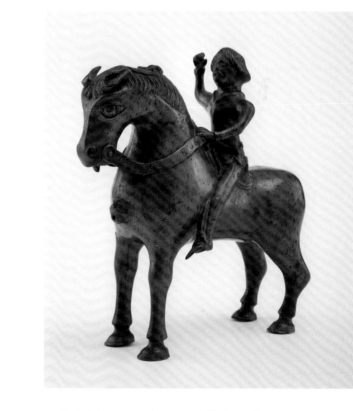

31. AQUAMANILE OF A HORSE WITH RIDER, NUREMBERG, CA. 1430–40

32. SAINT THADDEUS, NORTH GERMAN, LOWER SAXONY OR WESTPHALIA, CA. 1350

33. MADONNA AND CHILD, FRENCH OR NETHERLANDISH, CA. 1420

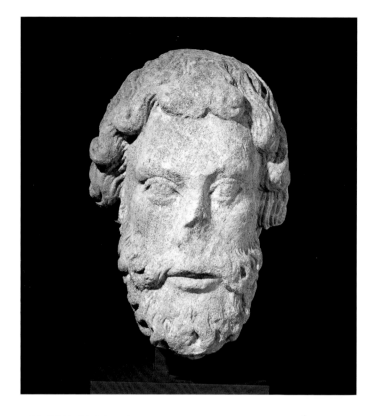

34. HEAD OF AN APOSTLE, NORTHEASTERN FRANCE, THÉROUANNE, CA. 1235

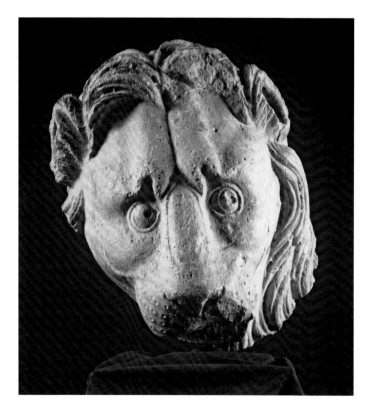

35. ASSISTANT OR WORKSHOP OF GIOVANNI PISANO, HEAD OF A LION, ITALIAN, CA. 1250–1315

MINIATURE FROM AN ILLUMINATED MANUSCRIPT, ENGLISH, CA. 1270:

36A. RECTO: APOCALYPSE 6:1-2

36B. VERSO: APOCALYPSE 6:3-4

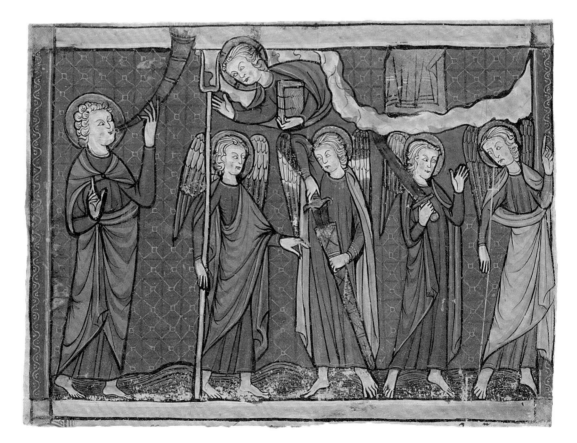

MINIATURE FROM AN ILLUMINATED MANUSCRIPT, ENGLISH, CA. 1270:

37A. RECTO: APOCALYPSE 9:13-16

37B. VERSO: APOCALYPSE 9:17-21

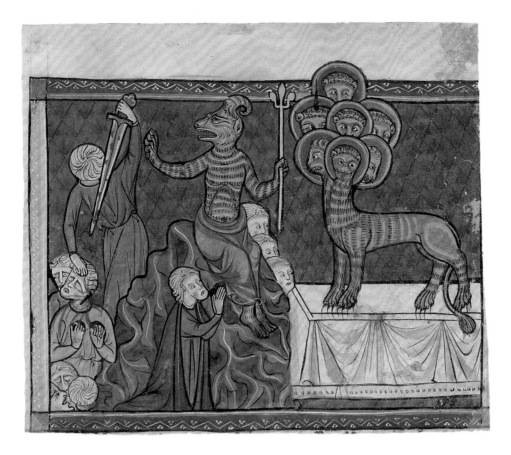

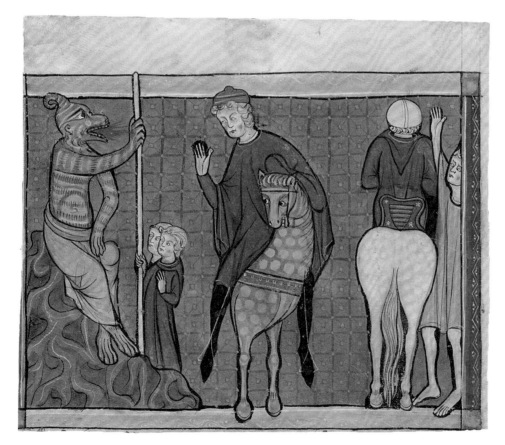

MINIATURE FROM AN ILLUMINATED MANUSCRIPT, ENGLISH, CA. 1270:

38A. RECTO: APOCALYPSE 13:14-15

38B. VERSO: APOCALYPSE 13:16-18

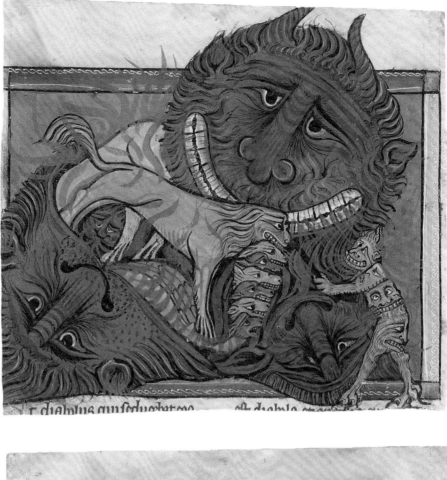

MINIATURE FROM AN ILLUMINATED MANUSCRIPT, ENGLISH, CA. 1270:

39A. RECTO: APOCALYPSE 20:7-9

39B. VERSO: APOCALYPSE 20:9-10

40. THE WOODCUTTERS/LES BÛCHERONS TAPESTRY, SOUTH NETHERLANDS, PROBABLY TOURNAI, THIRD QUARTER FIFTEENTH CENTURY

TAPESTRY (DETAIL)

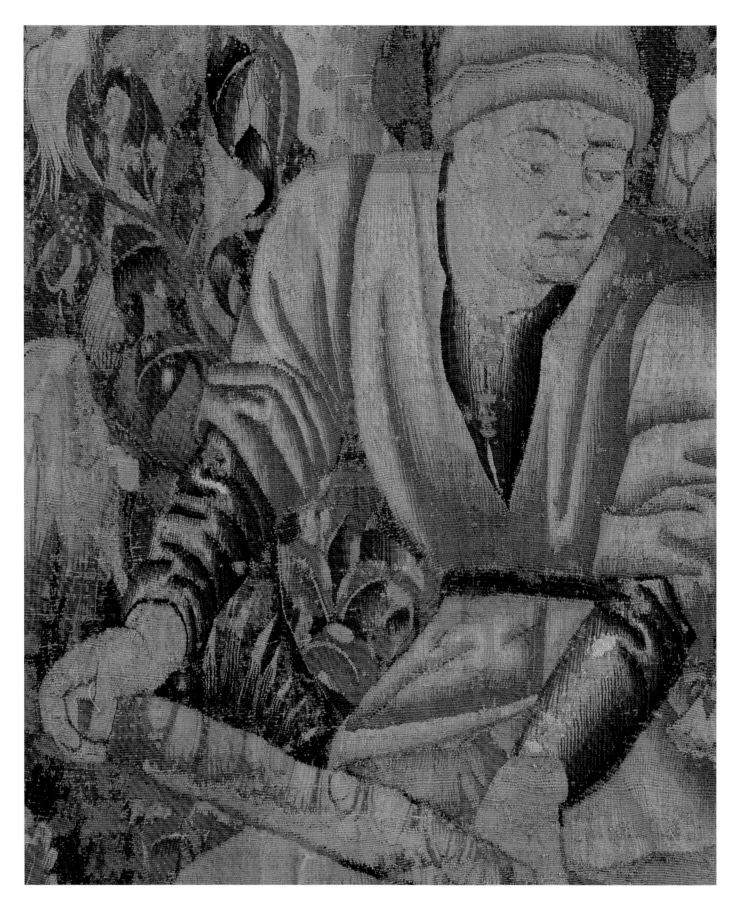

TAPESTRY (DETAIL)

TAPESTRY (DETAIL)

TAPESTRY (DETAIL)

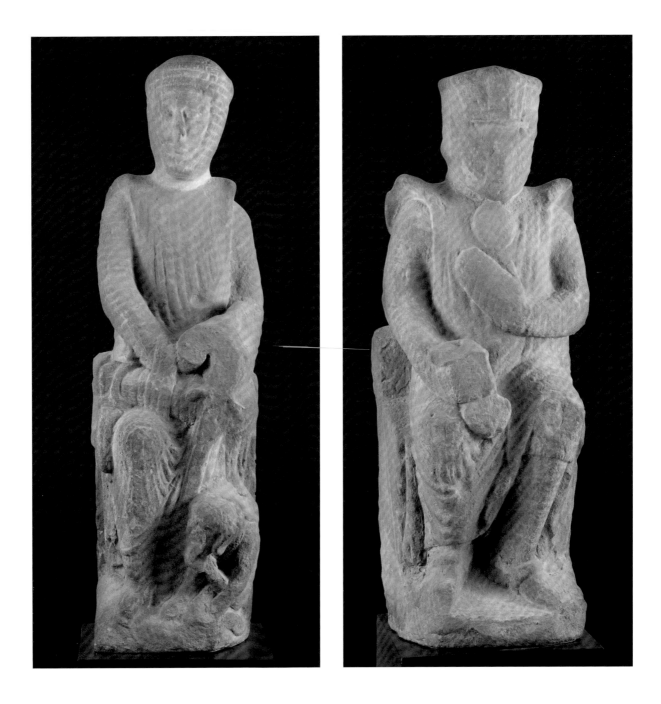

41. TWO FIGURES OF SEATED KNIGHTS, ENGLISH, HEREFORD, 1230–50

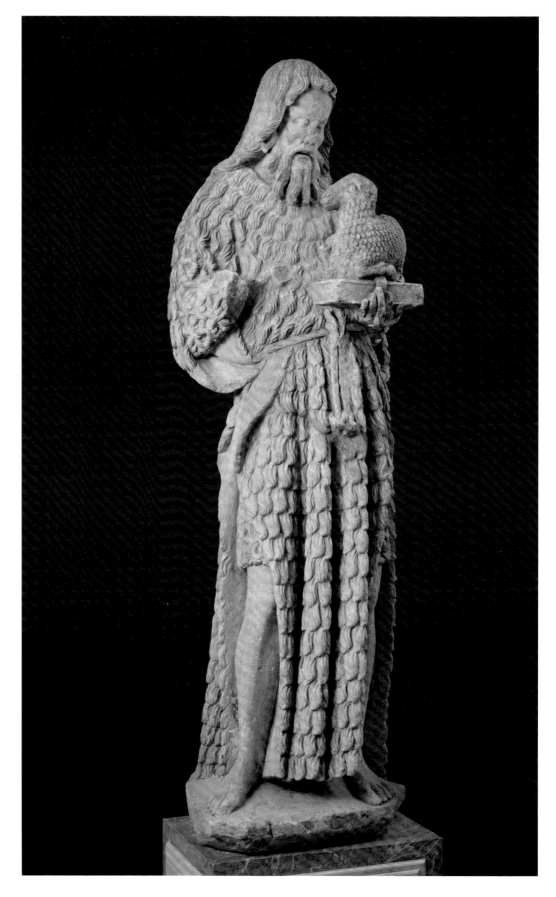

42. SAINT JOHN THE BAPTIST, BURGUNDY, THIRD QUARTER FIFTEENTH CENTURY

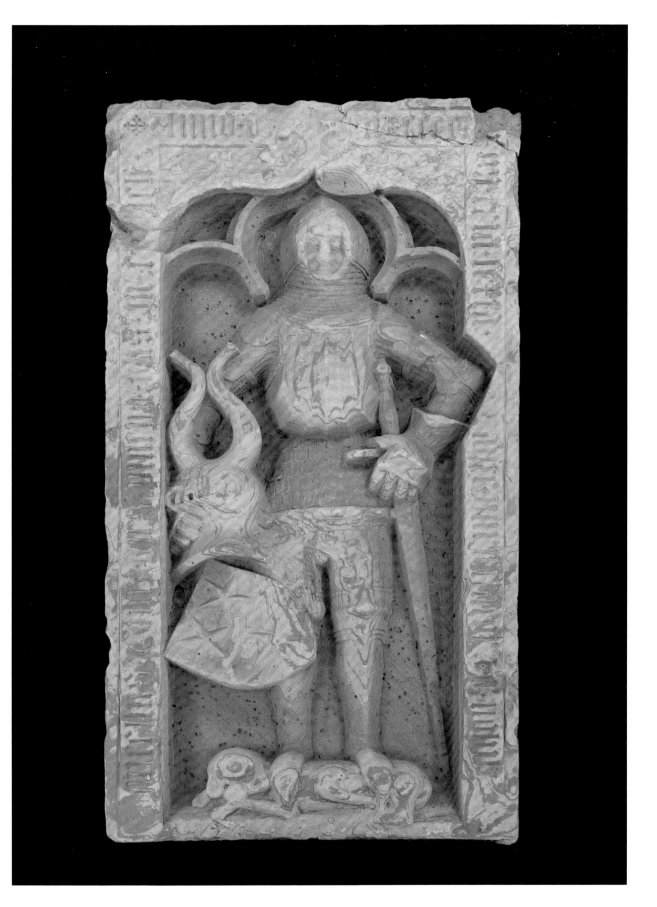

43. THE ERBACH STONE (THE GRAVESTONE OF CONRADUS SCHRENK ERBACH), GERMAN, 1417

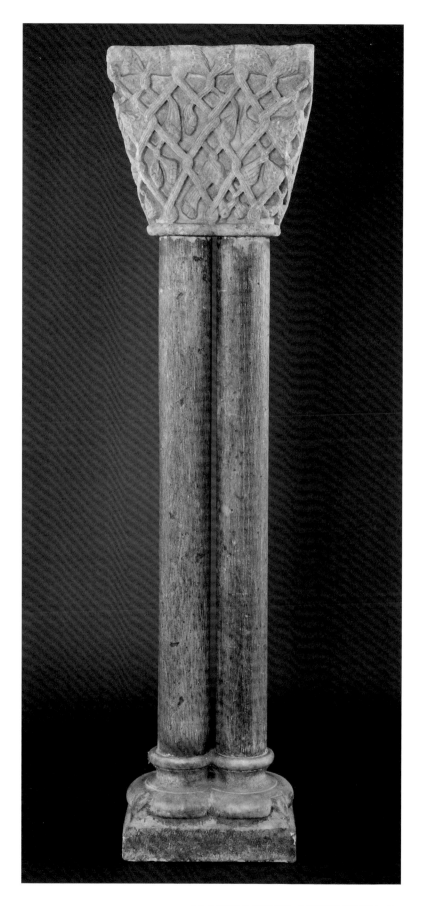

**44. DOUBLE CAPITAL, SOUTHWEST FRANCE,
SAINT BERTRAND DE COMMINGES (?), MID-TWELFTH CENTURY**

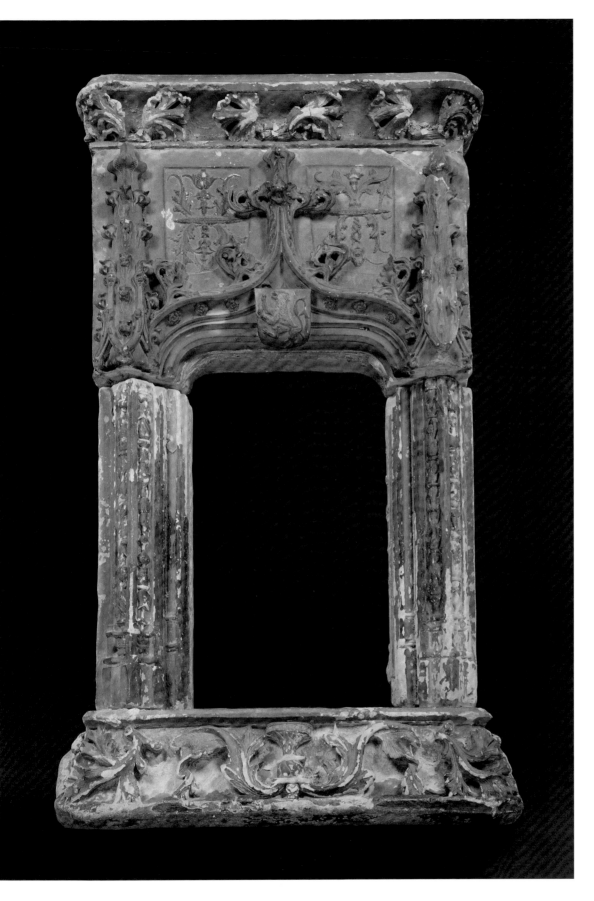

45. WINDOW, FRENCH, FIFTEENTH CENTURY (WITH LATER ADDITIONS)

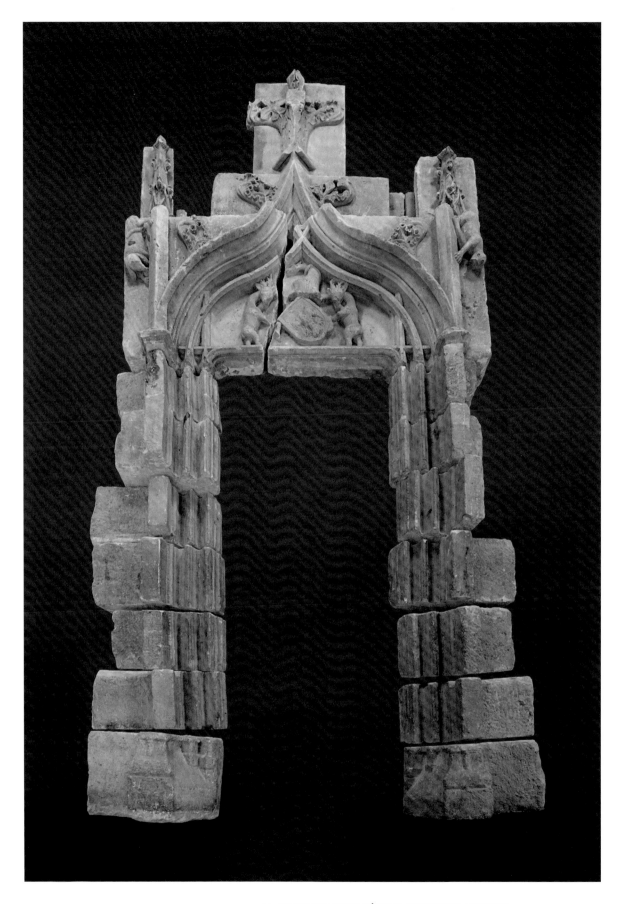

46. DOORWAY, DEUX-SÈVRES, FIFTEENTH CENTURY

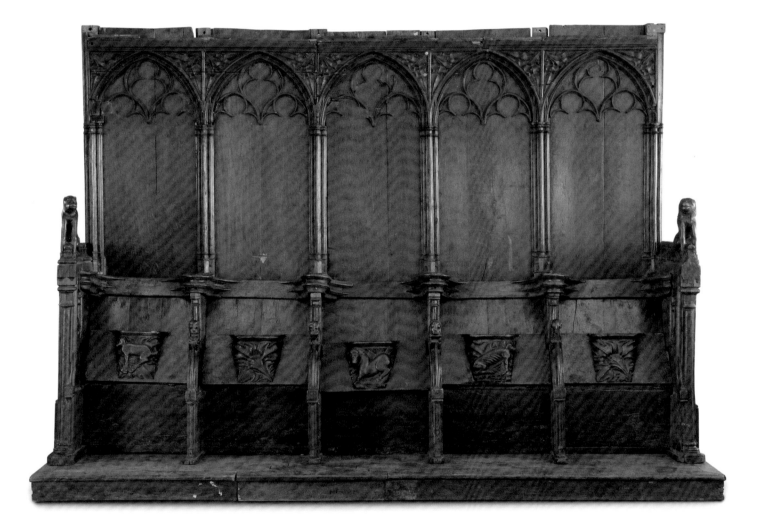

47. CHOIR STALL, FRENCH, CA. 1500

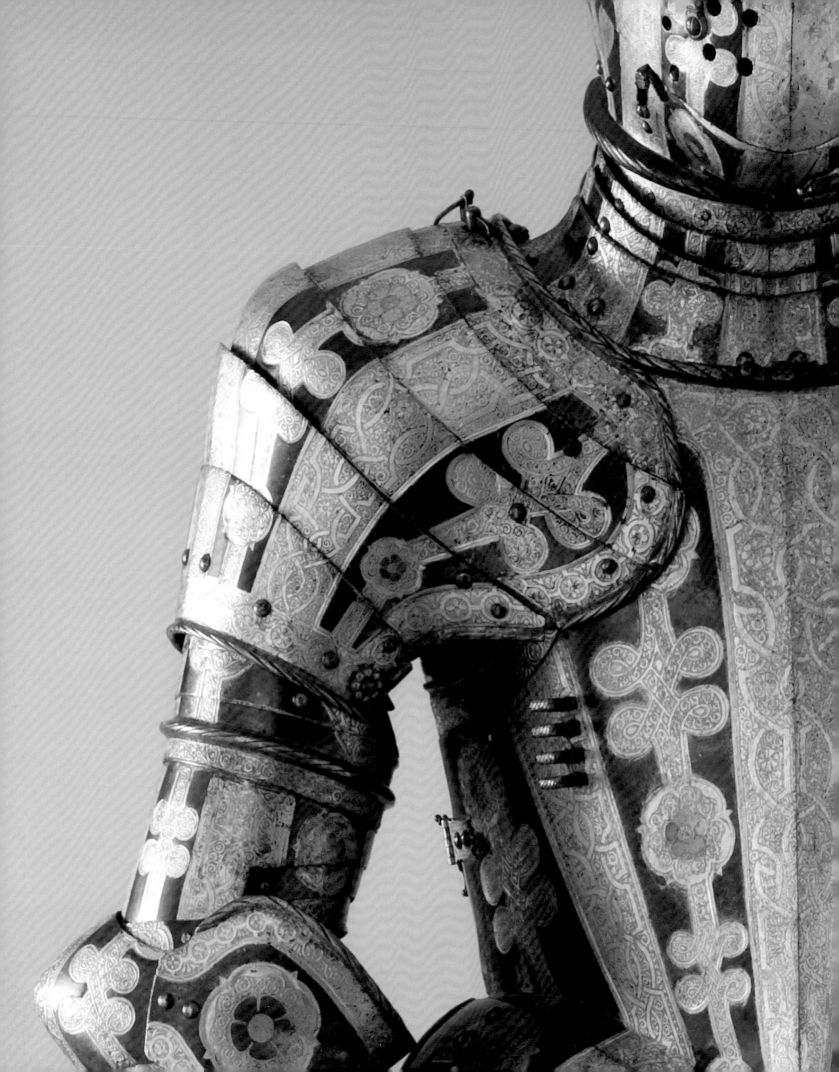

ARMS AND ARMOR

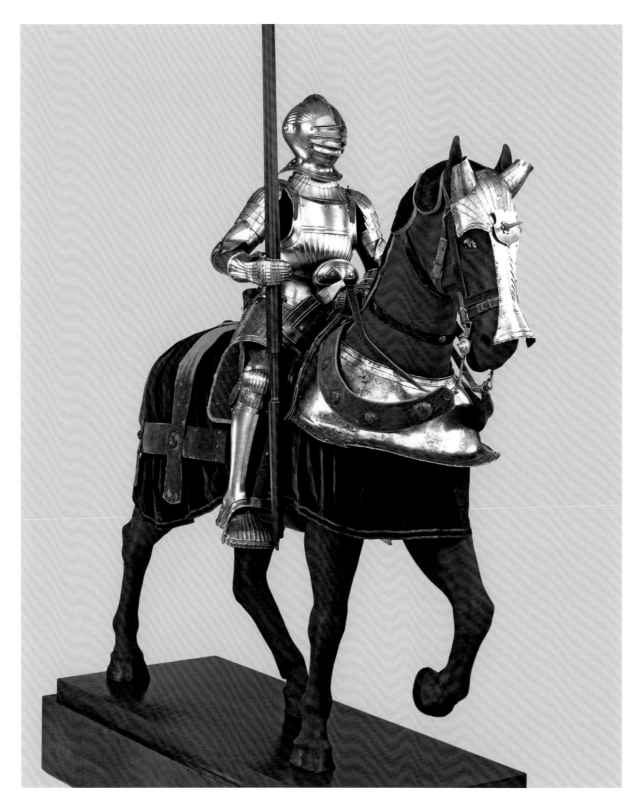

48. COMPOSITE ARMOR FOR MAN AND HORSE, GERMAN, MOSTLY NUREMBERG, COMPREHENSIVELY CA. 1515–30

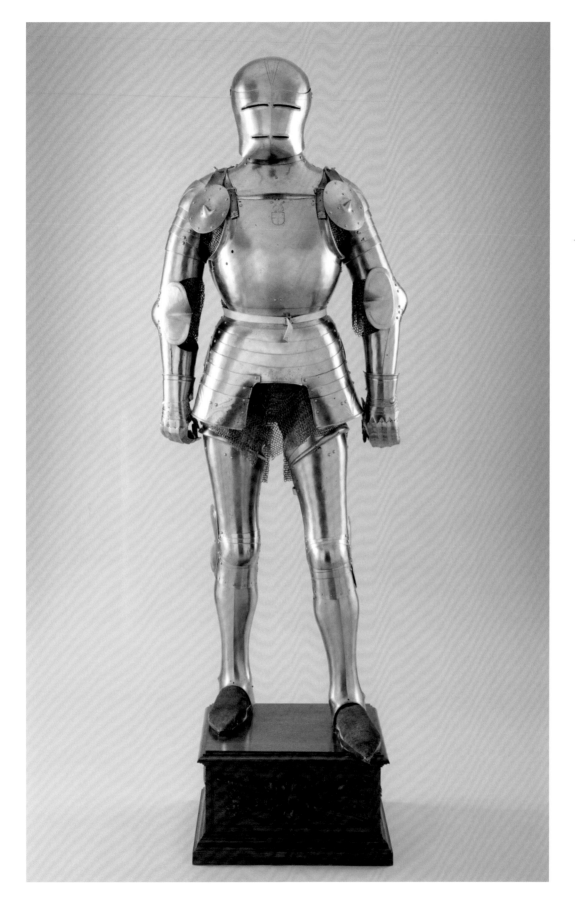

49. ARMOR FOR THE FIELD, TRADITIONALLY THAT OF KUNZ SCHOTT VON HELLINGEN, GERMAN, CA. 1500–10

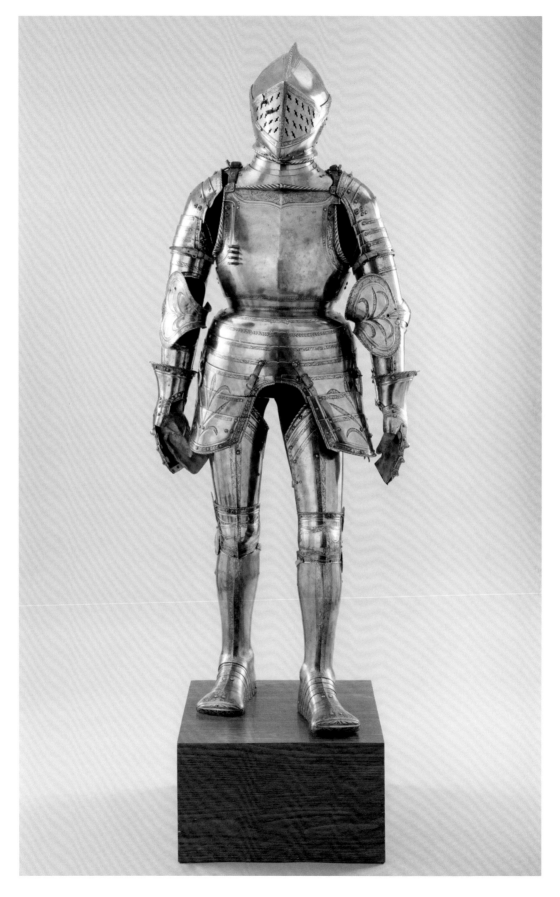

50. MICHEL WITZ THE YOUNGER, ARMOR FOR THE FIELD AND TOURNAMENT, INNSBRUCK, CA. 1530–35

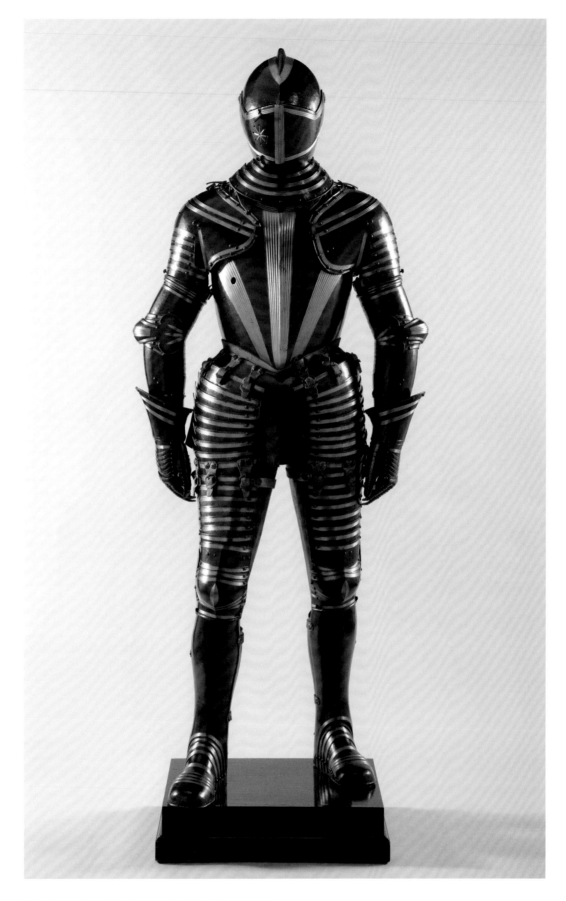

51. ARMOR FOR THE FIELD, FLORENCE, CA. 1600–10

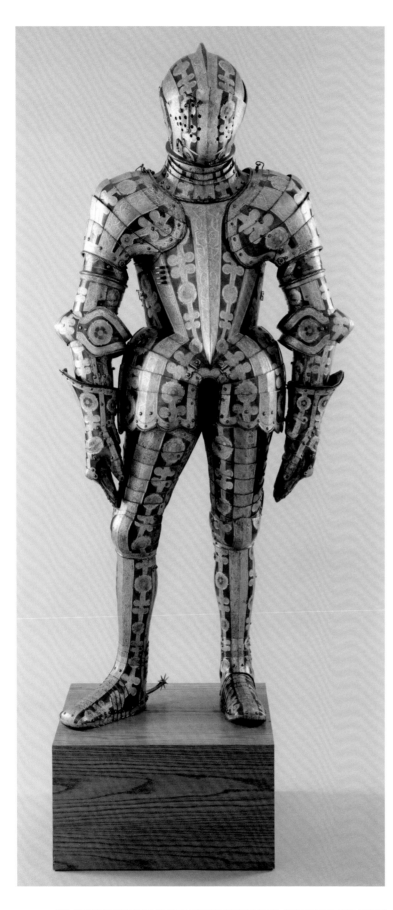

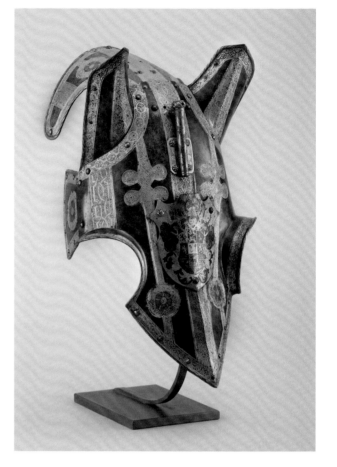

53. HALF-SHAFFRON BELONGING TO THE DUKE FRIEDRICH ULRICH OF BRUNSWICK, GREENWICH, 1610–13

52. ARMOR FOR THE FIELD AND TOURNAMENT, MADE FOR THE DUKE FRIEDRICH ULRICH OF BRUNSWICK, GREENWICH, 1610–13

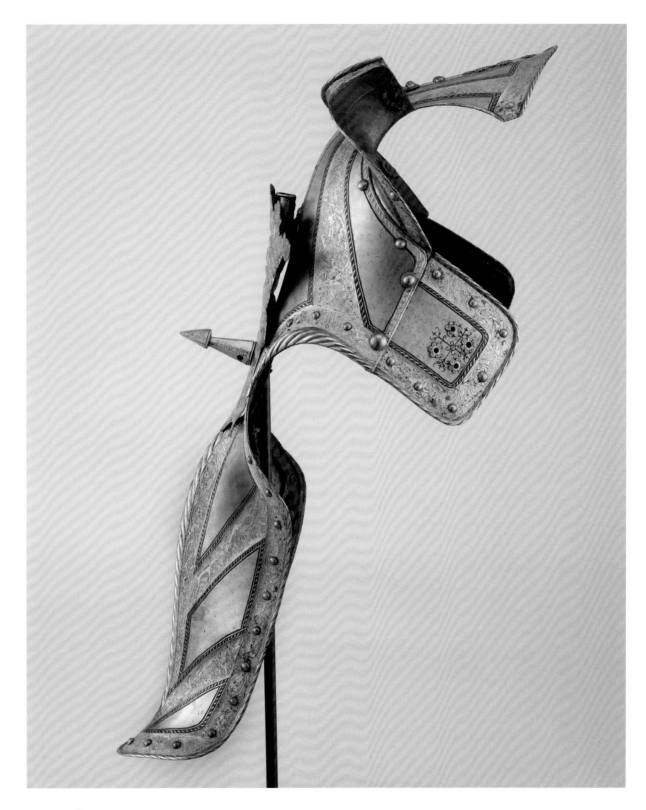

54. MATTHÄUS FRAUENPREISS THE ELDER, SHAFFRON FROM THE "KING'S GARNITURE"
OF THE FUTURE EMPEROR MAXIMILIAN II, AUGSBURG, CA. 1548–50

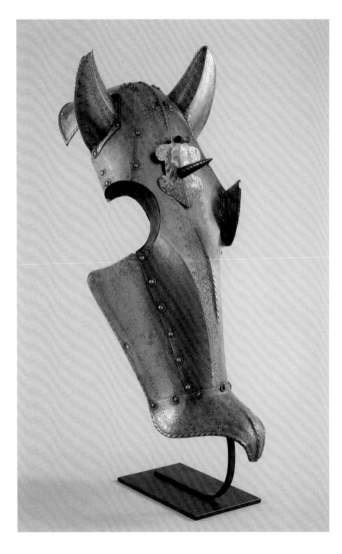

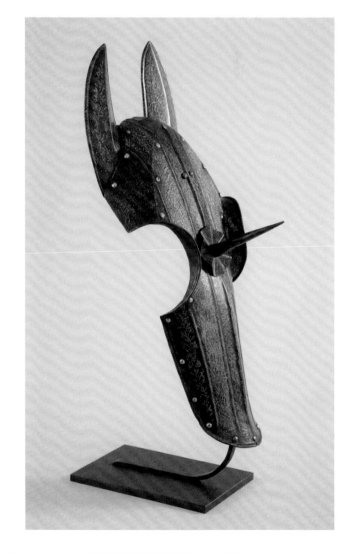

55. SHAFFRON, ITALIAN, CA. 1550–60

56. SHAFFRON, FRENCH, CA. 1600

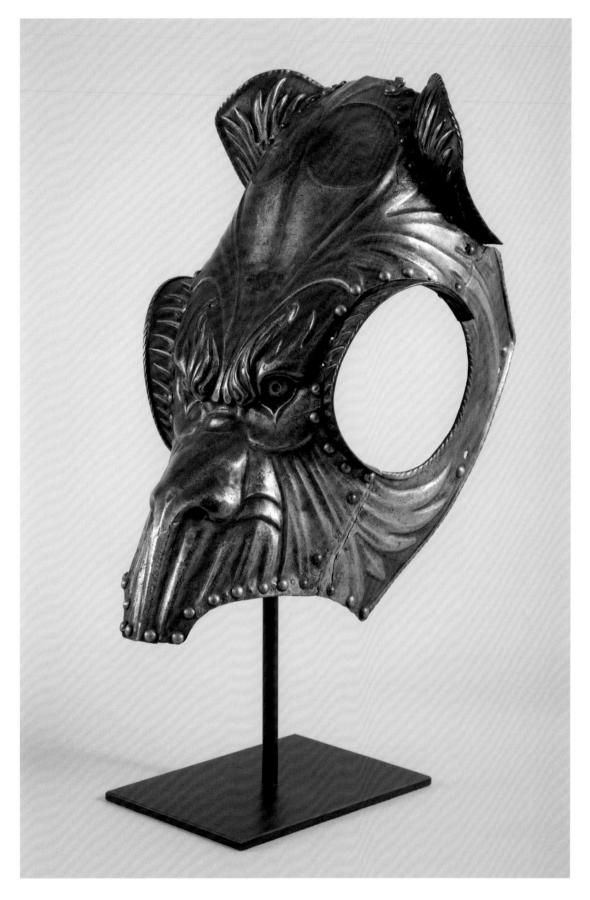

57. EMBOSSED SHAFFRON, ITALIAN, CA. 1550

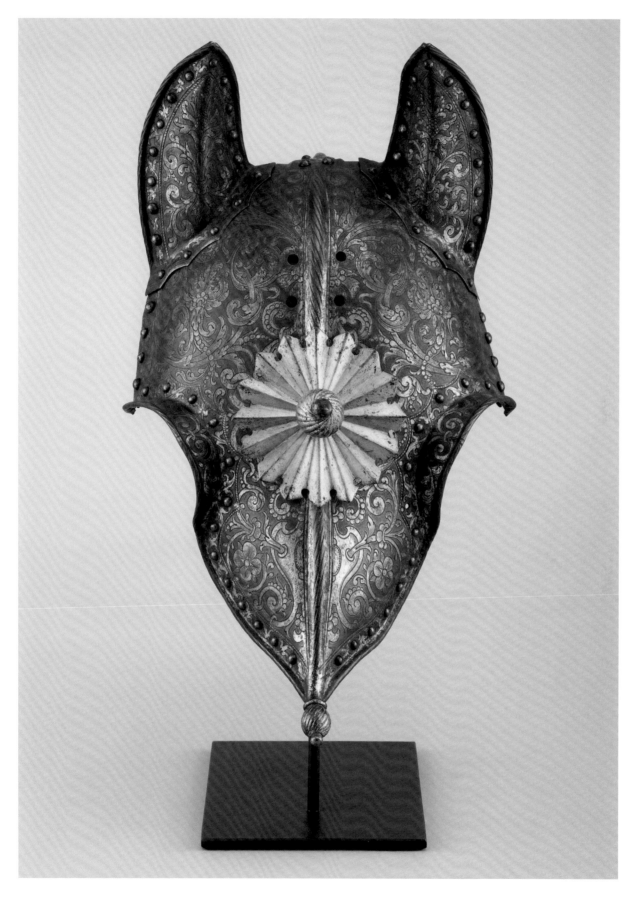

58. HALF-SHAFFRON FOR AN ARMOR OF KING PHILIP IV OF SPAIN, BRUSSELS, 1624–26

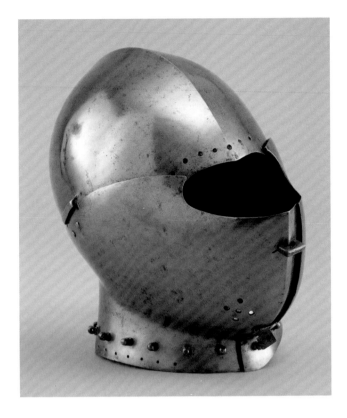

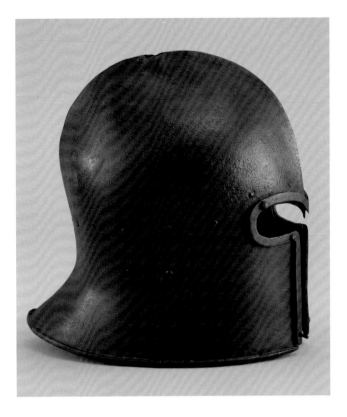

59. ARMET, ITALIAN, PROBABLY MILAN, CA. 1420

60. SALLET, MILAN, CA. 1450

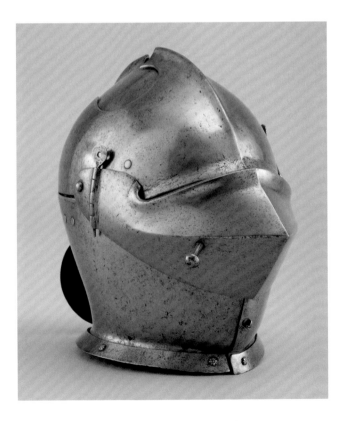

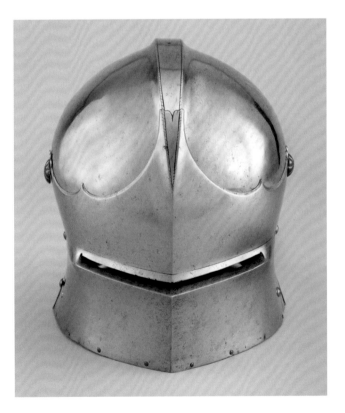

61. ARMET, MILAN, CA. 1470

62. ATTRIBUTED TO LORENZ HELMSCHMID, VISORED SALLET PROBABLY MADE FOR THE EMPEROR MAXIMILIAN I AS ARCHDUKE OF AUSTRIA, AUGSBURG, CA. 1480

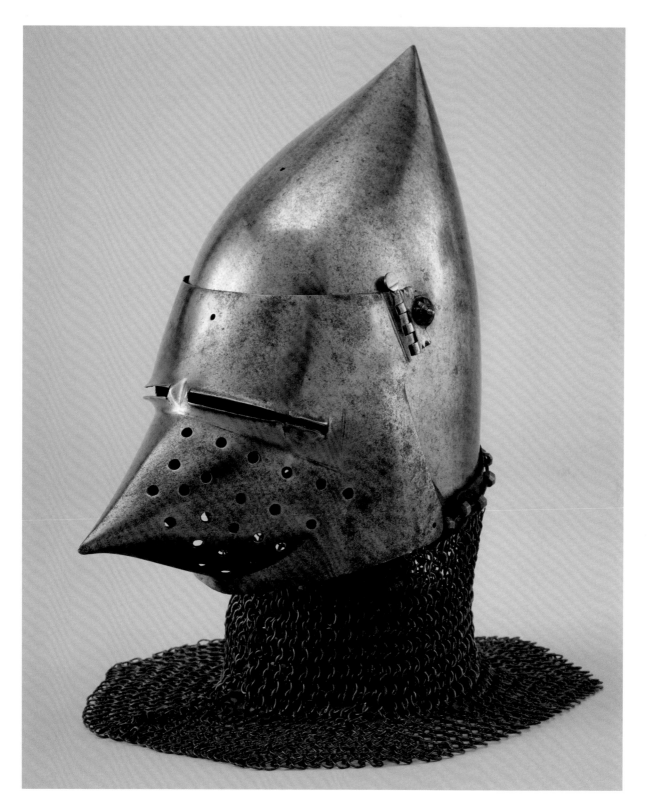

63. VISORED BACINET, WESTERN EUROPE, LATE FOURTEENTH CENTURY

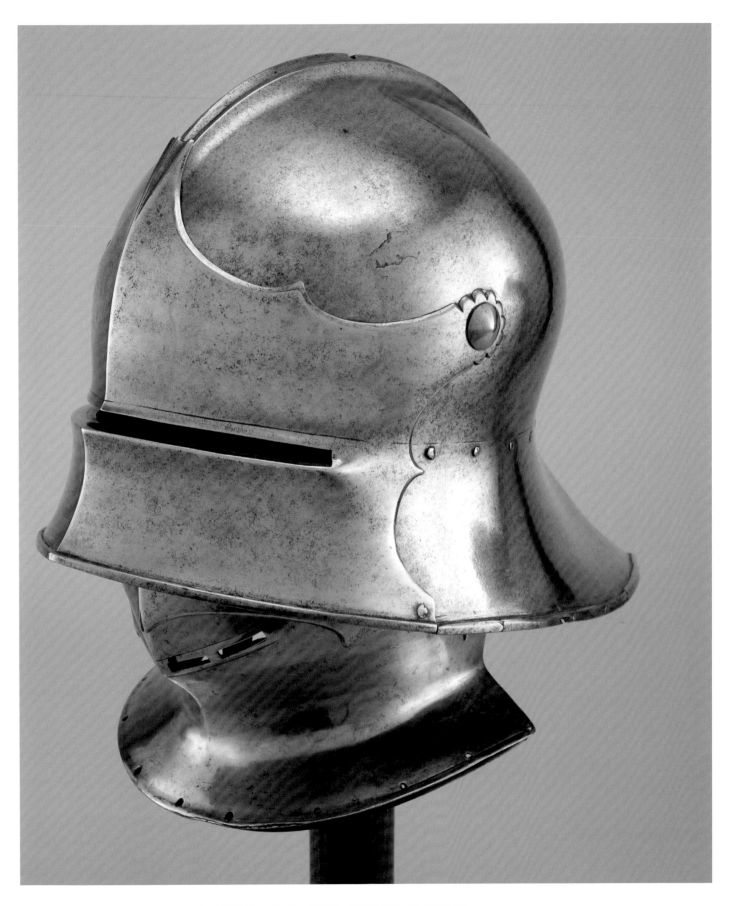

64. VISORED SALLET WITH ASSOCIATED BEVOR, AUGSBURG, CA. 1480–90

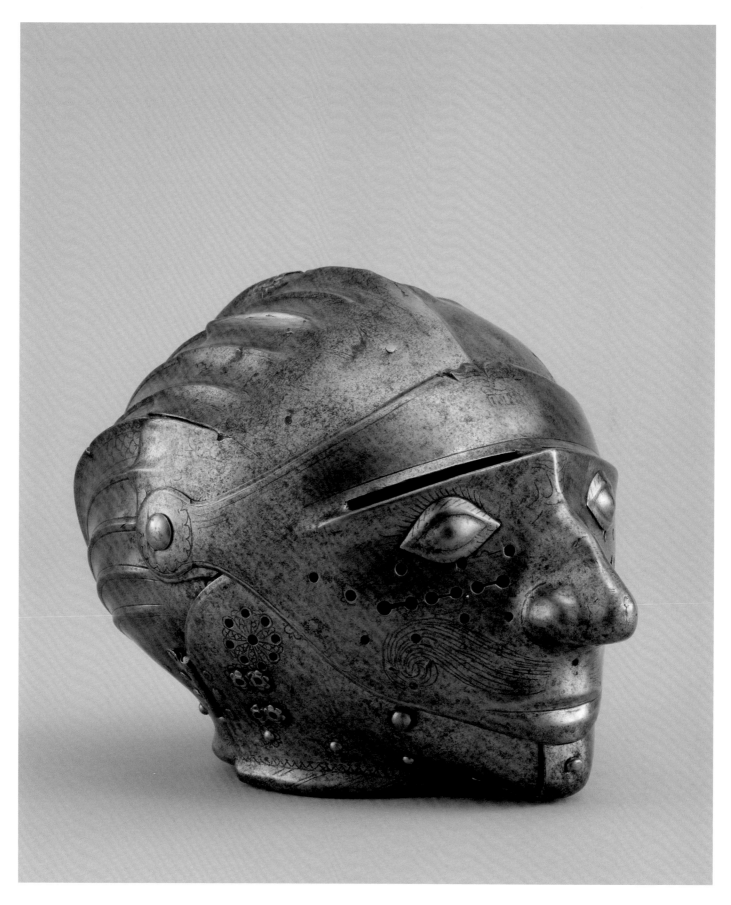

65. ATTRIBUTED TO KONRAD OR HANS SEUSENHOFER, CLOSE-HELMET WITH "MASK VISOR," INNSBRUCK, CA. 1515–20

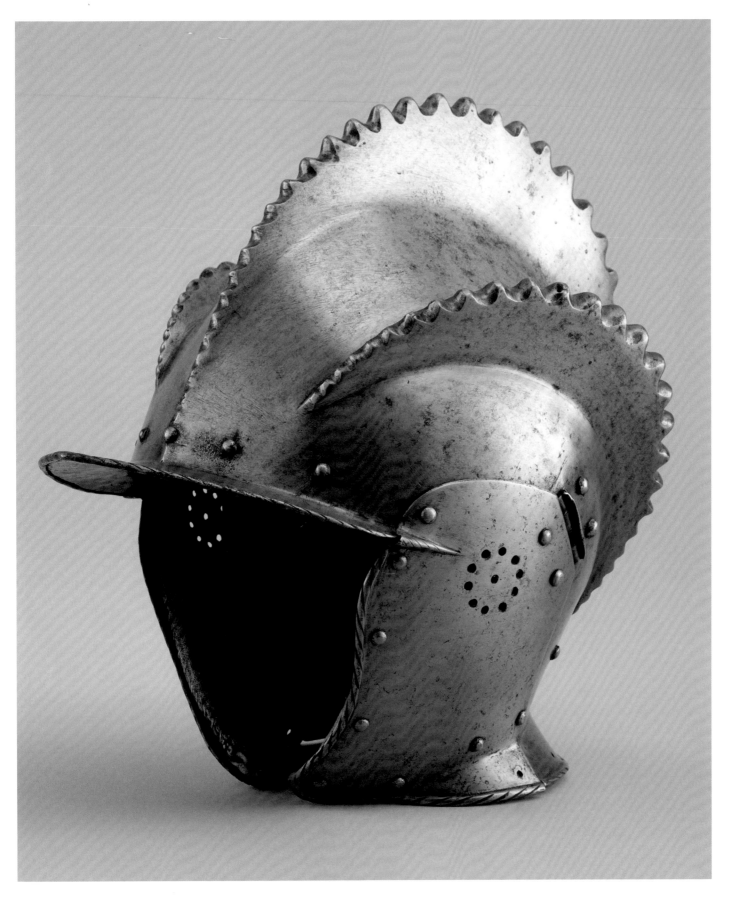

66. DESIDERIUS HELMSCHMID, TRIPLE COMBED BURGONET, AUGSBURG, CA. 1550

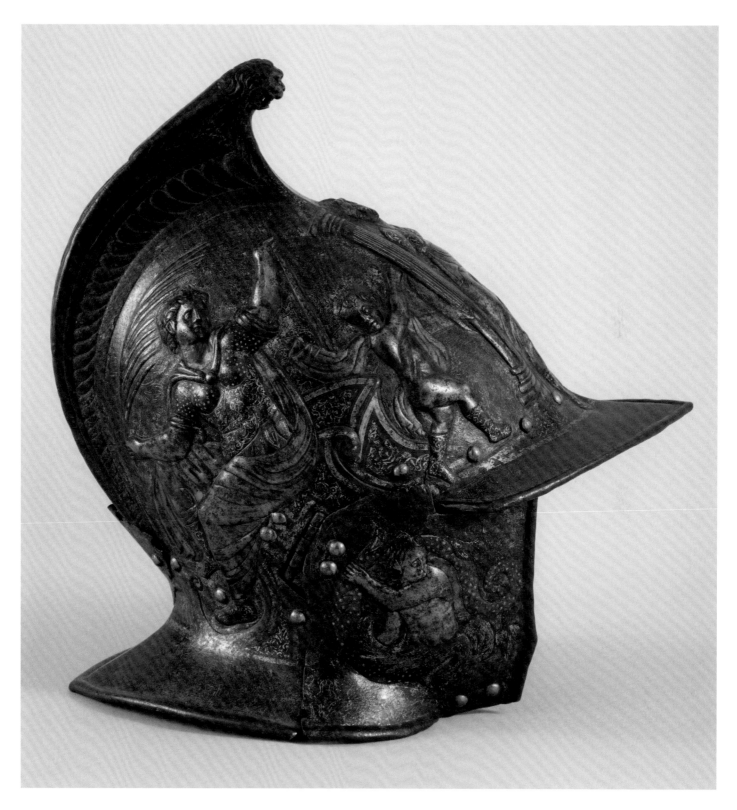

67. PARADE BURGONET FOR A MEMBER OF THE COLONNA FAMILY, MILAN, CA. 1560–70

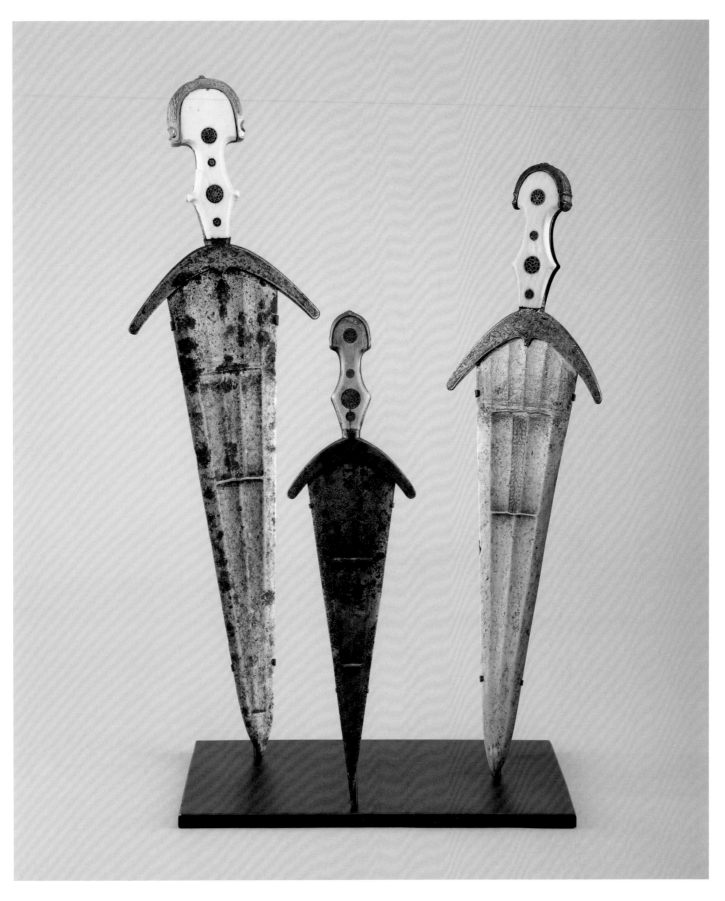

68. THREE DAGGERS (CINQUEDEAS), NORTH ITALIAN, LATE FIFTEENTH CENTURY

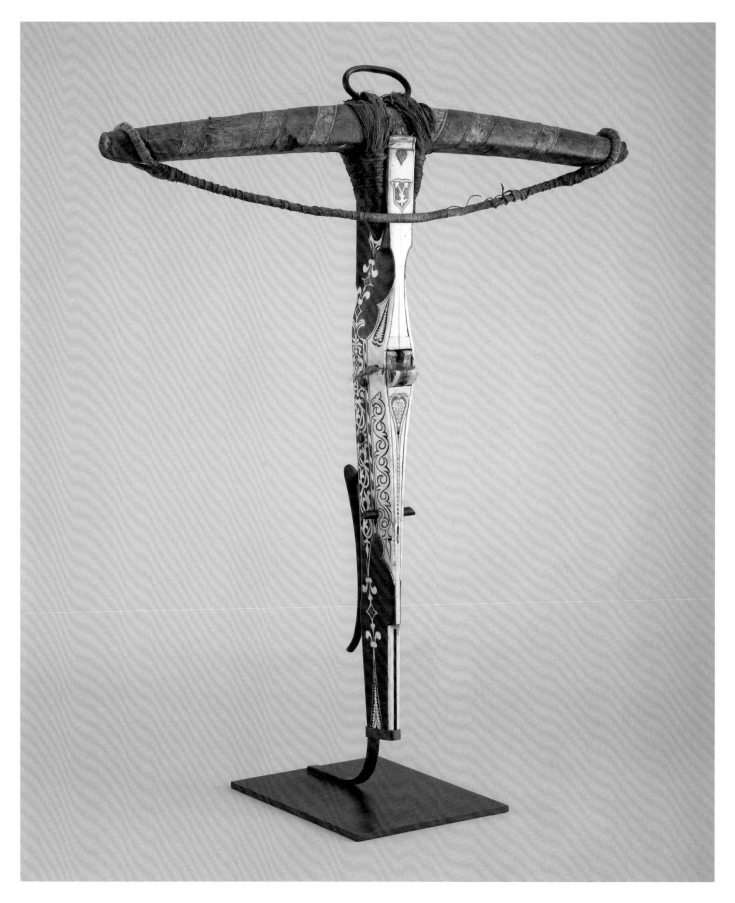

69. CROSSBOW, GERMAN, CA. 1500

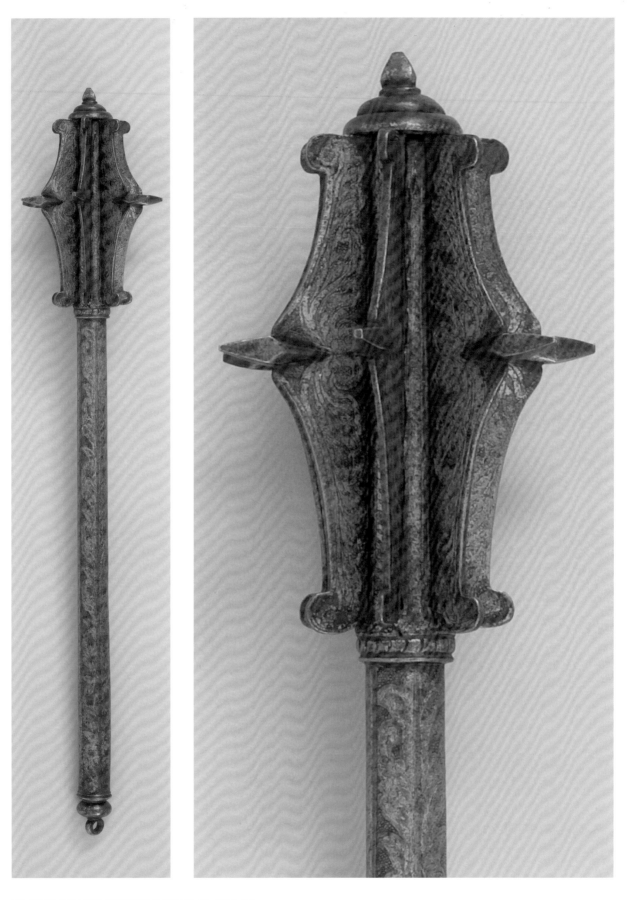

70. MACE, ITALIAN, PROBABLY MILAN, CA. 1560–80

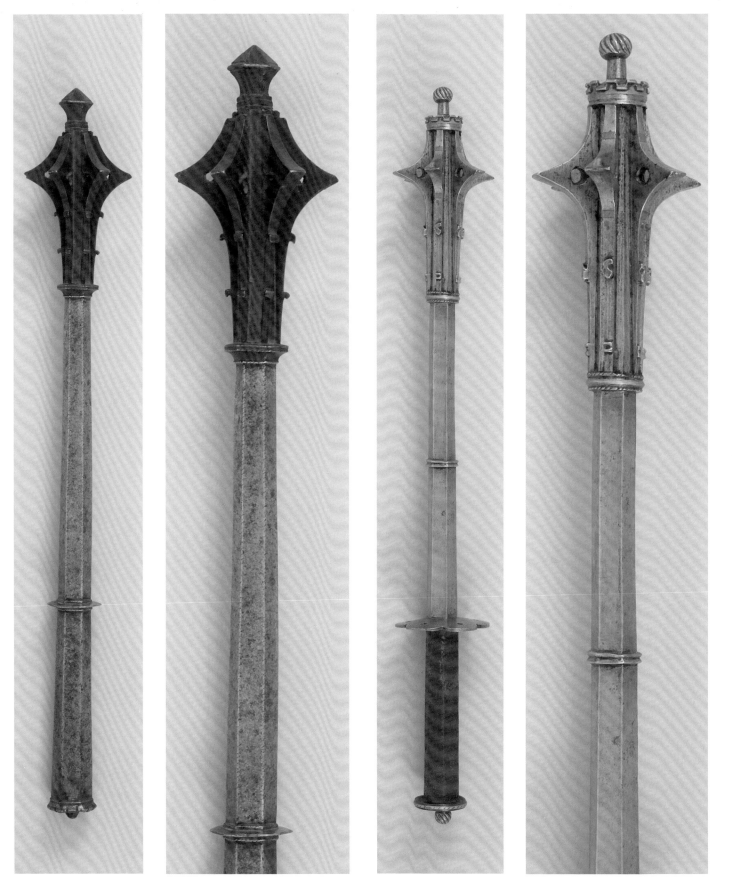

**71. MACE, EUROPEAN, LATE FIFTEENTH TO EARLY
SIXTEENTH CENTURY**

**72. MACE, EUROPEAN, LATE FIFTEENTH TO
EARLY SIXTEENTH CENTURY**

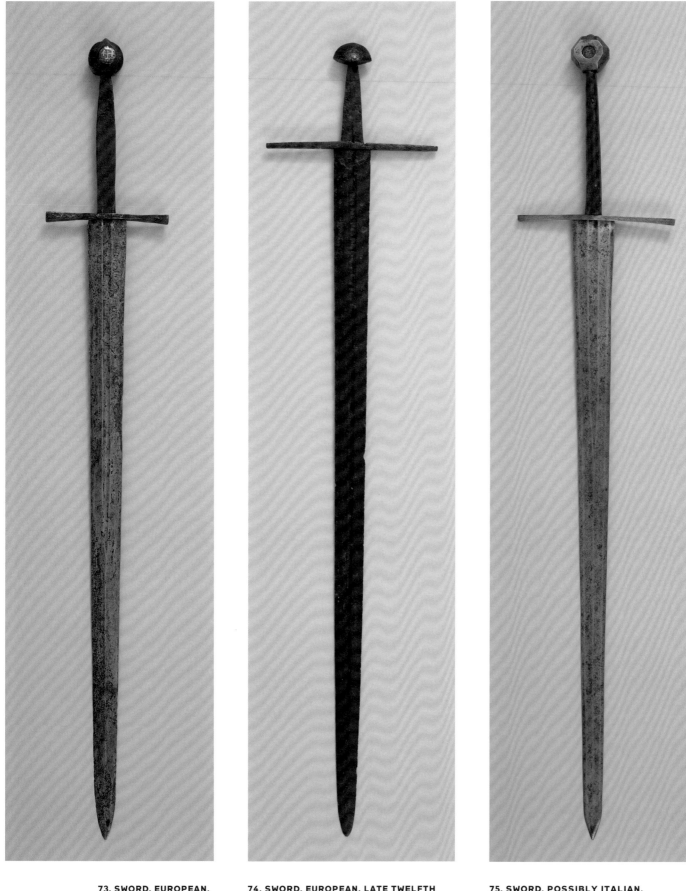

73. SWORD, EUROPEAN, EARLY FOURTEENTH CENTURY

74. SWORD, EUROPEAN, LATE TWELFTH TO EARLY THIRTEENTH CENTURY

75. SWORD, POSSIBLY ITALIAN, EARLY FIFTEENTH CENTURY

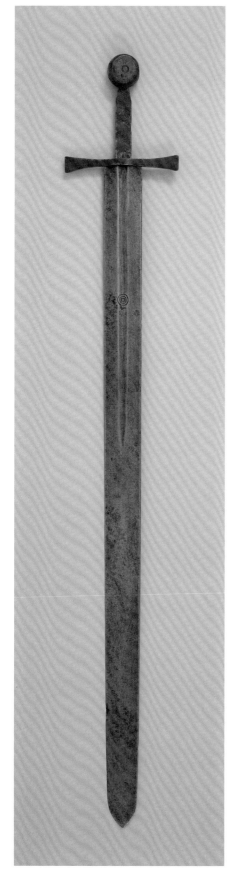

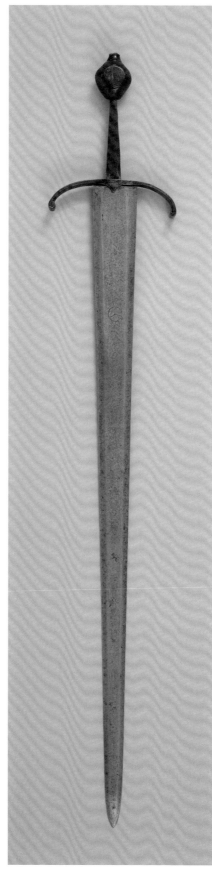

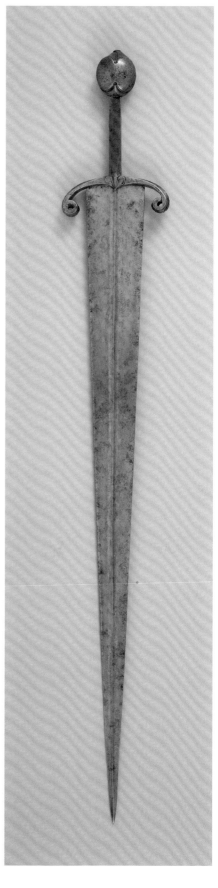

**76. SWORD, ITALIAN, EARLY- TO
MID-FOURTEENTH CENTURY**

**77. SWORD, ITALIAN, FIFTEENTH
CENTURY**

**78. SWORD, ITALIAN,
CA. 1500**

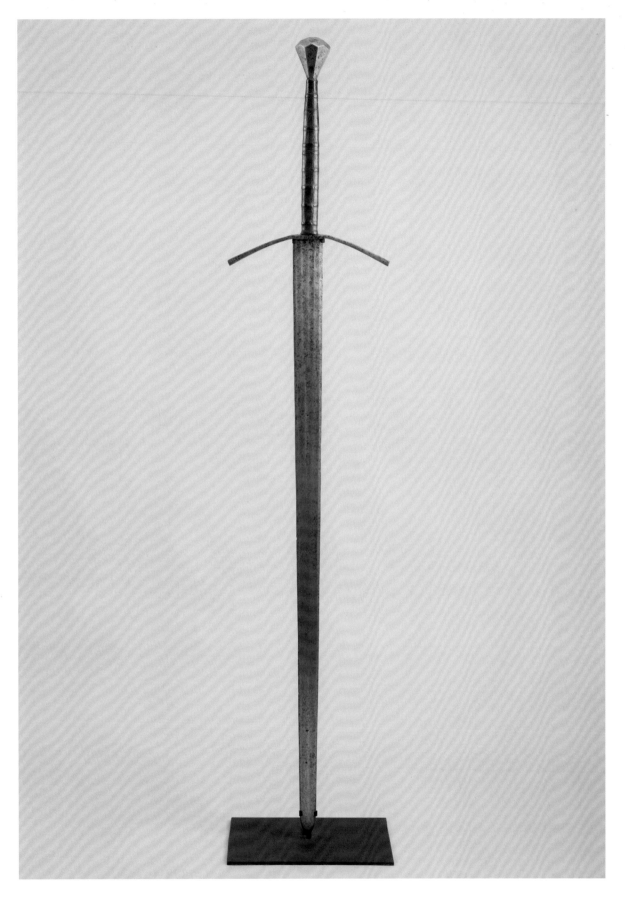

79. BEARING SWORD, AUSTRIAN, FOURTEENTH CENTURY

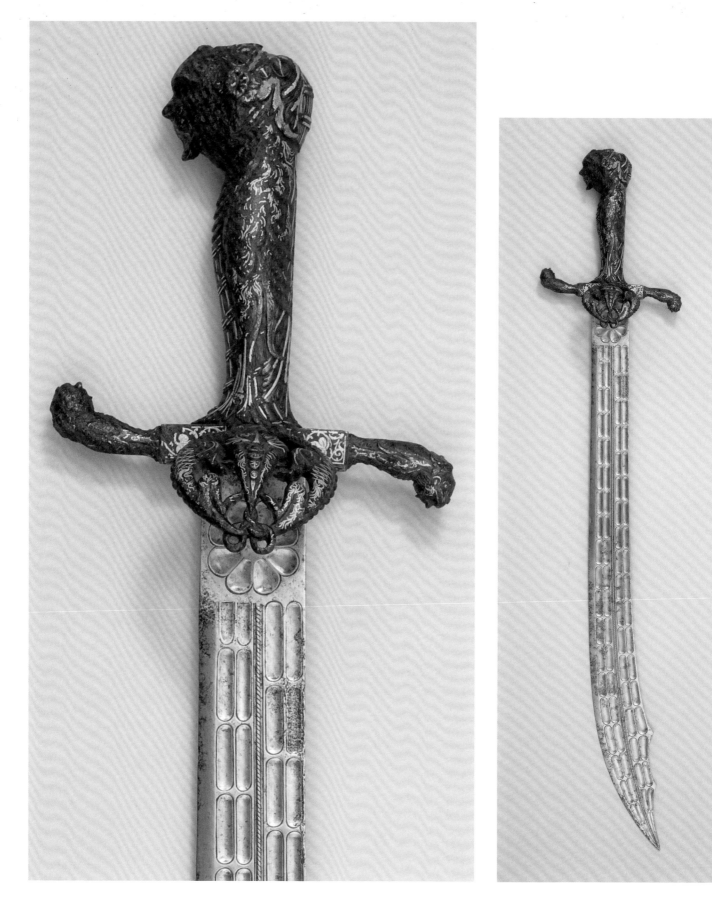

80. FALCHION, ITALIAN, PROBABLY BRESCIA, CA. 1550–70

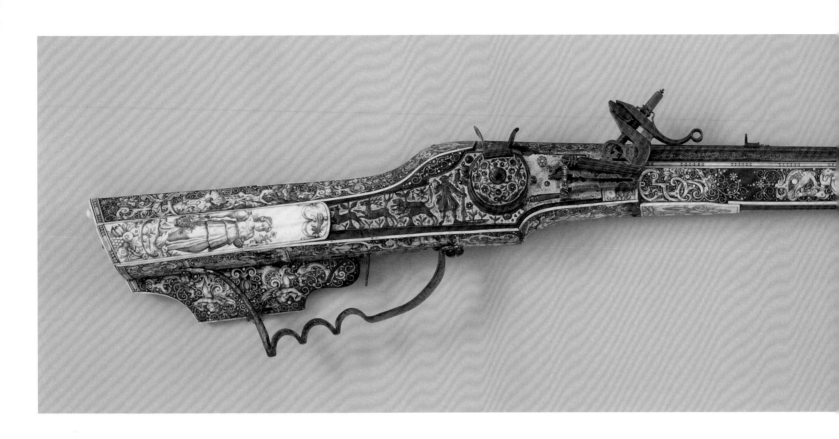

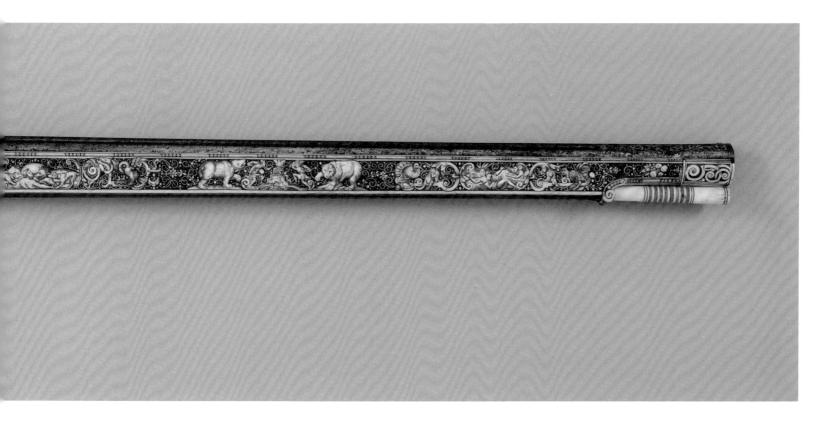

81. DANIEL SADELER, WHEELLOCK HUNTING RIFLE, MUNICH, CA. 1620

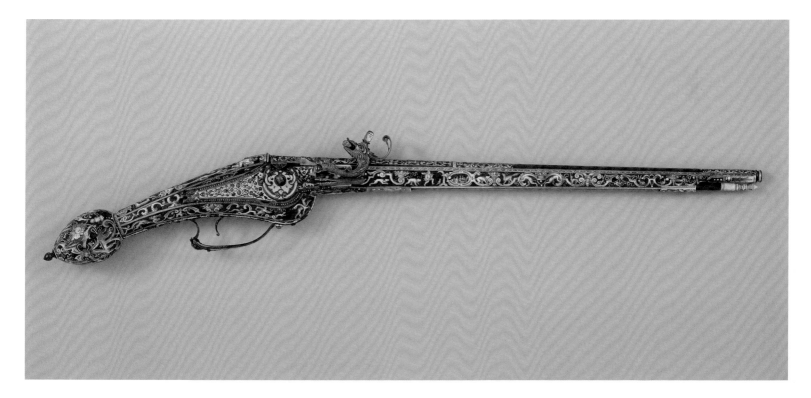

82. EMANUEL SADELER AND ADAM VISCHER, WHEELLOCK PISTOL, MUNICH, CA. 1600–10

**83. TULA WORKSHOPS, PAIR OF FLINTLOCK HOLSTER
PISTOLS, TULA, CA. 1745–55**

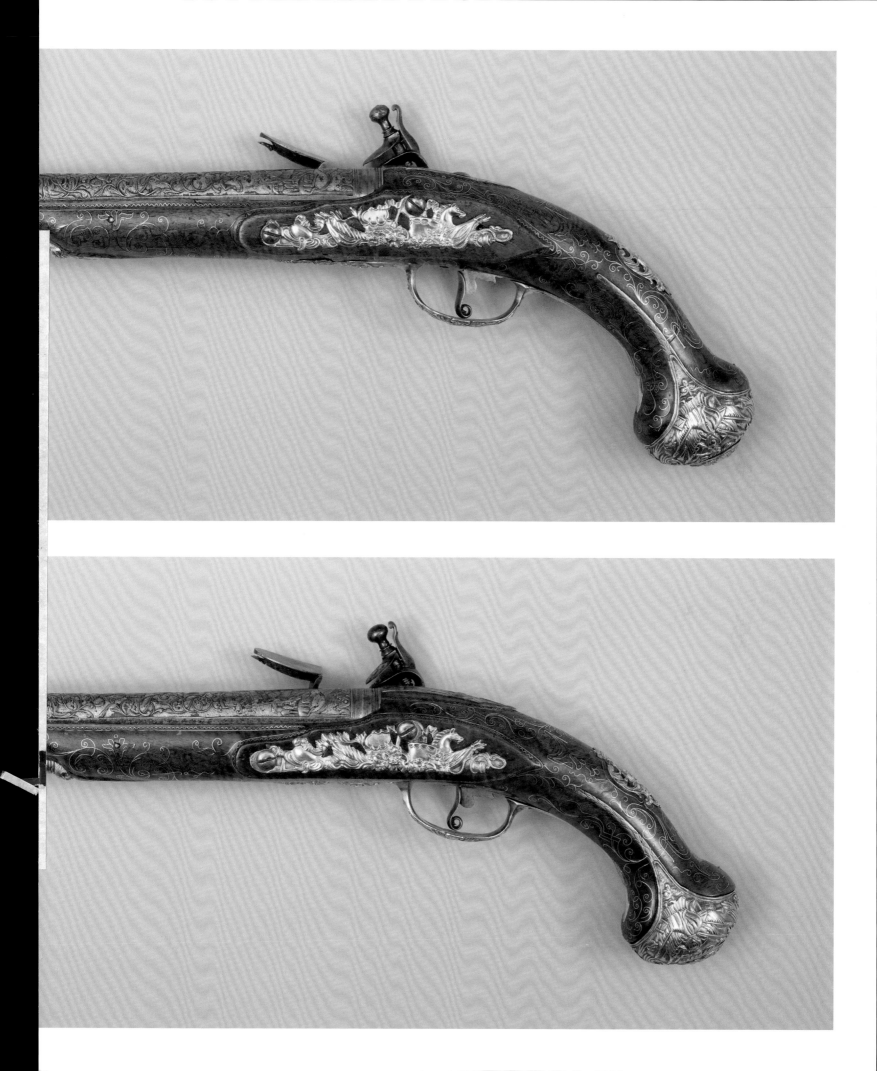

PAINTINGS AND SCULPTURE

- **OLD MASTER**

- **FRENCH**

- **AUSTRIAN**

- **GERMAN**

 EARLY 20TH-CENTURY

 POSTWAR

OLD MASTER
PAINTINGS AND SCULPTURE

84. ALBRECHT ALTDORFER, THE MIRACULOUS FOUNTAIN OF ST. FLORIAN, CA. 1518–20

85. BARTOLOMEO VIVARINI, MADONNA AND CHILD, CA. 1480–85

86. BERNAERT VAN ORLEY, MADONNA AND CHILD, CA. 1520

87. BERNHARD STRIGEL, PORTRAIT OF A MAN, UNDATED

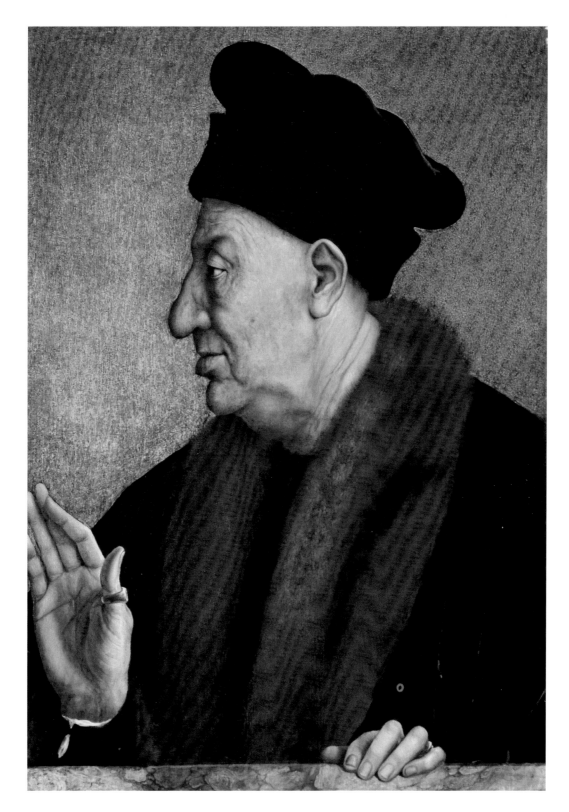

88. QUENTIN MASSYS, AN OLD MAN, CA. 1513

89. BARTHEL BRUYN THE ELDER, PORTRAIT, 1535

90. JAN GOSSAERT (CALLED MABUSE), PORTRAIT OF AN ABBOT, SIXTEENTH CENTURY

91. FRANZ XAVER MESSERSCHMIDT, THE DIFFICULT SECRET, 1771–83

92. FRANZ XAVER MESSERSCHMIDT, A STRONG MAN, CA. 1770

FRENCH
PAINTINGS AND SCULPTURE

93. HILAIRE-GERMAIN-EDGAR DEGAS, DEGAS IN A GREEN WAISTCOAT (SELF-PORTRAIT), 1855–56

94. HILAIRE-GERMAIN-EDGAR DEGAS, PORTRAIT OF A MAN, STANDING, WITH HANDS IN POCKETS (STUDY FOR INTERIOR), CA. 1868–69

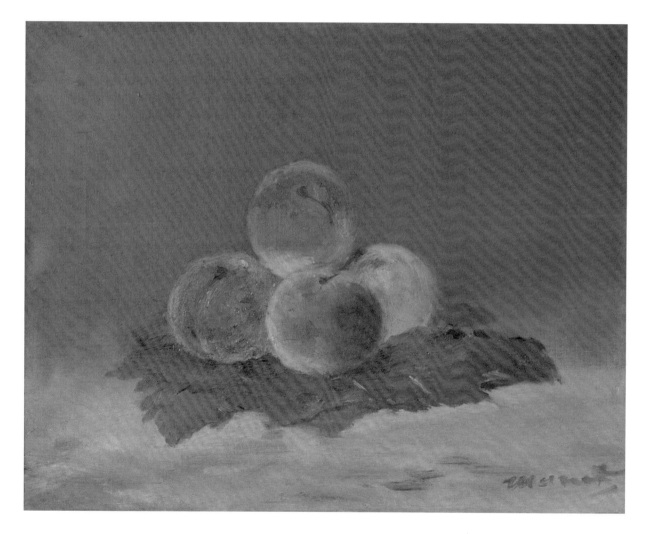

95. ÉDOUARD MANET, PEACHES, 1882

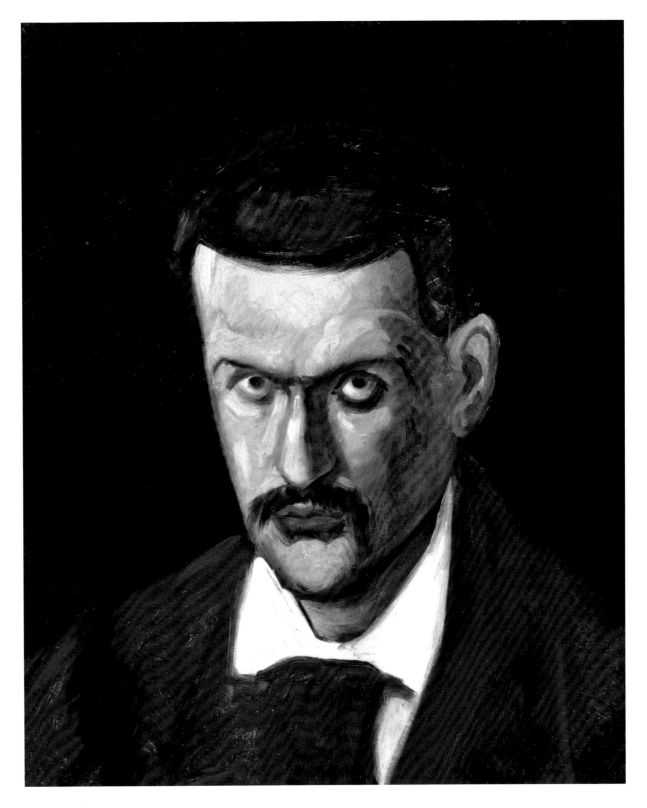

96. PAUL CÉZANNE, SELF-PORTRAIT, 1862–64

97. PAUL CÉZANNE, PICNIC ON THE GRASS, 1869–70

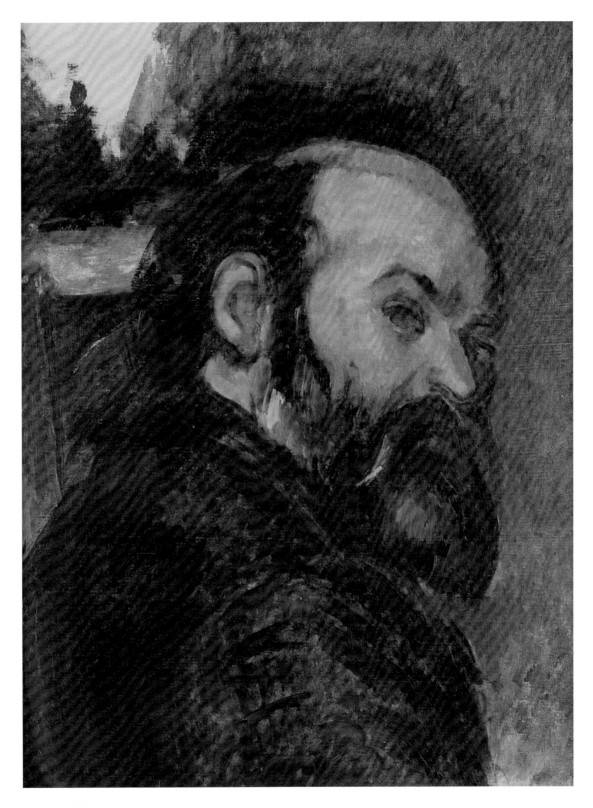

98. PAUL CÉZANNE, *SELF-PORTRAIT*, CA. 1885

99. PAUL CÉZANNE, STILL-LIFE: FLOWERS IN A VASE, 1885–88

100. PAUL CÉZANNE, MAN WITH CROSSED ARMS, CA. 1899

101. PAUL CÉZANNE, STILL-LIFE WITH DRAPERY AND FRUIT, 1904–06

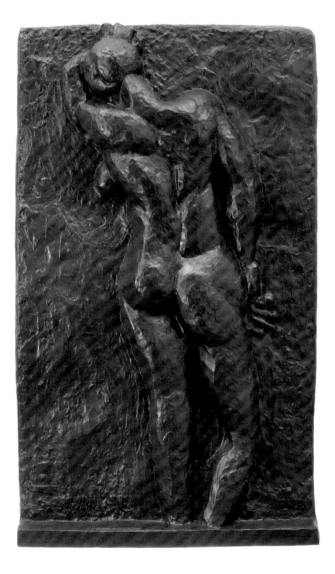 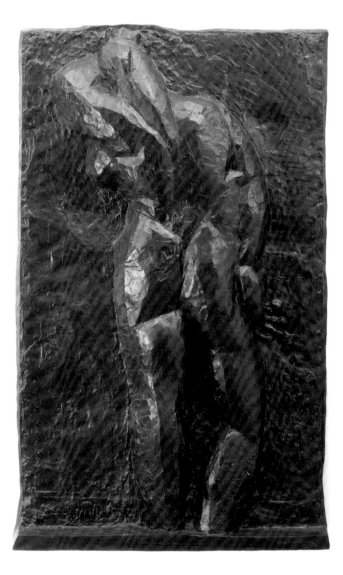

102. HENRI MATISSE, THE BACK (I), 1909 (CAST 1963) 103. HENRI MATISSE, THE BACK (II), 1913 (CAST 1978)

104. HENRI MATISSE, THE BACK (III), 1916/17 (CAST 1981) **105. HENRI MATISSE, THE BACK (IV), 1930 (CAST CA. 1960)**

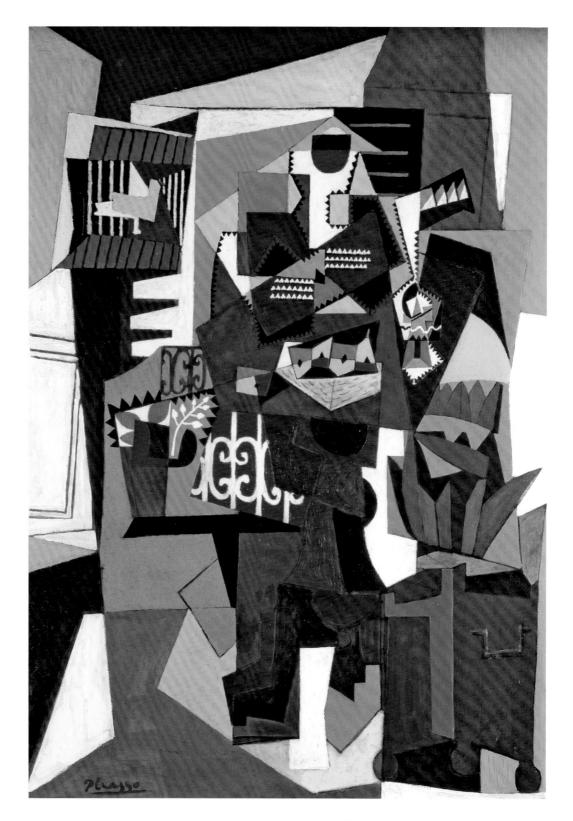

106. PABLO PICASSO, THE BIRDCAGE, 1923

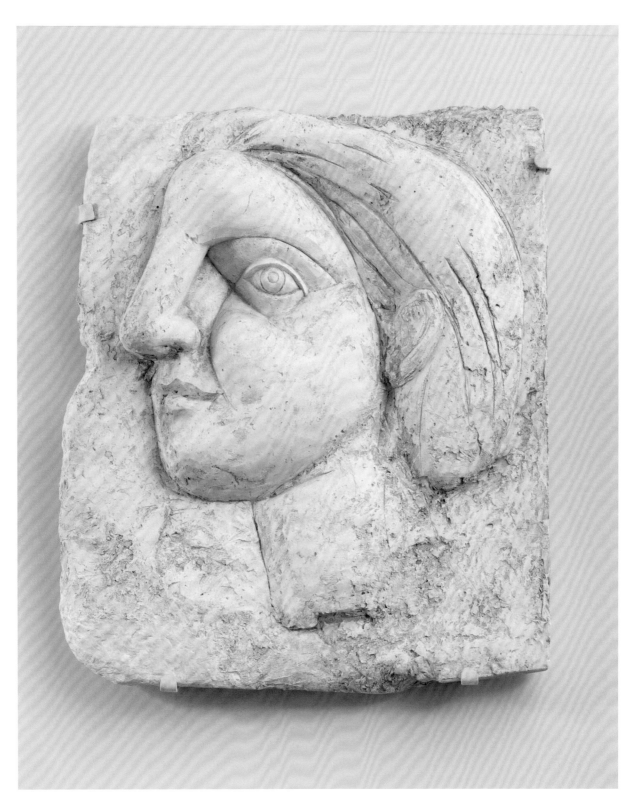

107. PABLO PICASSO, HEAD OF A WOMAN, 1931

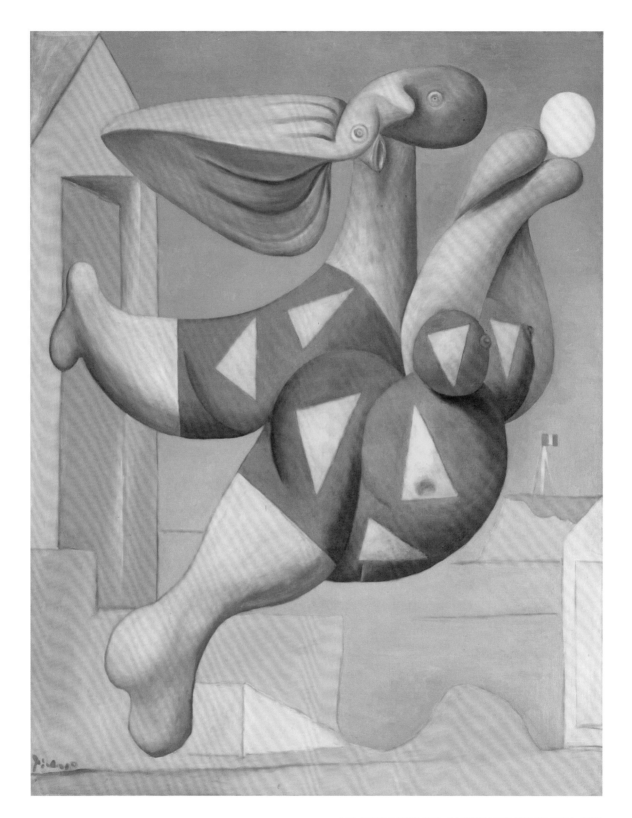

108. PABLO PICASSO, BATHER WITH BEACH BALL, 1932

109. CONSTANTIN BRANCUSI, VIEW OF THE STUDIO, CA. 1918

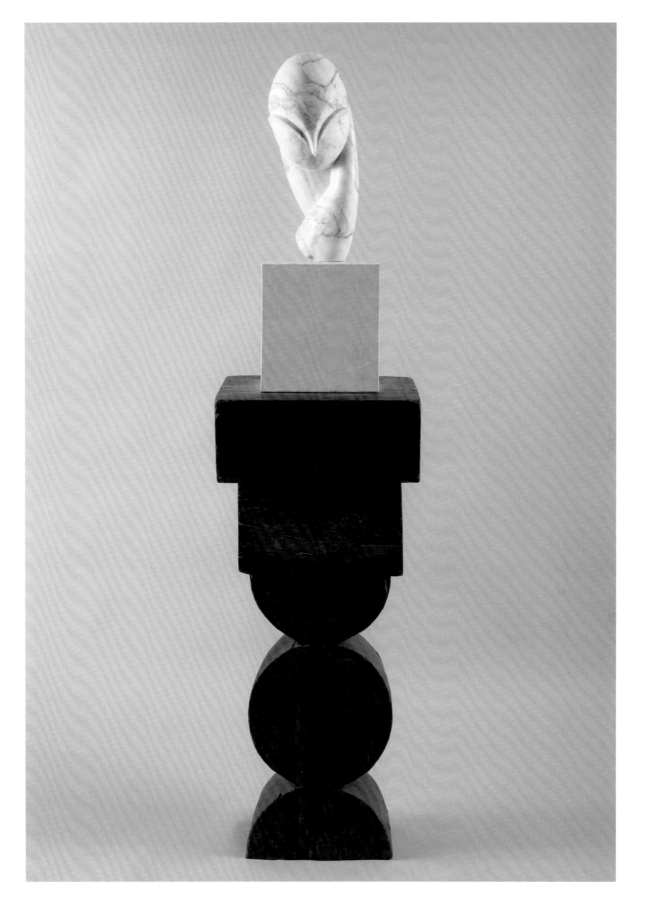

110. CONSTANTIN BRANCUSI, MADEMOISELLE POGANY II, 1919

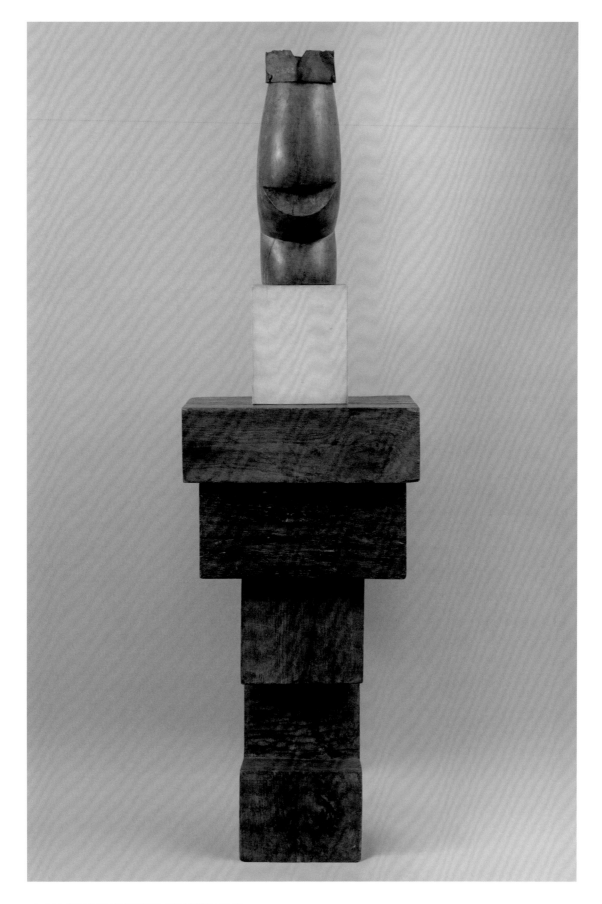

111. CONSTANTIN BRANCUSI, THE CHIEF, 1925

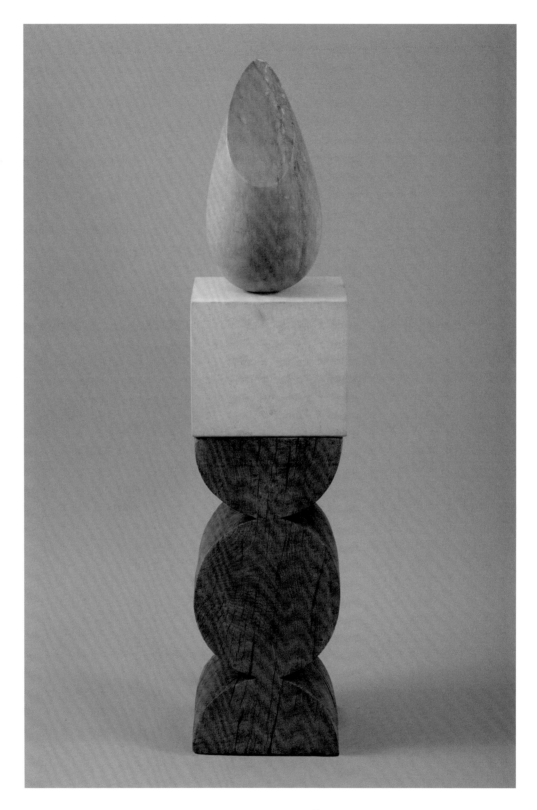

112. CONSTANTIN BRANCUSI, LITTLE BIRD, 1925

113. CONSTANTIN BRANCUSI, THE FISH, 1926/1939

114. CONSTANTIN BRANCUSI, BIRD IN SPACE, CA. 1925

115. ALBERTO GIACOMETTI, DISAGREEABLE OBJECT, 1931

AUSTRIAN PAINTINGS AND SCULPTURE

116. GUSTAV KLIMT, ADELE BLOCH-BAUER I, 1907

117. GUSTAV KLIMT, THE BLACK FEATHER HAT (LADY WITH FEATHER HAT), 1910

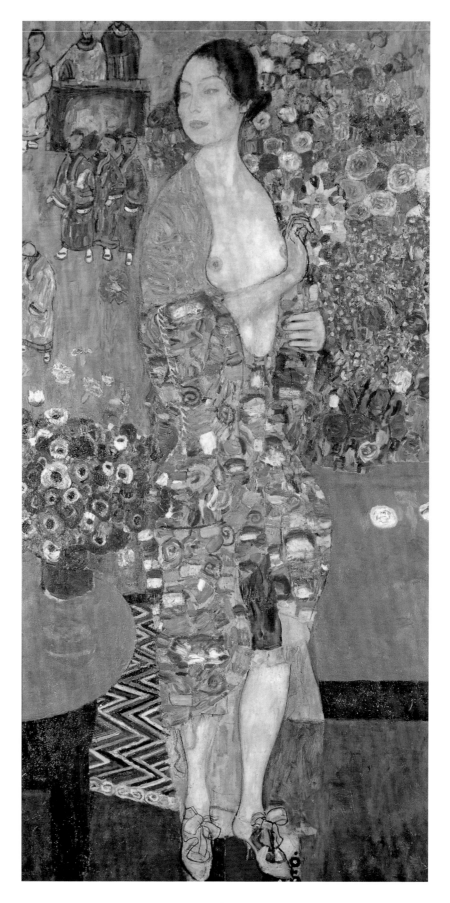

118. GUSTAV KLIMT, THE DANCER, CA. 1916–18

119. EGON SCHIELE, MAN AND WOMAN I (LOVERS I), 1914

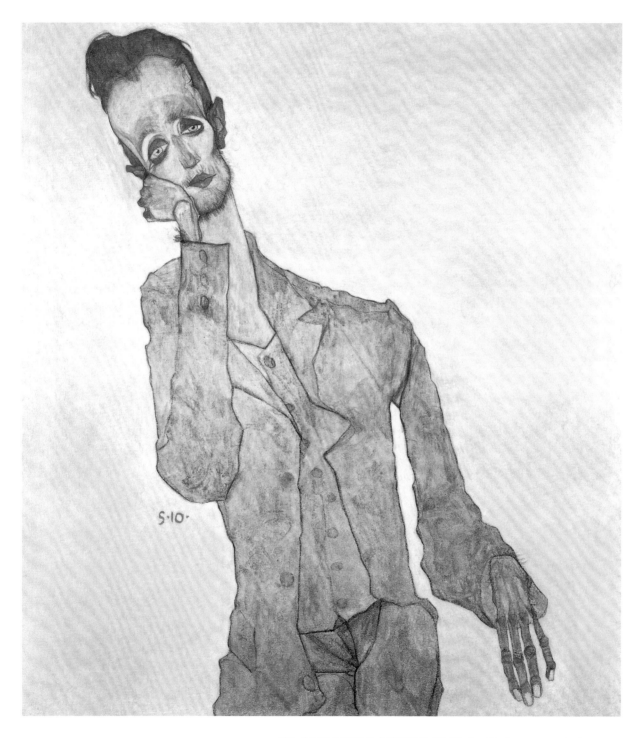

120. EGON SCHIELE, PORTRAIT OF THE PAINTER KARL ZAKOVSEK, 1910

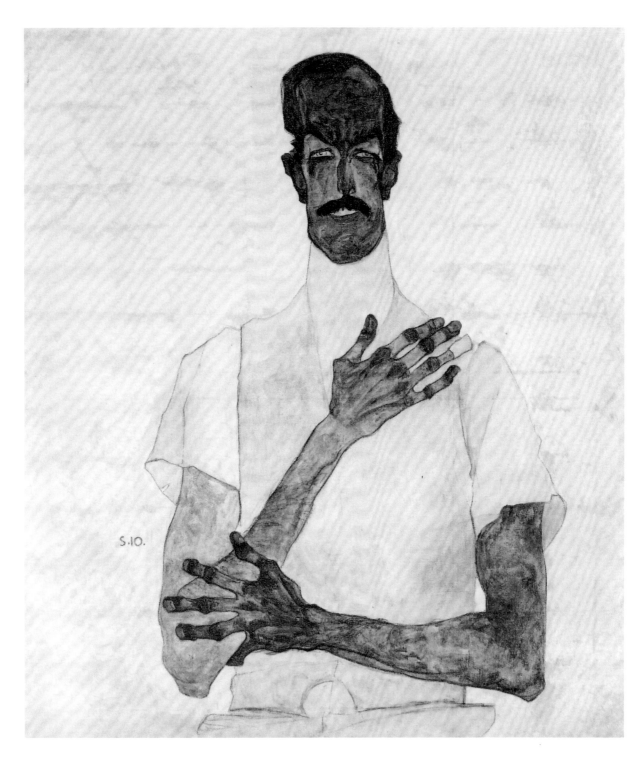

121. EGON SCHIELE, PORTRAIT OF DR. ERWIN VON GRAFF, 1910

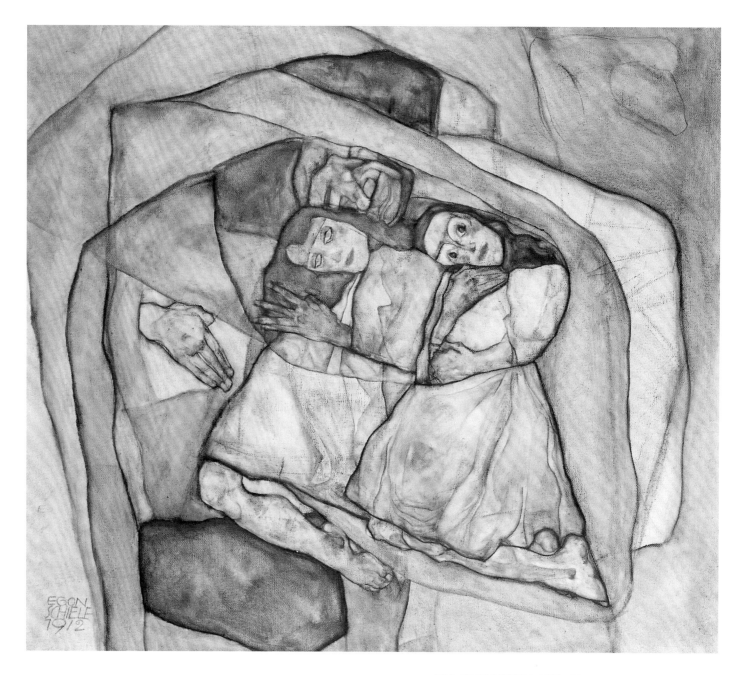

121A. EGON SCHIELE, CONVERSION, 1912

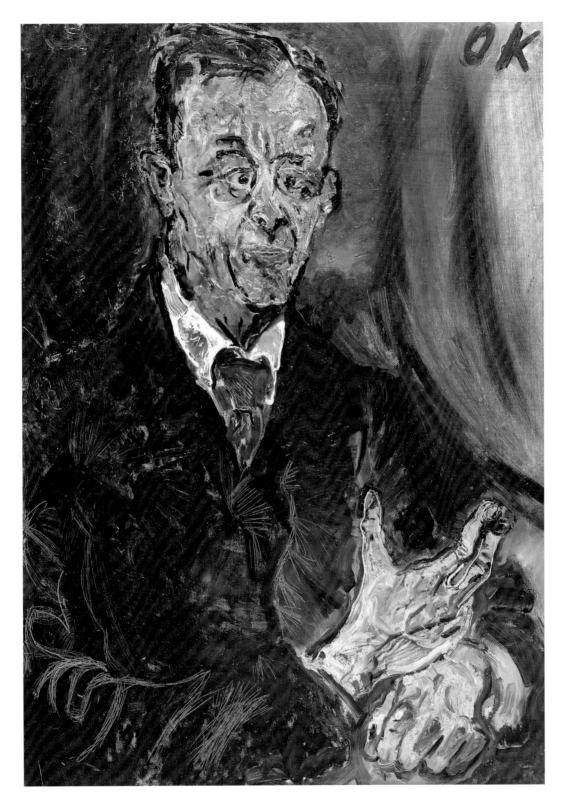

122. OSKAR KOKOSCHKA, DR. RUDOLF BLÜMNER, 1910

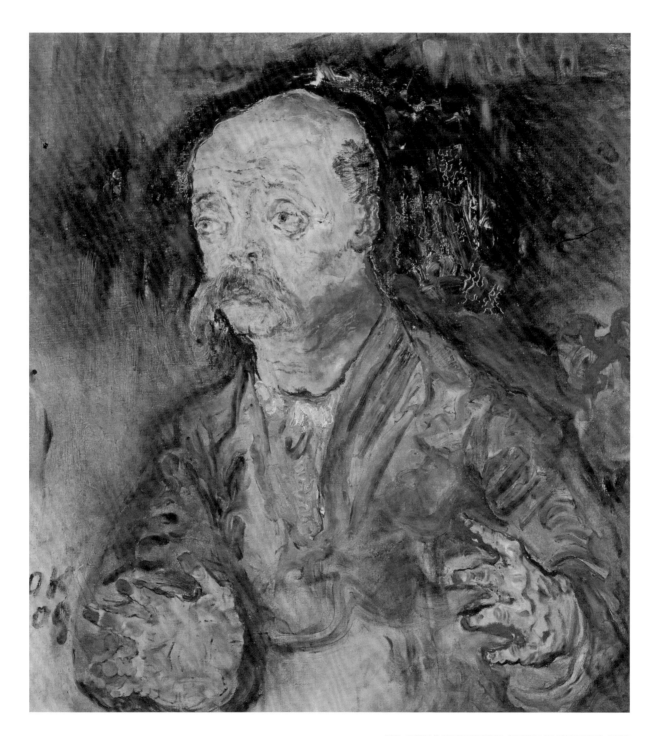

123. OSKAR KOKOSCHKA, PETER ALTENBERG, 1909

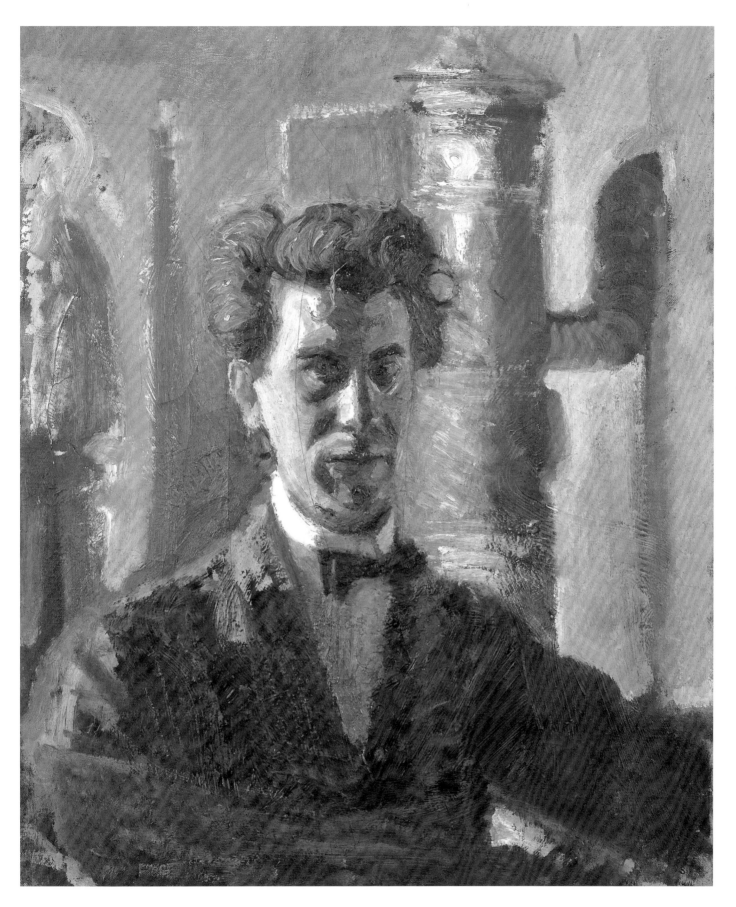

124. RICHARD GERSTL, SELF-PORTRAIT IN FRONT OF A STOVE, 1907

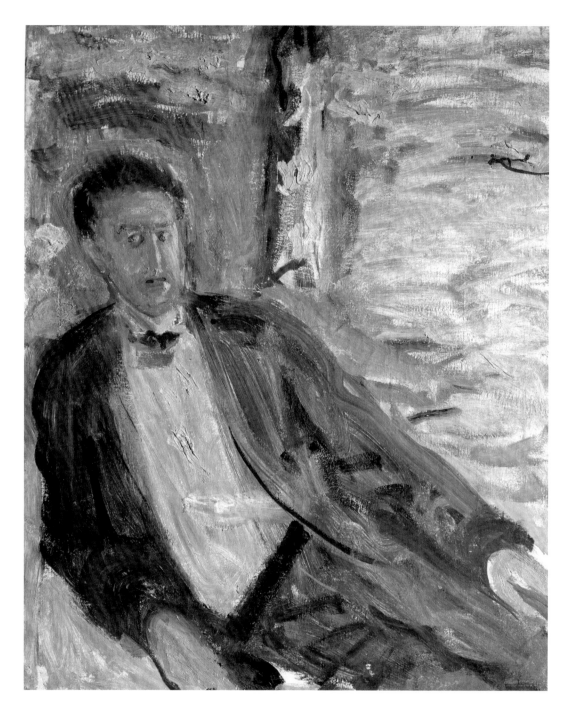

124A. RICHARD GERSTL, PORTRAIT OF A MAN ON THE LAWN, 1907

EARLY 20TH-CENTURY GERMAN PAINTINGS AND SCULPTURE

125. ERICH HECKEL, BATHERS IN A POND, 1908

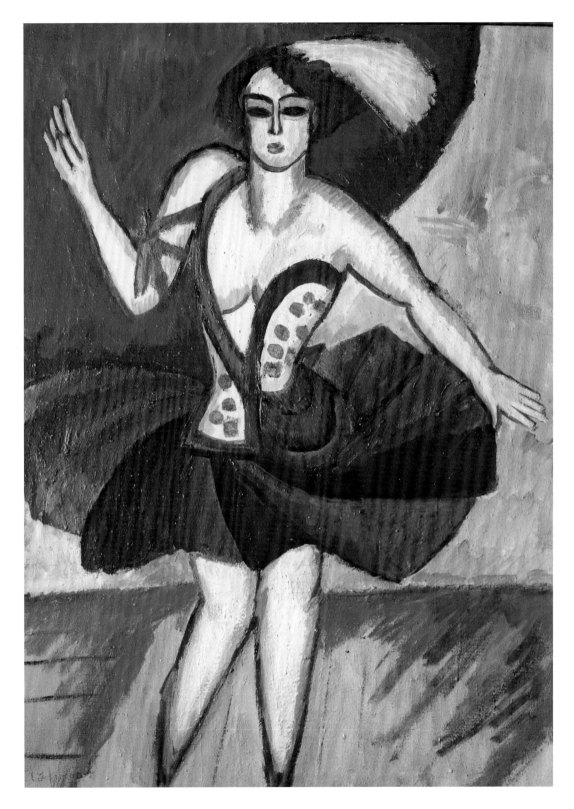

126. ERNST LUDWIG KIRCHNER, THE RUSSIAN DANCER MELA, 1911

127. VASILY KANDINSKY, WITH GREEN RIDER, 1918

128. VASILY KANDINSKY, COMPOSITION V, 1911

←OPEN

129. VASILY KANDINSKY, SEPT, MARCH 1943

275

130. WILLIAM WAUER, PORTRAIT OF HERWARTH WALDEN, 1917 (CAST BETWEEN 1945 AND 1962)

131. WILHELM LEHMBRUCK, BUST OF THE ASCENDING YOUNG MAN, CA. 1914

132. KURT SCHWITTERS, UNTITLED (MERZ PICTURE HORSE FAT), CA. 1920

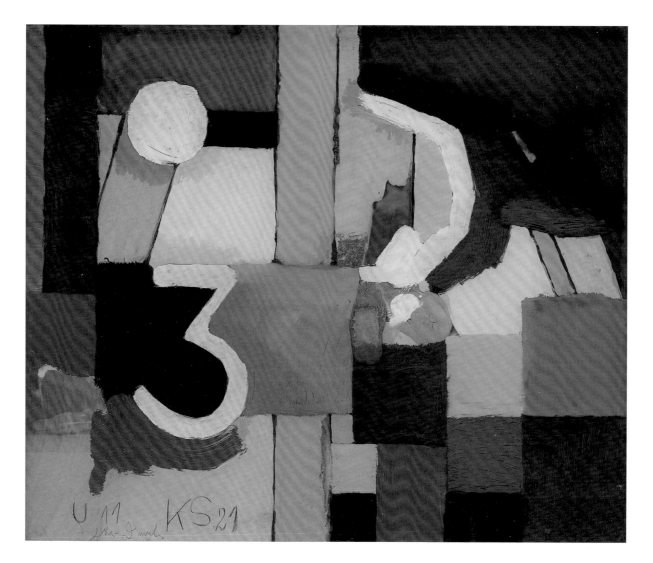

133. KURT SCHWITTERS, U11 FOR DEXEL, 1921

134. OTTO DIX, PORTRAIT OF THE LAWYER DR. FRITZ GLASER, 1921

135. OTTO DIX, HALF-NUDE, 1926

136. LUDWIG MEIDNER, I AND THE CITY, 1913

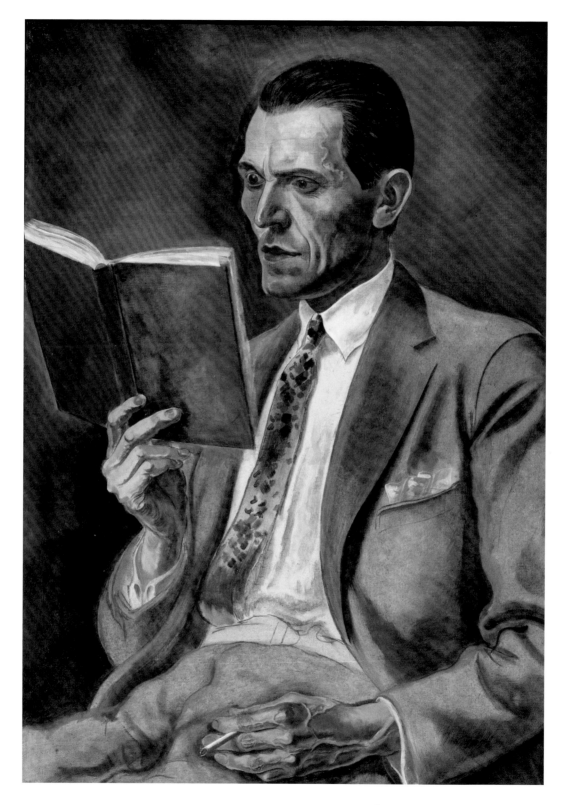

137. GEORGE GROSZ, PORTRAIT OF JOHN FÖRSTE, MAN WITH GLASS EYE, 1926

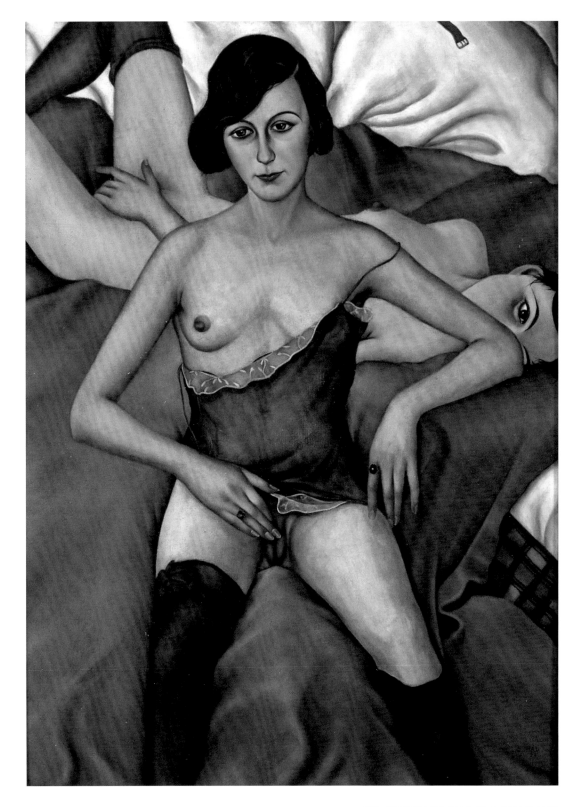

138. CHRISTIAN SCHAD, TWO GIRLS, 1928

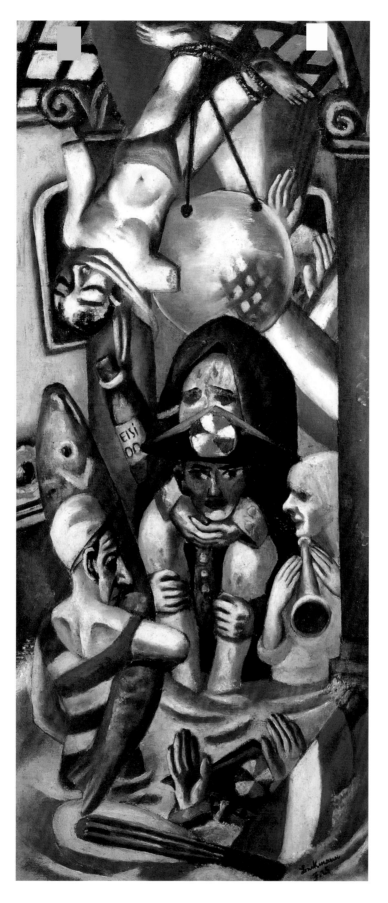

139. MAX BECKMANN, GALLERIA UMBERTO, 1925

140. MAX BECKMANN, SELF-PORTRAIT IN FRONT OF A RED CURTAIN, 1923

141. PAUL KLEE, GAY REPAST (COLORFUL MEAL), 1928–29

142. OSKAR SCHLEMMER, FIVE NUDES, 1929

POSTWAR GERMAN
PAINTINGS AND SCULPTURE

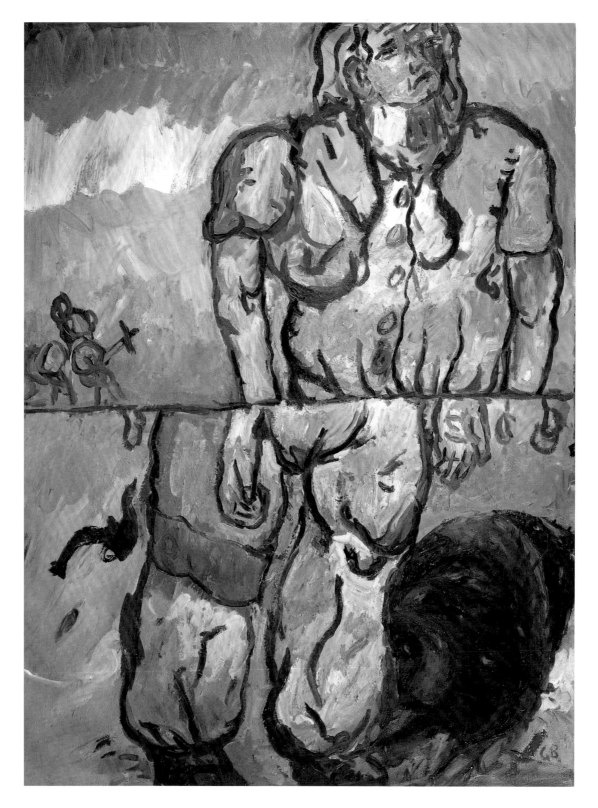

143. GEORG BASELITZ, MMM IN G UND A, 1961/62/66

144. SIGMAR POLKE, THE TENNIS PLAYER, 1964

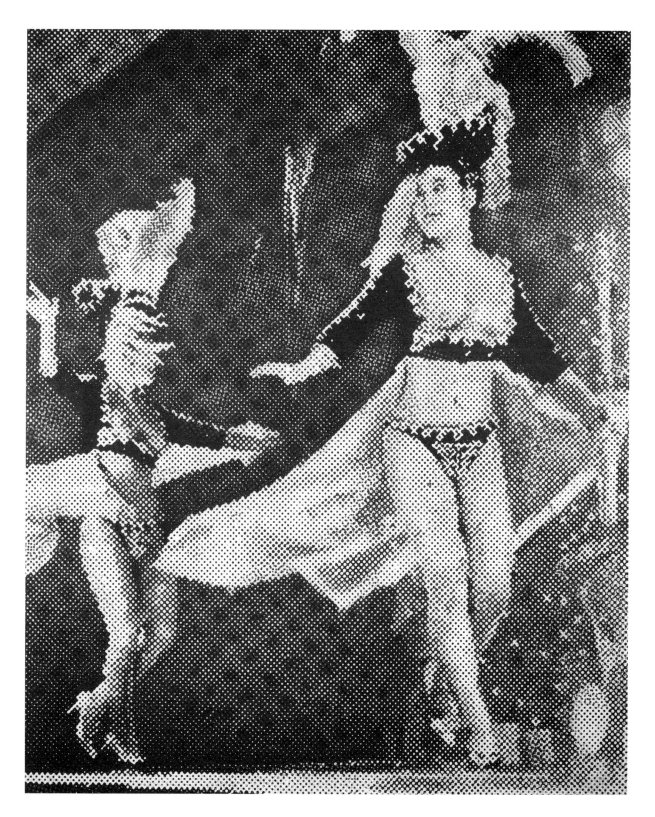

145. SIGMAR POLKE, JAPANESE DANCERS, 1966

146. SIGMAR POLKE, WATCHTOWER, 1984

147. SIGMAR POLKE, UNTITLED, 1998

148. GERHARD RICHTER, STAG, 1963

149. GERHARD RICHTER, CITYSCAPE PL, 1970

150. GERHARD RICHTER, STUDY FOR SERIAL NUMBER 324 (FREUD), 1971

151. GERHARD RICHTER, GRAY, 1974

152. GERHARD RICHTER, TWO SCULPTURES FOR A ROOM BY PALERMO, 1971

153. GÜNTHER UECKER, SPIRAL, 1962

304

154. GÜNTHER UECKER, UNTITLED, 1967

155. JÖRG IMMENDORFF, FRUIT MAN, 1965

156. JÖRG IMMENDORFF, MILDE SORTE, 1964

157. EUGEN SCHÖNEBECK, THE CRUCIFIED II, 1964

158. MARKUS LÜPERTZ, SOLDIER – DITHYRAMBIC II, 1972

159. JOSEPH BEUYS, RED IN THE MIDDLE, 1984

160. JOSEPH BEUYS, INFILTRATION-HOMOGEN FOR CELLO, EXECUTED 1967; COMPLETED 1985

161. JOSEPH BEUYS, UNTITLED, 1968

162. JOSEPH BEUYS, THE END OF 100 DAYS AT DOCUMENTA, 1972

163. JOSEPH BEUYS, THREE BLACKBOARDS, 1974

164. MARTIN KIPPENBERGER, UNTITLED, 1990

165. ANSELM KIEFER, HELIOGABAL, 1983

WORKS ON PAPER

- FRENCH

- AUSTRIAN

- GERMAN

 EARLY 20TH-CENTURY

 POSTWAR

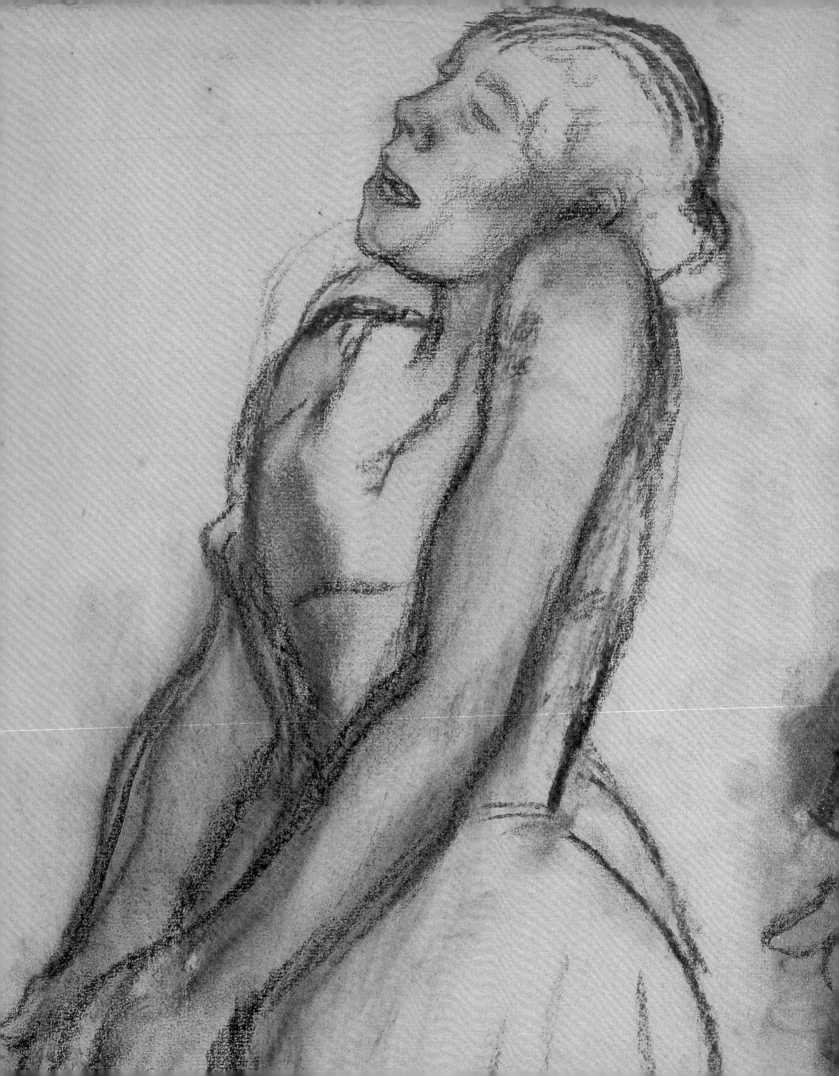

FRENCH WORKS ON PAPER

166. HILAIRE-GERMAIN-EDGAR DEGAS, PORTRAIT OF A MAN, UNDATED

167. HILAIRE-GERMAIN-EDGAR DEGAS, STANDING DANCER FASTENING HER SASH, CA. 1873

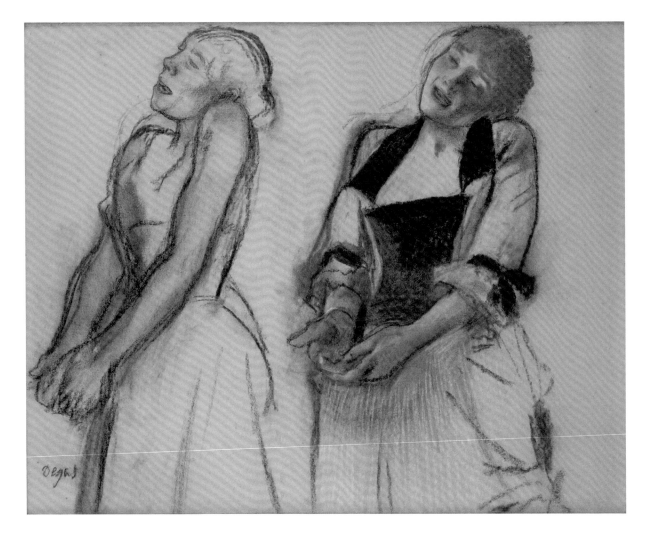

168. HILAIRE-GERMAIN-EDGAR DEGAS, TWO STUDIES FOR MUSIC HALL SINGERS, CA. 1878–80

169. HILAIRE-GERMAIN-EDGAR DEGAS, LANDSCAPE, 1892

170. PAUL CÉZANNE, BATHERS, 1870–75

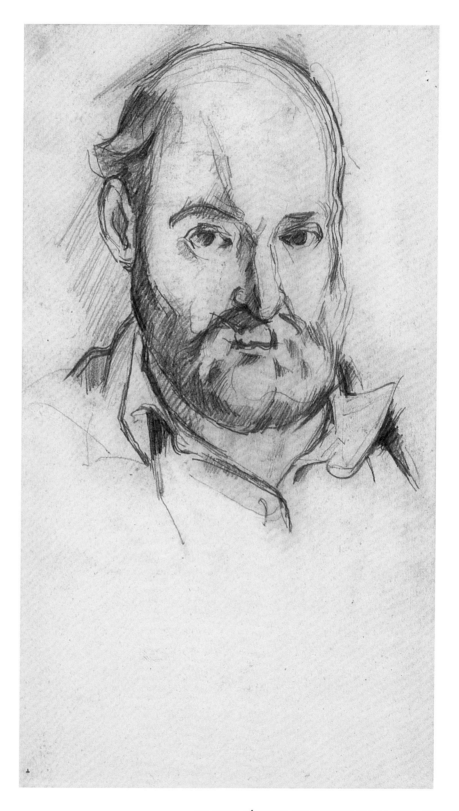

171. PAUL CÉZANNE, SELF-PORTRAIT, CA. 1882–83

172. PAUL CÉZANNE, FULL-LENGTH PORTRAIT OF THE ARTIST'S SON PAUL, CA. 1885–86

173. PAUL CÉZANNE, STILL-LIFE WITH SPIRIT LAMP, 1887–90

174. PAUL CÉZANNE, COAT ON A CHAIR, 1890–95

175. PAUL CÉZANNE, ROCKS NEAR THE CAVES ABOVE CHÂTEAU NOIR (ROCKS NEAR BIBÉMUS), 1895–1900

176. PAUL CÉZANNE, MONT SAINTE-VICTOIRE, 1900–02

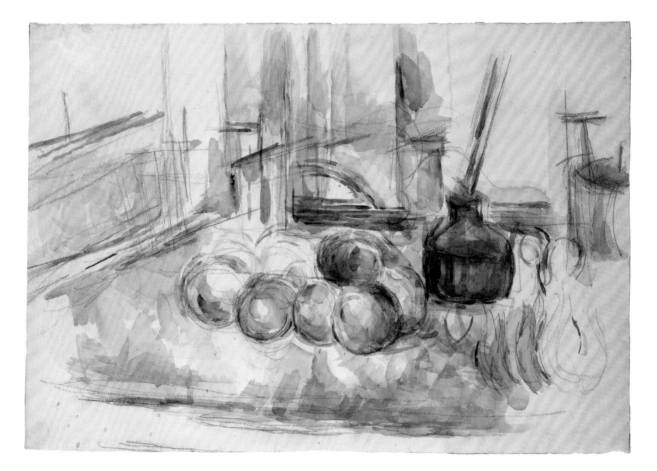

177. PAUL CÉZANNE, APPLES AND INKWELL, CA. 1902–06

**178. VINCENT VAN GOGH, SOUVENIR OF SAINTES-MARIES ON THE MEDITERRANEAN;
BOATS ON THE BEACH, SAINTES-MARIES-DE-LA-MER, 1888**

179. VINCENT VAN GOGH, PORTRAIT OF JOSEPH ROULIN, 1888

180. VINCENT VAN GOGH, GARDEN WITH FLOWERS, 1888

181. VINCENT VAN GOGH, OLIVE TREES WITH LES ALPILLES IN THE BACKGROUND, 1889

182. GEORGES PIERRE SEURAT, SLEEPING MAN, 1881–84

183. GEORGES PIERRE SEURAT, MAN IN A BOWLER HAT (STUDY FOR *BAIGNADE*), 1883

184. GEORGES PIERRE SEURAT, GIRL IN A SLOUCH HAT, 1882–84

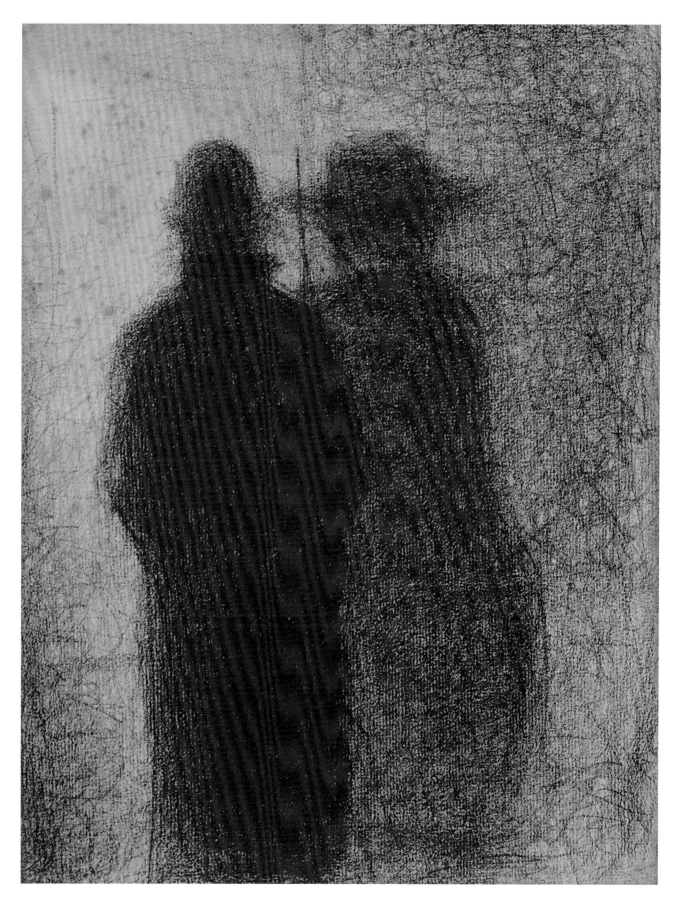

185. GEORGES PIERRE SEURAT, THE COUPLE (AT DUSK), 1882–83

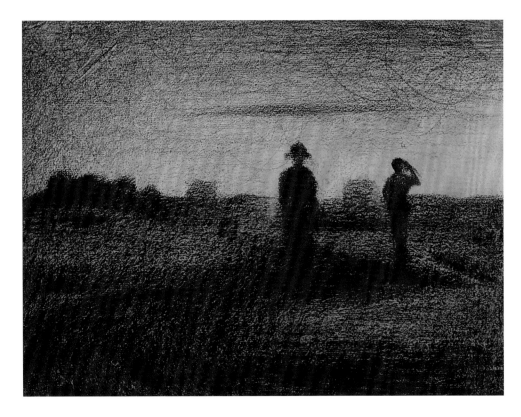

186. GEORGES PIERRE SEURAT, DUSK (THE ANGELUS), CA. 1883

187. GEORGES PIERRE SEURAT, THE PIER OF PORT-EN-BESSIN, CA. 1888

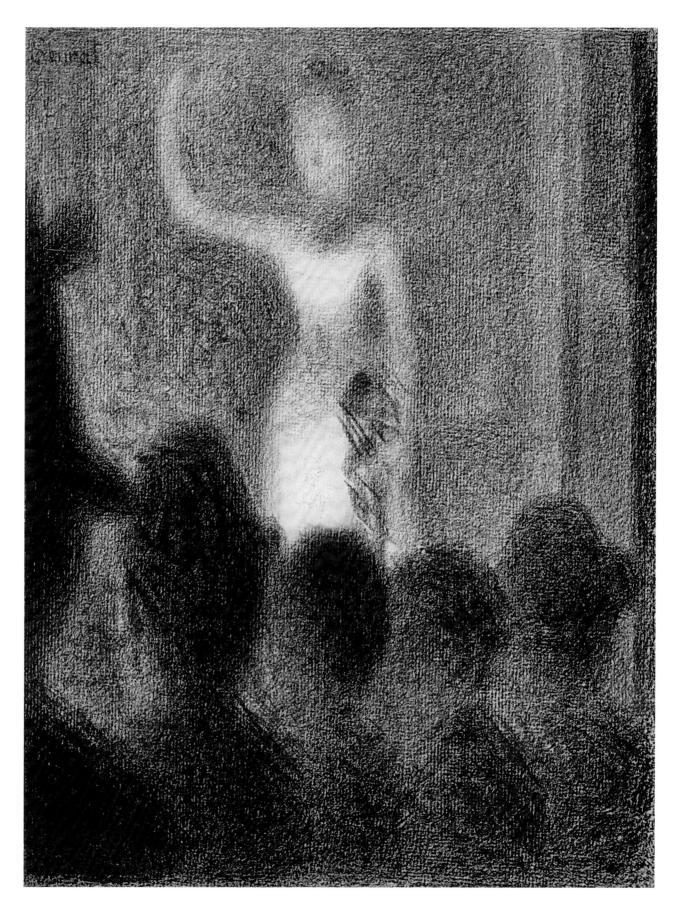

188. GEORGES PIERRE SEURAT, HIGH C, 1887–88

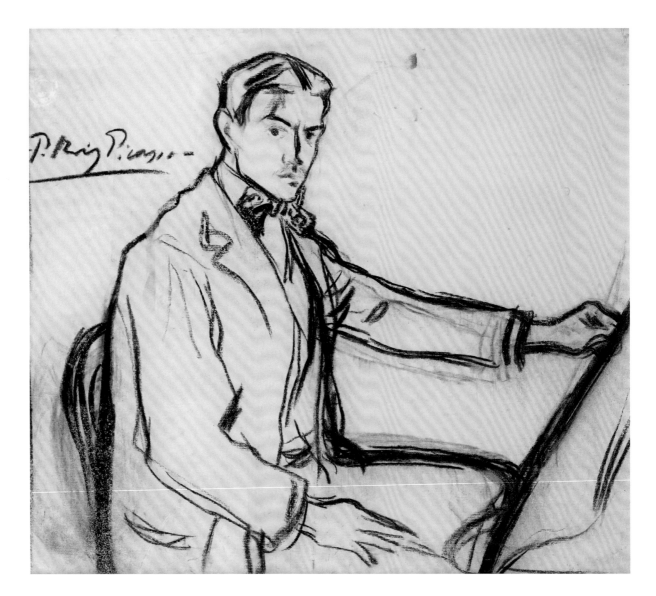

189. PABLO PICASSO, SELF-PORTRAIT, 1899

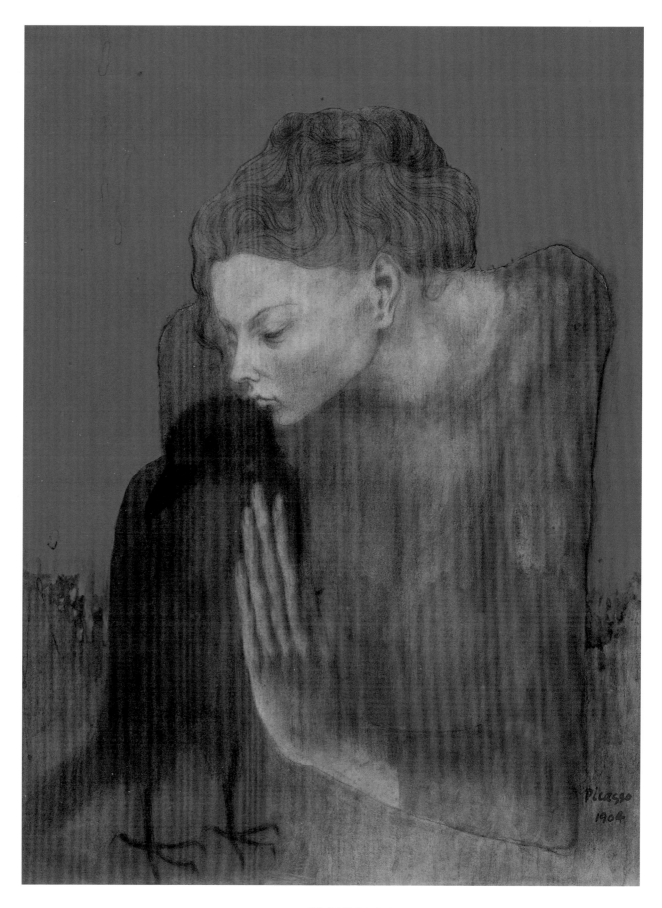

190. PABLO PICASSO, WOMAN WITH A RAVEN, 1904

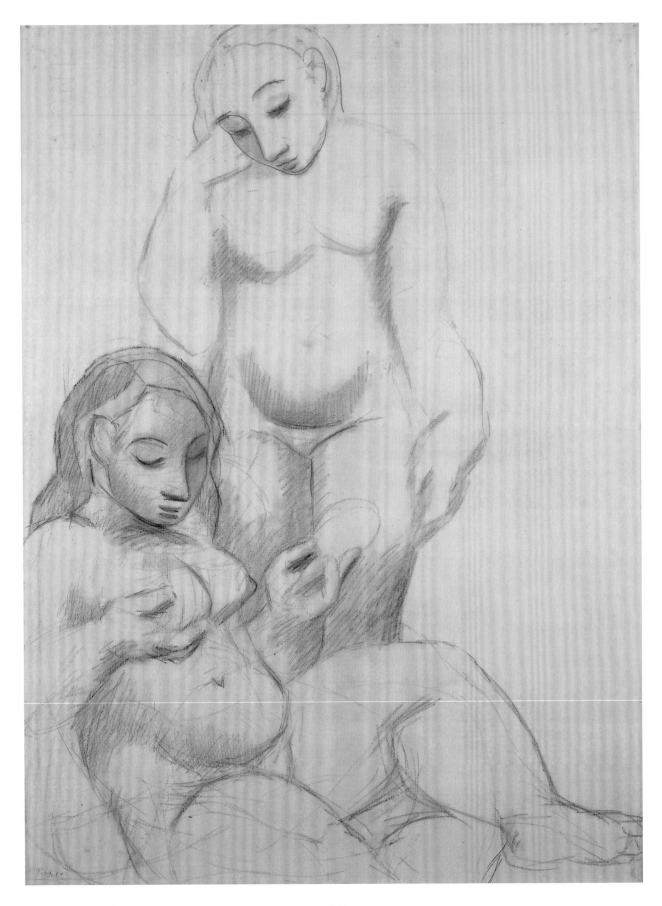

191. PABLO PICASSO, TWO FEMALE NUDES, 1906

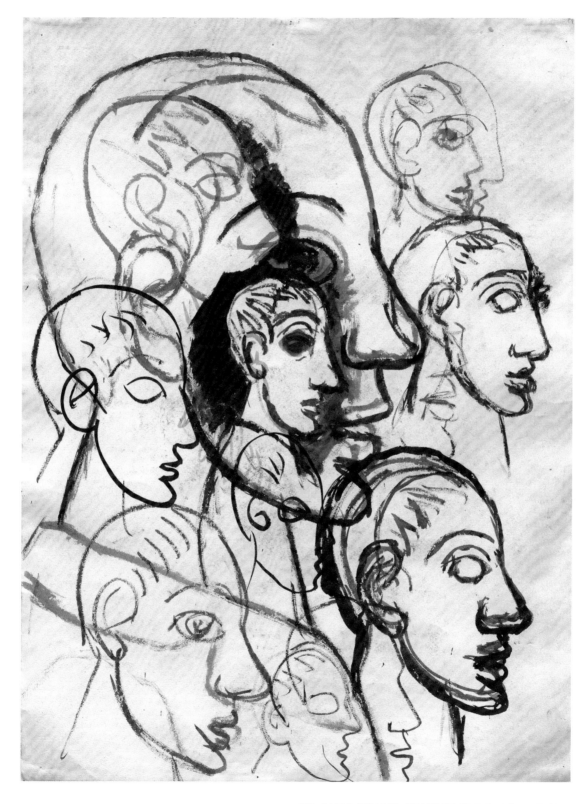

192. PABLO PICASSO, PROFILES OF A MAN'S HEAD, 1907

193. PABLO PICASSO, HEAD, 1907

194. PABLO PICASSO, HEAD OF A WOMAN, FERNANDE, 1908–09

195. PABLO PICASSO, STANDING NUDE SEEN FROM THE BACK, 1908

196. PABLO PICASSO, FEMALE NUDE, 1910

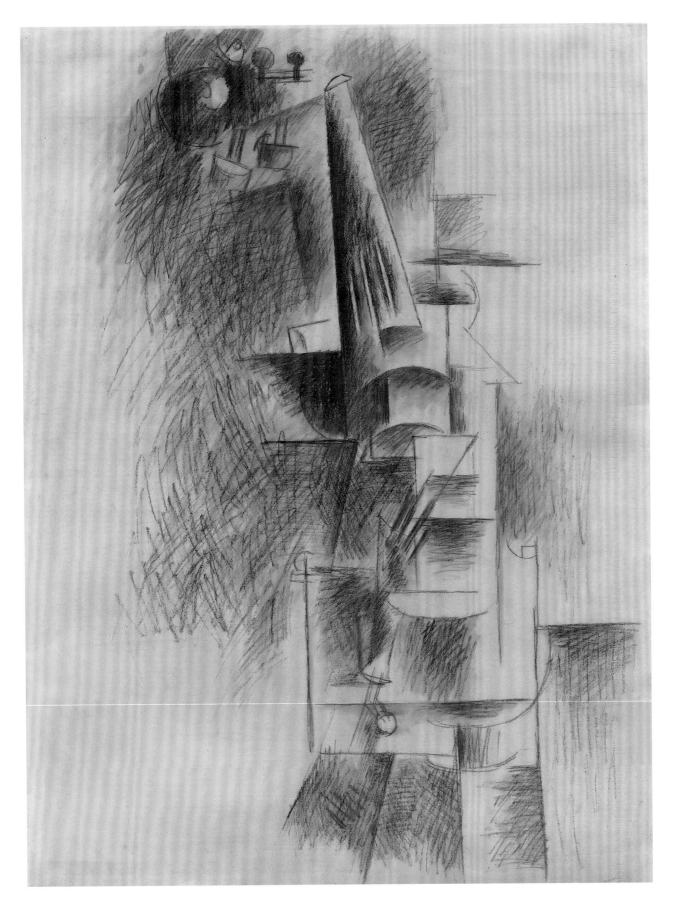

197. PABLO PICASSO, VIOLIN, 1912

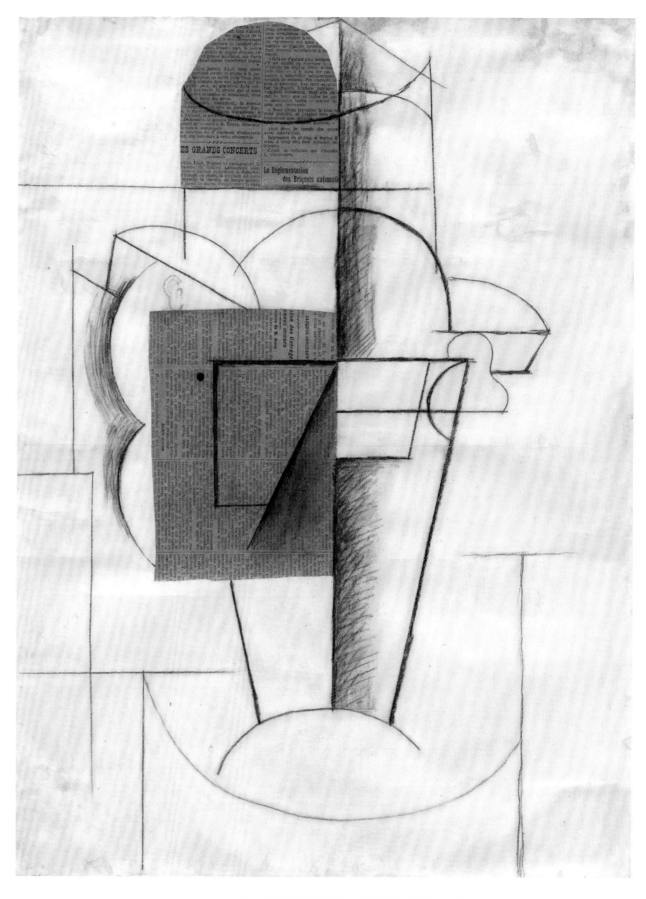

198. PABLO PICASSO, HEAD OF A MAN IN A BOWLER HAT, 1912

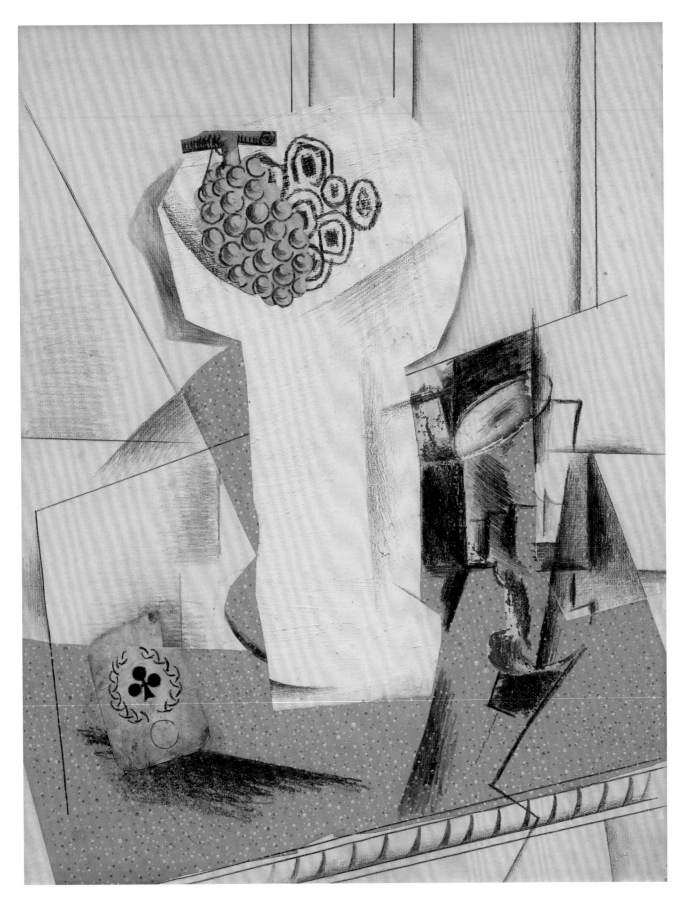

199. PABLO PICASSO, PLAYING CARD, FRUIT DISH, GLASS, 1914

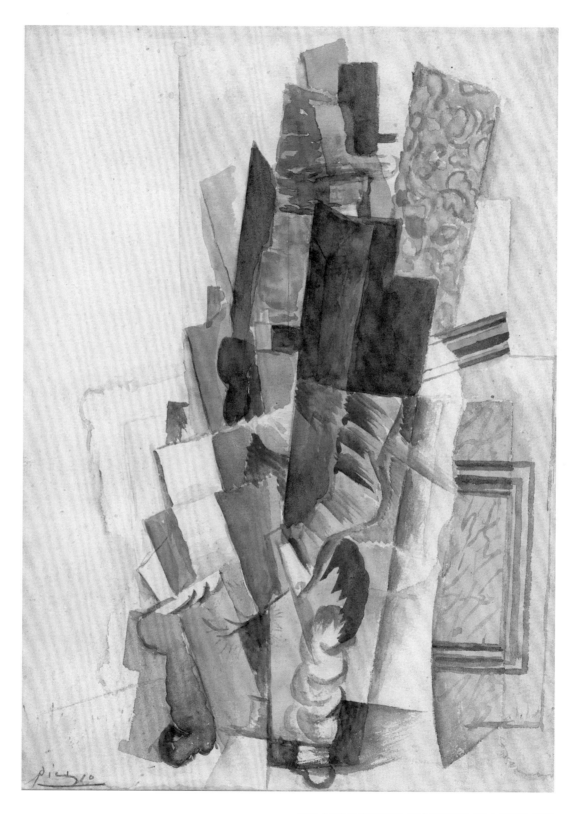

200. PABLO PICASSO, MAN SEATED ON A CHAIR, 1915

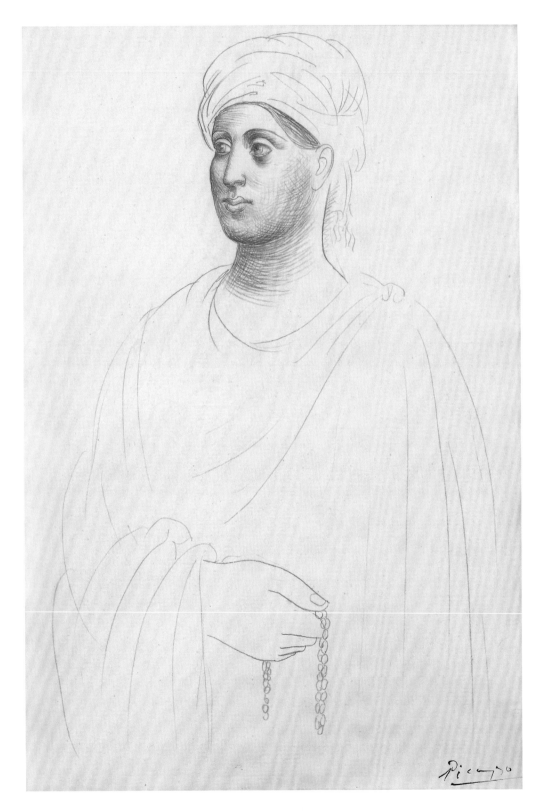

201. PABLO PICASSO, WOMAN WITH ROSARY, 1919

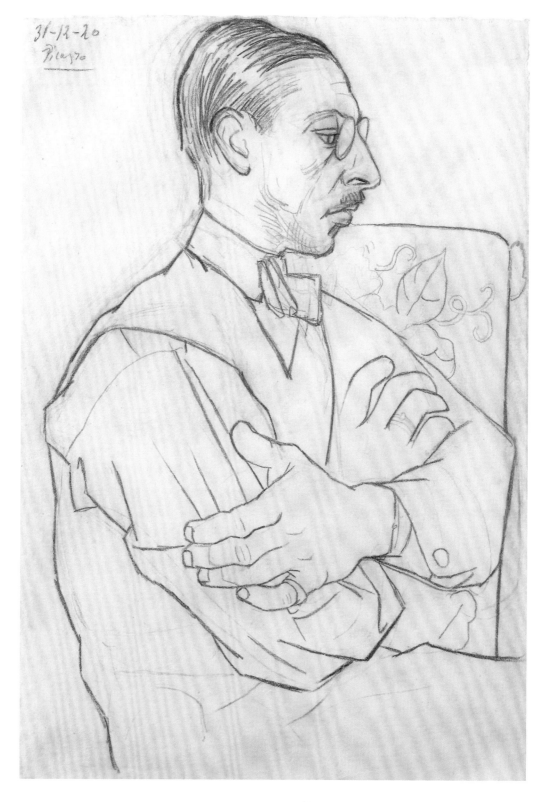

202. PABLO PICASSO, IGOR STRAVINSKY, 1920

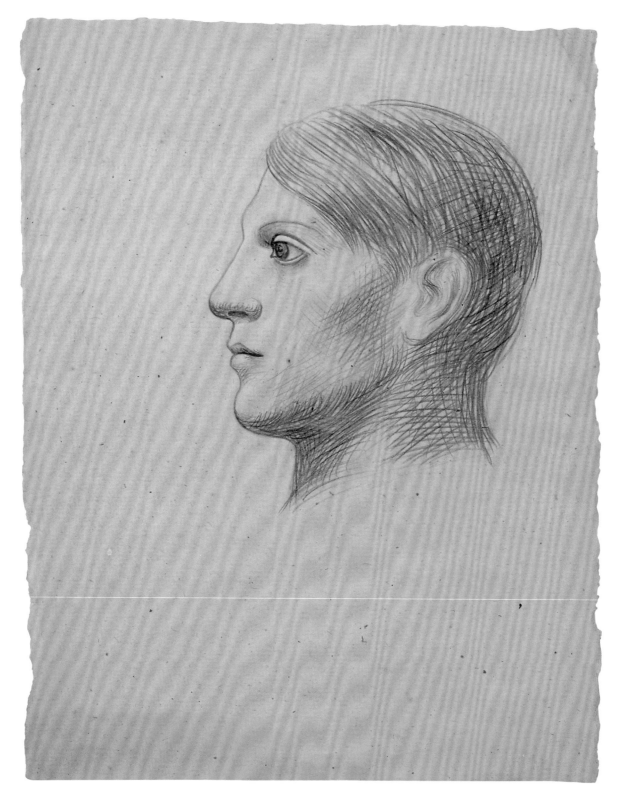

203. PABLO PICASSO, SELF-PORTRAIT IN PROFILE, 1921

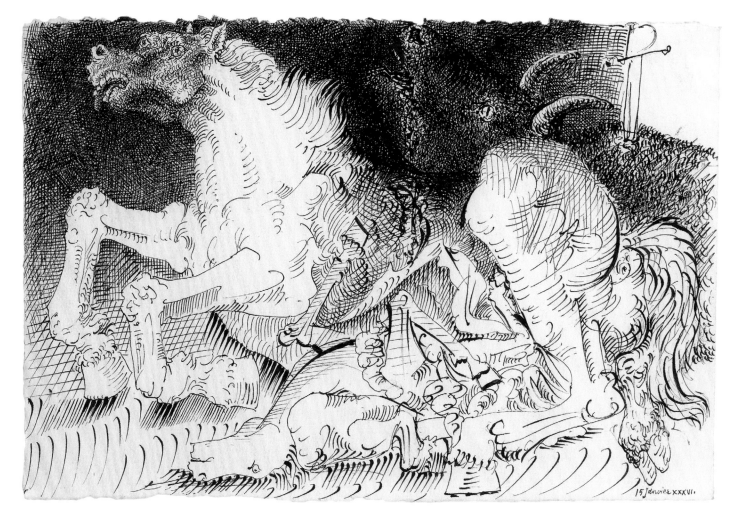

204. PABLO PICASSO, BULL AND HORSES, 1936

205. HENRI MATISSE, RECLINING NUDE PLAYING PIPES (STUDY FOR *JOY OF LIFE*), 1905–06

206. HENRI MATISSE, SEATED WOMAN (STUDY FOR THE LINOLEUM CUT, *NU ASSIS*), CA. 1906

207. HENRI MATISSE, HAT WITH FEATHERS, 1919

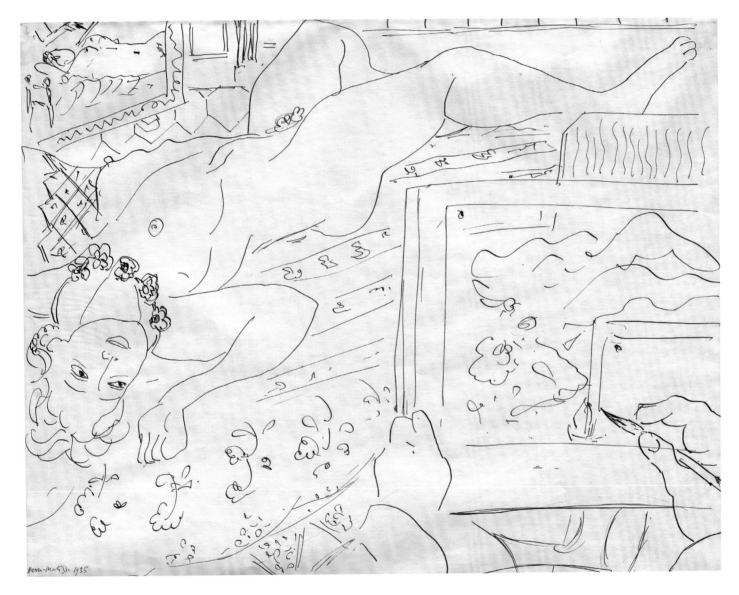

208. HENRI MATISSE, STUDIO OF THE ARTIST, 1935

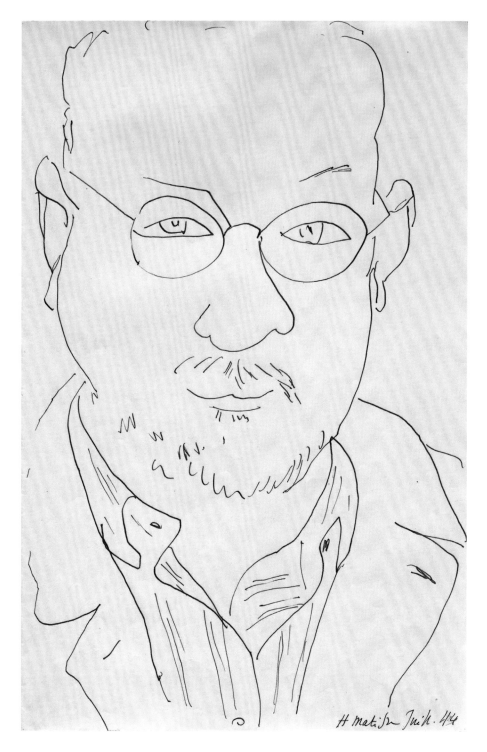

209. HENRI MATISSE, SELF-PORTRAIT, OPEN SHIRT, 1944

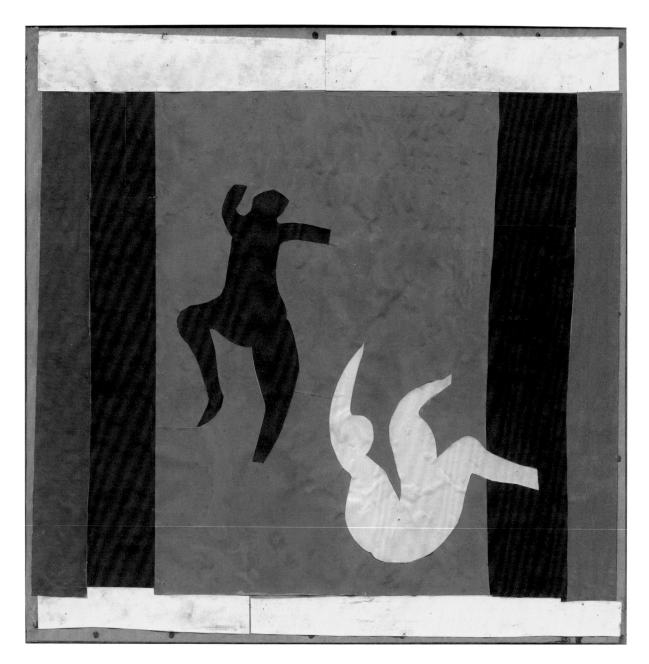

210. HENRI MATISSE, TWO DANCERS (STUDY FOR THE CURTAIN OF STRANGE FARANDOLE), 1938

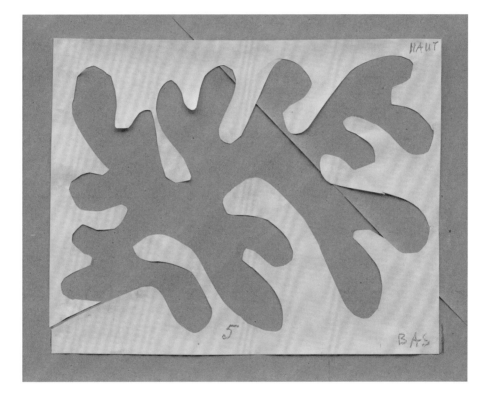

211. HENRI MATISSE, ASCHER SQUARE (MAQUETTE B), ELEMENT #5, 1946

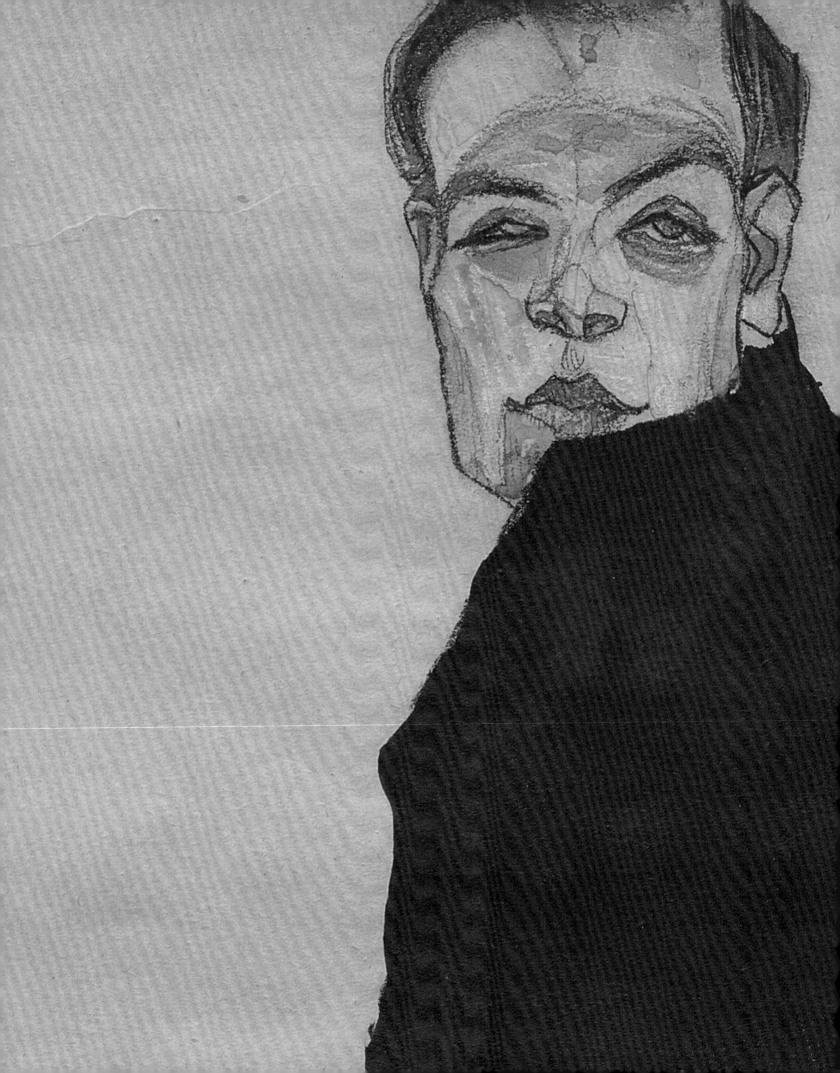

AUSTRIAN WORKS ON PAPER

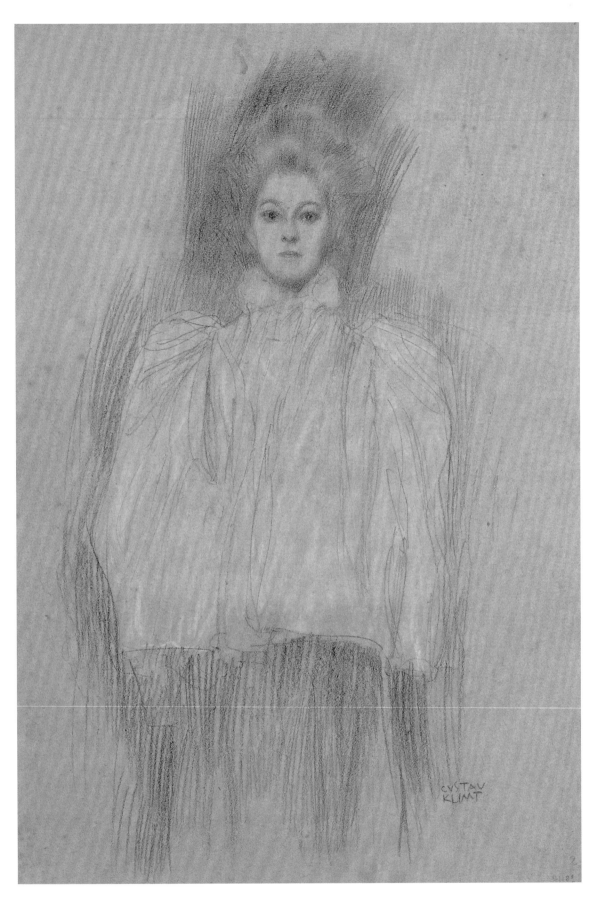

212. GUSTAV KLIMT, STANDING WOMAN WITH CAPE, CA. 1896

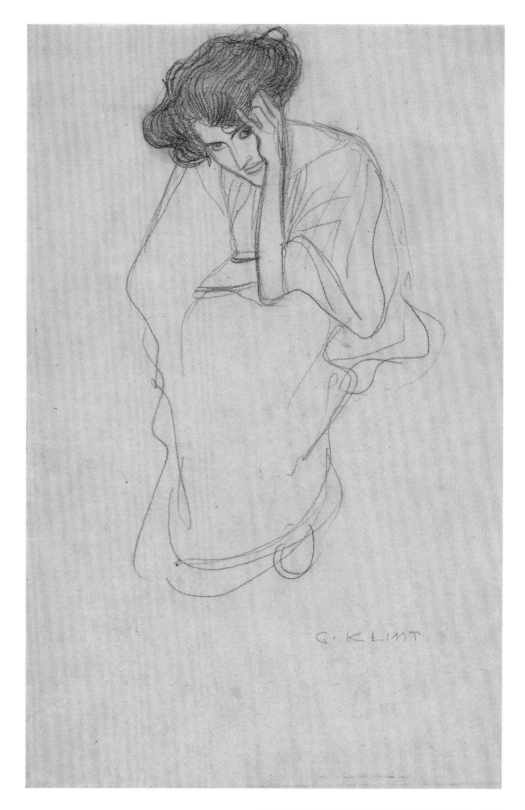

213. GUSTAV KLIMT, SEATED WOMAN RESTING, 1902

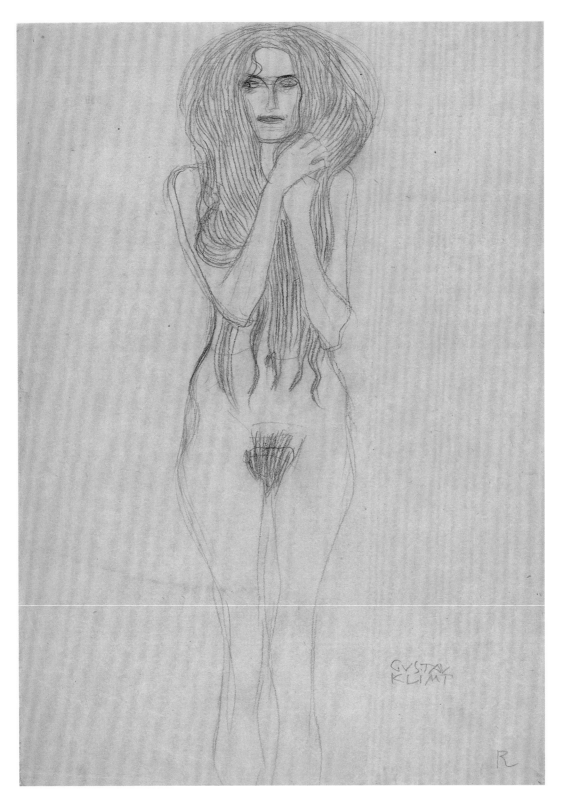

214. GUSTAV KLIMT, FEMALE NUDE FROM THE FRONT, 1902

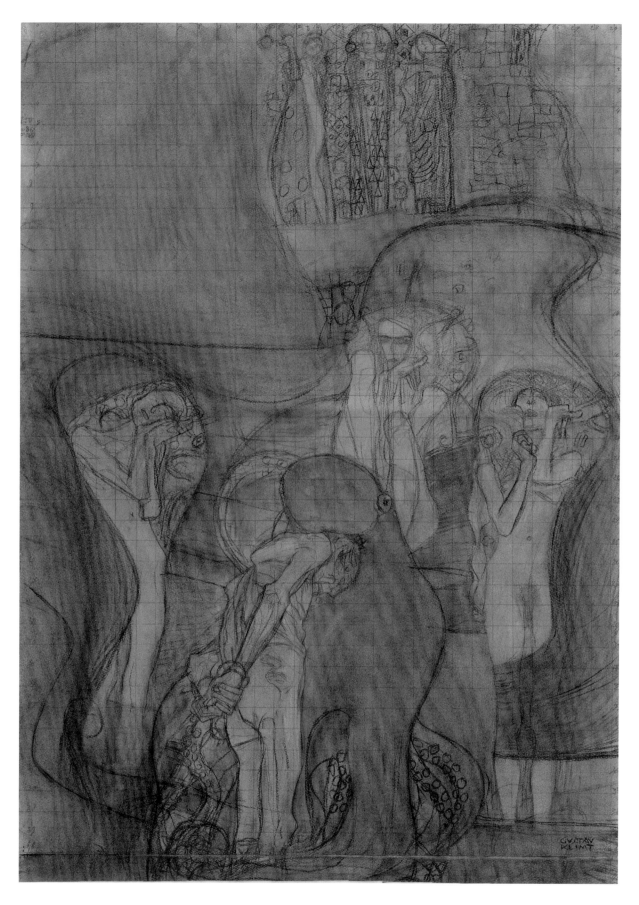

215. GUSTAV KLIMT, TRANSFER DRAWING FOR *JURISPRUDENCE*, 1902–03

216. GUSTAV KLIMT, SEATED OLD WOMAN IN PROFILE FACING LEFT, CA. 1904

217. GUSTAV KLIMT, WOMAN, RAISED LOWER ARMS, HANDS BENT BACKWARDS, CA. 1905–11

218. GUSTAV KLIMT, TWO RECLINING WOMEN FACING RIGHT, CA. 1904

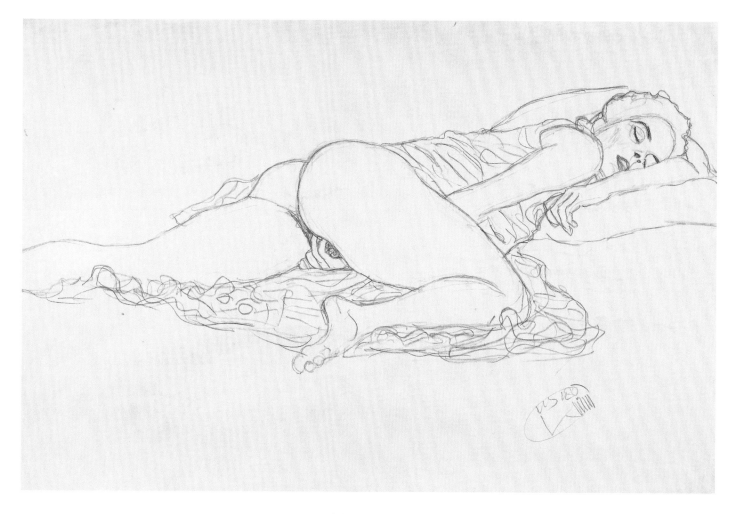

219. GUSTAV KLIMT, RECLINING NUDE FACING RIGHT, 1912–13

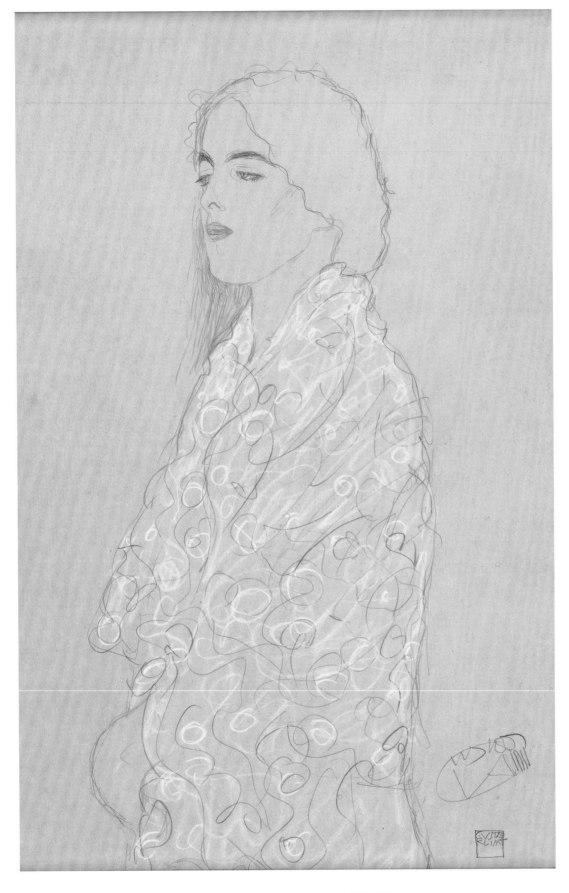

220. GUSTAV KLIMT, WOMAN IN KIMONO FACING LEFT, 1910

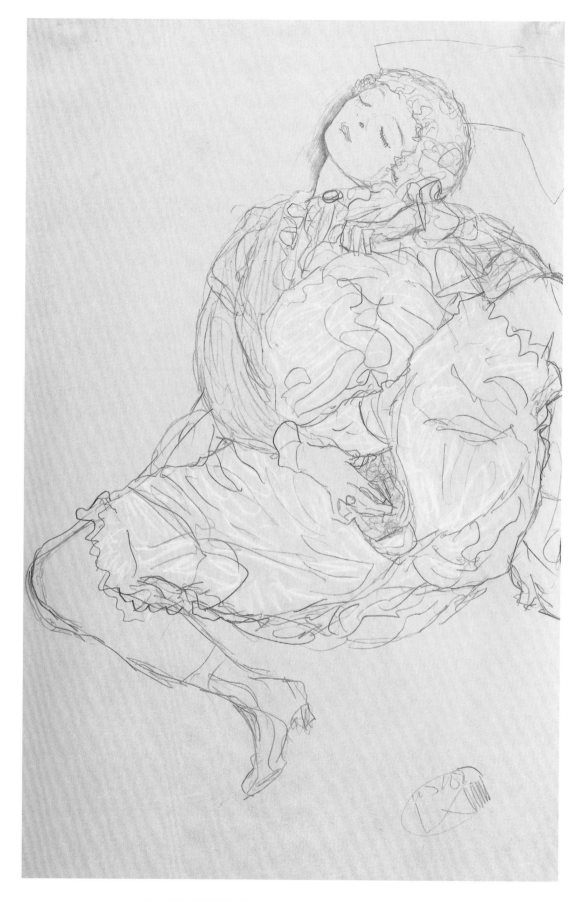

221. GUSTAV KLIMT, SEATED WOMAN WITH SPREAD THIGHS, 1916–17

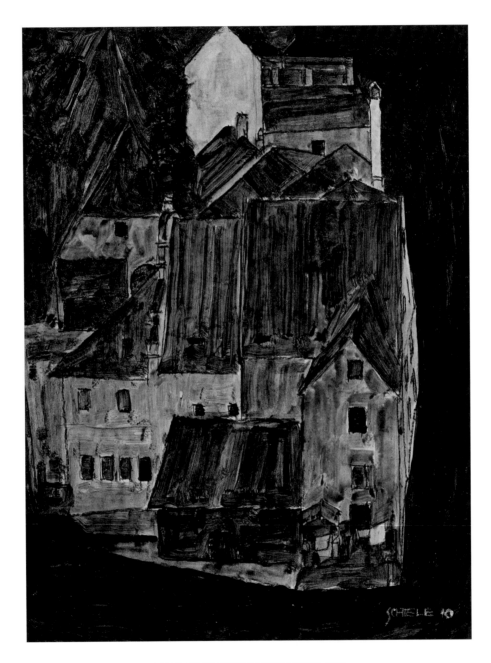

222. EGON SCHIELE, CITY ON THE BLUE RIVER I (DEAD CITY I), 1910

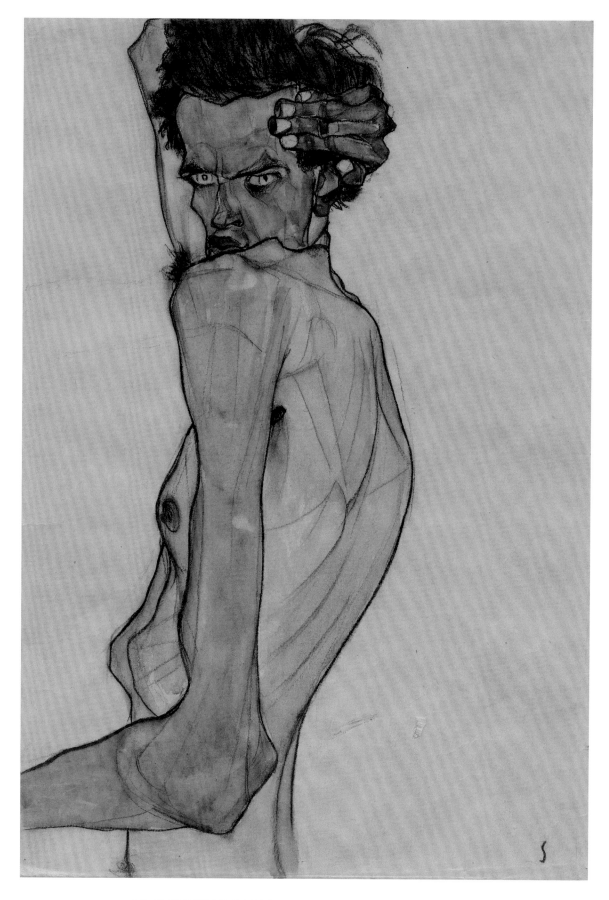

223. EGON SCHIELE, SELF-PORTRAIT WITH ARM TWISTED ABOVE HEAD, 1910

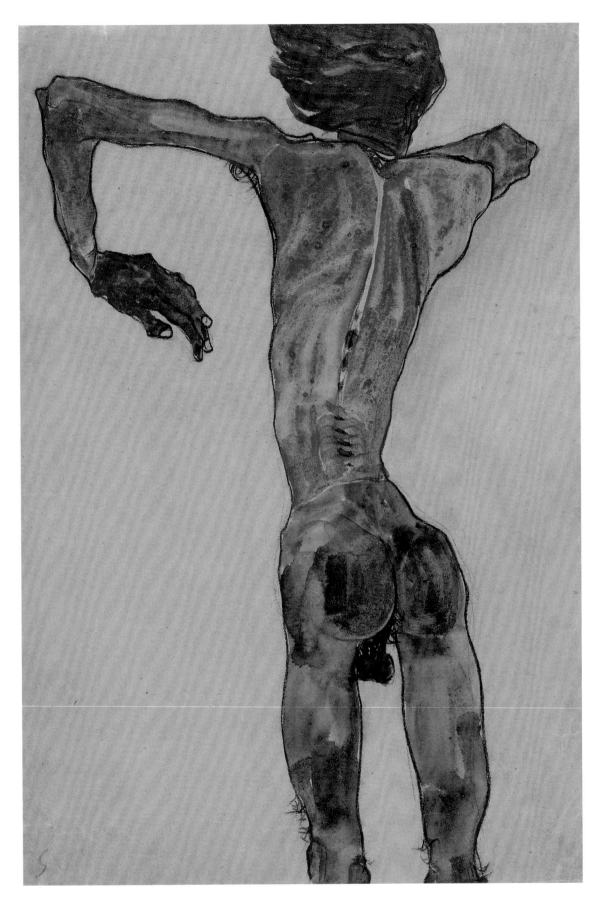

224. EGON SCHIELE, STANDING MALE NUDE, BACK VIEW, 1910

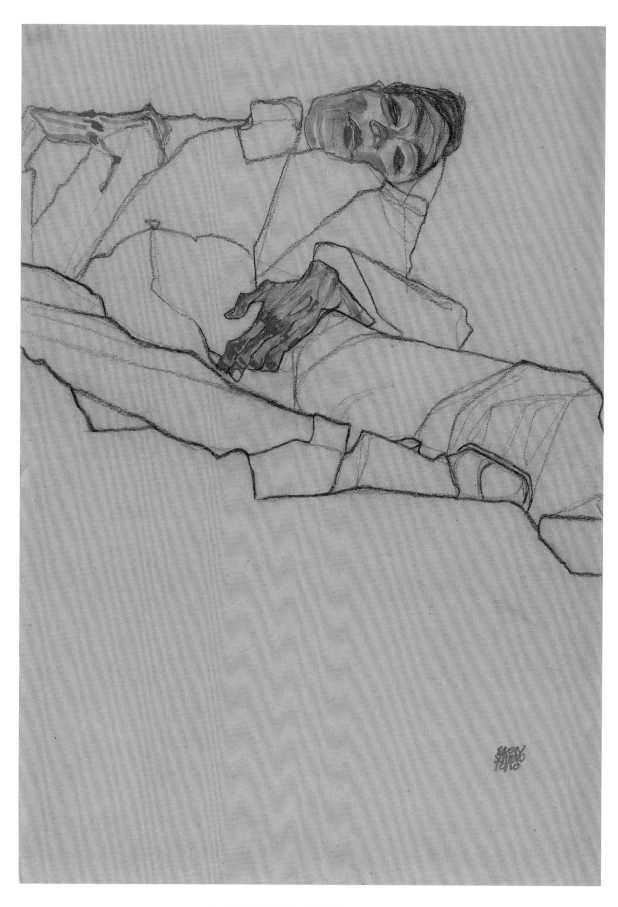

225. EGON SCHIELE, RECLINING MAN (MAX OPPENHEIMER), 1910

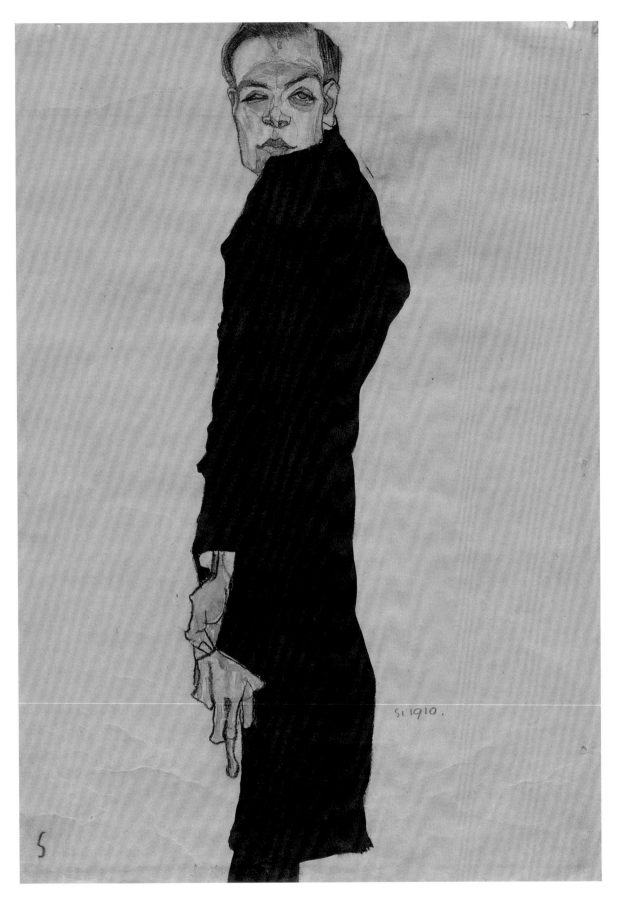

226. EGON SCHIELE, PORTRAIT OF THE PAINTER MAX OPPENHEIMER, 1910

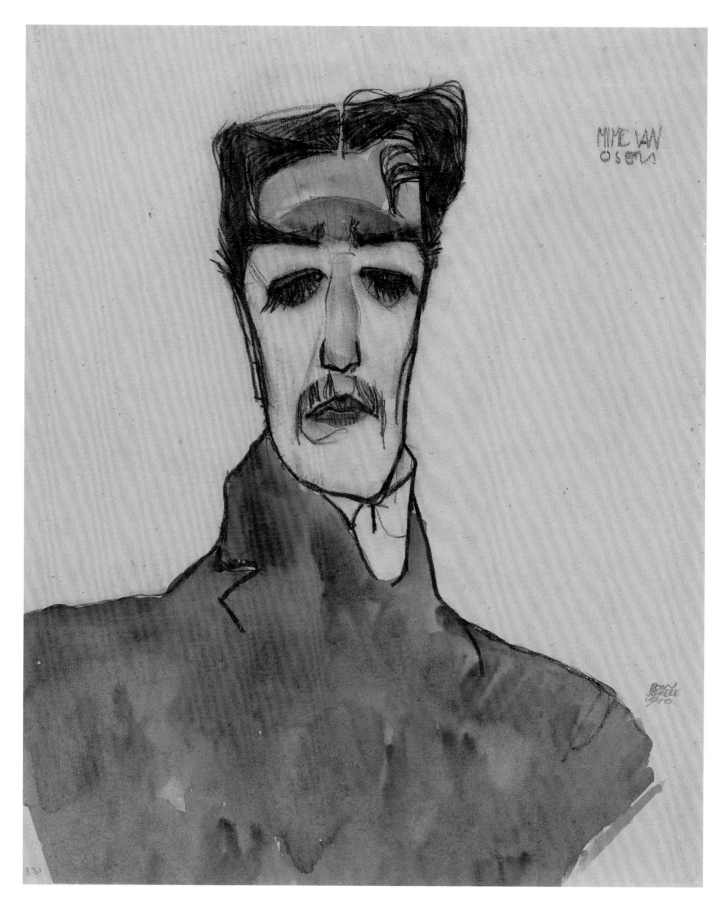

227. EGON SCHIELE, MIME VAN OSEN, 1910

228. EGON SCHIELE, PORTRAIT OF DR. OSKAR REICHEL, 1910

229. EGON SCHIELE, PORTRAIT OF EDUARD KOSMACK WITH RAISED LEFT HAND, 1910

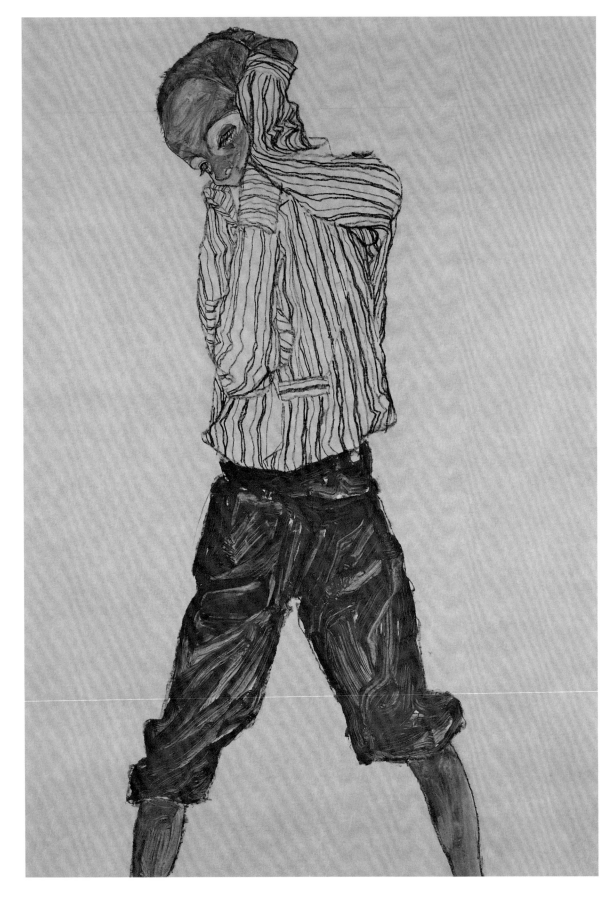

230. EGON SCHIELE, STANDING BOY IN STRIPED SHIRT, 1910

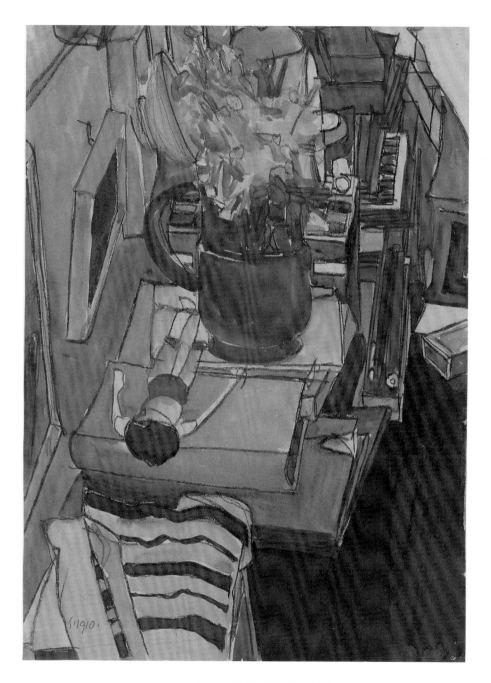

231. EGON SCHIELE, VIEW OF THE ARTIST'S STUDIO, 1910

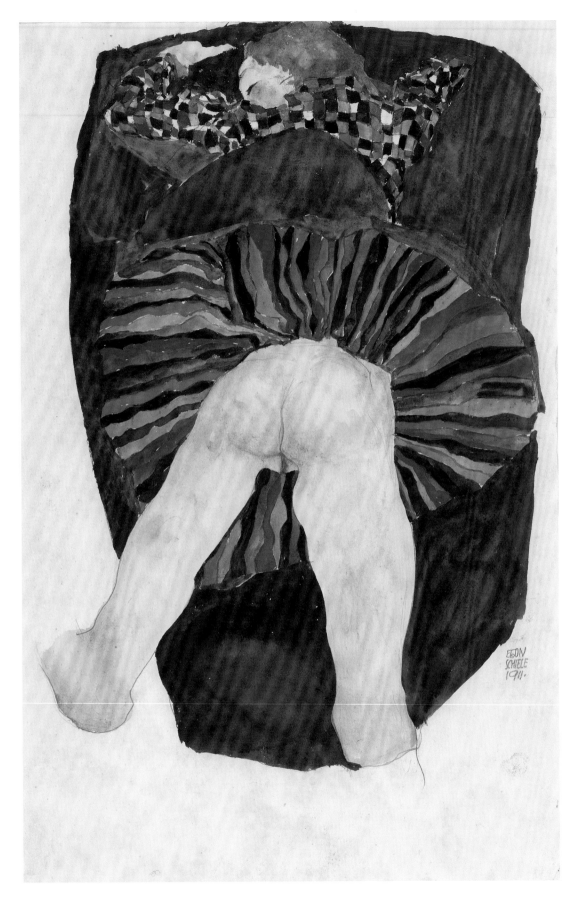

232. EGON SCHIELE, RECLINING SEMI-NUDE, 1911

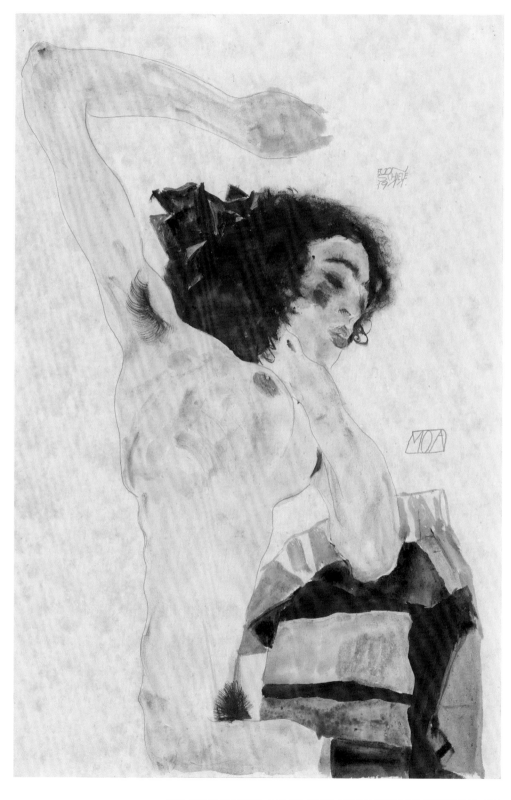

233. EGON SCHIELE, SEATED NUDE, THREE-QUARTER VIEW (MOA), 1911

234. EGON SCHIELE, SUNFLOWER, 1916

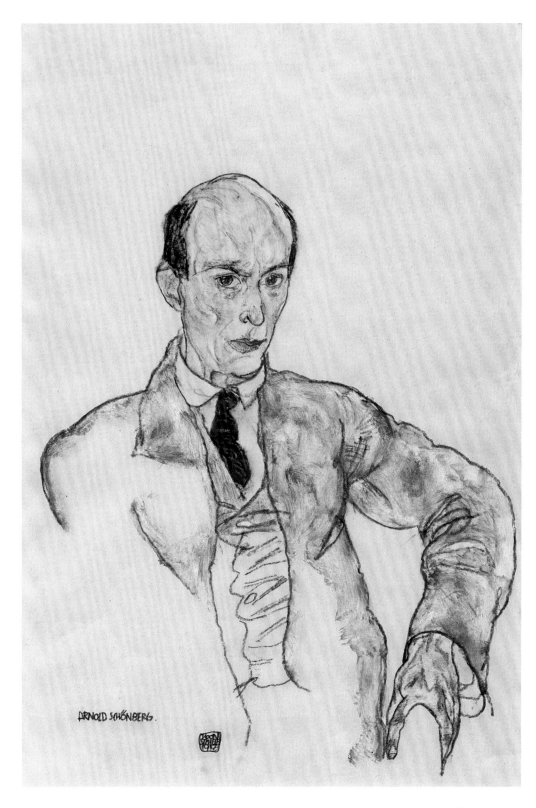

235. EGON SCHIELE, PORTRAIT OF THE COMPOSER ARNOLD SCHÖNBERG, 1917

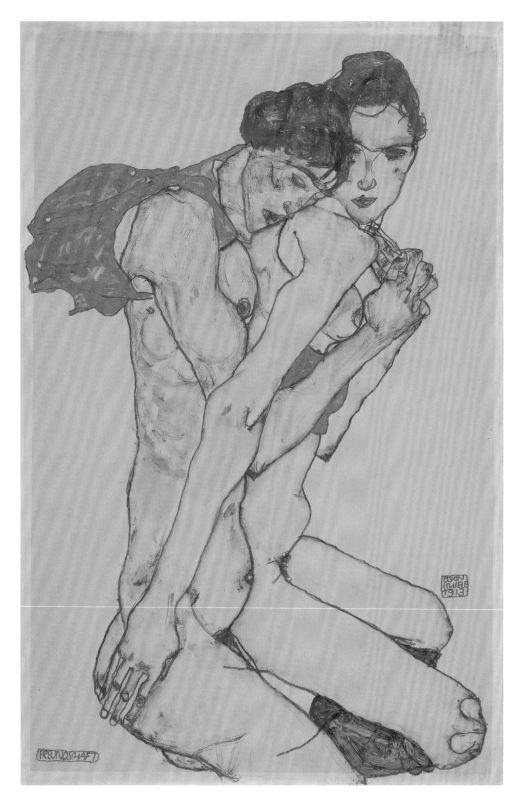

236. EGON SCHIELE, FRIENDSHIP, 1913

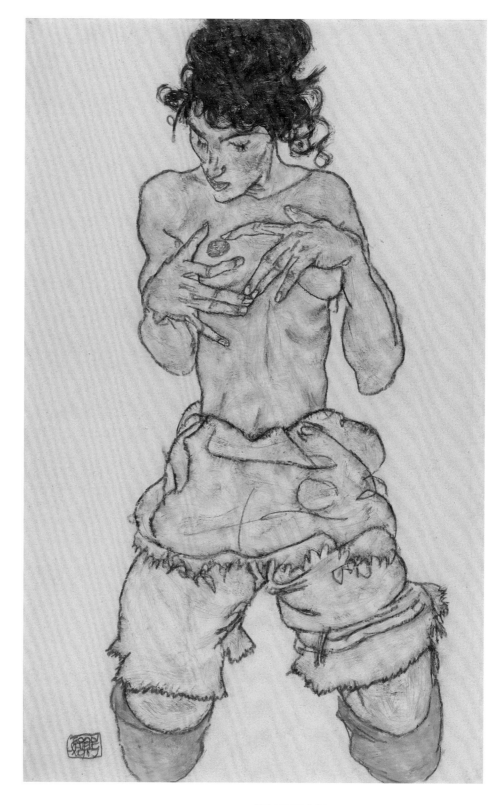

237. EGON SCHIELE, KNEELING SEMI-NUDE, 1917

238. EGON SCHIELE, SUPPLY DEPOT, TRENTO BRANCH: EXTERIOR VIEW WITH NOTICE BOARD, 1917

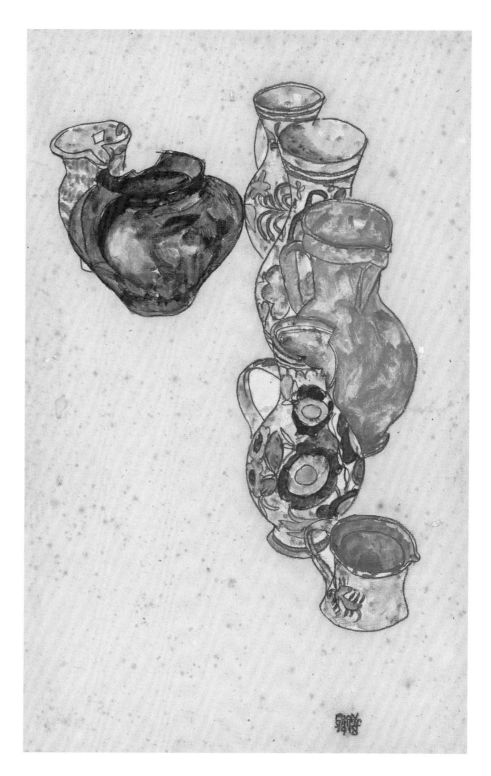

239. EGON SCHIELE, PEASANT JUGS, 1918

240. OSKAR KOKOSCHKA, THE NARROW PATH, CA. 1907

241. OSKAR KOKOSCHKA, STANDING FEMALE NUDE, 1908

242. OSKAR KOKOSCHKA, RECLINING WOMAN, CA. 1910

243. OSKAR KOKOSCHKA, TINI SENDERS, 1912

244. OSKAR KOKOSCHKA, WILHELM KÖHLER, 1912

245. OSKAR KOKOSCHKA, GIRL WITH TURBAN, EARLY 1920s

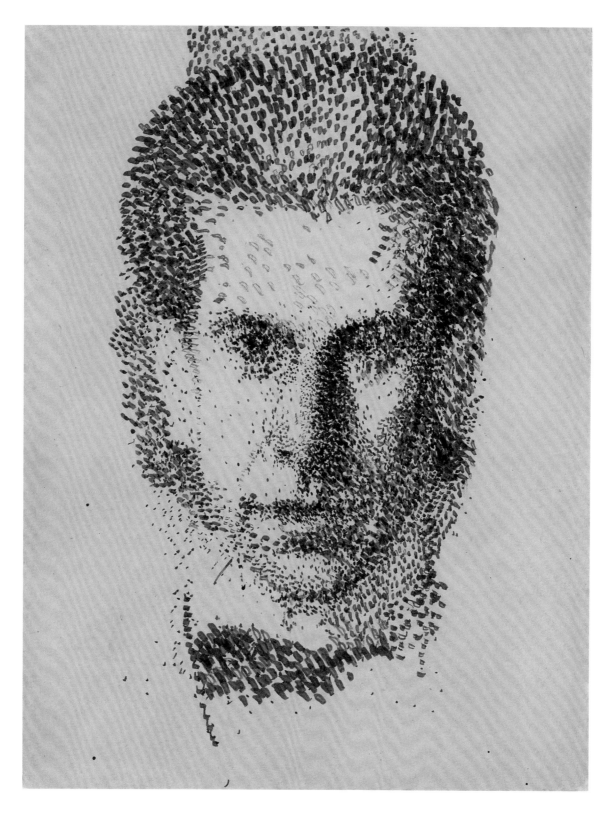

246. RICHARD GERSTL, SELF-PORTRAIT, CA. 1907

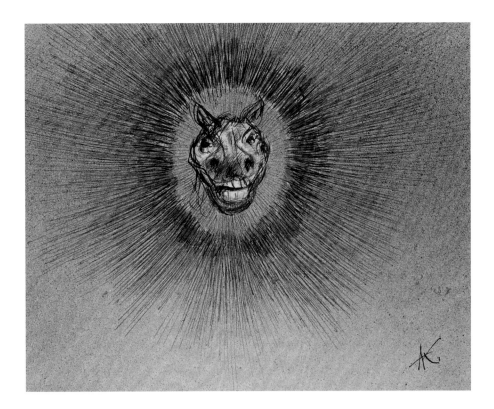

247. ALFRED KUBIN, STALLION, CA. 1899

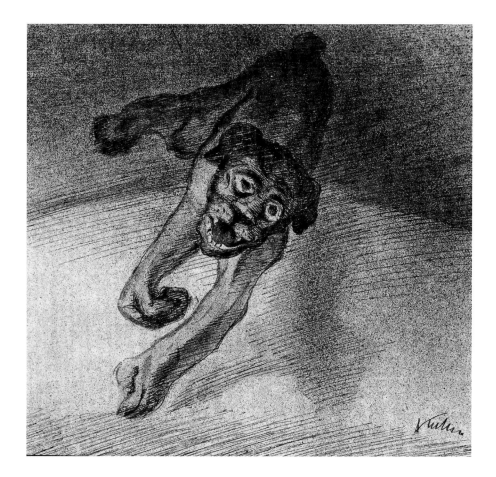

248. ALFRED KUBIN, RABID DOG, CA. 1900–01

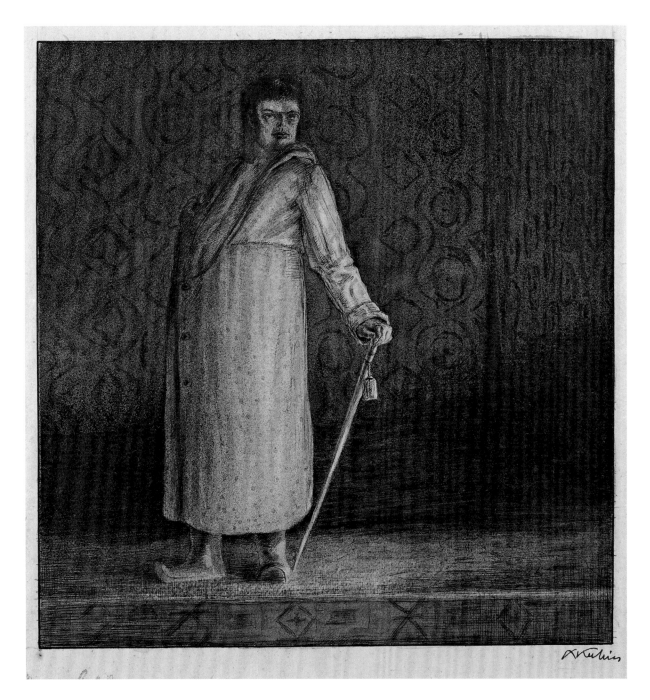

249. ALFRED KUBIN, THE GLUTTON, CA. 1903–04

Sterben

250. ALFRED KUBIN, DYING, 1899

251. ALFRED KUBIN, SUICIDE BEFORE AN IDOL, CA. 1900

252. ALFRED KUBIN, CHARON, CA. 1902–03

253. ALFRED KUBIN, DESTINY, CA. 1903–04

Der Wind

254. ALFRED KUBIN, THE WIND, CA. 1902–03

413

EARLY 20TH-CENTURY GERMAN WORKS ON PAPER

255. ERICH HECKEL, SEATED GIRL ON RED PILLOW, 1910

256. VASILY KANDINSKY, STUDY FOR *SKETCH FOR DELUGE II*, 1912

257. VASILY KANDINSKY, RED AND BLUE, 1913

258. VASILY KANDINSKY, UNTITLED (DRAWING FOR PAINTING WITH WHITE FORM), 1913

259. VASILY KANDINSKY, UNTITLED (ABSTRACT COMPOSITION), 1916

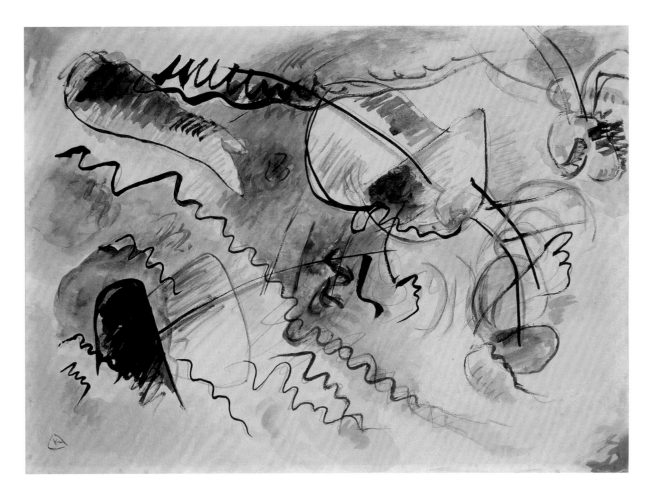

260. VASILY KANDINSKY, UNTITLED, 1913

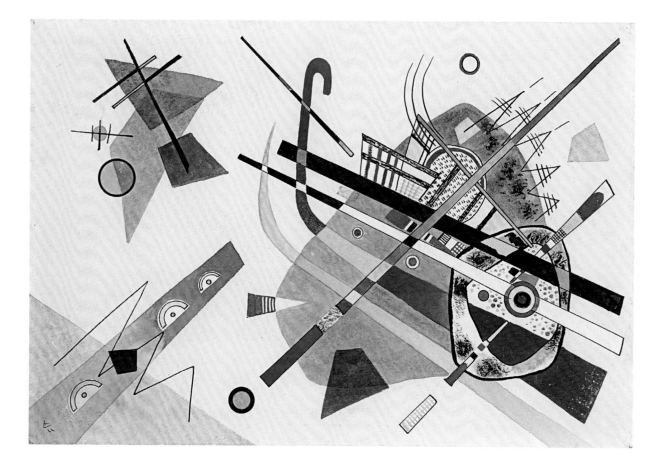

261. VASILY KANDINSKY, UNTITLED, 1922

262. FRANZ MARC, DOUBLE SKETCH OF FOUR HORSES, CA. 1911

424

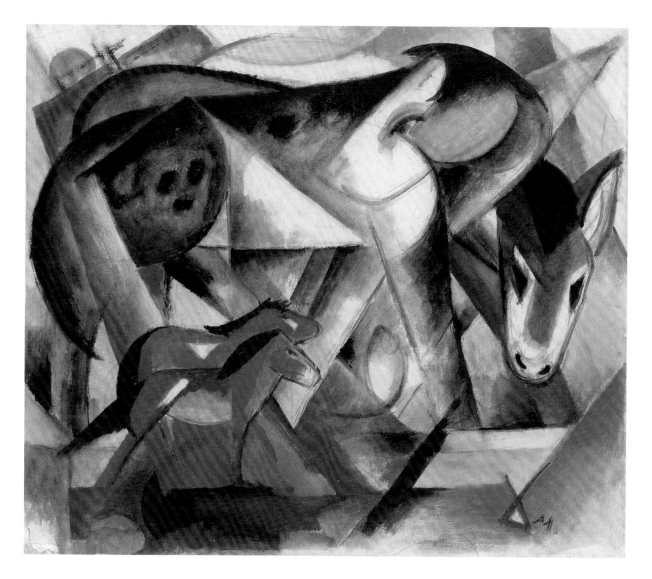

263. FRANZ MARC, THE FIRST ANIMALS, 1913

264. AUGUST MACKE, WOMAN ON A STREET, 1914

265. AUGUST MACKE, DONKEY RIDER, 1914

266. PAUL KLEE, SELF-PORTRAIT, FULL FACE, HAND SUPPORTING HEAD, 1909

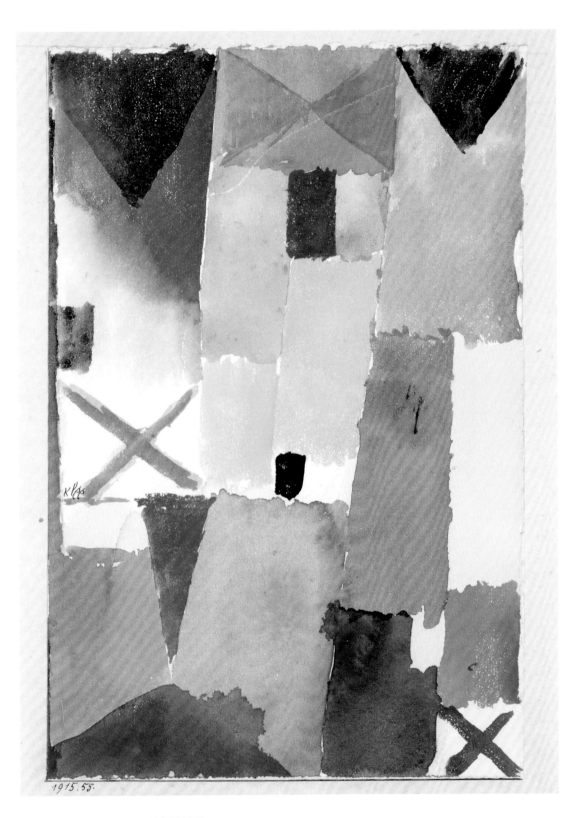

267. PAUL KLEE, YELLOW HOUSE, 1915

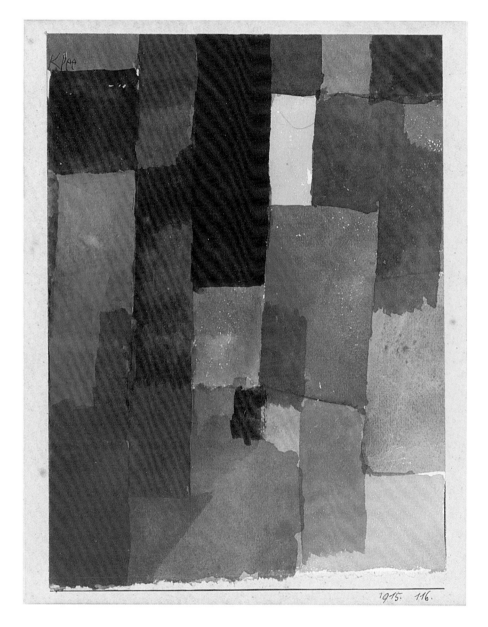

268. PAUL KLEE, SMALL BLACK DOOR, 1915

269. PAUL KLEE, UTOPIAN CONSTRUCTION WITH BOARDS, 1922

270. PAUL KLEE, PORTRAIT OF AN EXPRESSIONIST, 1922

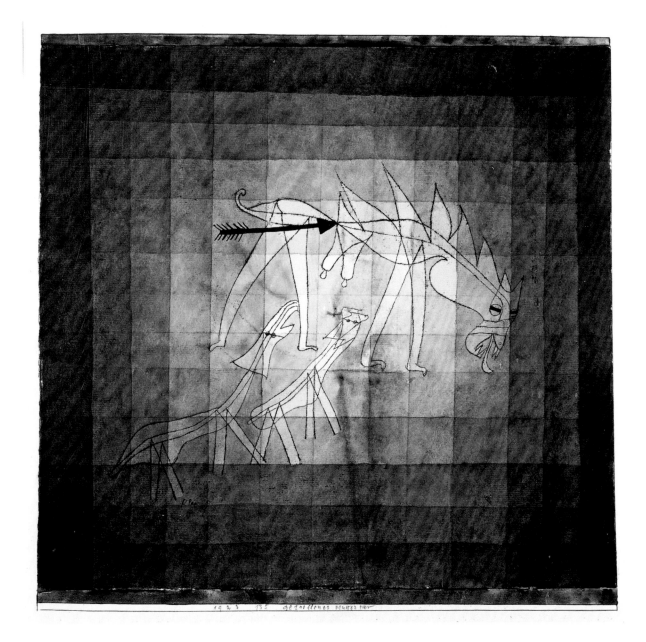

271. PAUL KLEE, STRICKEN DAM, 1923

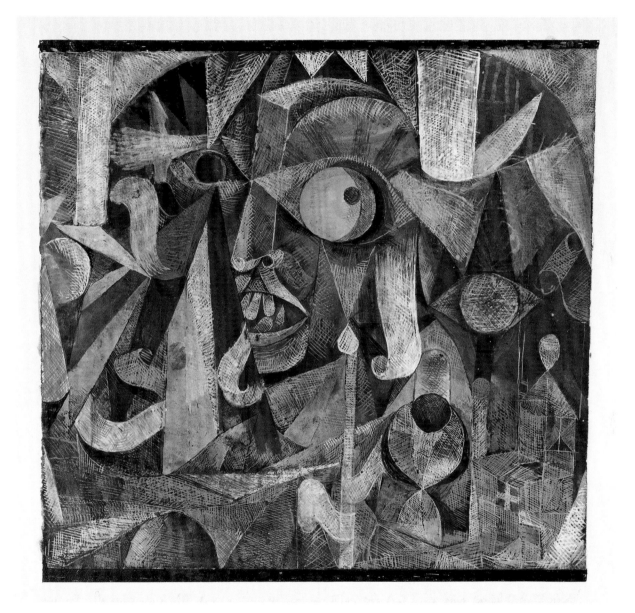

272. PAUL KLEE, THE MOON WAS ON THE WANE AND SHOWED ME THE GROTESQUE FACE
OF AN ENGLISHMAN, A NOTORIOUS LORD, 1918

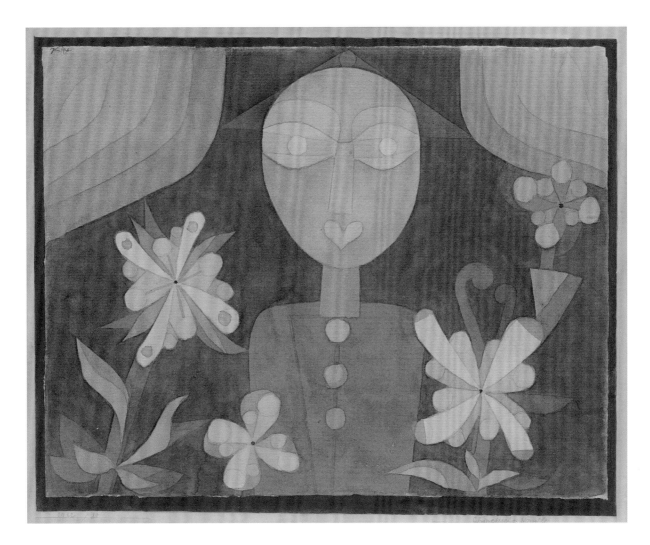

273. PAUL KLEE, CHINESE NOVELLA, 1922

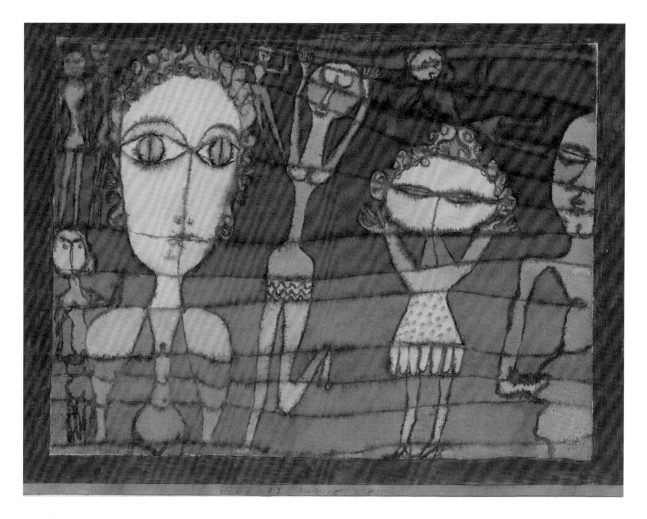

274. PAUL KLEE, ON THE LAWN, 1923

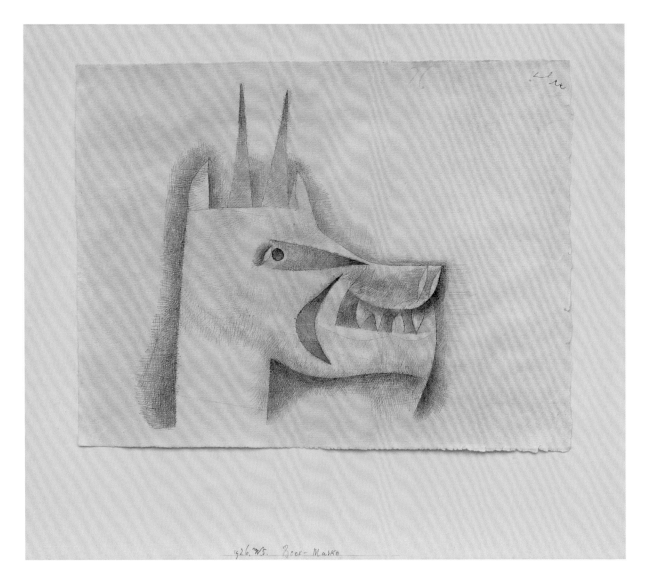

275. PAUL KLEE, BILLY-GOAT MASK, 1926

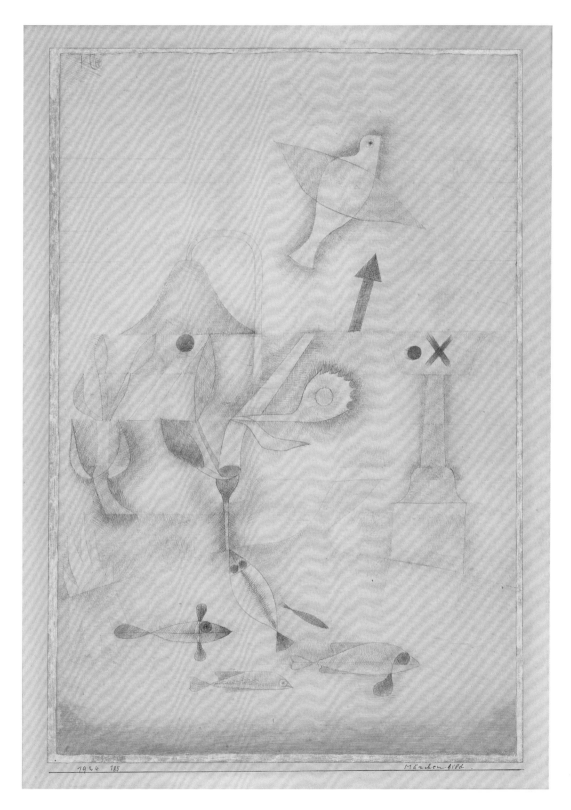

276. PAUL KLEE, FAIRY TALE PICTURE, 1924

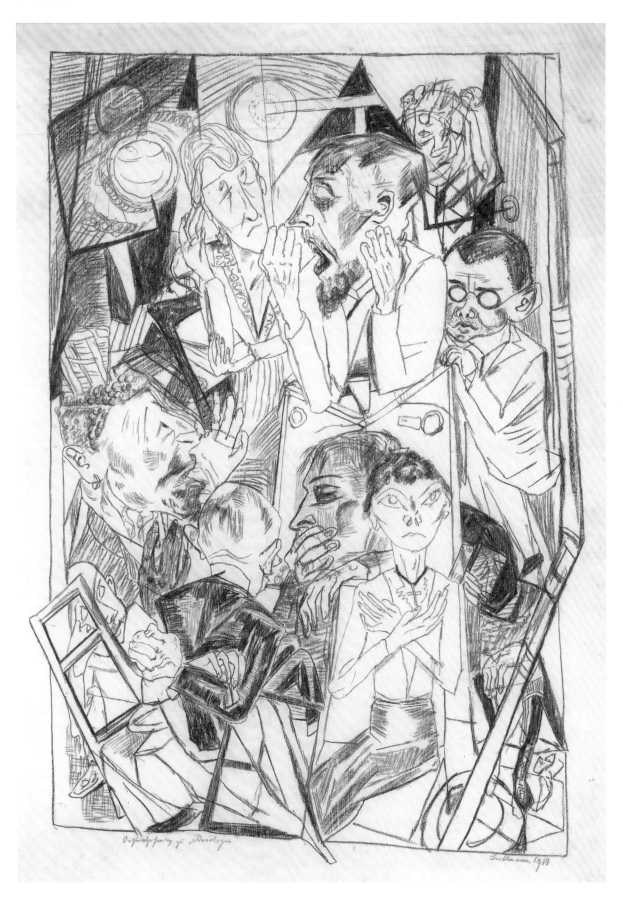

277. MAX BECKMANN, THE IDEOLOGUES, 1919

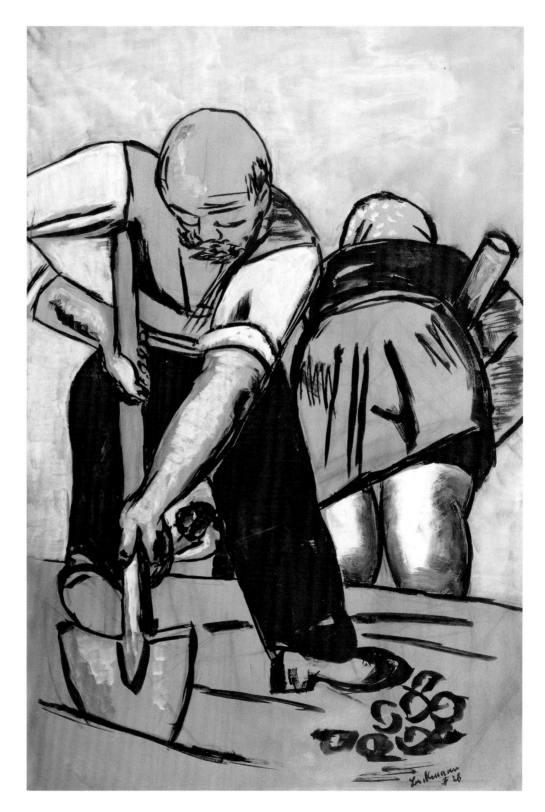

278. MAX BECKMANN, FIELD WORKERS, 1928

279. LOVIS CORINTH, PORTRAIT OF RUDOLF GROSSMAN, UNDATED

280. LOVIS CORINTH, SELF-PORTRAIT, 1921

281. OTTO DIX, SELF-PORTRAIT, GRINNING, HEAD RESTING ON HAND, 1917

282. OTTO DIX, SELF-PORTRAIT, 1922

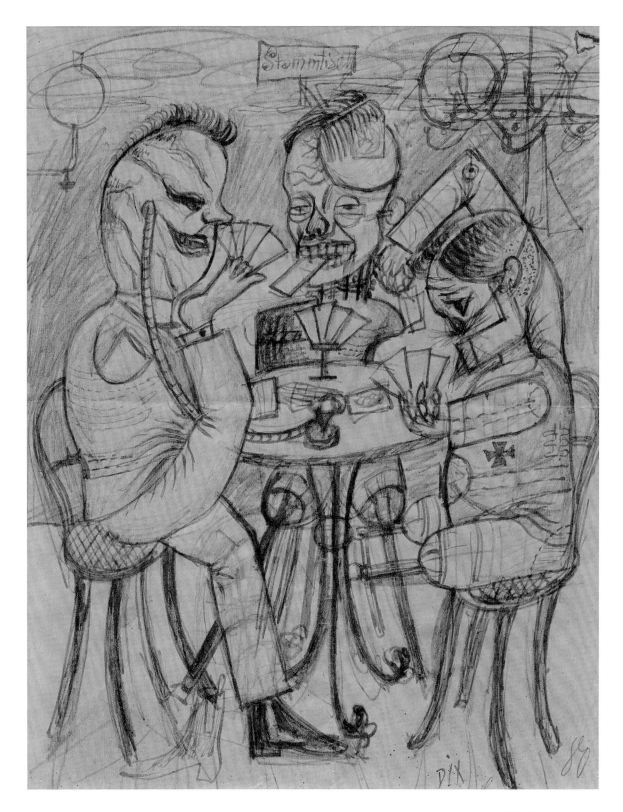

283. OTTO DIX, THE SKAT PLAYERS, 1920

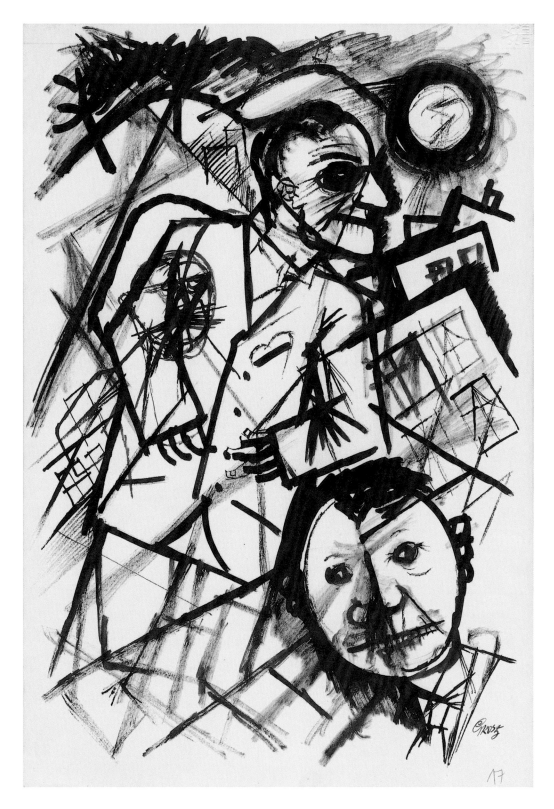

284. GEORG GROSZ, NIGHT, 1917

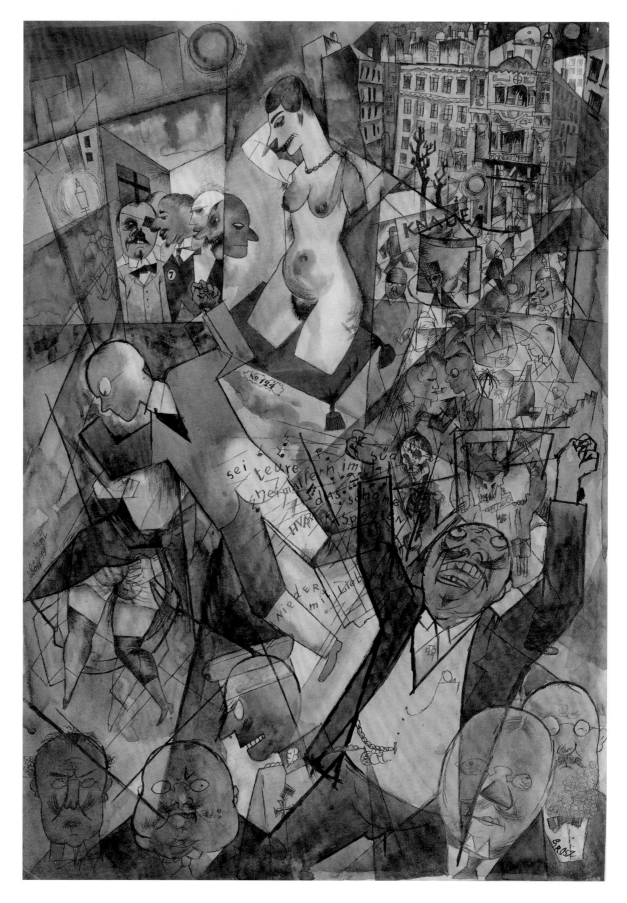

285. GEORG GROSZ, PANORAMA (DOWN WITH LIEBKNECHT), 1919

286. GEORG GROSZ, DIABOLO PLAYER, 1920

287. RAOUL HAUSMANN, DADA TRIUMPHS (THE EXACTING BRAIN OF A BOURGEOIS CALLS FORTH A WORLD MOVEMENT), 1920

288. HANNAH HÖCH, AND WHEN YOU THINK THE MOON IS SETTING, 1921

DIE SÄNGERIN

H, HOCH 1926

289. HANNAH HÖCH, THE SINGER, 1926

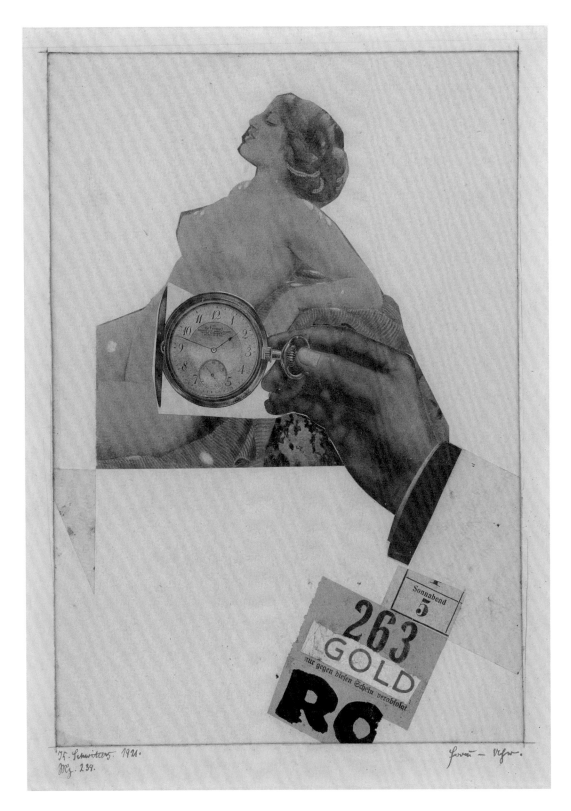

290. KURT SCHWITTERS, MZ 239, WOMAN-WATCH, 1921

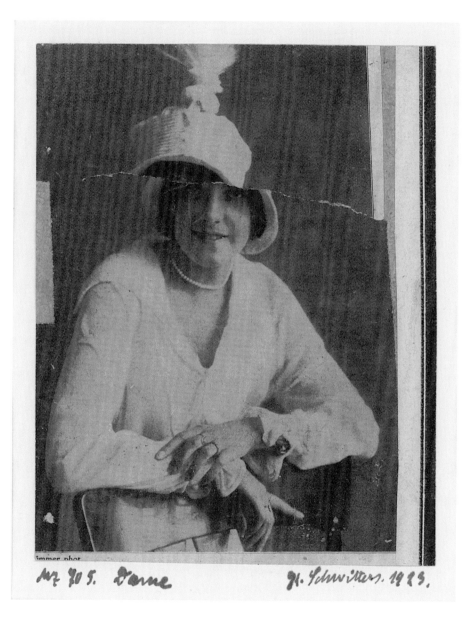

291. KURT SCHWITTERS, MZ 705, LADY, 1923

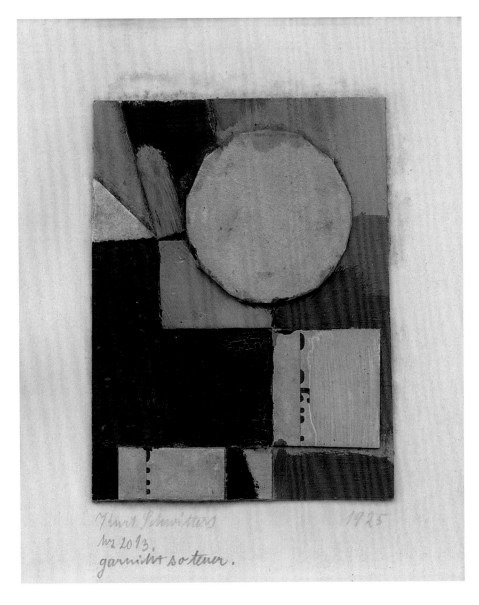

292. KURT SCHWITTERS, MZ 2013, REALLY NOT SO EXPENSIVE, 1925

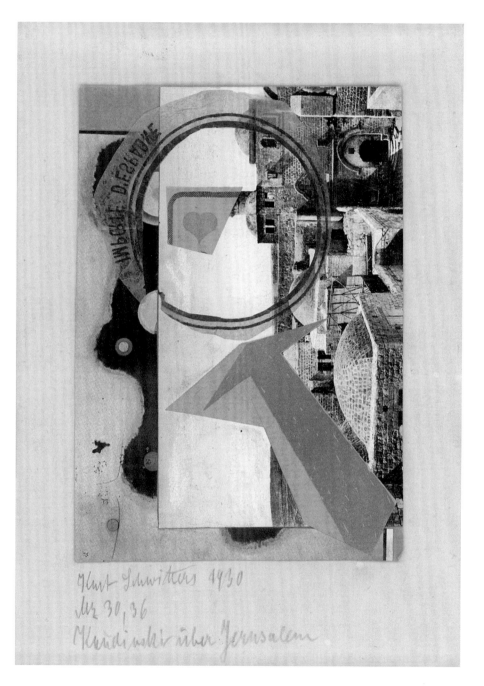

293. KURT SCHWITTERS, MZ 30, 36, KANDINSKI ABOVE JERUSALEM, 1930

294. MARIANNE BRANDT, ER/ER, HAROLD LLOYD, 1930

295. LILLY REICH, COLLAGE, 1930

296. CHRISTIAN SCHAD, CONVERSATION BETWEEN FRIENDS, 1929

297. CHRISTIAN SCHAD, ZACHARIAS I (GROTESQUE), 1935

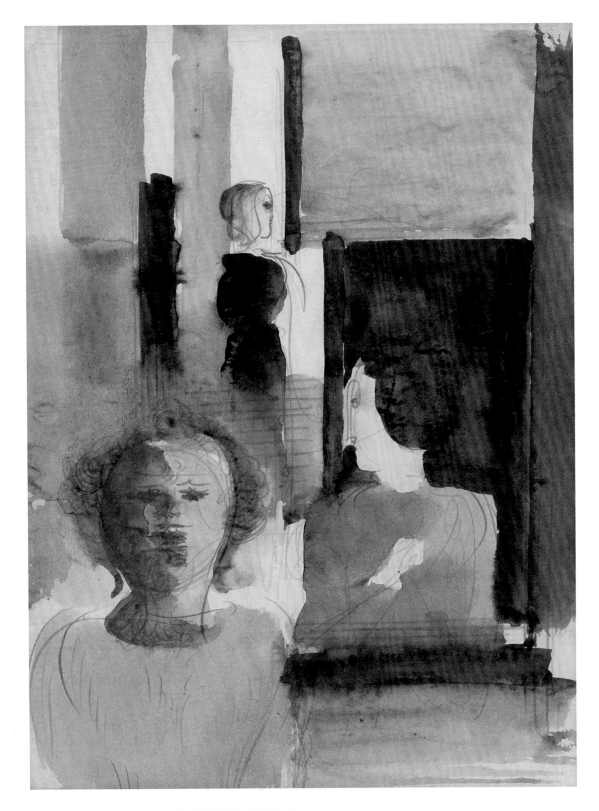

298. OSKAR SCHLEMMER, THREE WOMEN IN A ROOM, 1924

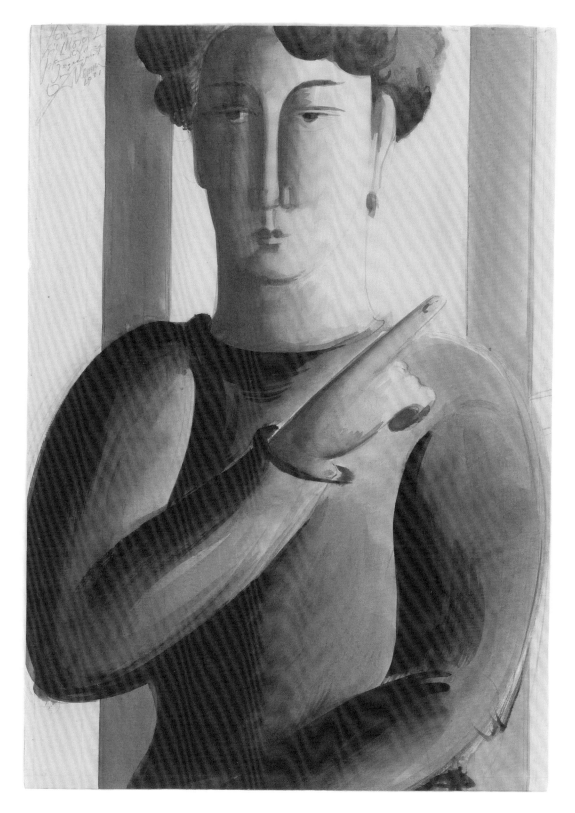

299. OSKAR SCHLEMMER, POINTING MAN, 1931

POSTWAR GERMAN
WORKS ON PAPER

300. JOSEPH BEUYS, BAT, 1958

301. JOSEPH BEUYS, MEETING PLACE, DDR, 1984

302. SIGMAR POLKE, UNTITLED, 1979

303. SIGMAR POLKE, UNTITLED, 1994

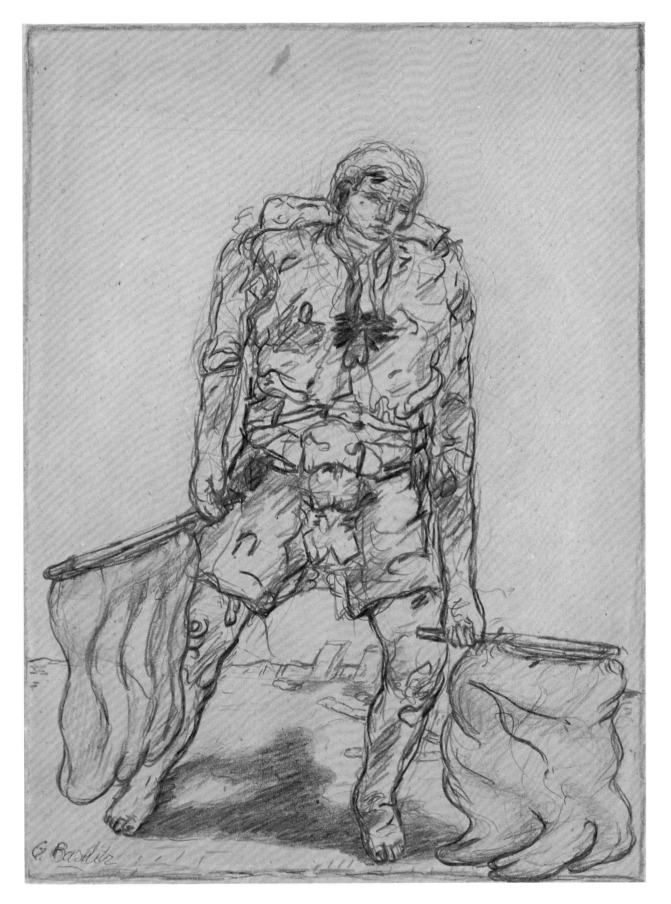

304. GEORG BASELITZ, UNTITLED (HERO), 1965

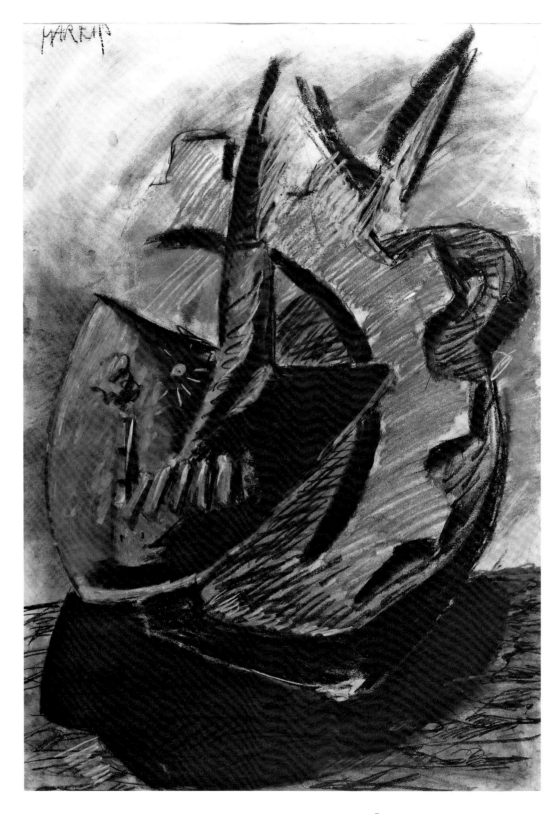

305. MARKUS LÜPERTZ, SHOVEL AND WHEEL, 1975

306. GERHARD RICHTER, 48 PORTRAITS, 1972

307. ANSELM KIEFER, KHLEBNIKOV, 1969/80

308. ANSELM KIEFER, ELISABETH OF AUSTRIA, 1988

DECORATIVE ARTS

- **FURNITURE**
- **METALWORK**
- **JEWELRY**

FURNITURE

309. OTTO WAGNER, VITRINE DESIGNED FOR THE HECKSCHER RESIDENCE, VIENNA 1886

310. OTTO WAGNER, VITRINE DESIGNED FOR THE HECKSCHER RESIDENCE, VIENNA 1886

311. OTTO WAGNER, ARMCHAIR FOR THE GOVERNOR'S OFFICE OF THE AUSTRIAN POSTAL SAVINGS BANK, VIENNA 1902–06

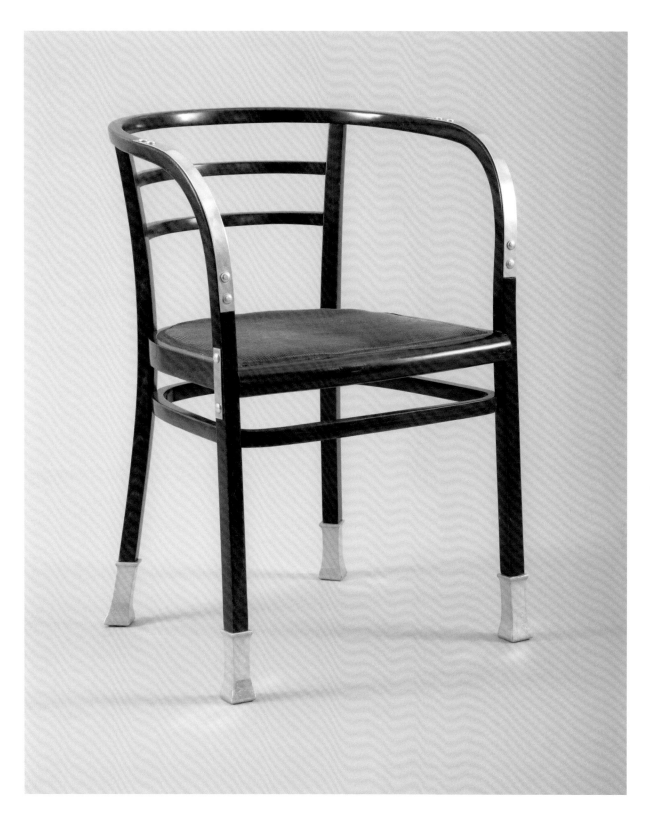

312. OTTO WAGNER, ARMCHAIR FROM THE CONFERENCE ROOM OF THE AUSTRIAN POSTAL SAVINGS BANK, VIENNA 1906

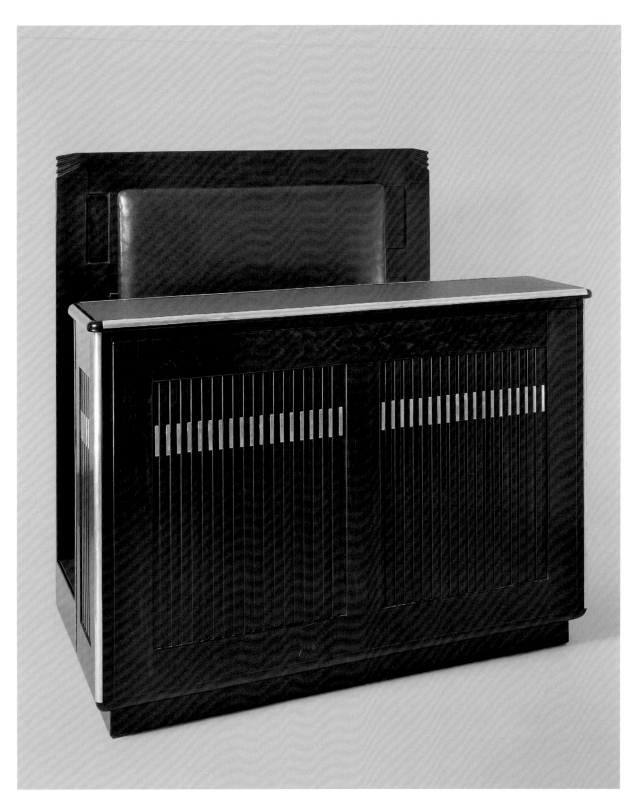

313. OTTO WAGNER, RECEPTION DESK FOR THE TELEGRAPH OFFICE OF THE NEWSPAPER DIE ZEIT, VIENNA CA. 1902

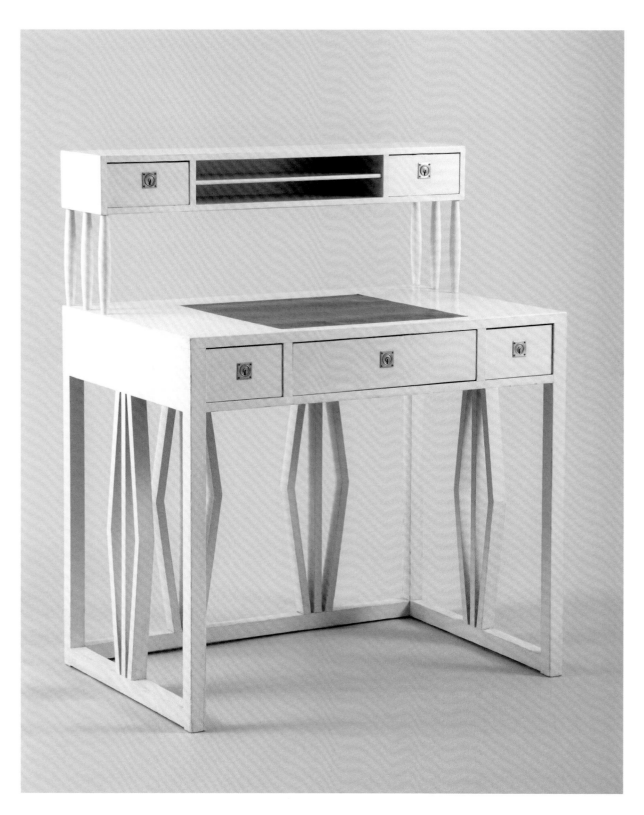

314. JOSEF HOFFMANN, WRITING DESK FROM THE BEDROOM OF KATHARINA BIACH, VIENNA 1902–03

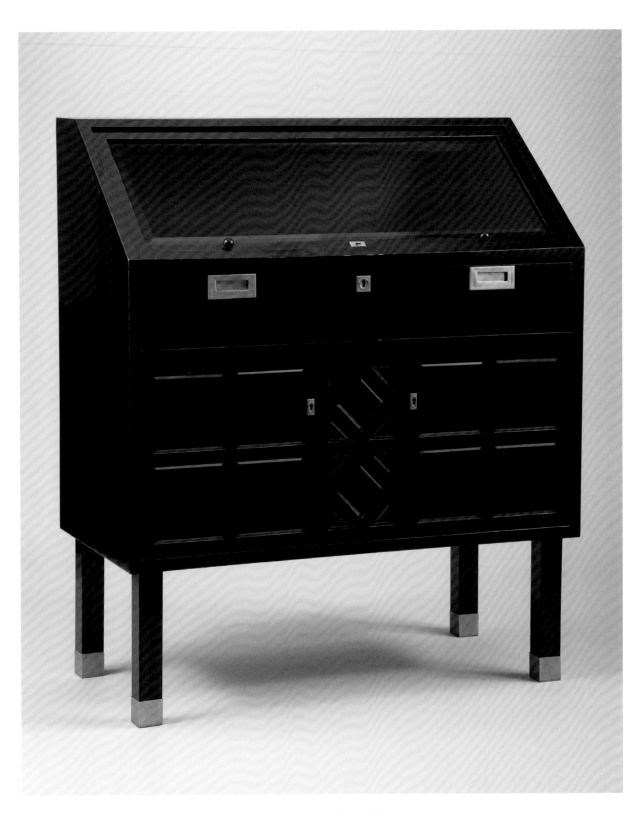

315. KOLOMAN MOSER, DISPLAY CASE FOR THE SCHWESTERN FLÖGE (FLÖGE SISTERS) FASHION SALON, VIENNA 1904

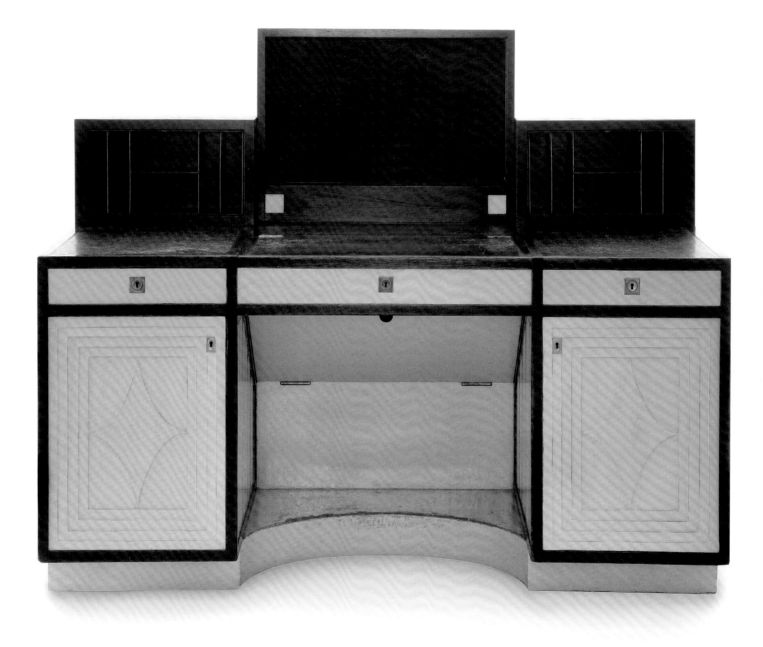

316. KOLOMAN MOSER, WRITING DESK FOR MAGDA MAUTNER-MARKHOF, VIENNA CA. 1905

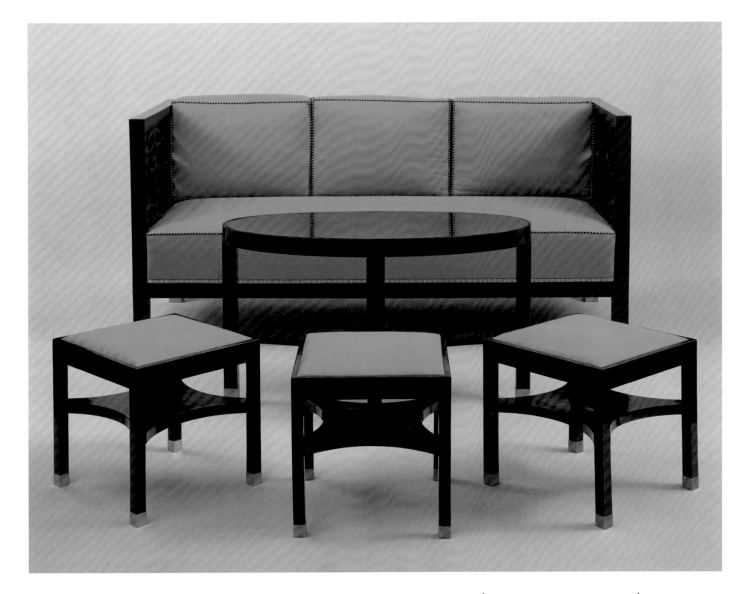

317. KOLOMAN MOSER, GROUP OF SEATING FURNITURE FOR LADISLAUS RÉMY-BERZENKOVICH VON SZILLÁS AND MARGARETE HELLMANN, VIENNA 1904

318. ADOLF LOOS, MANTELPIECE CLOCK, VIENNA CA. 1902

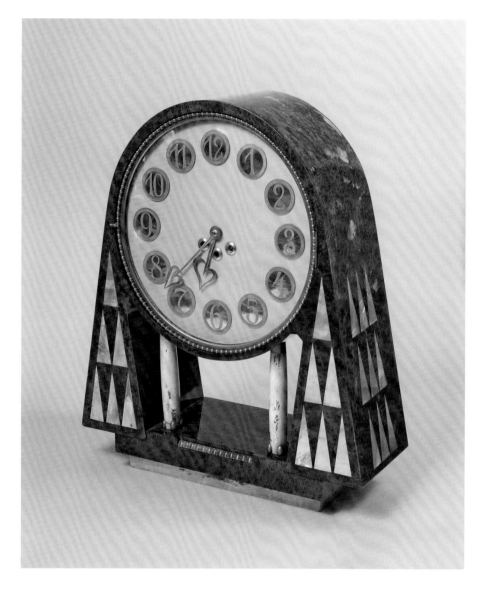

319. JOSEPH URBAN, MANTELPIECE CLOCK FOR PAUL HOPFNER RESTAURANT, VIENNA 1906

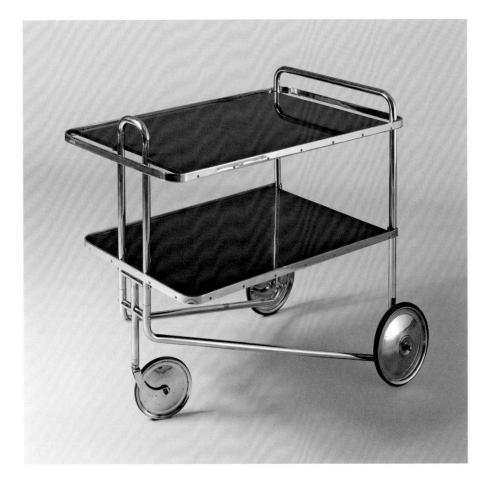

320. MARCEL BREUER, B54 SERVING CART (FIRST VERSION), BERLIN 1928

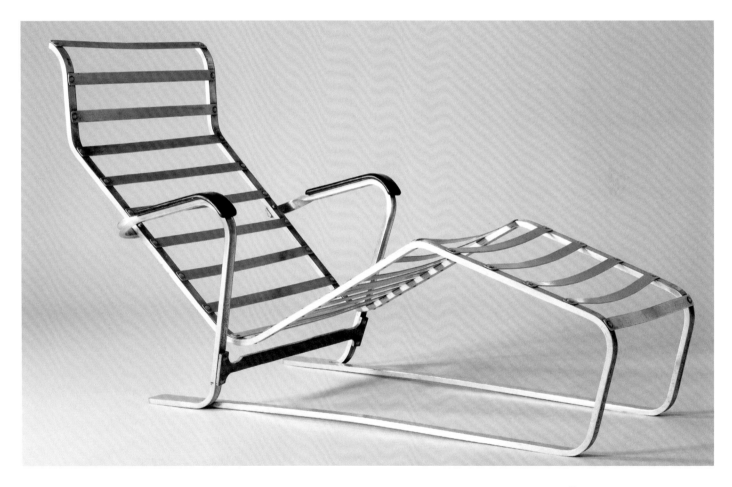

321. MARCEL BREUER, CHAISE LONGUE NO. 313, ZÜRICH 1932

METALWORK

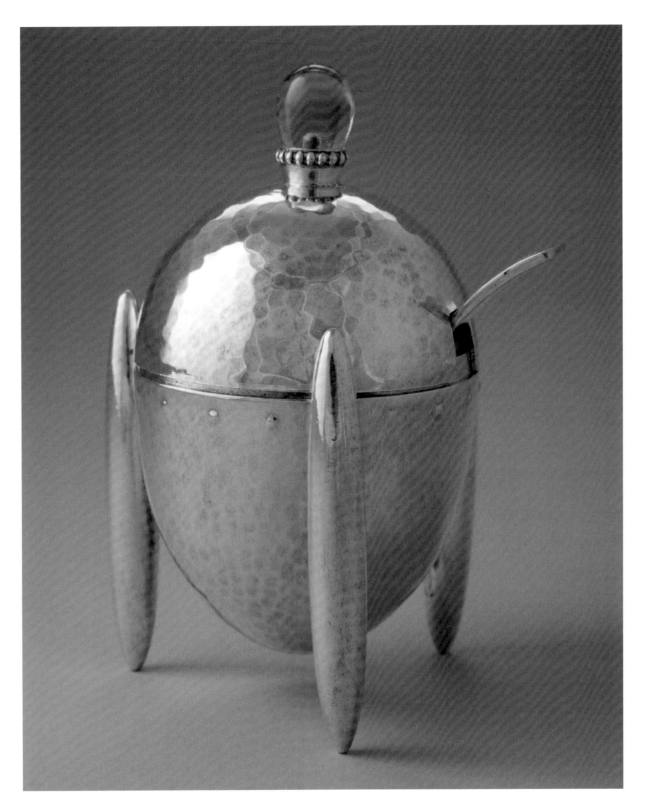

322. JOSEF HOFFMANN, MUSTARD POT, VIENNA 1902

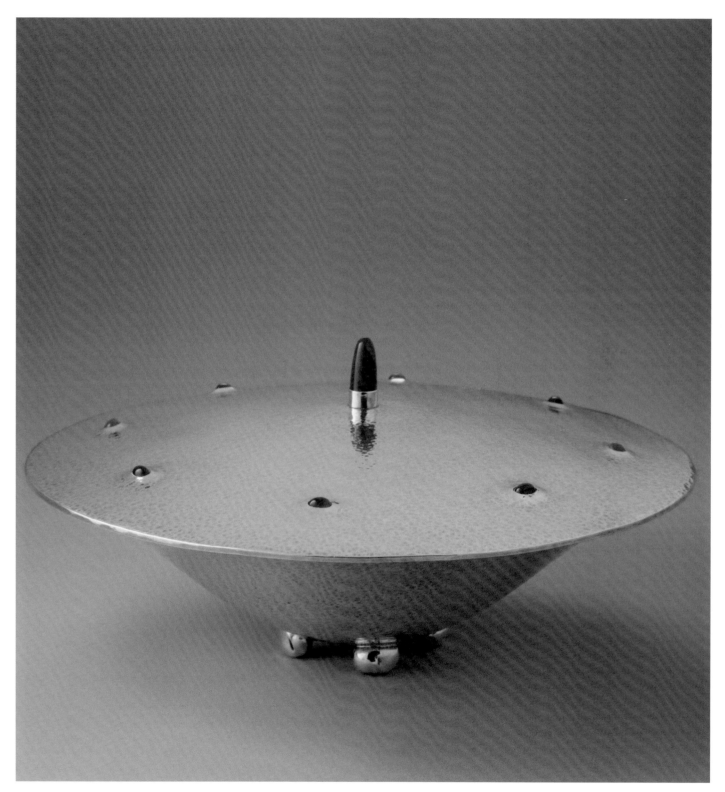

323. JOSEF HOFFMANN, COVERED DISH, VIENNA 1904

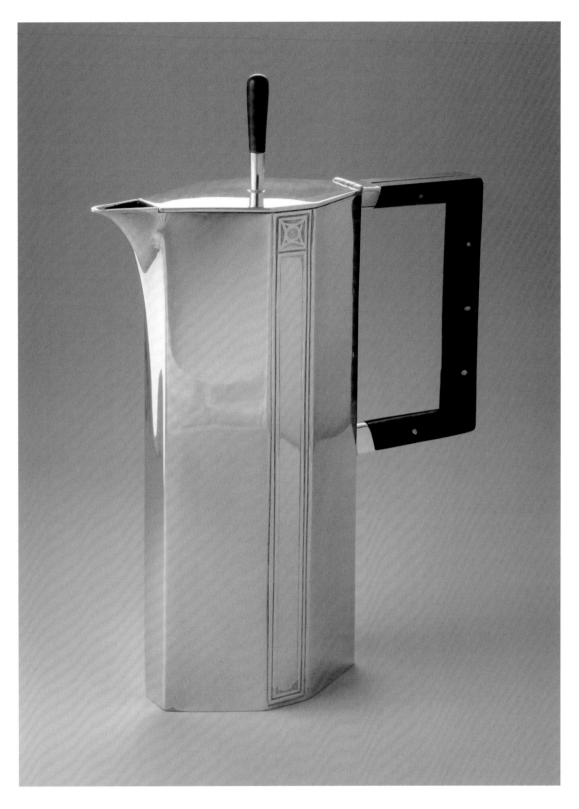

324. JOSEF HOFFMANN, COFFEE POT, VIENNA 1904

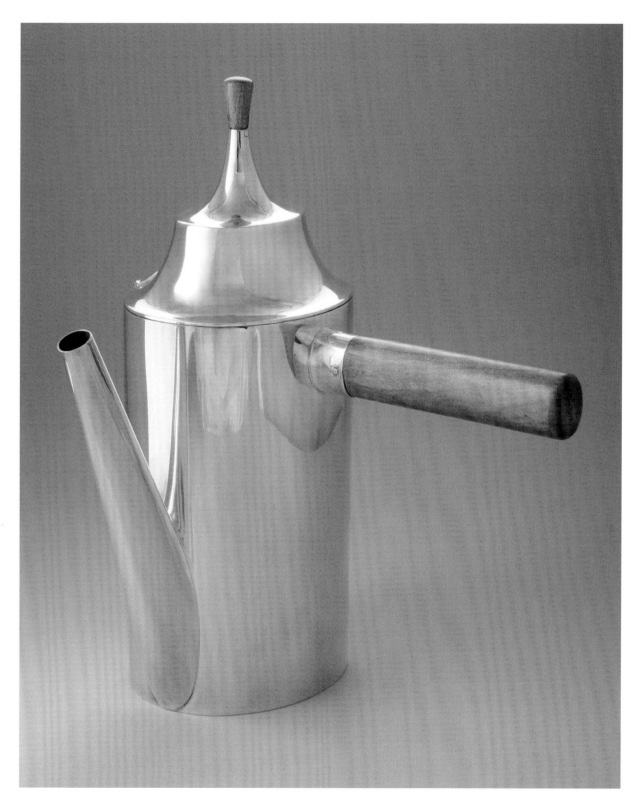

325. JOSEF HOFFMANN, COFFEE POT PURCHASED BY JENNY MAUTNER AND MORIZ SCHUR
FOR KÄTHY BREUER, NÉE MAUTNER, VIENNA 1906

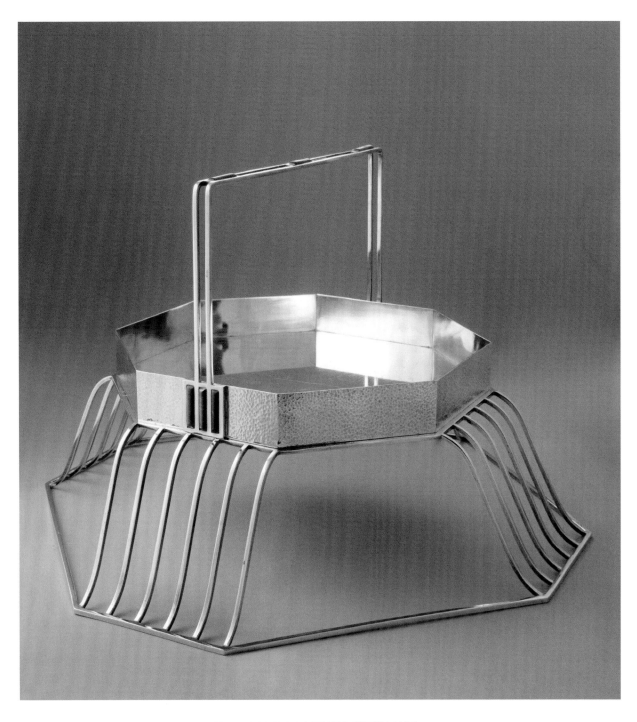

326. JOSEF HOFFMANN, CENTERPIECE ACQUIRED BY H. HIRSCHWALD, VIENNA 1904

327. JOSEF HOFFMANN, TRAY, VIENNA 1904

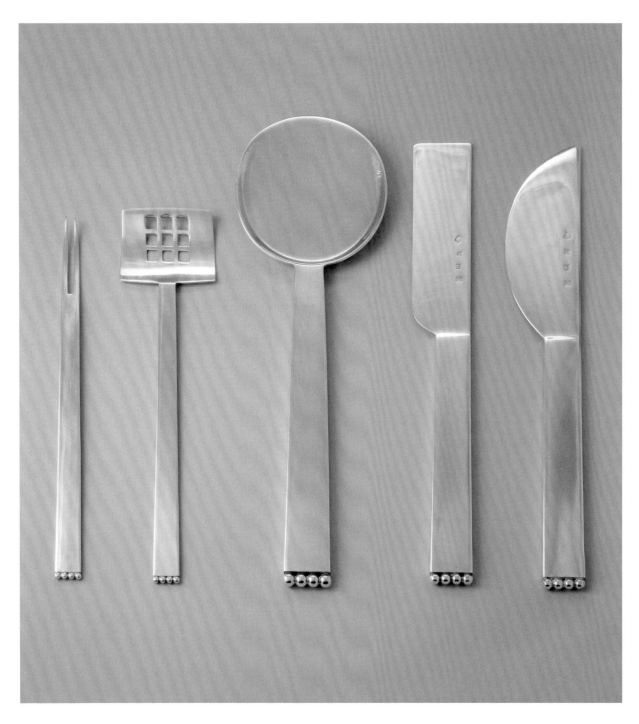

328. JOSEF HOFFMANN, FIVE PIECES FROM THE FLAT MODEL FLATWARE SERVICE, CONSISTING OF CRAB FORK, SARDINE SERVER, PASTRY SERVING SPOON, CHEESE KNIFE, AND BUTTER KNIFE, VIENNA 1904–08

329. JOSEF HOFFMANN, SPOON, VIENNA 1905

330. JOSEF HOFFMANN, BOX ACQUIRED BY EMILIE FLÖGE, VIENNA 1905

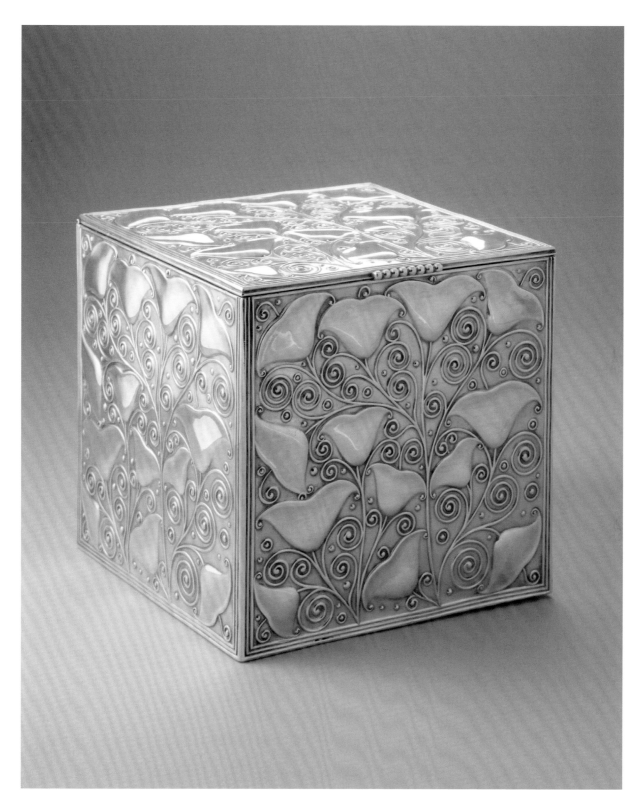

331. JOSEF HOFFMANN, BOX, VIENNA 1910

332. JOSEF HOFFMANN, *BONBONNIÈRE* ACQUIRED BY PAUL WITTGENSTEIN, VIENNA 1905

333. JOSEF HOFFMANN, *BONBONNIÈRE*, VIENNA 1906

334. KOLOMAN MOSER, COFFER GIVEN BY GUSTAV MAHLER TO ALMA MAHLER FOR CHRISTMAS, VIENNA 1902

335. KOLOMAN MOSER, TRAY ACQUIRED BY FRITZ WAERNDORFER FOR LINA HELLMANN, VIENNA 1904

336. KOLOMAN MOSER, MUSTARD POT ACQUIRED BY LEOPOLDINE WITTGENSTEIN,
NÉE KALLMUS, VIENNA 1905

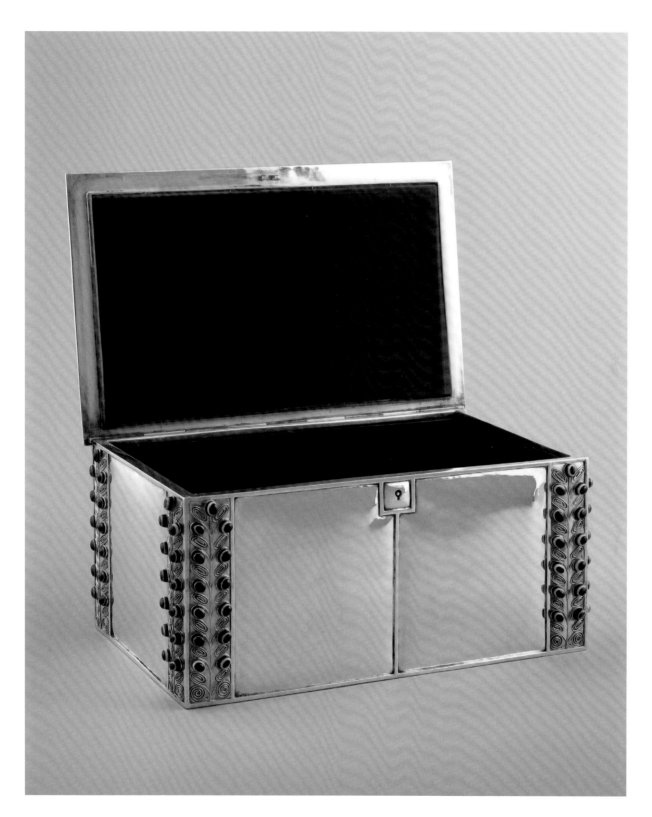

337. KOLOMAN MOSER, JEWELRY BOX, VIENNA 1907

JEWELRY

338. JOSEF HOFFMANN, BROOCH ACQUIRED BY HELENE DONNER, NÉE KLIMT, VIENNA 1907

339. JOSEF HOFFMANN, BROOCH, VIENNA 1908

340. JOSEF HOFFMANN, BROOCH, VIENNA 1907

341. JOSEF HOFFMANN, BROOCH, VIENNA 1912

342. JOSEF HOFFMANN, BROOCH, VIENNA 1908

343. JOSEF HOFFMANN, BROOCH ACQUIRED BY BERTA WAERNDORFER, VIENNA 1907

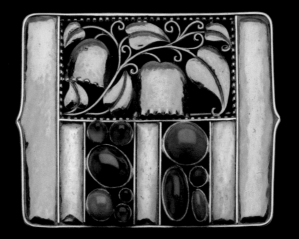

344. JOSEF HOFFMANN, BROOCH, VIENNA 1911

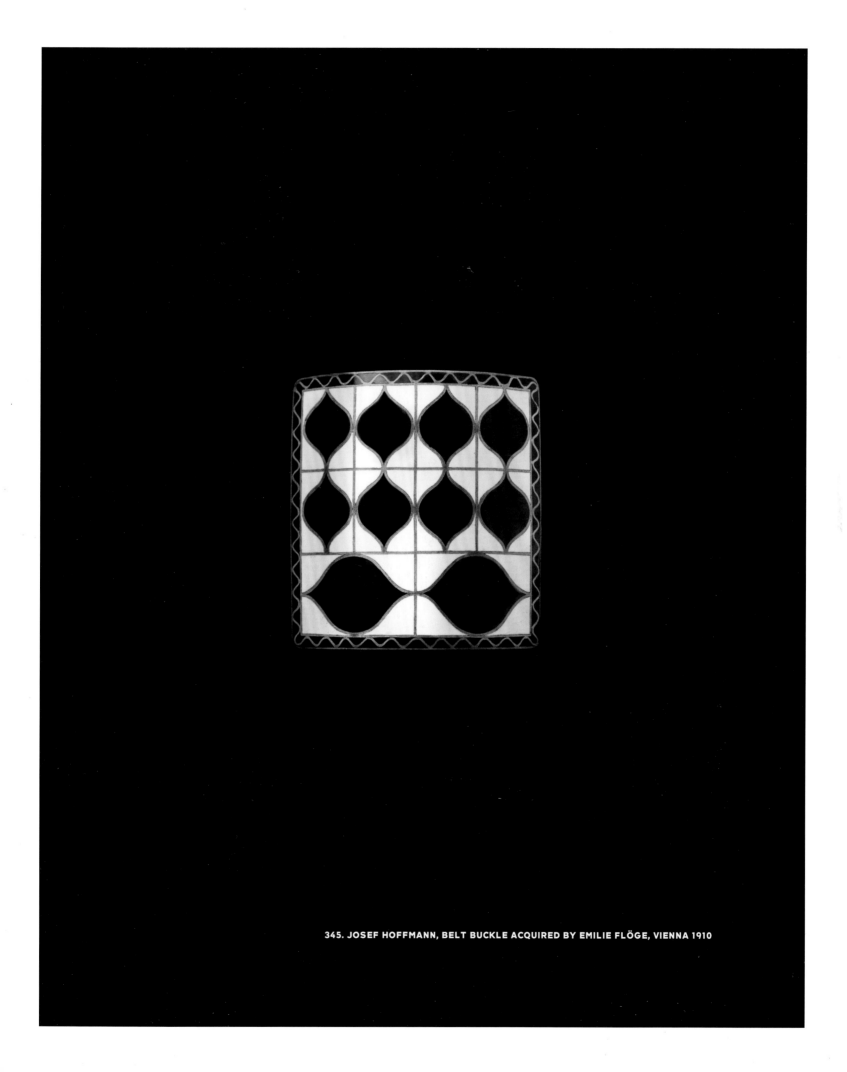

345. JOSEF HOFFMANN, BELT BUCKLE ACQUIRED BY EMILIE FLÖGE, VIENNA 1910

CHECKLIST

23
PHYLACTERY (RELIQUARY), MOSAN,
CA. 1160–70
Copper alloy, gilt; rock crystal
3.8 x 18.4 cm (1 ¹/₂ x 7 ¹/₄ in.)
Inscribed on the central pyramidal square section:
S.IEHAN

24
PRICKET CANDLESTICK, MOSAN,
CA. 1150
Copper alloy
11 x 10 x 8.9 cm (4 ⁵/₁₆ x 3 ¹⁵/₁₆ x 3 ¹/₂ in.)

25
PRICKET CANDLESTICK, GERMAN,
LATE TWELFTH-THIRTEENTH CENTURY
Copper alloy
17.9 x 13.3 x 6.5 cm (7 ¹/₁₆ x 5 ¹/₄ x 2 ⁹/₁₆ in.)

26
AQUAMANILE OF SAMSON AND THE LION,
MAGDEBURG (?), LATE TWELFTH CENTURY
Copper alloy
21.9 x 21.6 x 10.2 cm (8 ⁵/₈ x 8 ¹/₂ x 4 in.)

27
AQUAMANILE OF A LION, NORTH
GERMAN, PROBABLY HILDESHEIM,
MID-THIRTEENTH CENTURY
Copper alloy
25.1 x 24.1 x 10.8 cm (9 ⁷/₈ x 9 ¹/₂ x 4 ¹/₄ in.)

28
AQUAMANILE OF A SADDLED HORSE,
NORTH GERMAN, CA. 1300
Copper alloy
32.7 x 32.7 x 12.7 cm (12 ⁷/₈ x 12 ⁷/₈ x 5 in.)

29
AQUAMANILE OF A UNICORN,
NORTH GERMAN, CA. 1300
Copper alloy
27 x 30.5 x 10.2 cm (10 ⁵/₈ x 12 x 4 in.)

30
AQUAMANILE OF A HORSE, NUREMBERG,
CA. 1400
Copper alloy
29.2 x 29.2 x 9.8 cm (11 ¹/₂ x 11 ¹/₂ x 3 ⁷/₈ in.)

31
AQUAMANILE OF A HORSE WITH RIDER,
NUREMBERG, CA. 1430–40
Copper alloy
31.8 x 30.5 x 14.3 cm (12 ¹/₂ x 12 x 5 ⁵/₈ in.)
Inscribed between the front legs in ink: K43/[illeg.] 1515

32
SAINT THADDEUS, NORTH GERMAN,
LOWER SAXONY OR WESTPHALIA,
CA. 1350
Copper alloy, gilt
33 x 10.5 x 5.7 cm (13 x 4 ¹/₈ x 2 ¹/₄ in.)

33
MADONNA AND CHILD, FRENCH OR
NETHERLANDISH, CA. 1420
Copper alloy, gilt
11.4 x 3.8 x 3.2 cm (4 ¹/₂ x 1 ¹/₂ x 1 ¹/₄ in.)

34
HEAD OF AN APOSTLE, NORTHEASTERN
FRANCE, THÉROUANNE, CA. 1235
Limestone
45.1 x 31.1 x 34.3 cm (17 ³/₄ x 12 ¹/₄ x 13 ¹/₂ in.)

35
Assistant of or workshop of Giovanni Pisano
HEAD OF A LION, ITALIAN, CA. 1250–1315
Marble
33.7 x 30.5 x 30.5 cm (13 ¹/₄ x 12 x 12 in.)

36A
MINIATURE FROM AN ILLUMINATED
MANUSCRIPT, RECTO: APOCALYPSE
6:1-2, ENGLISH, CA. 1270
Tempura and burnished gold on vellum
10.5 x 14.3 cm (4 ¹/₈ x 5 ⁵/₈ in.)

36B
MINIATURE FROM AN ILLUMINATED
MANUSCRIPT, VERSO: APOCALYPSE
6:3-4, ENGLISH, CA. 1270
Tempura and burnished gold on vellum
10.5 x 14.3 cm (4 ¹/₈ x 5 ⁵/₈ in.)

37A
MINIATURE FROM AN ILLUMINATED
MANUSCRIPT, RECTO: APOCALYPSE
9:13-16, ENGLISH, CA. 1270
Tempura and burnished gold on vellum
10.2 x 16.5 cm (4 x 6 ¹/₂ in.)

37B
MINIATURE FROM AN ILLUMINATED
MANUSCRIPT, VERSO: APOCALYPSE
9:17-21, ENGLISH, CA. 1270
Tempura and burnished gold on vellum
10.2 x 16.5 cm (4 x 6 ¹/₂ in.)

38A
MINIATURE FROM AN ILLUMINATED
MANUSCRIPT, RECTO: APOCALYPSE
13:14-15, ENGLISH, CA. 1270
Tempura and burnished gold on vellum
11.8 x 13.7 cm (4 ⁵/₈ x 5 ³/₈ in.)

38B
MINIATURE FROM AN ILLUMINATED
MANUSCRIPT, VERSO: APOCALYPSE
13:16-18, ENGLISH, CA. 1270
Tempura and burnished gold on vellum
11.8 x 13.7 cm (4 ⁵/₈ x 5 ³/₈ in.)

39A
MINIATURE FROM AN ILLUMINATED
MANUSCRIPT, RECTO: APOCALYPSE
20:7-9, ENGLISH, CA. 1270
Tempura and burnished gold on vellum
10.2 x 14 cm (4 x 5 ¹/₂ in.)

39B
MINIATURE FROM AN ILLUMINATED
MANUSCRIPT, VERSO: APOCALYPSE
20:9-10, ENGLISH, CA. 1270
Tempura and burnished gold on vellum
10.2 x 14 cm (4 x 5 ¹/₂ in.)

40
THE WOODCUTTERS/LES BÛCHERONS
TAPESTRY, SOUTH NETHERLANDS,
PROBABLY TOURNAI, THIRD QUARTER
FIFTEENTH CENTURY
Wool with silk threads
362 x 391.8 cm (141 ¹/₂ x 154 ¹/₄ in.)

41
TWO FIGURES OF SEATED KNIGHTS,
ENGLISH, HEREFORD, 1230–50
Sandstone
.1: 138.4 x 40.6 x 45.7 cm (54 ¹/₂ x 16 x 18 in.)
.2: 128.3 x 43.2 x 38.7 cm (50 ¹/₂ x 17 x 15 ¹/₄ in.)

42
SAINT JOHN THE BAPTIST, BURGUNDY,
THIRD QUARTER FIFTEENTH CENTURY
Limestone
167.64 x 50.8 x 38.1 cm (66 x 20 x 15 in.)

43
THE ERBACH STONE (THE GRAVESTONE
OF CONRADUS SCHRENK ERBACH),
GERMAN, 1417
German red sandstone
31.8 x 219.1 x 106.7 cm (12 ¹/₂ x 86 ¹/₄ x 42 in.)
Inscribed around the border: ANNO.D(NI).MCCCC??/
ON.FEIA.SEXTIL.ANTE. PURIFICACOS.A.NOBL (IS)/
DOMICELIVS.CONRADVS.PINCE RNA.DNS.IN E(RPA)CH

44
DOUBLE CAPITAL, SOUTHWEST FRANCE,
SAINT BERTRAND DE COMMINGES (?),
MID-TWELFTH CENTURY
Marble
177.8 x 47 x 27.3 cm (70 x 18 ¹/₂ x 10 ³/₄ in.)

45
WINDOW, FRENCH, FIFTEENTH CENTURY
(WITH LATER ADDITIONS)
Limestone
210.8 x 104.1 cm (83 x 41 in.)

46
DOORWAY, DEUX-SÈVRES,
FIFTEENTH CENTURY
Limestone
Height: 457 cm (180 in.)

47
CHOIR STALL, FRENCH, CA. 1500
Sculpted wood
257.2 x 268.3 x 117.5 cm (101 ¹/₄ x 145 x 46 ¹/₄ in.)

ARMS AND ARMOR

48
COMPOSITE ARMOR FOR MAN AND HORSE,
GERMAN, MOSTLY NUREMBERG, COMPRE-
HENSIVELY CA. 1515-30
Steel, leather, textile, wood, paint
223.5 x 96.5 x 251.5 cm (88 x 38 x 99 in.)

49
ARMOR FOR THE FIELD, TRADITIONALLY THAT
OF KUNZ SCHOTT VON HELLINGEN, GERMAN,
CA. 1500–10
Steel, leather

179.1 x 76.2 x 45.7 cm (70 ¹/₂ x 30 x 18 in.)
Nuremberg guild mark

50
Michel Witz the Younger (active 1539–1565)
**ARMOR FOR THE FIELD AND TOURNAMENT,
INNSBRUCK, CA. 1530–35**
Etched steel, copper alloy, leather
174 x 71.1 x 45.7 cm (68 ¹/₂ x 28 x 18 in.)

51
**ARMOR FOR THE FIELD, FLORENCE,
CA. 1600–10**
Steel, partly gilt; leather, textile
175.6 x 75.6 x 45.7 cm (69 ¹/₈ x 29 ³/₄ x 18 in.)
Two metal tags attached to the left shoulder: "7",
"L64-.14.20"
Rear of base engraved with "NDP 121A 1929"

52
**ARMOR FOR THE FIELD AND TOURNAMENT,
MADE FOR THE DUKE FRIEDRICH ULRICH OF
BRUNSWICK, GREENWICH, 1610–13**
Steel, etched, blued, and gilt; leather, textile
180.3 x 72.4 x 48.3 cm (71 x 28 ¹/₂ x 19 in.)
Pair of gauntlets lent by The Metropolitan Museum of Art,
Gift of William H. Riggs, 1913

53
**HALF-SHAFFRON BELONGING TO THE
DUKE FRIEDRICH ULRICH OF BRUNSWICK,
GREENWICH, 1610–13**
Steel, etched, blued and gilt with polychromy
44.5 x 30.5 x 35.6 cm (17 ¹/₂ x 12 x 14 in.)

54
Matthäus Frauenpreiss the Elder (ca. 1505–1549)
**SHAFFRON FROM THE "KING'S
GARNITURE" OF THE FUTURE EMPEROR
MAXIMILIAN II, AUGSBURG, CA. 1548–50**
Steel, etched and gilt, enhanced with black wax and
pigment; leather and copper alloy
68.6 x 22.9 x 23.8 cm (27 x 9 x 9 ⁵/₈ in.)

55
SHAFFRON, ITALIAN, CA. 1550–60
Steel, etched and gilt; copper alloy
73.7 x 27.3 x 50.8 cm (29 x 10 3/4 x 20 in.)

56
SHAFFRON, FRENCH, CA. 1600
Steel, etched and partly gilt; copper alloy, textile, leather
58.4 x 23.5 x 20.3 cm (23 x 9 ¹/₄ x 8 in.)

57
EMBOSSED SHAFFRON, ITALIAN, CA. 1550
Steel, copper alloy
47.3 x 25.4 x 31.1 cm (18 ⁵/₈ x 10 x 12 ¹/₄ in.)

58
**HALF-SHAFFRON FOR AN ARMOR OF KING
PHILIP IV OF SPAIN, BRUSSELS, 1624–26**
Steel, engraved, punched, and partly silvered; copper alloy
45.1 x 26 x 43.2 cm (17 ³/₄ x 10 ¹/₄ x 17 in.)

59
**ARMET, ITALIAN, PROBABLY MILAN,
CA. 1420**
Steel, copper alloy
27.3 x 31.8 x 21.6 cm (10 ³/₄ x 12 ¹/₂ x 8 ¹/₂ in.)

Maker's mark: "P.E." struck twice, rear of helmet

60
SALLET, MILAN, CA. 1450
Steel
27.9 x 19.4 x 28.3 cm (11 x 7 ⁵/₈ x 11 ¹/₈ in.)
Struck at the rear with a triple mark of Northern Italian type
involving split crosses over letters "RA" or "BA" and near the
front bottom left corner of the face-opening with the
Venetian winged lion of Saint Mark.

61
ARMET, MILAN, CA. 1470
Steel
28.3 x 19.1 x 33 cm (11 ¹/₈ x 7 ¹/₂ x 13 in.)
Hallmark to verso (probably armorer's mark)

62
Attributed to Lorenz Helmschmid (German, active from
1467, d. 1515)
**VISORED SALLET, PROBABLY MADE FOR
EMPEROR MAXIMILIAN I AS ARCHDUKE OF
AUSTRIA, AUGSBURG, CA. 1480**
Steel, copper alloy, leather, paint
35.6 x 22.2 x 38.7 cm (14 x 8 ³/₄ x 15 ¹/₄ in.)

63
**VISORED BACINET, WESTERN EUROPE,
LATE FOURTEENTH CENTURY**
Steel, iron, copper alloy, leather
50.8 x 20 x 39.4 cm (20 x 7 ⁷/₈ x 15 ¹/₂ in.)

64
**VISORED SALLET WITH ASSOCIATED
BEVOR, AUGSBURG, CA. 1480–90**
Steel, leather
Helmet: 24.1 x 21.6 x 46.4 cm (9 ¹/₂ x 8 ¹/₂ x 18 ¹/₄ in.)
Bevor: 19.1 x 22.2 x 18.4 cm (7 ¹/₂ x 8 ³/₄ x 7 ¹/₄ in.)

65
Attributed to Konrad Seusenhofer (German, ca.
1450–60—1517 or 1518 Innsbruck) or Hans
Seusenhofer (German, 1470–1555 Innsbruck)
**CLOSE-HELMET WITH "MASK" VISOR,
INNSBRUCK, CA. 1515–20**
Steel and copper alloy
23.5 x 25.4 x 31.8 cm (9 ¹/₄ x 10 x 12 ¹/₂ in.)

66
Desiderius Helmschmid (German, Augsburg 1513–1578
or 1579)
**TRIPLE-COMBED BURGONET, AUGSBURG,
CA. 1550**
Steel, leather, textile
29.9 x 20.3 x 33 cm (11 ³/₄ x 8 x 13 in.)

67
**PARADE BURGONET FOR A MEMBER OF THE
COLONNA FAMILY, MILAN, CA. 1560–70**
Steel, embossed and damascened in gold and silver;
copper alloy
30.5 x 21.6 x 33 cm (12 x 8 ¹/₂ x 13 in.)

68
Left:
**DAGGER (CINQUEDEA), NORTH ITALIAN,
LATE FIFTEENTH CENTURY**
Steel, etched and partly gilt; bone, copper alloy
51.8 x 15.6 x 1.6 cm (20 ³/₈ x 6 ¹/₈ x ⁵/₈ in.)
Cast inscriptions to hilt: AUXILIUMSUPERIS, UDACES

FORTUNATIVA

Middle:
**DAGGER (CINQUEDEA), NORTH ITALIAN,
LATE FIFTEENTH CENTURY**
Steel, bone, copper alloy
35.1 x 9.7 x 1 cm (13 ¹³/₁₆ x 3 ¹³/₁₆ x ³/₈ in.)

Right:
**DAGGER (CINQUEDEA), NORTH ITALIAN,
LATE FIFTEENTH CENTURY**
Steel, partly etched and gilt; bone, copper alloy
45.1 x 12.9 x 1.9 cm (17 ³/₄ x 5 ¹/₁₆ x ³/₄ in.)

69
CROSSBOW, GERMAN, CA. 1500
Composite bow covered with painted birch bark, wood
tiller veneered with bone, iron trigger and stirrup
71.1 x 68.6 x 12.7 cm (28 x 27 x 5 in.)

70
**MACE, ITALIAN, PROBABLY MILAN,
CA. 1560–80**
Iron, etched and gilt
57.8 x 10.2 cm (22 ³/₄ x 4 in.)

71
**MACE, EUROPEAN, LATE FIFTEENTH TO
EARLY SIXTEENTH CENTURY**
Iron
52.1 x 8.3 cm (20 ¹/₂ x 3 ¹/₄ in.)
Marked on the mace head with red paint: 10., 2459

72
**MACE, EUROPEAN, LATE FIFTEENTH TO
EARLY SIXTEENTH CENTURY**
Steel, copper alloy
52.1 x 7 cm (20 ¹/₂ x 2 ³/₄ in.)

73
**SWORD, EUROPEAN, EARLY FOURTEENTH
CENTURY**
Steel, copper alloy
118.8 x 18.4 cm (46 ³/₄ x 7 ¹/₄ in.)

74
**SWORD, EUROPEAN, LATE TWELFTH TO
EARLY THIRTEENTH CENTURY**
Steel
104.1 x 23.5 cm (41 x 9 ¹/₄ in.)
The blade inscribed on both sides: +IN NOMINE DII+ and
+NISO ME FECIT+

75
**SWORD, POSSIBLY ITALIAN,
EARLY FIFTEENTH CENTURY**
Steel, copper alloy, wood
110.5 x 22.2 cm (43 ¹/₂ x 8 ³/₄ in.)
Inscribed on one face in Nashki script, translated as:
Deposited in the Arsenal in the frontier city of Alexandria in
the name of al-Malik Abu Nasr Shaikh al-Mu'ayyad in the
year 818 AH [1415 AD]

76
**SWORD, ITALIAN, EARLY-TO
MID-FOURTEENTH CENTURY**
Steel, copper alloy
110.5 x 16.5 cm (43 ¹/₂ x 6 ¹/₂ in.)

77
SWORD, ITALIAN, FIFTEENTH CENTURY
Steel
99.1 x 17.2 cm (39 x 6 ³/₄ in.)

78
SWORD, ITALIAN, CA. 1500
Steel
95.3 x 14 cm (37 ¹/₂ x 5 ¹/₂ in.)

79
BEARING SWORD, AUSTRIAN, FOURTEENTH CENTURY
Steel, wood, leather, copper alloy
180.3 x 38.1 cm (71 x 15 in.)

80
FALCHION, ITALIAN, PROBABLY BRESCIA, CA. 1550–70
Steel, iron hilt damascened in gold
76.8 x 16.5 cm (30 ¹/₄ x 6 ¹/₂ in.)

81
Daniel Sadeler (active Munich 1610–d. 1632)
WHEELLOCK HUNTING RIFLE, MUNICH, CA. 1620
Iron barrel, lock, and mounts, chiseled, blued and gilt; wood stock inlaid with engraved bone
Length: 115.3 cm (45 ³/₈ in.)
Steel medallion numbered "1260" wired to the trigger guard.

82
Emanuel Sadeler (active Munich 1594/95–d. 1610) and Adam Vischer (active Munich 1599-1610)
WHEELLOCK PISTOL, MUNICH, CA. 1600–10
Iron barrel, lock, and mounts, chiseled, blued, and gilt; wood stock inlaid with engraved bone
Length: 75.57 cm (29 ³/₄ in.)
Full stock signed behind the barrel tang with maker's monogram: AV

83
Tula Workshops
PAIR OF FLINTLOCK HOLSTER PISTOLS, TULA, CA. 1745–55
Steel barrels and locks, chiseled and partly gilt; wood stocks with cast silver mounts, horn
Length: 67 cm (18 ¹/₂ in.)

PAINTINGS AND SCULPTURE

Old Master

84
Albrecht Altdorfer (German, Regensburg ca. 1480–1538 Regensburg)
THE MIRACULOUS FOUNTAIN OF ST. FLORIAN, CA. 1518–20
Oil on wood panel
81.3 x 67.3 cm (32 x 26 1/2 in.)
Monogram on the buttress of the church

85
Bartolomeo Vivarini (Italian, Murano?, ca. 1432–ca. 1499)
MADONNA AND CHILD, CA. 1480–85
Oil and gold leaf on wood panel

54.3 x 44.1 cm (21 ³/₈ x 17 ³/₈ in.)

86
Bernaert van Orley (Flemish, Brussels ca. 1487–1541 Brussels)
MADONNA AND CHILD, CA. 1520
Oil on panel
27 x 19.4 cm (10 ⁵/₈ x 7 ⁵/₈ in.)

87
Bernhard Strigel (German, Memmingen 1460–1528 Memmingen)
PORTRAIT OF A MAN, UNDATED
Oil on panel
28.7 x 24.1 cm (11 ⁵/₁₆ x 9 ¹/₂ in.)

88
Quentin Massys (Flemish, Leuven 1466–1530 Antwerp)
AN OLD MAN, CA. 1513
Oil on wood panel
64.1 x 45.1 cm (25 ¹/₄ x 17 ³/₄ in.)

89
Barthel Bruyn the Elder (German, Wesel 1493–1555 Cologne)
PORTRAIT, 1535
Oil on panel
67.3 x 50.8 cm (26 ¹/₂ x 20 in.)
Dated in the composition: 1535

90
Jan Gossaert (called Mabuse) (Flemish, Maubeuge 1478–1536 Middelburg)
PORTRAIT OF AN ABBOT, SIXTEENTH CENTURY
Oil on oak panel
53.3 x 40.6 cm (21 x 16 in.)

91
Franz Xaver Messerschmidt (German, Wiesensteg 1736–1783 Messerschmidt)
THE DIFFICULT SECRET/DAS SCHWERE GEHEIMNIS, 1771–83
Tin cast
43.2 x 22.5 x 24.5 cm (17 x 8 ⁷/₈ x 9 ⁵/₈ in.)
Incised on the base at the lower right: no. 43; in front, at the bottom of the bust, are the remains of an old adhesive label, partially torn, printed and inscribed in ink: 1207 / Nr. 43 / Das Schwere Geheim…

92
Franz Xaver Messerschmidt (German, Wiesensteg 1736–1783 Messerschmidt)
A STRONG MAN/EIN KRAFTVOLLER MANN, CA. 1770
Tin-lead cast
44.5 x 26.7 x 23 cm (17 ¹/₂ x 10 ¹/₂ x 9 in.)
Incised on the based, at the lower right: no. 7; in front, at the bottom of the bust, are the remains of an old label, printed and inscribed in ink: Nr. 7 / Ein Kraftvoller Mann

French

93
Hilaire-Germain-Edgar Degas (French, Paris 1834–1917 Paris)
DEGAS IN A GREEN WAISTCOAT (SELF-PORTRAIT)/DEGAS EN GILET VERT (AUTOPORTRAIT), 1855-56
Oil on canvas

38.6 x 30.8 cm (15 ⁵/₁₆ x 12 ¹/₈ in.)

94
Hilaire-Germain-Edgar Degas (French, Paris 1834–1917 Paris)
PORTRAIT OF A MAN, STANDING, WITH HANDS IN POCKETS (STUDY FOR INTERIOR)/PORTRAIT D'HOMME, DEBOUT, LES MAINS DANS LES POCHES (ÉTUDE POUR L'INTERIEUR), CA. 1868-69
Oil on panel
35 x 27 cm (13 ³/₄ x 10 ⁵/₈ in.)
Lower right stamped with the signature: Degas

95
Édouard Manet (French, Paris 1832–1883 Paris)
PEACHES/PÊCHES, 1882
Oil on canvas
32.7 x 40.6 cm (12 7/8 x 16 in.)
Signed lower right: Manet

96
Paul Cézanne (French, Aix-en-Provence, 1839–1906 Aix-en-Provence)
SELF-PORTRAIT/PORTRAIT DE PAUL CÉZANNE, 1862-64
Oil on canvas
46.4 x 38.3 cm (18 ¹/₄ x 15 ¹/₁₆ in.)

97
Paul Cézanne (French, Aix-en-Provence, 1839–1906 Aix-en-Provence)
PICNIC ON THE GRASS/LE DÉJEUNER SUR L'HERBE, 1869-70
Oil on canvas
60 x 81 cm (23 ⁵/₈ x 31 ⁷/₈ in.)

98
Paul Cézanne (French, Aix-en-Provence, 1839–1906 Aix-en-Provence)
SELF-PORTRAIT/PORTRAIT DE L'ARTISTE, CA. 1885
Oil on canvas
33.2 x 25.4 cm (13 x 9 ⁷/₈ in.)

99
Paul Cézanne (French, Aix-en-Provence, 1839–1906 Aix-en-Provence)
STILL-LIFE: FLOWERS IN A VASE/NATURE MORTE: FLEURS DANS UN VASE, 1885-88
Oil on canvas
46.4 x 55.6 cm (18 ¹/₄ x 21 ⁷/₈ in.)

100
Paul Cézanne (French, Aix-en-Provence, 1839–1906 Aix-en-Provence)
MAN WITH CROSSED ARMS/L'HOMME AUX BRAS CROISÉS, CA. 1899
Oil on canvas
92.1 x 72.7 cm (36 ¹/₄ x 28 ⁵/₈ in.)

101
Paul Cézanne (French, Aix-en-Provence, 1839–1906 Aix-en-Provence)
STILL-LIFE WITH DRAPERY AND FRUIT/NATURE MORTE: RIDEAU À FLEURS ET FRUITS, 1904-06
Oil on canvas
73 x 91.1 cm (28 ³/₄ x 36 ¹/₄ in.)

102
Henri Matisse (French, Le Cateau-Cambrésis
1869–1954 Nice)
**THE BACK I, NO. 7/10/NU DE DOS I,
ISSY-LES-MOULINEAUX, 1909; CAST 1963**
Bronze
189.2 x 115.6 x 17.8 cm (74 1/2 x 45 1/2 x 7 in.)
Signed lower left: Henri Matisse; initialed and number
lower right: HM / 7/10; stamped lower right base:
Georges Rudier / fondeur, Paris

103
Henri Matisse (French, Le Cateau-Cambrésis
1869–1954 Nice)
**THE BACK II, NO. 00/10/NU DE DOS II,
ISSY-LES-MOULINEAUX, AUTUMN 1913;
CAST 1978**
Bronze
188.6 x 121 x 15.2 cm (74 1/4 x 47 5/8 x 6 in.)
Initialed and numbered lower right in relief: HM 00/10;
inscribed on base: Susse Fondeur, Paris

104
Henri Matisse (French, Le Cateau-Cambrésis
1869–1954 Nice)
**THE BACK III, NO. 3/10/NU DE DOS III,
ISSY-LES-MOULINEAUX, 1916/17;
CAST 1981**
Bronze
188.6 x 113 x 15.9 cm (74 1/4 x 44 1/2 x 6 1/4 in.)
Signed lower left in the relief: Henri M; initialed and
numbered lower right in relief: HM/3/10; inscribed lower
right on the edge: Susse Fondeur, Paris

105
Henri Matisse (French, Le Cateau-Cambrésis
1869–1954 Nice)
**THE BACK IV, NO. 1/10/NU DE DOS IV,
NICE, 1930; CAST CA. 1960**
Bronze
188.28 x 114.3 x 16.5 cm (74 1/8 x 45 x 6 1/2 in.)
Initialed and numbered lower right: HM / 1/10; stamped
lower left base: Georges Rudier / fondeur, Paris

106
Pablo Picasso (Spanish, Málaga 1881–1973 Mougins)
**THE BIRDCAGE/LA CAGE D'OISEAUX,
PARIS, 1923**
Oil on canvas
201.3 x 140.3 cm (79 1/4 x 55 1/4 in.)
Signed lower left: Picasso

107
Pablo Picasso (Spanish, Málaga 1881–1973 Mougins)
**HEAD OF A WOMAN/TÊTE DE FEMME,
1931**
Plaster
69 x 60 x 10 cm (27 1/8 x 23 5/8 x 3 7/8 in.)

108
Pablo Picasso (Spanish, Málaga 1881–1973 Mougins)
**BATHER WITH BEACH BALL/BAIGNEUSE
JOUANT AVEC UNE BALLE, BOISGELOUP,
AUGUST 30, 1932**
Oil on canvas
147 x 114.62 cm (57 7/8 x 45 1/8 in.)
Signed lower left: Picasso; dated verso: 1932
The Museum of Modern Art, New York. Partial gift of an
anonymous donor and promised gift of Jo Carole and
Ronald S. Lauder

109
Constantin Brancusi (Romanian-French, Gorj
1876–1957 Paris)
**VIEW OF THE STUDIO/VUE D'ATELIER,
CA. 1918**
Gouache on paper mounted on canvas
54 x 43.2 cm (21 1/4 x 17 in.)
Signed lower right: C Brancusi

110
Constantin Brancusi (Romanian-French, Gorj
1876–1957 Paris)
MADEMOISELLE POGANY II, 1919
Veined marble on limestone and wood bases
44.1 x 20 x 27 cm (17 3/8 x 7 1/2 x 10 5/8 in.)
Signed: C. Brancusi

111
Constantin Brancusi (Romanian-French, Gorj
1876–1957 Paris)
THE CHIEF/LE CHEF, 1925
Wood and iron on limestone and wood bases
51.3 x 19.8 x 29.9 cm (20 3/16 x 7 5/8 x 11 3/4 in.)
Inscribed on underside of head: 18C / Brancusi / Paris

112
Constantin Brancusi (Romanian-French, Gorj
1876–1957 Paris)
LITTLE BIRD/L'OISELET, 1925
Colored marble on limestone and wood base
41 x 22.2 x 30.8 cm (16 1/8 x 8 1/2 x 11 3/4 in.)
Inscribed beneath: C. Brancusi Paris 1925

113
Constantin Brancusi (Romanian-French, Gorj
1876–1957 Paris)
THE FISH/LE POISSON, 1926/1939
Polished bronze on a carved wood base
12.7 x 44.4 x 3.5 cm (5 x 16 11/16 x 1 3/8 in.)
Signed and dated on the underside of the disk: C.
Brancusi Paris 1926; signed and dated on the underside
of the base: C. Brancusi PARIS 1939

114
Constantin Brancusi (Romanian-French, Gorj
1876–1957 Paris)
**BIRD IN SPACE/L'OISEAU DANS L'ESPACE,
CA. 1925**
White marble, in two sections
188.9 x 48.3 cm (74 3/8 x 19 in.)

115
Alberto Giacometti (Swiss, Borgonovo, Stampa
1901–1966 Chur)
**DISAGREEABLE OBJECT / OBJET
DÉSAGRÉABLE, 1931**
Carved wood
15.6 x 49.1 x 11 cm (6 1/8 x 19 5/16 x 4 5/16 in.)
Promised gift to The Museum of Modern Art, New York,
in honor of Kirk Varnedoe

Austrian

116
Gustav Klimt (Austrian, Baumgarten 1862–1918 Vienna)
**ADELE BLOCH-BAUER I / BILDNIS ADELE
BLOCH-BAUER I, 1907**
Oil, silver, and gold on canvas
140 x 140 cm (55 1/8 x 55 1/8 in.)
Neue Galerie New York. This acquisition made available in

part through the generosity of the heirs of the Estates of
Ferdinand and Adele Bloch-Bauer
Frame by Josef Hoffmann
Signed and dated lower right: GUSTAV/ KLIMT/1907

117
Gustav Klimt (Austrian, Baumgarten 1862–1918 Vienna)
**THE BLACK FEATHER HAT (LADY WITH
FEATHER HAT)/DER SCHWARZE FEDERHUT,
1910**
Oil on canvas
79 x 63 cm (31 1/8 x 24 3/4 in.)
Signed and dated lower right: GUSTAV/ KLIMT/1910

118
Gustav Klimt (Austrian, Baumgarten 1862–1918 Vienna)
THE DANCER/DIE TÄNZERIN, CA. 1916–18
Oil on canvas
180 x 90 cm (71 1/16 x 35 3/8 in.)
Unsigned, undated

119
Egon Schiele (Austrian, Tulln 1890–1918 Vienna)
**MAN AND WOMAN I (LOVERS I)/MANN UND
FRAU I (LIEBESPAAR I), 1914**
Oil on canvas
121.3 X 140.5 cm (47 3/8 X 55 1/4 in.)
Signed and dated lower center: EGON/SCHIELE/1914

120
Egon Schiele (Austrian, Tulln 1890–1918 Vienna)
**PORTRAIT OF THE PAINTER KARL
ZAKOVSEK/BILDNIS DES MALERS KARL
ZAKOVSEK, 1910**
Oil, tempera, and charcoal on canvas
100.3 x 90.3 cm (39 1/2 x 35 1/2 in.)
Initialed and dated lower left: S.10.

121
Egon Schiele (Austrian, Tulln 1890–1918 Vienna)
**PORTRAIT OF DR. ERWIN VON GRAFF/
BILDNIS DR. ERWIN VON GRAFF, 1910**
Oil, gouache, and charcoal on canvas
100 x 90 cm (39 3/8 x 35 7/16 in.)
Initialed and dated lower left: S.10.

121A
Egon Schiele (Austrian, Tulln 1890–1918 Vienna)
CONVERSION/BEKEHRUNG, 1912
Oil on canvas
70.1 x 80.2 cm (27 5/8 x 35 5/8 in.)
Signed and dated lower left: EGON/SCHIELE/1912

122
Oskar Kokoschka (Austrian, Pöchlarn [Moravia]
1886–1980 Montreux)
DR. RUDOLPH BLÜMNER, 1910
Oil on canvas
80 x 57.5 cm (31 1/2 x 22 5/8 in.)
Initialed upper right: O.K.
Private Collection

123
Oskar Kokoschka (Austrian, Pöchlarn [Moravia]
1886–1980 Montreux)
PETER ALTENBERG, 1909
Oil on canvas
76 x 71.5 cm (29 7/8 x 28 1/8 in.)
Initialed and dated lower left: OK/09

124

Richard Gerstl (Austrian, Vienna 1883–1908 Vienna)

SELF-PORTRAIT IN FRONT OF A STOVE/ SELBSTBILDNIS VOR EINEM OFEN, 1906–07

Oil on canvas on board

69 X 55 cm (27 ¹/₈ X 21 ⁵/₈ in.)

Neue Galerie New York

124A

Richard Gerstl (Austrian, Vienna 1883–1908 Vienna)

PORTRAIT OF A MAN ON THE LAWN/ BILDNIS EINES MANNES IN DER WIESE, 1907

Oil on canvas

109.5 x 90.2 cm (43 ¹/₈ x 35 ¹/₂ in.)

Richard Gerstl Estate stamp on stretcher

German Early 20th-Century

125

Erich Heckel (German, Dobeln 1883–1970 Hemmenhofen)

BATHERS IN A POND/BADENDE IM TEICH, 1908

Oil on canvas

75 x 95 cm (29 ¹/₂ x 37 ³/₈ in.)

Signed and dated lower right: EH08

Signed, titled, and dated on stretcher: Heckel: Badende im Teich, 1908

126

Ernst Ludwig Kirchner (German, Aschaffenburg, Lower Bavaria 1880–1938 Davos/Friedenheim, Switzerland)

THE RUSSIAN DANCER MELA/ DIE RUSSISCHES TÄNZERIN MELA, 1911

Oil on canvas

100 x 79 cm (45 ¹/₂ x 35 ¹/₈ x 2 in.)

Signed lower left.: Kirchner

127

Vasily Kandinsky (Russian, Moscow 1866–1944 Neuilly-sur-Seine)

WITH GREEN RIDER/MIT GRÜNEM REITER, 1918

Oil on glass

25 x 31 cm (9 ³/₄ x 12 ¹/₂ in.)

Monogrammed lower left in oil: K

128

Vasily Kandinsky (Russian, Moscow 1866–1944 Neuilly-sur-Seine)

COMPOSITION V/KOMPOSITION V, 1911

Oil on canvas

190 x 275 cm (74 ³/₄ x 108 ¹/₄ in.) [6 ft 3 ⁷/₈ x 9 ft. ¹/₄ in.]

Signed and dated lower left: Kandinsky 1911

129

Vasily Kandinsky (Russian, Moscow 1866–1944 Neuilly-sur-Seine)

SEPT, MARCH 1943

Oil on cardboard

57.8 x 41.9 cm (22 ³/₄ x 16 ¹/₂ in.)

Initialed and dated lower left, recto: wk/43

Initialed, numbered, and dated, verso: wk/no 714 1943

130

William Wauer (German, Oberwiesenthal 1866–1962 Berlin)

PORTRAIT OF HERWARTH WALDEN,

DESIGNED 1917; CAST BETWEEN 1945 AND 1962

Bronze with brown patina

Height: 52.5 cm (20 ³/₄ in.)

Signed on left: W. Wauer; inscribed: H.C.; stamped rear right: W. Fuessel Berlin

131

Wilhelm Lehmbruck (German, Duisbourg 1881–1919 Berlin)

BUST OF THE ASCENDING YOUNG MAN/BÜSTE DES EMPORSTEIGENDEN JÜNGLINGS, PARIS, CA. 1914

Bronze

52.7 x 51.1 x 33 cm (20 ³/₄ x 20 ¹/₈ x 13 in.)

132

Kurt Schwitters (German, Hanover 1887–1948 Ambleside)

UNTITLED (MERZPICTURE HORSE FAT)/ OHNE TITEL (MERZBILD ROSSFETT), CA. 1920

Merzbild (Assemblage of oil, paper, cardboard, lace, wood, and glass nailed on wood)

48.3 x 45.7 x 8.9 cm (19 x 18 x 3 ¹/₂ in.)

133

Kurt Schwitters (German, Hanover 1887–1948 Ambleside)

U 11 FOR DEXEL/U 11 FÜR DEXEL, 1921

Collage: Oil, glass, and fabric on glass

22.4 x 27.1 cm (9 ³/₈ x 11 ¹/₈ in.)

Titled, initialed, dated, and inscribed lower left in pencil: U 11 KS 21 / für Dexel

Signed and dated on verso of backing in pencil: Kurt Schwitters 1921

134

Otto Dix (German, Gera/Untermhaus 1891–1969 Singen)

PORTRAIT OF THE LAWYER DR. FRITZ GLASER/BILDNIS RECHTSANWALT DR. FRITZ GLASER, 1921

Oil on canvas

105.9 x 78.75 cm (41 ³/₄ x 31 in.)

Signed and dated lower right: DIX 1921

Signed, titled, and dated verso, top half of canvas: DIX 1921/ Dr. Glaser

135

Otto Dix (German, Gera/Untermhaus 1891–1969 Singen)

HALF-NUDE/HALBAKT, 1926

Oil and tempera on wood

73.1 x 54.9 cm (28 ³/₄ x 21 ⁵/₈ in.)

Signed and dated upper right with the monogram OD and dated "26"

Inscribed by the artist on the back of the painting: Das bild ist bis auf einige Teil im Gesicht mit Temperafarbe gemalt

136

Ludwig Meidner (German, Bernstadt, Silesia 1884–1966 Darmstadt)

I AND THE CITY/ICH UND DIE STADT, 1913

Oil on canvas

65.1 x 49.8 cm (25 ⁵/₈ x 19 ⁵/₈ in.)

Initialed and dated bottom right: LM 1913

137

Georg Grosz (German, Berlin 1893–1959 Berlin)

PORTRAIT OF JOHN FÖRSTE, MAN WITH GLASS EYE/PORTRAIT JOHN FÖRSTE, MANN MIT GLASAUGE, 1926

Oil on canvas

102.9 x 73 cm (40 ¹/₂ x 28 ³/₄ in.)

Signed and dated on verso: Grosz 1926

Inscribed on stretcher: angefangen 24. Sept. 26

138

Christian Schad (German, Miesbach 1894–1982 Stuttgart)

TWO GIRLS/ZWEI MÄDCHEN, 1928

Oil on canvas

109.5 x 80 cm (43 ¹/₈ x 31 ¹/₂ in.)

Signed and dated lower right in oil: SCHAD / 28

139

Max Beckmann (German, Leipzig 1884–1950 New York)

GALLERIA UMBERTO, 1925

Oil on canvas

113 x 50 cm (44 ¹/₂ x 19 ⁵/₈ in.)

Signed and dated lower right in black oil: Beckmann / F.25

140

Max Beckmann (German, Leipzig 1884–1950 New York)

SELF-PORTRAIT IN FRONT OF A RED CURTAIN/SELBSTBILDNIS VOR ROTEM VORHANG, 1923

Oil on canvas

122.9 x 59.2 cm (43 ³/₈ x 23 ⁵/₁₆ in.)

Signed and date lower right: Beckmann / F.23

Private Collection

141

Paul Klee (German/Swiss, b. Münchenbuchsee bei Bern, 1879–1940 Muralto, near Locarno)

GAY REPAST (COLORFUL MEAL)/ BUNTE MAHLZEIT, 1928-29

Oil and watercolor on canvas

83.8 x 67 cm (33 x 26 3/8 in.)

142

Oskar Schlemmer (German, Stuttgart 1888–1943 Baden-Baden)

FIVE NUDES/FUNF AKTE, 1929

Oil on canvas

90.2 x 60 cm (35 ¹/₂ x 23 ⁵/₈ in.)

Signed, dated, and inscribed on verso: 5 Mai 1929 '5 Akte' Osk Schlemmer

German Postwar

143

Georg Baselitz (German, Deutschbaselitz b. 1938–)

MMM IN G UND A, 1961/62/66

Oil on canvas

198.4 x 146 cm (77 ⁵/₁₆ x 57 ⁷/₁₆ in.)

Initialed lower right in oil: G.B.

Signed verso upper right in black marker: G. Baselitz

Titled and dated verso upper right in black oil: M.M.M. in G und A./1961-62/-66

144

Sigmar Polke (German, Oels, Lower Silesia 1941–2010 Cologne)

THE TENNIS PLAYER/DER TENNISSPIELER, 1964

Dispersion on canvas
199.6 x 149.9 cm (78 ⅝ x 58 ¾ in.)

146
Sigmar Polke (German, Oels, Lower Silesia 1941–2010 Cologne)
JAPANESE DANCERS/JAPANISCHE TÄNZERINNEN, 1966
Dispersion on canvas
200 x 170 cm (78 ¾ x 66 ⅞ in.)
Signed and titled verso

146
Sigmar Polke (German, Oels, Lower Silesia 1941–2010 Cologne)
WATCHTOWER/HOCHSITZ, 1984
Synthetic polymer paints and dry pigment on fabric
299.8 x 224.7 cm (118 x 88 ½ in.)
The Museum of Modern Art, New York. Fractional and promised gift of Jo Carole and Ronald S. Lauder

147
Sigmar Polke (German, Oels, Lower Silesia 1941–2010 Cologne)
UNTITLED/OHNE TITEL, 1998
Artificial resin on polyester
116.8 x 137 cm (46 x 53 ¹⁵/₁₆ in.)
Signed and dated lower left: S. Polke 98

148
Gerhard Richter (German, b. Dresden 1932–)
STAG/HIRSCH, 1963
Oil on canvas
150 x 199.8 cm (59 x 78 ¾ in.)
Numbered, signed, and dated upper left verso: 150-200/Richter V. 63

149
Gerhard Richter (German, b. Dresden 1932–)
CITYSCAPE PL/STADTBILD PL, 1970
Oil on canvas
200 x 200 cm (78 ¾ x 78 ¾ in.)
Signed and dated lower right in blue ink: Richter 1970; numbered upper right verso in red ink: Nr, 249
The Museum of Modern Art, New York. Fractional and promised gift of Jo Carole and Ronald S. Lauder

150
Gerhard Richter (German, b. Dresden, 1932–)
STUDY FOR SERIAL NUMBER 324 (FREUD)/STUDIE ZU WERKUR 324 (FREUD), 1971
Oil on canvas
70 x 55 cm (27 ½ x 21 ⅝ in.)
Signed, dated, titled, and inscribed on verso in blue pen: Studie für 324/ Richter '71 / für Ludwig Schafer

151
Gerhard Richter (German, b. Dresden, 1932–)
GRAY/GRAU, 1974
Oil on canvas
199.7 x 150.2 cm (78 ⅝ x 59 ⅛ in.)
Signed, numbered, and dated on verso: Richter 1974 366/1

152
Gerhard Richter (German, b. Dresden, 1932–)
TWO SCULPTURES FOR A ROOM BY PALERMO/ZWEI SKULPTUREN FÜR EINEN RAUM VON PALERMO, 1971
Cast bronze, gray paint, and marble in two parts

Two parts, each: 174 x 20.6 x 20 cm (68 ½ x 8 ⅛ x 10 ¼ in.)
Both heads stamped on the bottom edge: Guss Schmake Dusseldorf

153
Günther Uecker (German, b. Wendorf/ Mecklenburg, 1930–)
SPIRAL/SPIRALE, 1962
Painted nails and kaolin on canvas laid down on board
50.5 x 49.5 x 5 cm (19 ⅞ x 19 ½ x 2 in.)
Signed and titled on verso

154
Günther Uecker (German, b. Wendorf/ Mecklenburg, 1930–)
UNTITLED/OHNE TITEL, 1967
Painted nails, tempera and varnish on canvas laid down on board
78.8 x 100 x 7.6 cm (31 x 39 ⅜ x 3 in.)
Signed and dated verso upper right in pencil: Uecker 67
Inscribed verso upper center in pencil: Oben
Inscribed verso lower right in pencil: Für meine/ Freund/Jef Verheyen

155
Jörg Immendorf (German, Bleckede, Lower Saxony 1945–2007 Düsseldorf)
FRUIT MAN/FRUCHTMANN, 1965
Acrylic on canvas
100 x 100 cm (39 ⅜ x 39 ⅜ in.)

156
Jörg Immendorf (German, Bleckede, Lower Saxony 1945–2007 Düsseldorf)
MILDE SORTE, 1964
Emulsion paint on canvas
151 x 124 cm (59 ⅜ x 48 ¹³/₁₆ in.)

157
Eugen Schönebeck (German, Heidenau b. 1936–)
THE CRUCIFIED II/DER GEKREUZIGTE II, 1964
Oil on canvas
162.4 x 130.5 cm (63 ¹⁵/₁₆ x 51 ⅜ in.)
Signed lower right: E. Schönebeck
Signed verso upper right in black oil: E. Schönebeck
Inscribed verso on the horizontal crossbar in pencil: Der Gekreuzigte II, 1964
Inscribed verso on the top horizontal stretcher upper left in black permanent marker: no 10 le Crucifie
Inscribed verso on the left vertical stretcher: 2600

158
Markus Lüpertz (German, b. Liberc, Bohemia, 1941–)
SOLDIER-DITHYRAMBIC II/SOLDAT-DITHYAMBISCH II, 1972
Distemper on canvas
128.3 x 159.4 cm (51 ³/₁₆ x 63 in.)
Signed and titled verso cross bar: Soldat (Dithyrambisch) Markus Lüpertz

159
Joseph Beuys (German, Kleve 1921–1986 Düsseldorf)
RED IN THE MIDDLE/ROT AUF MITTE, 1984
Metal plate on board in artist's frame
52.2 x 42 cm (20 ⁹/₁₆ x 16 ⁹/₁₆ x ¾ in.)
Titled upper center in pencil: Rot auf Mitte
Signed and dated lower right in pencil: Joseph Beuys 1984

160
Joseph Beuys (German, Kleve 1921–1986 Düsseldorf)
INFILTRATION-HOMOGEN FOR CELLO/ INFILTRATION-HOMOGEN FÜR CELLO, EXECUTED 1967; COMPLETED 1985
Cello, felt, and fabric
138.4 x 47 x 29.2 cm (54 ½ x 18 ¼ x 11 ½ in.)

161
Joseph Beuys (German, Kleve 1921–1986 Düsseldorf)
UNTITLED/OHNE TITEL, 1968
Two record disks, paper covers, and paint
Each: 26 x 27 cm (10 ¼ x 10 ⅝ in.)

162
Joseph Beuys (German, Kleve 1921–1986 Düsseldorf)
THE END OF 100 DAYS AT DOCUMENTA/ DAS ENDE DER 100 TAGE DOCUMENTA, 1972
Wooden board, felt marker, red paint, plastic wrap, cardboard, and battery
96 x 83.2 x 10 cm (37 ⁹/₁₆ x 32 ¾ x 4 in.)

163
Joseph Beuys (German, Kleve 1921–1986 Düsseldorf)
THREE BLACKBOARDS, 1974
White chalk on 3 blackboards
.1-99 x 150.2 cm (39 x 59 ³/₁₆ in.)
.2-90.5 x 120 cm (35 ⁹/₁₆ x 47 ¼ in.)
.3-99 x 150.2 cm (39 x 59 ³/₁₆ in.)

164
Martin Kippenberger (German, Dortmund 1953–1997 Vienna)
UNTITLED/OHNE TITEL, 1990
Oil and lacquer on canvas
240.3 x 200 cm (94 ⁹/₁₆ x 78 ¾ in.)

165
Anselm Kiefer (German, b. Donauschingen 1945–)
HELIOGABAL, 1983
Oil, emulsion, woodcut, shellac, acrylic, and straw on canvas
280.4 x 280.4 cm (110 ³/₅ x 110 ³/₅ in.)
Titled lower center: Heliogabal, with inscriptions

WORKS ON PAPER

French

166
Hilaire-Germain-Edgar Degas (French, Paris 1834–1917 Paris)
PORTRAIT OF A MAN/PORTRAIT D'HOMME, UNDATED
Pencil on paper
19.1 x 14.9 cm (7 ½ x 5 ⅞ in.)
Estate stamp lower left: Nepveu Degas

167
Hilaire-Germain-Edgar Degas (French, Paris 1834–1917 Paris)
STANDING DANCER FASTENING HER SASH/DANSEUSE DEBOUT RATTACHANT SA CEINTURE, CA. 1873
Gouache on paper
53.3 x 36.8 cm (21 x 14 ½ in.)
Signed in pencil lower left: Degas

168
Hilaire-Germain-Edgar Degas (French, Paris 1834–1917 Paris)
TWO STUDIES FOR MUSIC HALL SINGERS/ DEUX ÉTUDES POUR CHANTEUSES DE CAFÉ-CONCERT, CA. 1878–80
Pastel and charcoal on heavy gray paper
44.5 x 57 cm (17 1/2 x 22 7/16 in.)

169
Hilaire-Germain-Edgar Degas (French, Paris 1834–1917 Paris)
LANDSCAPE/PAYSAGE, 1892
Pastel over monotype on laid paper
24.8 x 29.9 cm (9 3/4 x 11 3/4 in.)
Signed lower left in red: Degas

170
Paul Cézanne (French, Aix-en-Provence, 1839–1906 Aix-en-Provence)
BATHERS/BAIGNEURS ET BAIGNEUSES, 1870–75
Watercolor and pencil on paper
12.1 x 24.1 cm (4 3/4 x 9 1/2 in.)

171
Paul Cézanne (French, Aix-en-Provence, 1839–1906 Aix-en-Provence)
SELF-PORTRAIT/AUTOPORTRAIT, CA. 1882–83
Pencil on paper
21.6 x 12.1 cm (8 1/2 x 4 3/4 in.)

172
Paul Cézanne (French, Aix-en-Provence, 1839–1906 Aix-en-Provence)
FULL-LENGTH PORTRAIT OF THE ARTIST'S SON PAUL/PORTRAIT DU FILS DE L'ARTISTE, PAUL, CA. 1885–86
Pencil on gray brown paper
48.9 x 31.4 cm (19 1/4 x 12 3/8 in.)

173
Paul Cézanne (French, Aix-en-Provence, 1839–1906 Aix-en-Provence)
STILL-LIFE WITH SPIRIT LAMP/ NATURE MORTE: "PAIN SANS MIE," 1887–90
Pencil on paper
31.8 x 49.2 cm (12 1/2 x 19 3/8 in.)

174
Paul Cézanne (French Aix-en-Provence, 1839–1906 Aix-en-Provence)
COAT ON A CHAIR/VESTE SUR UNE CHAISE, 1890–95
Pencil and watercolor on white paper
46.4 x 29.9 cm (18 1/4 x 11 3/4 in.)

175
Paul Cézanne (French, Aix-en-Provence, 1839–1906 Aix-en-Provence)
ROCKS NEAR THE CAVES ABOVE CHÂTEAU NOIR (ROCKS NEAR BIBÉMUS)/ROCHERS PRÈS DES GROTTES AU-DESSUS DE CHÂTEAU NOIR (ROCHERS À BIBÉMUS), 1895–1900
Watercolor on paper
46.2 x 30.3 cm (18 3/16 x 11 15/16 in.)

176
Paul Cézanne (French, Aix-en-Provence, 1839–1906 Aix-en-Provence)
MONT SAINTE-VICTOIRE, 1900–02
Watercolor and pencil on white paper
31.1 x 47.6 cm (12 1/4 x 18 3/4 in.)
Inscribed verso lower right in blue crayon: 70

177
Paul Cézanne (French, Aix-en-Provence, 1839–1906 Aix-en-Provence)
APPLES AND INKWELL/POMMES ET ENCRIER, CA. 1902–06
Watercolor and pencil on white paper
31.1 x 45.7 cm (12 1/4 x 18 in.)

178
Vincent Willem van Gogh (Dutch, Zundert 1853–1890 Auvers-sur-Oise)
SOUVENIR OF SAINTES-MARIES ON THE MEDITERRANEAN; BOATS ON THE BEACH, SAINTES-MARIES-DE-LA-MER/SOUVENIR DE SAINTES MARIES MÉDITERRANÉE, CA. JUNE 4, 1888
Reed pen and carbon-based ink over graphite on wove paper
39.5 x 53.6 cm (15 1/2 x 21 1/8 in.)
Signed lower left: Vincent; annotated upper left: Souvenir de Stes. Maries Méditerranée; on the boats are color annotations and the name "Amitié"

179
Vincent Willem van Gogh (Dutch, Zundert 1853–1890 Auvers-sur-Oise)
PORTRAIT OF JOSEPH ROULIN, 1888
Reed pen, brush, ink, and graphite on paper
31.8 x 24.1 cm (12 1/2 x 9 1/2 in.)
Color annotations on the bottom

180
Vincent Willem van Gogh (Dutch, Zundert 1853–1890 Auvers-sur-Oise)
GARDEN WITH FLOWERS, ARLES, CA. JULY 1–AUGUST 3, 1888
Pencil, reed pen and brown ink on wove paper
24.1 x 31.4 cm (9 1/2 x 12 3/8 in.)
Signed lower left: VINCENT

181
Vincent Willem van Gogh (Dutch, Zundert 1853–1890 Auvers-sur-Oise)
OLIVE TREES WITH LES ALPILLES IN THE BACKGROUND/OLIVIERS AVEC LES ALPILLES AU FOND, SAINT-RÉMY, LATE JUNE OR EARLY JULY 1889
Pencil, reed pen, quill and ink on wove paper
47 x 61.9 cm (18 1/2 x 24 3/8 in.)

182
Georges Pierre Seurat (French, Paris 1859–1891 Paris)
SLEEPING MAN/LE DORMEUR, 1881–84
Conté crayon on paper
24 x 31.5 cm (9 1/2 x 12 3/8 in.)
Inscribed verso with estate inventory no. 145

183
Georges Pierre Seurat (French, Paris 1859–1891 Paris)
MAN IN A BOWLER HAT (STUDY FOR *BAIGNADE*)/L'HOMME AU CHAPEAU MELON (ÉTUDE POUR *BAIGNADE*), 1883

Conté crayon on paper
24.1 x 29.8 cm (9 1/2 x 11 3/4 in.)
Inscribed in blue on verso: G. Seurat; and in red crayon: La Baignade, 320

184
Georges Pierre Seurat (French, Paris 1859–1891 Paris)
GIRL IN A SLOUCH HAT/PETITE FILLE AU CHAPEAU NINICHE, 1882–84
Conté crayon on paper
31.8 x 24 cm (12 1/2 x 9 1/2 in.)
Signed verso in red crayon: No. 131 Seurat S.; inscribed below in another hand: 53 9 bis.

185
Georges Pierre Seurat (French, Paris 1859–1891 Paris)
THE COUPLE (AT DUSK)/AU CRÉPUSCULE, 1882–83
Conté crayon on paper
30.5 x 24 cm (12 1/8 x 9 3/8 in.)

186
Georges Pierre Seurat (French, Paris 1859–1891 Paris)
DUSK (THE ANGELUS)/CRÉPUSCULE DU SOIR (L'ANGELUS), CA. 1883
Conté crayon and graphite on paper
23.5 x 31.4 cm (9 1/4 x 12 3/8 in.)

187
Georges Pierre Seurat (French, Paris 1859–1891 Paris)
THE PIER OF PORT-EN-BESSIN/ L'ESTACADE DE PORT-EN-BESSIN, CA. 1888
Charcoal on paper
21.5 x 29 cm (8 1/2 x 11 3/8 in.)

188
Georges Pierre Seurat (French, Paris 1859–1891 Paris)
HIGH C/FORTE CHANTEUSE, 1887–88
Conté crayon and white gouache on paper
30 x 23 cm (11 13/16 x 9 1/8 in.)
Signed upper left: Seurat

189
Pablo Picasso (Spanish, Málaga 1881–1973 Mougins)
SELF-PORTRAIT/PORTRAIT DE L'ARTISTE, BARCELONA, 1899
Charcoal on paper
45.1 x 51.1 cm (17 3/4 x 20 1/8 in.)
Signed upper left: P. Ruiz Picasso

190
Pablo Picasso (Spanish, Málaga 1881–1973 Mougins)
WOMAN WITH A RAVEN/LA FEMME AU CORBEAU, PARIS, 1904
Gouache and pastel on paper
60.5 x 45.5 cm (23 7/8 x 17 7/8 in.)
Signed and dated lower right: Picasso/1904

191
Pablo Picasso (Spanish, Málaga 1881–1973 Mougins)
TWO FEMALE NUDES/NU DEBOUT ET NU ASSIS, PARIS, AUTUMN 1906
Charcoal on paper
62.9 x 47 cm (24 15/16 x 18 3/4 in.)
Signed lower left: Picasso

192
Pablo Picasso (Spanish, Málaga 1881–1973 Mougins)
PROFILES OF A MAN'S HEAD/TÊTES DE

PROFIL, PARIS, WINTER-SPRING 1907
Brush and ink on paper
62.9 x 48 cm (24 ³/₄ x 18 ⁷/₈ in.)

193
Pablo Picasso (Spanish, Málaga 1881–1973 Mougins)
HEAD/TÊTE, 1907
Pencil on paper
64.1 x 49.8 cm (25 ¹/₄ x 19 ⁵/₈ in.)

194
Pablo Picasso (Spanish, Málaga 1881–1973 Mougins)
HEAD OF A WOMAN, FERNANDE/ VISAGE, TROIS-QUART GAUCHE, 1908–09
Charcoal on paper
32.4 x 43.2 cm (12 ³/₄ x 17 in.)
Inscribed upper right: 537

195
Pablo Picasso (Spanish, Málaga 1881–1973 Mougins)
STANDING NUDE SEEN FROM THE BACK/ NU DEBOUT DE DOS, PARIS, AUTUMN 1908
Gouache and pencil on paper
62.6 x 48.6 cm (24 ⁵/₈ x 19 ¹/₈ in.)

196
Pablo Picasso (Spanish, Málaga 1881–1973 Mougins)
FEMALE NUDE/FEMME NUE, PARIS, SPRING 1910
Watercolor, pen and ink on paper
75.3 x 47 cm (29 ⁵/₈ x 18 ¹/₂ in.)
Signed and dated lower right: Picasso 10

197
Pablo Picasso (Spanish, Málaga 1881–1973 Mougins)
VIOLIN/VIOLON, PARIS OR CERET, SPRING 1912
Charcoal on heavy cream wove paper
63.5 x 48.3 cm (25 x 19 in.)
Signed on reverse in graphite: Picasso; stamp of Kahnweiler sale over signature

198
Pablo Picasso (Spanish, Málaga 1881–1973 Mougins)
HEAD OF A MAN IN A BOWLER HAT/ TÊTE D'HOMME AU CHAPEAU MELON, PARIS, AUTUMN-WINTER 1912
Pasted papers and charcoal on paper
62.9 x 47.1 cm (24 ³/₄ x 18 ⁹/₁₆ in.)

199
Pablo Picasso (Spanish, Málaga 1881–1973 Mougins)
PLAYING CARD, FRUIT DISH, GLASS/ CARTE À JOUER, COMPOTIER, VERRE, 1914
Pasted papers, oil, and charcoal on paper
61.2 x 47.7 cm (24 ¹/₈ x 18 ³/₄ in.)
Signed verso in pencil: Picasso

200
Pablo Picasso (Spanish, Málaga 1881–1973 Mougins)
MAN SEATED ON A CHAIR/HOMME ASSIS SUR UNE CHAISE, PARIS, 1915
Watercolor and pencil on paper
34 x 24.8 cm (13 ³/₈ x 9 ³/₄ in.)
Signed lower left: Picasso

201
Pablo Picasso (Spanish, Málaga 1881–1973 Mougins)
WOMAN WITH ROSARY/FEMME AU CHAPELET, PARIS, 1919

Pencil on paper
33 x 22 cm (13 x 8 ³/₄ in.)
Signed lower right in pen and black ink: Picasso

202
Pablo Picasso (Spanish, Málaga 1881–1973 Mougins)
IGOR STRAVINSKY, PARIS, DECEMBER 31, 1920
Pencil on paper
34.5 x 24 cm (13 ⁵/₈ x 9 ¹/₂ in.)
Dated and signed upper left in pencil: 31-12-20/Picasso

203
Pablo Picasso (Spanish, Málaga 1881–1973 Mougins)
SELF-PORTRAIT IN PROFILE/ AUTOPORTRAIT, PARIS, 1921
Pencil on paper
27 x 21 cm (10 ⁵/₈ x 8 ¹/₄ in.)
Signed upper left: P. Ruiz Picasso

204
Pablo Picasso (Spanish, Málaga 1881–1973 Mougins)
BULL AND HORSES/TAUREAU ET CHEVAUX, PARIS, JANUARY 15, 1936
Pen and ink on paper
17.2 x 25.1 cm (6 ³/₄ x 9 ⁷/₈ in.)
Dated lower right and verso: 15 Janvier XXXVI

205
Henri Matisse (French, Le Cateau-Cambrésis 1869–1954 Nice)
RECLINING NUDE PLAYING PIPES (STUDY FOR JOY OF LIFE)/NU ALLONGÉ JOUANT DU PIPEAU (ÉTUDE POUR LE BONHEUR DE VIVRE), 1905–06
Black ink on paper
45.72 x 60.33 cm (18 x 23 ³/₄ in.)

206
Henri Matisse (French, Le Cateau-Cambrésis 1869–1954 Nice)
SEATED WOMAN (STUDY FOR THE LINOLEUM CUT, NU ASSIS)/FEMME ASSISE, PARIS, CA. 1906
Brush and ink on paper
33.3 x 27 cm (13 ¹/₈ x 10 ⁵/₈ in.)
Initialed lower left: HM

207
Henri Matisse (French, Le Cateau-Cambrésis 1869–1954 Nice)
HAT WITH FEATHERS/LE CHAPEAU AUX PLUMES, 1919
Pencil on paper
34.93 x 29.21 cm (13 ³/₄ x 11 ¹/₂ in.)
Signed and dated in pencil lower left: Henri Matisse 1919

208
Henri Matisse (French, Le Cateau-Cambrésis 1869–1954 Nice)
STUDIO OF THE ARTIST/L'ATELIER DE L'ARTISTE, 1935
Pen and ink on paper
40 x 52 cm (15 ³/₄ x 20 ¹/₂ in.)
Signed and dated lower left in pen: Henri-Matisse 1935
Inscribed verso lower left in pencil: ML1501/MN 1322

209
Henri Matisse (French, Le Cateau-Cambrésis 1869–1954 Nice)

SELF-PORTRAIT, OPEN SHIRT/ AUTOPORTRAIT DE FACE, CHEMISE OUVERTE, JULY 1944
India ink on paper
40.3 x 26.4 cm (15 ⁷/₈ x 10 ³/₈ in.)
Signed and dated lower right, in ink: H. Matisse Juill. 44

210
Henri Matisse (French, Le Cateau-Cambrésis 1869–1954 Nice)
TWO DANCERS (STUDY FOR THE CURTAIN OF STRANGE FARANDOLE)/ DEUX DANSEURS (ÉTUDE POUR LE RIDEAU D'ÉTRANGE FARANDOLE), 1938
Gouache on paper cut-out mounted on a board
63 x 64.5 cm (24 ¹³/₁₆ x 25 ³/₈ in.)

211
Henri Matisse (French, Le Cateau-Cambrésis 1869–1954 Nice)
ASCHER SQUARE (MAQUETTE B) ELEMENT #5, 1946
Paper cut-out
24.8 x 30.8 cm (9 ³/₄ x 12 ¹/₈ in.)

Austrian

212
Gustav Klimt (Austrian, Baumgarten 1862–1918 Vienna)
STANDING WOMAN WITH CAPE/ STEHENDE DAME MIT CAPE VON VORNE, CA. 1896
Pencil with white heightening on paper
44.1 x 29.8 cm (17 ³/₈ x 11 ³/₄ in.)
Signed lower right in charcoal below image: GUSTAV KLIMT

213
Gustav Klimt (Austrian, Baumgarten 1862–1918 Vienna)
SEATED WOMAN RESTING/AUFGESTÜZT SITZENDE FRAU, 1902
Black chalk on paper
44.5 x 31.7 cm (17 ¹/₂ x 12 ¹/₂ in.)
Inscribed lower right: G. KLIMT
Inscribed lower right corner: R

214
Gustav Klimt (Austrian, Baumgarten 1862–1918 Vienna)
FEMALE NUDE FROM THE FRONT/ FRAUENAKT VON VORNE, 1902
Black chalk on paper
44.8 x 32.8 cm (17 ⁵/₈ x 12 ⁷/₈ in.)
Inscribed lower right: GUSTAV/KLIMT
Inscribed lower right corner: R

215
Gustav Klimt (Austrian, Baumgarten 1862–1918 Vienna)
TRANSFER DRAWING FOR JURISPRU- DENCE/ÜBERTRAGUNGSSKIZZE FÜR DIE JURISPRUDENZ, 1902-03
Black chalk and pencil on paper
82.5 x 60.3 cm (32 ¹/₂ x 23 ³/₄ in.)

216
Gustav Klimt (Austrian, Baumgarten 1862–1918 Vienna)
SEATED OLD WOMAN IN PROFILE FACING LEFT/SITZENDE ALTE FRAU IM PROFIL NACH LINKS, CA. 1904
Black chalk on paper
55 x 34.9 cm (21 ⁵/₈ x 13 ³/₄ in.)

217

Gustav Klimt (Austrian, Baumgarten 1862–1918 Vienna)

WOMAN, RAISED LOWER ARMS, HANDS BENT BACKWARDS/MIT ERHOBENEN UNTERARMEN, DIE HANDE NACH HINTEN ABGEWINKELT, CA. 1905–11

Pencil and red and blue pencil and white chalk on paper
55.9 x 36.8 cm (22 x 14 1/2 in.)

218

Gustav Klimt (Austrian, Baumgarten 1862–1918 Vienna)

TWO RECLINING WOMEN FACING RIGHT/FREUNDINNEN NACH RECHTS LIEGEND, CA. 1904

Pencil on paper
35.3 x 55.6 cm (13 7/8 x 21 7/8 in.)
Sighed lower right in pencil: GUSTAV KLIMT

219

Gustav Klimt (Austrian, Baumgarten 1862–1918 Vienna)

RECLINING NUDE FACING RIGHT/ LIEGENDER HALBAKT NACH RECHTS, 1912–13

Pencil and red and blue pencil
37.1 x 56 cm (14 5/8 x 22 in.)
Signed lower right: Gustav/Klimt (encircled)

220

Gustav Klimt (Austrian, Baumgarten 1862–1918 Vienna)

WOMAN IN KIMONO FACING LEFT/ FRAU IM KIMONO IM DREIVIERTELPROFIL NACH LINKS, 1910

Pencil and red crayon and white chalk on paper
54.8 x 36.9 cm (21 5/8 x 14 1/2 in.)
Signed lower right in pencil twice: Gustav/Klimt
(encircled); Gustav/Klimt (in a square)

221

Gustav Klimt (Austrian, Baumgarten 1862–1918 Vienna)

SEATED WOMAN WITH SPREAD THIGHS/ SITZENDE FRAU MIT GESPREIZTEN SCHENKELN, 1916–17

Pencil and red pencil and white chalk on paper
37.4 x 55.8 cm (22 1/2 x 14 3/4 in.)
Signed lower right in pencil: Gustav/Klimt (encircled)

222

Egon Schiele (Austrian, Tulln 1890–1918 Vienna)

CITY ON THE BLUE RIVER I (DEAD CITY I)/ STADT AM BLAUEM FLUSS I (TOTE STADT I), 1910

Gouache with glue and black crayon on paper
41.2 x 30.8 cm (16 1/4 x 12 1/8 in.)
Signed and dated lower right: SCHIELE 10.

223

Egon Schiele (Austrian, Tulln 1890–1918 Vienna)

SELF-PORTRAIT WITH ARM TWISTED ABOVE HEAD/SELBSTBILDNIS MIT ARM ÜBER DEN KOPF GEZOGEN, 1910

Watercolor and charcoal on paper
45.1 x 31.7 cm (17 3/4 x 12 1/2 in.)
Initialed lower right: S
Initialed lower left corner: S
Inscribed center lower edge on verso: 7 (encircled)
Inscribed in center on verso: 4 / 32 (in green pencil)

224

Egon Schiele (Austrian, Tulln 1890–1918 Vienna)

STANDING MALE NUDE, BACK VIEW/

STEHENDER MÄNNLICHER RÜCKENAKT, 1910

Watercolor, gouache, and charcoal on paper
44.8 x 30.8 cm (17 5/8 x 12 1/8 in.)
Initialed lower left: S
Inscribed center lower edge on verso: 7 (encircled)

225

Egon Schiele (Austrian, Tulln 1890–1918 Vienna)

RECLINING MAN (MAX OPPENHEIMER)/ LIEGENDER [MAX OPPENHEIMER], 1910

Watercolor, gouache, and black crayon on paper
44.8 x 31.5 cm (17 5/8 x 12 3/8 in.)
Signed and dated lower right: EGON / SCHIELE / 1910
Inscribed in center on verso in green pencil: 10

226

Egon Schiele (Austrian, Tulln 1890–1918 Vienna)

PORTRAIT OF THE PAINTER MAX OPPENHEIMER/BILDNIS DES MALERS MAX OPPENHEIMER, 1910

Watercolor, gouache, ink and black crayon on paper
45.5 x 32.1 cm (17 7/8 x 12 5/8 in.)
Initialed and dated lower right: S. 1910.
Initialed lower left corner in black crayon: S
Inscribed upper right corner (possibly in charcoal): OPP
(erased and almost illegible)
Inscribed lower center on verso in brownish ink: Herrn
Oberinspektor Benesch / in Erinnerung an gemeinsam
verlebte / Stunden / O. Reichel / 14 (in blue pencil)
Estate stamp upper left corner on verso (almost completely
faded): OSKAR REICHEL / WIEN / X …
asse 11

227

Egon Schiele (Austrian, Tulln 1890–1918 Vienna)

MIME VAN OSEN, 1910

Watercolor, gouache and crayon on paper
38.3 x 31.5 cm (15 1/8 x 12 3/8 in.)
Signed and dated lower right: EGON/SCHIELE/ 1910.
Inscribed upper right: MIME VAN/OSEN
Inscribed lower right corner: 10
Inscribed lower left corner: 831
Inscribed in center on verso in red pencil: 4
Inscribed lower left on verso: E I/8 / Az(?) 831 E L(?)
Inscribed lower right on verso: 41
Stamped lower right corner on verso in mauve ink: GA
(inscribed into rectangle) [stamp of the collector Guido
Arnot]
Inscribed upper left on verso: Sugg(?)

228

Egon Schiele (Austrian, Tulln 1890–1918 Vienna)

PORTRAIT OF DR. OSKAR REICHEL/ BILDNIS DR. OSKAR REICHEL, 1910

Watercolor, gouache and black crayon on paper
43.8 x 31.4 cm (17 1/4 x 12 3/8 in.)
Initialed and dated lower right: S.10.

229

Egon Schiele (Austrian, Tulln 1890–1918 Vienna)

PORTRAIT OF EDUARD KOSMACK WITH RAISED LEFT HAND/BILDNIS EDUARD KOSMACK MIT ERHOBENER LINKER HAND, 1910

Watercolor, gouache, and black chalk on paper
44.5 x 31.8 cm (17 1/2 x 12 1/2 in.)
Initialed and dated: S.10; inscribed center right:
Kosmak [sic]

230

Egon Schiele (Austrian, Tulln 1890–1918 Vienna)

STANDING BOY IN STRIPED SHIRT/ STEHENDER KNABE IN GESTREIFTEM HEMD, 1910

Watercolor, gouache, and crayon on paper
45.2 x 31.4 cm (17 3/4 x 12 3/8 in.)
Stamped upper right corner on verso in mauve ink: VON
DER / ZENTRALSTELLE / FÜR DENKMALSCHUTZ /
ZUR AUSFUHR / FREIGEGEBEN (inscribed into triangle
with eagle at top)
Inscribed in center on verso in blue pencil: 63
Inscribed lower left corner on verso: V(?) E (underlined)
Inscribed center lower edge on verso: …37 (erased and
barely legible)
Inscribed lower right corner on verso: …92… (erased and
barely legible)

231

Egon Schiele (Austrian, Tulln 1890–1918 Vienna)

VIEW OF THE ARTIST'S STUDIO/ BLICK IN DAS ATELIER DES KÜNSTLERS, 1910

Watercolor, gouache, and black crayon on paper
44.1 x 31.7 cm (17 1/2 x 12 5/8 in.)
Initialed and dated lower left: S. 1910.
Inscribed lower right verso: 6
Inscribed in center on verso in green pencil: 104

232

Egon Schiele (Austrian, Tulln 1890–1918 Vienna)

RECLINING SEMI-NUDE /LIEGENDER HALBAKT, 1911

Watercolor, gouache, and pencil on paper
48.2 x 31.7 cm (19 x 12 1/2 in.)
Signed and dated lower right: EGON/SCHIELE/
1911.

233

Egon Schiele (Austrian, Tulln 1890–1918 Vienna)

SEATED NUDE, THREE-QUARTER-VIEW (MOA)/SITZENDER AKT IN HALBER FIGUR (MOA), 1911

Watercolor, gouache, pen and ink, and pencil on paper
48.2 x 32.1 cm (19 x 12 5/8 in.)
Signed and dated upper right: EGON/SCHIELE/1911.
Inscribed center right: MOA (inscribed into rectangle)
Inscribed lower left corner on verso: 38
Inscribed upper right on verso: 53

234

Egon Schiele (Austrian, Tulln 1890–1918 Vienna)

SUNFLOWER/SONNENBLUME, 1916

Gouache and black crayon on paper
46.3 x 29.6 cm (18 1/8 x 11 5/8 in.)
Signed and dated lower right: EGON/SCHIELE/1916

235

Egon Schiele (Austrian, Tulln 1890–1918 Vienna)

PORTRAIT OF THE COMPOSER ARNOLD SCHÖNBERG/BILDNIS DES KOMPONISTEN ARNOLD SCHÖNBERG, 1917

Watercolor, gouache, and black crayon on paper
45.7 x 29.2 cm (18 x 11 1/2 in.)
Signed and dated lower left: Egon / Schiele / 1917
(inscribed into rectangle)
Inscribed lower left: ARNOLD SCHÖNBERG
Stamped lower left corner on verso: …ERREICH
…DESDENKMALAMT (printed in circle with eagle in
center [probably for Vom Bundesdenkmalamt Österreich

zur Ausfuhr freigegeben])
Inscribed lower right corner on verso: 1830
Inscribed center upper edge on verso in brown ink: 127
(the last number superimposed in pencil with 5)
Inscribed upper right on verso in brown ink: Karl Grünwald

236
Egon Schiele (Austrian, Tulln 1890–1918 Vienna)
FRIENDSHIP/FREUNDSCHAFT, 1913
Watercolor, gouache, and pencil on paper
48.2 x 32 cm (19 x 12 5/8 in.)
Signed and dated lower right: EGON SCHIELE/1913
(inscribed into rectangle)
Inscribed lower left: FREUNDSCHAFT (inscribed into rectangle)

237
Egon Schiele (Austrian, Tulln 1890–1918 Vienna)
KNEELING SEMI-NUDE /KNIENDER HALBAKT, 1917
Watercolor, gouache, black crayon, and pencil on paper
45.7 x 28.6 cm (18 x 11 1/4 in.)
Signed and dated lower left: EGON / SCHIELE / 1917
(inscribed into rectangle)

238
Egon Schiele (Austrian, Tulln 1890–1918 Vienna)
SUPPLY DEPOT, TRENTO BRANCH: EXTERIOR VIEW WITH NOTICE BOARD/ KONSUMANSTALT, FILIALE TRIENT: AUSSENANSICHT MIT SCHILD, 1917
Black crayon on paper
46.2 x 29.5 cm (18 1/4 x 11 5/8 in.)
Signed and dated lower right: EGON / SCHIELE / 1917
(inscribed into rectangle)
Inscribed lower left: Trient

239
Egon Schiele (Austrian, Tulln 1890–1918 Vienna)
PEASANT JUGS/BAUERNKRUEGE, 1918
Gouache and black crayon on paper
46.4 x 30.5 cm (18 3/16 x 12 in.)
Signed and dated lower right in black crayon: EGON / SCHIELE / 1918
Inscription: O.W.

240
Oskar Kokoschka (Austrian, Pöchlarn [Moravia] 1886–1980 Montreux)
THE NARROW PATH/DER SCHMALE WEG, CA. 1907
Ink on paper
22.2 x 18.4 cm (8 3/4 x 7 3/16 in.)
Initialed lower right: OK

241
Oskar Kokoschka (Austrian, Pöchlarn [Moravia] 1886–1980 Montreux)
STANDING FEMALE NUDE/STEHENDER WEIBLICHER AKT, 1908
Pencil on cream wove paper
43.2 x 22.5 cm (17 x 8 7/8 in.)
Initialed lower right: OK

242
Oskar Kokoschka (Austrian, Pöchlarn [Moravia] 1886–1980 Montreux)
RECLINING WOMAN/LIEGENDER FRAU, CA. 1910

Watercolor and pencil on paper
30.5 x 44.5 cm (12 x 17 1/2 in.)
Initialed lower right: OK

243
Oskar Kokoschka (Austrian, Pöchlarn [Moravia] 1886–1980 Montreux)
TINI SENDERS, 1912
Charcoal on paper
44.5 x 28.9 cm (17 9/16 x 11 3/8 in.)
Initialed lower right in charcoal: OK

244
Oskar Kokoschka (Austrian, Pöchlarn [Moravia] 1886–1980 Montreux)
WILHELM KÖHLER, 1912
Black chalk and ink on paper
34.5 x 24.5 cm (13 5/8 x 9 5/8 in.)
Initialed lower right: OK

245
Oskar Kokoschka (Austrian, Pöchlarn [Moravia] 1886–1980 Montreux)
GIRL WITH TURBAN/MÄDCHEN MIT TURBAN, EARLY 1920S
Watercolor on Butten paper
69.8 x 52.1 cm (27 1/2 x 20 1/2 in.)
Signed lower right in pencil: OKokoschka
Inscribed lower center in pencil: 4217
Inscribed verso: Mädchen mit Turban

246
Richard Gerstl (Austrian, Vienna 1883–1908 Vienna)
SELF-PORTRAIT/SELBSTBILDNIS, CA. 1907
Pen and ink on paper
46 x 31.5 cm (13 5/8 x 10 1/4 in.)
Estate stamp on verso and the number 61

247
Alfred Kubin (Czech, Leitmeritz 1877–1959 Wernstein)
STALLION/HENGST, CA. 1899
Ink, wash, and spray on paper
13.2 x 16.6 cm (5 3/16 x 6 1/2 in.)
Monogram lower right; text on verso by Kubin: eines der ersten Hengstlein, schon 1903, sehr charakteristisch für diese Zeit; ist es etwas wie irres in dieser Physiognomie

248
Alfred Kubin (Czech, Leitmeritz 1877–1959 Wernstein)
RABID DOG/TOLLWÜTIGER HUND, CA. 1900–01
Pen and ink and spray on paper
12.4 x 13.3 cm (4 7/8 x 5 1/4 in.)
Signed lower right in ink: KUBIN

249
Alfred Kubin (Czech, Leitmeritz 1877–1959 Wernstein)
THE GLUTTON/DER SCHLEMMER, CA. 1903–04
Pen and ink, wash, and stipple on paper
29.8 x 30.2 cm (11 3/4 x 11 7/8 in.)
Signed lower right in margin in ink: A Kubin
Titled lower left in pencil: Der Schlemmer

250
Alfred Kubin (Czech, Leitmeritz 1877–1959 Wernstein)
DYING/STERBEN, 1899
Pen and ink, wash, and spray on paper
21 x 30.2 cm (8 5/16 x 11 15/16 in.)

Signed lower left in ink: S. L. Holstscher / von ore/ und Kubin (illegible)
Titled lower center in ink: Sterben

251
Alfred Kubin (Czech, Leitmeritz 1877–1959 Wernstein)
SUICIDE BEFORE AN IDOL/ SELBSTOPFER VOR EINEM GOETZENBILD, CA. 1900
Pen, ink, watercolor and spray on paper
21.6 x 8.9 cm (8 1/2 x 3 1/2 in.)

252
Alfred Kubin (Czech, Leitmeritz 1877–1959 Wernstein)
CHARON, CA. 1902–03
Pen and ink on paper
17.1 x 26 cm (6 3/4 x 10 1/4 in.)
Signed lower right in ink: Kubin

253
Alfred Kubin (Czech, Leitmeritz 1877–1959 Wernstein)
DESTINY/DAS SCHICKSAL, CA. 1903–04
Watercolor on paper
19.1 x 27 cm (7 1/2 x 10 5/8 in.)
Titled lower left in pencil: Schicksal
Signed lower right in ink: Kubin

254
Alfred Kubin (Czech, Leitmeritz 1877–1959 Wernstein)
THE WIND/DER WIND, CA. 1902–03
Ink on paper
38.5 x 30.5 cm (15 1/4 x 12 in.)
Signed lower right margin in pencil: A. Kubin
Titled lower left margin in pencil: Der Wind
Inscribed verso top left in pencil: Frau Dr. Pauwels/in dankbarer Erinnerung/an Münchner Wintertage 1912/Feliz Grafe

German

255
Erich Heckel (German, Dobeln 1883–1970 Hemmenhofen)
SEATED GIRL ON RED PILLOW/SITZENDES MÄDCHEN AUF ROTEM KISSEN, 1910
Black crayon, tempera, and watercolor on paper
34 x 43.5 cm (13 3/8 x 17 1/8 in.)
Signed and dated lower right: Erich Heckel 10

256
Vasily Kandinsky (Russian, Moscow 1866–1944 Neuilly-sur-Seine)
STUDY FOR SKETCH FOR *DELUGE III*/ENTWURF ZU SKIZZE FÜR *SINFLUT II*, SUMMER 1912
Watercolor, India ink, and pencil on off-white laid paper
52.4 x 57.2 cm (20 5/8 x 22 1/2 in.)
Monogrammed lower right (undated): K

257
Vasily Kandinsky (Russian, Moscow 1866–1944 Neuilly-sur-Seine)
RED AND BLUE/ROT UND BLAU, 1913
Watercolor, India ink, and pencil on paper
73.7 x 78.1 cm (29 x 30 3/4 in.)

Monogrammed lower right in triangle (undated): K

258
Vasily Kandinsky (Russian, Moscow 1866–1944 Neuilly-sur-Seine)
UNTITLED (STUDY FOR *PAINTING WITH*

WHITE FORM)/OHNE TITEL (ENTWURF ZU BILD MIT WEISSER FORM), 1913
Ink on paper
26.7 x 37.5 cm (10 ½ x 14 ¾ in.)

259
Vasily Kandinsky (Russian, Moscow 1866–1944 Neuilly-sur-Seine)
UNTITLED (ABSTRACT COMPOSITION)/ OHNE TITEL (ABSTRAKTE KOMPOSITION), STOCKHOLM, 1916
Pen and brush and ink on paper
18.4 x 24.4 cm (7 ¼ x 9 ⅝ in.)
Signed with monogram and dated: 16

260
Vasily Kandinsky (Russian, Moscow 1866–1944 Neuilly-sur-Seine)
UNTITLED/OHNE TITEL, 1913
Watercolor, graphite, and brush and ink on paper
27.3 x 38.1 cm (10 ¾ x 15 in.)
Monogrammed lower left in black crayon (undated): K

261
Vasily Kandinsky (Russian, Moscow 1866–1944 Neuilly-sur-Seine)
UNTITLED/OHNE TITEL, 1922
Watercolor, pen and brush with India ink on paper
33 x 47 cm (13 x 18 ½ in.)
Monogrammed lower left: K
Inscribed by Nina Kandinsky on a photograph paper attached to the backing: C'est le dessin de/ Kandinsky, je suis contente/ que vous l'avez

262
Franz Marc (German, Ried 1880–1916 Verdun)
DOUBLE SKETCH OF FOUR HORSES/ DOPPELGRUPPE VON VIER PFERDEN, CA. 1911
Pencil on paper
21.6 x 16.8 cm (8 ½ x 6 ⅝ in.)

263
Franz Marc (German, Ried 1880–1916 Verdun)
THE FIRST ANIMALS/DIE ERSTEN TIERE, 1913
Gouache and pencil on paper
38.7 x 46.4 cm (15 ¼ x 18 ¼ in.)
Initialed lower right: M

264
August Macke (German, Meschede [Westphalia] 1887–1914 Perthes-Les-Hurlus [Champagne])
WOMAN ON A STREET/STRASSE IN THUN, 1914
Charcoal on paper
17.1 x 10.8 cm (6 ¾ x 4 ¼ in.)
Titled and dated in pencil; estate stamp

265
August Macke (German, Meschede [Westphalia] 1887–1914 Perthes-Les-Hurlus [Champagne])
DONKEY RIDER/ESELREITER, 1914
Watercolor on paper
24.5 x 30.5 cm (9 ⅝ x 12 in.)
Estate stamp August Macke

266
Paul Klee (German/Swiss, b. Münchenbuchsee bei Bern, 1879–1940 Muralto, near Locarno)
SELF-PORTRAIT, FULL FACE, HAND

SUPPORTING HEAD/SELBSTPORTRÄT EN FACE, IN DIE HAND GESTÜTZT, 1909
Watercolor on paper mounted on board
16.5 x 13.5 cm (6 ½ x 5 ¼ in.)
Signed top left: Klee; dated lower right in pencil: 1909; inscribed lower right in black ink: 32

267
Paul Klee (German/Swiss, b. Münchenbuchsee bei Bern, 1879–1940 Muralto, near Locarno)
YELLOW HOUSE/GELBES HAUS, 1915
Watercolor and gouache on paper
19.7 x 13.3 cm (7 ¾ x 5 ¼ in.)
Signed center left in black ink: Klee
Inscribed lower left in black ink: 1915.55

268
Paul Klee (German/Swiss, b. Münchenbuchsee bei Bern, 1879–1940 Muralto, near Locarno)
SMALL BLACK DOOR/KLEINE SCHWARZE TÜR, 1915
Watercolor and gouache
16.2 x 12.4 cm (6 ⅜ x 4 ¹⁵/₁₆ in.)
Signed upper left in composition: Klee
Dated and numbered in margin on mount: 1915, 116

269
Paul Klee (German/Swiss, b. Münchenbuchsee bei Bern, 1879–1940 Muralto, near Locarno)
UTOPIAN CONSTRUCTION WITH BOARDS/ UTOPISCHE BRETTERCONSTRUCTION, 1922
Pen and ink and brush and gray wash on paper laid down on board
15.9 x 30.5 (6 ¼ x 12 ⅛ in.)
Signed, dated, and numbered upper right on sheet: 1922 9/12 Klee
Dated and numbered on the artist's mount: 1922/104

270
Paul Klee (German/Swiss, b. Münchenbuchsee bei Bern, 1879–1940 Muralto, near Locarno)
PORTRAIT OF AN EXPRESSIONIST/ BILDNIS EINES EXPRESSIONISTEN, 1922
Tempera on paper mounted on board
31 x 22.2 (12 ¼ x 8 ⅞ in.)
Signed upper right in ink: Klee
Dated upper right in pencil: 1922 9/12
Inscribed center left: 1922 240 Bildnis eines Expressionisten

271
Paul Klee (German/Swiss, b. Münchenbuchsee bei Bern, 1879–1940 Muralto, near Locarno)
STRICKEN DAM /GETROFFENES MUT-TERTIER, 1923
Watercolor
30.5 x 33 cm (12 x 13 in.)
Signed lower left in black ink: Klee; inscribed center border in brown ink: 1923 135 getroffenes Muttertier

272
Paul Klee (German/Swiss, b. Münchenbuchsee bei Bern, 1879–1940 Muralto, near Locarno)
THE MOON WAS ON THE WANE AND SHOWED ME THE GROTESQUE FACE OF AN ENGLISHMAN, A NOTORIOUS LORD/DER MOND WAR IM ABNEHMEN UND ZEIGTE MIR DIE FRATZE EINES ENGLÄNDERS EINES BERÜCHTIGEN LORD'S, 1918
Watercolor on a blue ground paper laid down on board

17.8 x 20.3 cm (7 x 8 in.)
Signed, dated, and titled

273
Paul Klee (German/Swiss, b. Münchenbuchsee bei Bern, 1879–1940 Muralto, near Locarno)
CHINESE NOVELLA/CHINESISCHE NOVELLE, 1922
Watercolor on paper
10 ⅜ x 13 ¹/₁₆ in.
Signed top left in ink: Klee
Dated bottom left on the mount in ink: 1922/80
Titled bottom right on the mount in ink: Chinesische Novelle

274
Paul Klee (German/Swiss, b. Münchenbuchsee bei Bern, 1879–1940 Muralto, near Locarno)
ON THE LAWN/AUF DER WIESE, 1923
Watercolor on paper, mounted on board, with black-and-green-wash border
22.9 x 30.5 cm (9 x 12 in.)
Signed on sheet lower right: Klee
Dated, numbered, and titled center border in green wash: 1923 / 93 Auf der Wiese

275
Paul Klee (German/Swiss, b. Münchenbuchsee bei Bern, 1879–1940 Muralto, near Locarno)
BILLY-GOAT MASK/BOCK-MASKE, 1926
Ink on paper mounted on board
24.1 x 31.8 cm (9 ½ x 12 ½ in.)
Signed upper right: Klee
Dated, numbered, and titled on mount: 1926.W.5. Bock-Maske

276
Paul Klee (German/Swiss, b. Münchenbuchsee bei Bern, 1879–1940 Muralto, near Locarno)
FAIRY TALE PICTURE/MÄRCHENBILD, 1924
Watercolor
38.1 x 27.3 cm (15 x 10 ¾ in.)
Signed upper left in pencil: Klee
Titled lower right in ink: Märchenbild
Dated and numbered lower left in ink: 1924 185

277
Max Beckmann (Leipzig 1884–1950 New York)
THE IDEOLOGUES/DIE IDEOLOGEN, 1919
Black crayon on paper
79.1 x 54.9 cm (31 ⅛ x 21 ⅝ in.)
Signed and dated lower right: Beckmann 1919; titled on bottom: Originalzeichnung zum "Ideologen"

278
Max Beckmann (Leipzig 1884–1950 New York)
FIELD WORKERS/FELDARBEITER, 1928
Chalk, charcoal and gouache on cream watercolor paper primed brick-red
90.1 x 59.6 cm (35 ½ x 23 ½ in.)
Signed and dated lower right: Beckmann / F 28

279
Lovis Corinth (Tapiau 1858–1925 Zandvoort)
PORTRAIT OF RUDOLF GROSSMAN/BILDNIS RUDOLF GROSSMAN, UNDATED
Lithographic crayon and chalk
47.6 x 36.5 cm (18 ¾ x 14 ⅜ in.)
Signed lower right in pencil

280
Lovis Corinth (Tapiau 1858–1925 Zandvoort)
**SELF-PORTRAIT/SELBSTBILDNIS,
1921**
Pencil on heavy gray paper
36.8 x 26.7 cm (14 1/2 x 10 1/2 in.)
Signed lower right: Lovis Corinth
Dated lower center: 26 Januar 1921

281
Otto Dix (German, Gera/Untermhaus 1891–1969
Singen)
**SELF-PORTRAIT, GRINNING, HEAD
RESTING ON HAND/SELBST, GRINSEND,
DEN KOPF AUFGESTÜTZT, 1917**
Black chalk on paper
40.3 x 39.2 cm (15 7/8 x 15 3/8 in.)
Signed and dated upper right: Dix 17

282
Otto Dix (German, Gera/Untermhaus 1891–1969
Singen)
**SELF-PORTRAIT/SELBSTBILDNIS,
1922**
Pen and ink and watercolor on paper
47.5 x 31 cm (18 3/4 x 12 1/4 in.)
Unsigned

283
Otto Dix (German, Gera/Untermhaus 1891–1969
Singen)
**THE SKAT PLAYERS/DIE SKATSPIELER,
1920**
Pencil and brown and black India ink on paper
28 x 21.6 cm (11 x 8 1/2 in.)
Signed lower right in pen and brown ink: Dix

284
Georg Grosz (German, Berlin 1893–1959 Berlin)
NIGHT/NACHTS, 1917
Brush and pen and ink on paper
50.8 x 36.2 cm (20 x 14 1/2 in.)
Signed and dated lower right: Grosz 17

285
Georg Grosz (German, Berlin 1893–1959 Berlin)
**PANORAMA (DOWN WITH LIEBKNECHT)/
PANORAMA (NIEDER MIT LIEBKNECHT),
1919**
Pen and ink and watercolor on paper
48.9 x 34.6 cm (19 3/16 x 13 5/8 in.)
Signed lower right: Grosz

286
Georg Grosz (German, Berlin 1893–1959 Berlin)
**DIABOLO PLAYER/DIABOLO-SPIELER,
1920**
Pen and ink and watercolor on paper
42.9 x 55.7 cm (16 7/8 x 21 7/8 in.)

287
Raoul Hausmann (Austrian, Vienna 1886–1939
Limoges)
**DADA TRIUMPHS (THE EXACTING BRAIN
OF A BOURGEOIS CALLS FORTH A WORLD
MOVEMENT)/DADA SIEGT (EIN BÜRGER-
LICHES PRÄZIONSGEHIRN RUFT EINE
WELTBEWEGUNG HERVOR), 1920**
Watercolor and collage on wove paper mounted on board
59.8 x 42.5 cm (23 5/8 x 17 3/4 in.)

33.5 x 27.5 cm (14 x 10 5/8 in.) according to Comic
Grotesque
Signed and dated in ink lower right: R. Hausmann 1920
Titled center left on black surround: Dada siegt
Inscribed on the reverse (possibly by Hausmann): Ein
bürgerliches präzionsgehirn ruft eine Weltbewegung
hervor

288
Hannah Höch (German, Gotha 1889–1978 Berlin)
**AND WHEN YOU THINK THE MOON IS
SETTING/UND WENN DU DENKST DER
MOND GEHT UNTER, 1921**
Photomontage with collage
21 x 13.4 cm (8 1/4 x 5 1/4 in.)
Signed and dated bottom right in pencil: H. Höch 1921
Titled bottom left in pencil: Und wenn du denkst der mond
geht unter

289
Hannah Höch (German, Gotha 1889–1978 Berlin)
THE SINGER/DIE SÄNGERIN, 1926
Collage of photographic reproductions
27.6 x 27.9 cm (10 7/8 x 11 in.)
Signed lower right in ink: H. Höch, followed by date in
pencil: 1926
Titled lower left in ink: Die Sängerin

290
Kurt Schwitters (German, Hanover 1887–1948
Ambleside)
**MZ 239. WOMAN – WATCH/ MZ 239.
FRAU – UHR, 1921**
Collage (paper on paper)
31.3 x 22.2 cm (12 1/4 x 8 3/4 in.)
Signed and dated lower left in pencil: K. Schwitters 1921
Titled lower left in pencil: MZ.239
Titled lower right in pencil: Frau Uhr

291
Kurt Schwitters (German, Hanover 1887–1948
Ambleside)
**MZ 705. LADY/ MZ 705. DAME,
1923**
Collage (paper on paper)
27 x 21 cm (10 5/8 x 8 1/4 in.)
Signed and dated lower right: K. Schwitters 1923
Titled lower left: MZ 705. Dame

292
Kurt Schwitters (German, Hanover 1887–1948
Ambleside)
**MZ 2013. REALLY NOT SO EXPENSIVE/
MZ 2013. GAR NICHT SO TEUER, 1925**
Collage (oil, paper, plywood, cardboard)
11.2 x 8.9 cm (4 3/8 x 3 1/2 in.)
Signed and dated recto: Kurt Schwitters 1925
Inscribed on the original mount: MZ 2013 gar nicht so
teuer

293
Kurt Schwitters (German, Hanover 1887–1948
Ambleside)
**MZ 30,36 KANDINSKI ABOVE JERUSALEM/
MZ 30,36 KANDINSKI ÜBER JERSUALEM,
1930**
Collage (paper on cardboard)
14.1 x 10.2 cm (5 5/8 x 4 in.)
Signed, dated, and titled lower left in pencil: Kurt
Schwitters 1930/ MZ 30, 36/Kandinski über Jerusalem

294
Marianne Brandt (German, Chemnitz 1893–1983
Kirchberg, Saxony)
ER/ER, HAROLD LLOYD, 1930
Collage
64.8 x 50.2 cm (25 1/2 x 19 3/4 in.)
Signed and dated lower right: Marianne Brandt 30
Titled lower right in blue pen: ER-Harold Lloyd

295
Lilly Reich (German, Berlin 1885–1947 Berlin)
COLLAGE, 1930
Photographs, printed material, stencil, and gouache on
paper
39.1 x 55.6 cm (15 3/8 x 21 7/8 in.)
Signed in pencil lower right: L. Reich; dated below
signature in collage: 1930

296
Christian Schad (German, Miesbach 1894–1982
Stuttgart)
**CONVERSATION BETWEEN FRIENDS/
GESPRÄCH UNTER FREUNDINNEN, 1929**
Ink, colored chalk, and graphite on wove paper
47.6 x 35.6 cm (18 3/4 x 14 in.)
Signed and dated center left in pencil: SCHAD / 29

297
Christian Schad (German, Miesbach 1894–1982
Stuttgart)
**ZACHARIAS I (GROTESQUE)/ ZACHARIAS I
(GROTESKE), 1935**
Colored pencil on cardboard
30.2 x 21.3 cm (11 7/8 x 8 3/8 in.)
Signed and dated lower right: Schad 35

298
Oskar Schlemmer (German, Stuttgart 1888–1943
Baden-Baden)
**THREE WOMEN IN A ROOM/DREI FRAUEN IM
RAUM, 1924**
Watercolor over pencil
23.5 x 17.5 cm (9 1/4 x 6 7/8 in.)

299
Oskar Schlemmer (German, Stuttgart 1888–1943
Baden-Baden)
POINTING MAN/DEUTENDER, 1931
Watercolor, gouache, and pencil on paper
44.5 x 31.8 cm (17 1/2 x 12 1/2 in.)
Inscribed, signed, and dated upper left: Herrn / Fritz
Mosert / freundlichst / zugeeignet / von O Schlemmer /
1931

300
Joseph Beuys (German, Kleve 1921–1986 Dusseldorf)
BAT/FLEDERMAUS, 1958
Beize on double sheet of perforated paper with printed
numbers
20.6 X 26.5 cm (8 1/8 x 10 7/16 in.)
Titled in center in pencil: Fledermaus

301
Joseph Beuys (German, Kleve 1921–1986 Dusseldorf)
**MEETING PLACE, DDR/TREFFPUNKT,
DDR, 1984**
Collage on cardboard
45.7 x 54.7 cm (18 x 21 1/2 in.)
Titled center left in pencil: Treffpunkt DDR
Signed center right in pencil: Joseph Beuys

302
Sigmar Polke (German, Oels, Lower Silesia 1941–2010 Cologne)
UNTITLED/OHNE TITEL, 1979
Mixed media on paper with cut-outs
99.7 x 69.8 cm (39 1/4 x 27 1/2 in.)
Signed lower right center: S. Polke 79

303
Sigmar Polke (German, Oels, Lower Silesia 1941–2010 Cologne)
UNTITLED/OHNE TITEL, 1994
Mixed media on paper
69.8 x 100 cm (27 9/16 x 39 3/8 in.)
Signed and dated lower right in ink: Sigmar Polke 94

304
Georg Baselitz (German, Deutschbaselitz b. 1938–)
UNTITLED (HERO)/OHNE TITEL (HERO), 1965
Pencil and charcoal on tan paper
49.5 x 37.5 cm (19 1/2 x 14 3/4 in.)
Signed lower left in ink: G. Baselitz

305
Markus Lüpertz (German, b. Liberec, Bohemia, 1941–)
SHOVEL AND WHEEL/SCHNAUFEL UND RAD, 1975
Colored chalks on paper
85.1 x 61 cm (33 1/2 x 24 in.)
Signed upper left: Markus

306
Gerhard Richter (German, b. Dresden, 1932–)
48 PORTRAITS/48 BILDNISSE, 1972
48 photographs on cardboard
59.4 x 86 cm (23 3/8 x 33 3/4 in.)
Signed and dated bottom right in pencil: Richter, 1972

307
Anselm Kiefer (German, Donaueschingen b. 1945–)
KHLEBNIKOV, 1969/80
Oil paint over photograph
58.5 x 81.2 cm (23 x 32 in.)
Inscribed in oil: für Chlebnikow/kleine Panzerfaust Deutschland

308
Anselm Kiefer (German, Donaueschingen b. 1945–)
ELISABETH OF AUSTRIA/ELISABETH VON ÖSTERREICH, 1988
Lead on photographic paper mounted on wood
171.1 x 131 cm (67 3/8 x 51 13/16 x 1 5/8 in.)

DECORATIVE ARTS

Furniture

309
Otto Wagner (Austrian, Penzing, near Vienna 1841–1918 Vienna)
VITRINE DESIGNED FOR THE HECKSCHER RESIDENCE, VIENNA 1886
Execution: Portois & Fix, Vienna
French walnut, iron, glass
217.2 x 148.3 x 60.3 cm (85 1/2 58 3/8 x 23 3/4 in.)

310
Otto Wagner (Austrian, Penzing, near Vienna 1841–1918 Vienna)

VITRINE DESIGNED FOR THE HECKSCHER RESIDENCE, VIENNA 1886
Execution: Portois & Fix, Vienna
French walnut, iron, glass
217.2 x 148.3 x 60.3 cm (85 1/2 58 3/8 x 23 3/4 in.)

311
Otto Wagner (Austrian, Penzing, near Vienna 1841–1918 Vienna)
ARMCHAIR FOR THE GOVERNOR'S OFFICE OF THE AUSTRIAN POSTAL SAVINGS BANK, VIENNA 1902–06
Beech, stained red and polished; aluminum fittings and feet; red velvet upholstery
78.11 x 55.56 x 48.9 cm (30 3/4 x 21 7/8 x 19 1/4 in.)

312
Otto Wagner (Austrian, Penzing, near Vienna 1841–1918 Vienna)
ARMCHAIR FROM THE CONFERENCE ROOM OF THE AUSTRIAN POSTAL SAVINGS BANK, VIENNA 1906
Execution: Thonet, Vienna
Beechwood; bentwood, stained greenish black and polished; aluminum fittings; striped olive-green seat fabric
78.1 x 56.5 x 57.2 cm (30 3/4 x 22 1/4 x 22 1/2 in.)

313
Otto Wagner (Austrian, Penzing, near Vienna 1841–1918 Vienna)
RECEPTION DESK FOR THE TELEGRAPH OFFICE OF THE NEWSPAPER DIE ZEIT, VIENNA CA. 1902
Execution: Unknown
Stained and polished wood, with aluminum fittings and leather seat
136.5 x 143.5 x 92.7 cm (53 3/4 x 56 1/2 x 36 1/2 in.)

314
Josef Hoffmann (Austrian, Pirnitz 1870–1956 Vienna)
WRITING DESK FROM THE BEDROOM OF KATHARINA BIACH, VIENNA 1902–03
Execution: Unknown
Wood painted white and black
108.6 x 89.9 x 59.7 cm (42 3/4 x 35 3/8 x 23 1/2 in.)

315
Koloman Moser (Austrian, Vienna 1868–1918 Vienna)
DISPLAY CASE FOR THE SCHWESTERN FLÖGE (FLÖGE SISTERS) FASHION SALON, VIENNA 1904
Execution: Wiener Werkstätte
Maple, stained black and polished; white metal; faceted glass
115.9 x 100 x 49.8 cm (45 5/8 x 39 3/8 x 19 5/8 in.)

316
Koloman Moser (Austrian, Vienna 1868–1918 Vienna)
WRITING DESK FOR MAGDA MAUTNER-MARKHOF, VIENNA CA. 1905
Execution: Unknown
Oak, stained black, grain heightened in white; leather writing area, white metal mounts
121.29 x 150.81 x 81.92 cm (47 3/4 x 59 3/8 x 32 1/4 in.)

317
Koloman Moser (Austrian, Vienna 1868–1918 Vienna)
GROUP OF SEATING FURNITURE FOR LADISLAUS RÉMY-BERZENKOVICH VON SZILLÁS AND MARGARETE HELLMANN,

VIENNA 1904
Execution: Wiener Werkstätte
Black stained wood and green upholstery
Dimensions of settee: 78.5 x 184.5 x 77 cm (30 7/8 x 72 5/8 x 30 3/8 in.)
Dimensions of stool: 40.96 x 39.37 x 39.37 cm (16 1/8 x 15 1/2 x 15 1/2 in.)

318
Adolf Loos (Austrian, Brunn/Brno 1870–1933 Vienna)
MANTELPIECE CLOCK, VIENNA CA. 1902
Execution: Unknown
Nickel frame supporting beveled crystal glass panes, brass mechanism
49.8 x 42.5 x 32.1 cm (19 5/8 x 16 3/4 x 12 5/8 in.)

319
Josef Urban (Austrian, 1872–1933)
MANTELPIECE CLOCK FOR THE PAUL HOPFNER RESTAURANT, VIENNA 1906
Execution: Unknown
Marquetry of thuja and mother-of-pearl, walnut (back), brass nickeled, and brushed, onyx marble. Celluoid dial with numerals in enamel and silvered copper.
57.5 x 51.1 x 18.4 cm (22 5/8 x 20 1/8 x 7 1/4 in.)

320
Marcel Breuer (Pecs, Hungary 1902–1981 New York)
B54 SERVING CART (FIRST VERSION), BERLIN 1928
Execution: Thonet, Frankenberg
Nickel-plated tubular steel, wood-core plywood painted black, rubber wheels
77.5 x 88 x 46.5 cm (30 1/2 x 34 5/8 x 18 1/4 in.)

321
Marcel Breuer (Pecs, Hungary 1902–1981 New York)
CHAISE LONGUE, NO. 313, ZÜRICH 1932
Execution: Embru for Wohnbedarf, 1934 Switzerland
Aluminum, mahogany, original cushion with jacquard-weave cover
75 x 60 x 136.5 cm (30 x 24 x 54 x 53 3/4 in.)

Metalwork

322
Josef Hoffmann (Austrian, Pirnitz 1870–1956 Vienna)
MUSTARD POT, VIENNA 1902
Execution: Alexander Sturm & Company, Vienna
Silver, glass (finial), glass insert
10.16 x 6.35 x 5.72 cm (4 x 2 1/2 x 2 1/4 in.)
Marks: Vienna hallmark, cloverleaf mark

323
Josef Hoffmann (Austrian, Pirnitz 1870–1956 Vienna)
COVERED DISH, VIENNA 1904
Execution: Wiener Werkstätte, model no. S 99 (Josef Husnik)
Silver, carnelian
Marks: Vienna hallmark, JH, JH, WW, rose mark
9.84 x 20.32 cm (3 7/8 x 8 in.)

324
Josef Hoffmann (Austrian, Pirnitz 1870–1956 Vienna)
COFFEE POT, VIENNA 1904
Execution: Wiener Werkstätte, adaptation of model no. S 292 Adolf Erbrich)
Silver, ebony
Marks: Vienna hallmark, JH, AE, WW rose mark
24.4 x 5.7 x 16.8 cm (9 5/8 x 2 1/4 x 6 5/8 in.)

325
Josef Hoffmann (Austrian, Pirnitz 1870–1956 Vienna)
COFFEE POT PURCHASED BY JENNY MAUTNER AND MORIZ SCHUR FOR KÄTHY BREUER (NÉE MAUTNER), VIENNA 1906
Execution: Wiener Werkstätte, model no. S650 (Alfred Mayer)
Silver, snakewood
Marks: Vienna hallmark, JH, WW, AM, rose mark
22.9 x 19.4 x 15.2 cm (9 x 7 ⁵/₈ x 6 in.)

326
Josef Hoffmann (Austrian, Pirnitz 1870–1956 Vienna)
CENTERPIECE ACQUIRED BY H. HIRSCHWALD (HOHENZOLLERN-KUNST-GEWERBEHAUS, BERLIN), VIENNA 1904
Execution: Wiener Werkstätte, model no. S267 (Josef Hoszfeld)
Silver, malachite
21.6 x 33.9 x 33.9 cm (8 ¹/₂ x 13 ³/₈ x 13 ³/₈ in.)
Marks: Vienna hallmark, JH, JH, WW, rose mark

327
Josef Hoffmann (Austrian, Pirnitz 1870–1956 Vienna)
TRAY, VIENNA 1904
Execution: Wiener Werkstätte, model no. M 329
Silver-plated alpacca, blue opaque glass
Marks: JH, WW, rose mark
6.35 x 33.02 x 28.89 cm (2 ¹/₂ x 13 x 11 ³/₈ in.)

328
Josef Hoffmann (Austrian, Pirnitz 1870–1956 Vienna)
FIVE PIECES FROM THE FLAT MODEL FLATWARE SERVICE, CONSISTING OF CRAB FORK, SARDINE SERVER, PASTRY SERVING SPOON, CHEESE KNIFE, AND BUTTER KNIFE, VIENNA 1904-08
Execution: Wiener Werkstätte, model nos. S 204, 231, 1009 (1907), 213, 214
Silver
Marks: Vienna hallmark, JH, WW rose mark
Length, pastry serving spoon: 17.3 cm (6 ³/₄ inches)

329
Josef Hoffmann (Austrian, Pirnitz 1870–1956 Vienna)
SPOON, VIENNA 1905
Execution: Wiener Werkstätte (Alfred Mayer)
Silver, almandine, amethyst, coral, lapis lazuli, malachite, moonstone
14.92 X 4.76 cm (5 ⁷/₈ x 1 ⁷/₈ in.)

330
Josef Hoffmann (Austrian, Pirnitz 1870–1956 Vienna)
BOX ACQUIRED BY EMILIE FLÖGE, VIENNA 1905
Execution: Wiener Werkstätte, model no. S 585
Marks: Vienna hallmark, JH, WW, JW, rose mark
10.5 x 15.2 x 10.5 cm (4 ¹/₈ x 6 ¹/₁₆ x 4 ¹/₈ in.)

331
Josef Hoffmann (Austrian, Pirnitz 1870–1956 Vienna)
BOX, VIENNA 1910
Execution: Wiener Werkstätte, model no. S 1027 (Adolf Wertnik)
Silver; parcel-gilt (interior)
Marks: Vienna hallmark, JH, AW, WW, WIENER/WERK/STÄTTE, rose mark
12.1 x 12.1 x 12.1 cm (4 ³/₄ x 4 ³/₄ x 4 ³/₄ in.)

332
Josef Hoffmann (Austrian, Pirnitz 1870–1956 Vienna)
BONBONNIÈRE **ACQUIRED BY PAUL WITTGENSTEIN, VIENNA 1905**
Execution: Wiener Werkstätte, model no. S 332 (Alfred Mayer)
Silver, onyx
Marks: Vienna hallmark, JH, AM, WW, rose mark
H. 10.3 cm; diam: 4.1 in. (H. 4 ³/₈; diam: 3 ¹/₂ in.)

333
Josef Hoffmann (Austrian, Pirnitz 1870–1956 Vienna)
BONBONNIÈRE, **VIENNA 1906**
Execution: Wiener Werkstätte, model no. S 485 (Josef Hoszfeld)
Silver, lapis lazuli
Marks: Vienna hallmark, JH, JH, WW, rose mark
18.1 x 11.43 x 11.43 cm (7 ¹/₈ x 4 ¹/₂ x 7 ¹/₂ in.)

334
Koloman Moser (Austrian, Vienna 1868–1918 Vienna)
COFFER GIVEN BY GUSTAV MAHLER TO ALMA MAHLER FOR CHRISTMAS 1902, VIENNA 1902
Execution: Alexander Sturm & Company, Vienna
Silver, coral
Marks: Vienna hallmark, cloverleaf mark
13.5 cm square (5 ³/₈ in.)

335
Koloman Moser (Austrian, Vienna 1868–1918 Vienna)
TRAY ACQUIRED BY FRITZ WAERNDORFER FOR LINA HELLMANN, VIENNA 1904
Execution: Wiener Werkstätte, model no. S 270 (Alfred Mayer)
Silver, ivory, lapis lazuli
Marks: Vienna hallmark, KM, AM, WW, rose mark
25.2 x 10.1 x 10.1 cm (5 ⁷/₈ x 10 ¹/₈ x 10 ¹/₈ in.)

336
Koloman Moser (Austrian, Vienna 1868–1918 Vienna)
MUSTARD POT ACQUIRED BY LEOPOLDINE "POLDY" WITTGENSTEIN (NÉE KALLMUS), VIENNA 1905
Execution: Wiener Werkstätte, model no. S 458
Silver, agate, opal, moonstone, tiger's eye, tourmaline, jade, glass insert
Marks: Vienna hallmark, KM, WW rose mark
H. 10.1 (4 in.)

337
Koloman Moser (Austrian, Vienna 1868–1918 Vienna)
JEWELRY BOX, VIENNA 1907
Execution: Wiener Werkstätte, model no. S 914 (Adolf Erbrich)
Silver, ebony, agate
Marks: Vienna hallmark, KM, AE, WW, rose mark
12.54 x 27.62 x 16.99 cm (4 ¹⁵/₁₆ x 10 ⁷/₈ x 6 ¹¹/₁₆ in.)

338
Josef Hoffmann (Austrian, Pirnitz 1870–1956 Vienna)
BROOCH ACQUIRED BY HELENE DONNER (NÉE KLIMT), VIENNA 1907
Execution: Wiener Werkstätte, model no. G 686
Silver, partly gilt; agate, coral, lapis lazuli, malachite, turquoise, semi-precious stones
Marks: Vienna hallmark, WW, silver hallmark
5.1 x 5.1 cm (2 x 2 in.)

339
Josef Hoffmann (Austrian, Pirnitz 1870–1956 Vienna)
BROOCH, VIENNA 1908
Execution: Wiener Werkstätte, model no. G 1031
Silver, partly gilt; agate, almandine, carnelian, chrysoprase, coral, lapis lazuli, moonstone, opal, turquoise
Marks: Vienna hallmark, WW, silver hallmark
5.4 x 5.4 cm (2 ¹/₈ x 2 ¹/₈ in.)

340
Josef Hoffmann (Austrian, Pirnitz 1870–1956 Vienna)
BROOCH, VIENNA 1907
Execution: Wiener Werkstätte, model no. G 727
Silver, emerald, opal
Marks: Vienna hallmark, WW, silver hallmark
3 x 4 cm (1 ¹/₈ x 1 ⁵/₈ in.)

341
Josef Hoffmann (Austrian, Pirnitz 1870–1956 Vienna)
BROOCH, VIENNA 1912
Execution: Wiener Werkstätte, model no. S 2451
Silver, malachite
Marks: Vienna hallmark, JH, WW, silver hallmark
5.1 x 5.1 cm (2 x 2 in.)

342
Josef Hoffmann (Austrian, Pirnitz 1870–1956 Vienna)
BROOCH, VIENNA 1908
Execution: Wiener Werkstätte, model no. G 1034
Silver, partly gilt; agate, amethyst, bloodstone, jasper, coral, lapis lazuli, moonstone, opal, tourmaline, and other semi-precious stones
Marks: WW
5.4 x 5.4 cm (2 ¹/₈ x 2 ¹/₈ in.)

343
Josef Hoffmann (Austrian, Pirnitz 1870–1956 Vienna)
BROOCH ACQUIRED BY BERTA WAERNDORFER, VIENNA 1907
Execution: Wiener Werkstätte, model no. G 688
Silver, partly gilt; lapis lazuli
Marks: Vienna hallmark, JH, WW, rose mark, silver hallmark
5 x 5 cm (2 x 2 in.)

344
Josef Hoffmann (Austrian, Pirnitz 1870–1956 Vienna)
BROOCH, VIENNA 1911
Execution: Wiener Werkstätte, model no. G 1297 (Eugene Pflaumer)
Silver, partly gilt; carnelian, chrysoprase, coral, malachite
Marks: Vienna hallmark, JH, WW, silver hallmark
4 x 5.2 cm (1 ⁵/₈ x 2 in.)

345
Josef Hoffmann (Austrian, Pirnitz 1870–1956 Vienna)
BELT BUCKLE ACQUIRED BY EMILIE FLÖGE, VIENNA 1910
Execution: Josef Souval for the Wiener Werkstätte, model no. M 106
Copper, enamel, gilding
Marks: WIENER/WERK/STÄTTE
6 x 6 cm (2 ³/₈ x 2 ³/₈ in.)

INDEX

PHOTOGRAPH
AND COPYRIGHT CREDITS

We wish to thank the museums, galleries, and individuals named in the captions of plates and text illustrations for supplying the photographic material in this publication. Photographer's contributions are gratefully acknowledged below.

Photograph Credits

Art Resource, New York pp. 10 (bottom right) The Museum of Modern Art, New York, 11 (top) The Museum of Modern Art, New York, 11 (bottom) The Museum of Modern Art, New York, 14 (bottom, Photo: George Meguerditchian) CNAC/MNAM/Dist. Réunion des Musées Nationaux, 124 The Museum of Modern Art, New York, 126 The Museum of Modern Art, New York, 130 CNAC/MNAM/Dist. Réunion des Musées Nationaux, 133 The Museum of Modern Art, New York, 134 (bottom) CNAC/MNAM/Dist. Réunion des Musées Nationaux, 135 The Museum of Modern Art, New York, 137 The Museum of Modern Art, New York

Courtesy Gerhard Richter and Marian Goodman Gallery, New York pp. 138, 290-291, 298, 299, 300, 301, 470-471

Courtesy Sotheby's p. 38 (top)

Daniel Kukla for André Maier Photography p. 96

Donald Sigovich, New York pp. 19, 20, 26, 47 (bottom), 88, 90, 93, 110 (bottom left), 111, 112 (bottom left), 115 (bottom), 117 (bottom), 118, 119, 278, 279, 320-321, 322, 323, 324, 325, 326, 327, 328, 329, 330, 331, 332, 333, 334, 335, 336, 337, 338, 339, 340, 341, 342, 343, 344, 345, 346, 347, 348, 349, 350, 351, 352, 353, 354, 355, 356, 357, 358, 359, 361, 362, 363, 364, 365, 366, 367, 368-369, 371, 372, 373, 376, 378, 380, 381, 382, 383, 384, 385, 386, 387, 389, 390, 391, 392, 393, 394, 395, 396, 397, 398, 399, 400, 401, 402, 403, 405, 414-415, 417, 418, 419, 420, 421, 422, 423, 424, 425, 426, 427, 429, 431, 432, 433, 436, 437, 438, 439, 440, 442, 443, 444, 445, 447, 448, 449, 451, 452, 453, 454, 455, 456, 457, 458, 459, 460, 461, 462, 463

Frederick Elghanayan p. 18

Harvard Art Museum / Fogg Art Museum p. 123

Hulya Kolabas, New York pp. 16, 27, 30, 31, 39, 41 (top right), 43, 44, 45, 46, 47 (top), 49, 50, 51, 52, 73, 77, 78, 79, 80, 81, 83, 84, 94, 101, 102 (top), 104, 105, 107, 130 (top), 131, 144, 145, 146 (bottom), 147, 149, 150 (bottom), 152, 155, 156, 157, 160, 161, 162, 168-169, 170, 171, 172, 173, 174, 175, 176, 177, 178, 179, 180, 182-183, 186, 187, 188, 189, 190, 191, 192, 193, 194, 195, 196, 197, 198, 199, 200, 201, 202, 203, 204, 205, 206, 207, 208-209, 210-211, 224, 225, 238, 239, 245, 246, 247, 248, 249, 270-271, 276, 277, 302, 303, 311, 314, 315, 466, 467, 478-479, 480, 481, 482, 483, 485, 486, 487, 488, 489, 494-495, 496, 497, 498, 499, 500, 501, 502, 503, 504, 505, 506, 507, 508, 509, 510, 511, 520, 521

John Gilliland, New York p. 255

Laure Albin-Guillot/Roger-Viollet p. 10

Lillian Birnbaum p. 6

Mark Heithoff p. 2

Neue Galerie New York pp. 98, 100, 117

Patrick McMullan p. 10 (top)

Sari Goodfriend p. 12 (top)

Copyright Credits

© Anselm Kiefer

© 2011 Artists Rights Society (ARS), New York, for Paul Klee

© 2011 Artists Rights Society (ARS), New York / Pechstein Hamburg / Toekendorf / VG Bild-Kunst, Bonn

© 2011 Artists Rights Society (ARS), New York / VBK, Vienna, for Adolf Loos

© 2011 Artists Rights Society (ARS), New York / VG Bild-Kunst, Bonn, for Max Beckmann, Joseph Beuys, Marianne Brandt, Otto Dix, Lyonel Feininger, Erich Heckel, Hannah Höch, Ludwig Mies van der Rohe, Gabrielle Münter, Karl Schmidt-Rottluff, Kurt Schwitters, Eugen Schönebeck, Günther Uecker, William Wauer

© 2011 Brice Marden / Artists Rights Society (ARS), New York

© 2011 Christian Schad Aschaffenburg / ARS, New York / VG Bild-Kunst, Bonn

© 2011 Eberhard Spangenberg / Artists Rights Society (ARS), New York / VG Bild-Kunst, Bonn

© Ellsworth Kelly

© Estate Martin Kippenberger, Galerie Gisela Capitain, Cologne

© 2011 Estate Oskar Schlemmer, Munich

© 2011 Estate of Pablo Picasso / Artists Rights Society (ARS), New York

© Estate of Robert Rauschenberg / Licensed by VAGA, New York, NY

© The Estate of Jörg Immendorff, Courtesy Galerie Michael Werner Märkisch Wilmersdorf, Köln & New York

© 2011 The Estate of Sigmar Polke / ARS, New York / VG Bild-Kunst, Bonn

© 2011 Fondation Oskar Kokoschka / Artists Rights Society (ARS), New York / VG Bild-Kunst, Bonn, for Oskar Kokoschka

© Georg Baselitz

© Gerhard Richter

© Markus Lüpertz / Artists Rights Society (ARS), New York / VG Bild-Kunst, Bonn

© 2011 Mondrian / Holtzman Trust c/o HCR International Washington DC

© 2011 Richard Serra / Artists Rights Society (ARS), New York

© 2011 Sucession H. Matisse / Artists Rights Society (ARS), New York